W9-BUL-457

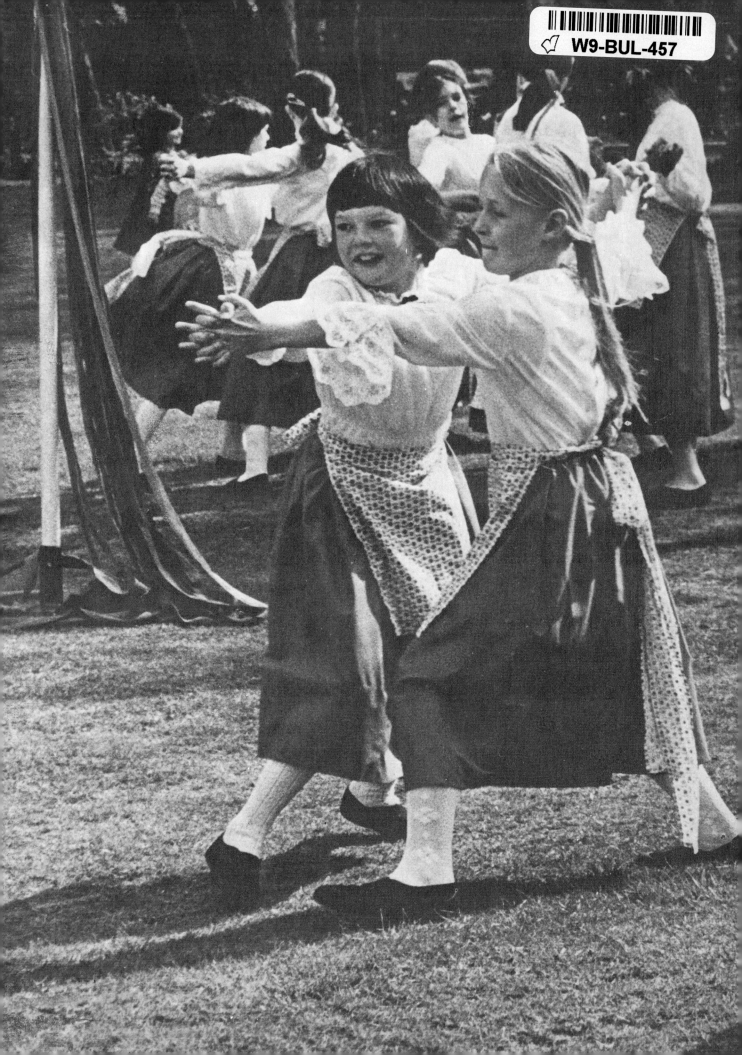

PHOTOGRAPHY
YEAR BOOK
1981
INTERNATIONALES
JAHRBUCH DER
FOTOGRAFIE 1981

Photography
Year Book
1981

Edited by R. H. Mason FIIP, Hon. FRPS

**INTERNATIONALES JAHRBUCH
DER FOTOGRAFIE 1981**

 FOUNTAIN PRESS

Deutsche Ausgabe: Wilhelm Knapp Verlag, Düsseldorf

Fountain Press,
Argus Books Ltd,
14 St James Road,
Watford, Herts,
England
ISBN 0 85242 732 8

Deutsche Ausgabe:
Wilhelm Knapp Verlag,
Niederlassung der Droste Verlag GmbH
4000 Düsseldorf I
ISBN 3 87420 127 9

© Argus Books Ltd, 1980
Published October 1980

All rights reserved. No part of this
book may be reproduced in any form
or by any means without the
permission of Argus Books Ltd

Typography & Layout by Kaye Bellman

Origination by Sun Litho Ltd

Printed on Clansman Art 135 gsm, supplied by McNaughton Publishing Papers Ltd

Printed and bound in Great Britain by
Morrison & Gibb Ltd, London and Edinburgh

CONTENTS INHALT

The Photographers / Die Fotografen

Introduction by The Editor

Ever since the *Photography Year Book* was first introduced, nearly 50 years ago, it has endeavoured to be representative of the year's best work. In the early days it was largely confined to commercial, news and advertising photography by professionals, but gradually amateurs' pictures were introduced, although there was still a predominance of news and photo-journalistic material.

In the 1980 edition the base was broadened to include all schools and types of photography other than the specialist spheres such as medicine, science and purely commercial or record applications. The proportion of amateur work to professionals' was approximately 50:50.

Judged by the sales and reviews it enjoyed, this policy was well received and the only critical review was written by the *Technical Editor* of a weekly photographic magazine who innacurately quoted from my introduction and twisted it to make a specious point!

Pictures of war, violence and mayhem have been omitted because they are ephemeral and have been widely published, or featured on television. Likewise, the pictures of suffering in underdeveloped countries do not have a place in this book because there are others which cater for them. On the other hand, there are a number of excellent news photos which feature sport or the more pleasant aspects of life, and which qualify for inclusion because they are original or artistic. The majority of these, mostly taken by provincial news photographers, have not, for one reason or another, been widely published.

The criterion for selection throughout has been a high degree of originality or evidence of creative ability and distinction. The whole entry was examined without any reference to authorship and the result is that some photographers are featured more than once, in spite of the enormous amount of work submitted. Some of them have even appeared in previous years, which shows a remarkably consistent high standard. The method of selection has also ensured that many new names have appeared, and they come from 29 different countries. However, as was to be expected, the much larger number of submissions by British photographers has resulted in a proportionately larger number of reproductions by them.

It is customary in annuals to draw conclusions about new trends in photography that have been observed during the year. In my opinion this is far too short a period to identify any new movement and it might be wiser to look over the last decade. Three things spring to mind. The first is that there has been a much greater sincerity in approach and the candid picture has become universally acceptable. For example, portraits taken in formal studio settings with static poses, pseudo-classical backgrounds and multi-directional lighting have been largely superseded by outdoor portraits of the subjects in action and in appropriate or characteristic environment. There is a much more frank approach to figure photography, and the days of the coy or shivering pose on the edge of a lake, entitled "September Morn" have gone. Today the models gaze directly at the camera and appear to be enjoying the occasion. Landscapes also have a refreshing, new look and the romantic serenity of chocolate box scenes in soft focus has almost disappeared, except on traditional calendars.

The second most noticeable trend in recent years has been in the use of wide-angle lenses. At one time their use was mainly confined to architectural interiors, but now they have to a large extent taken over from the standard 50 mm lenses on 35 mm cameras. A glance through the data pages at the back of this book shows the wide adoption of 24 mm and 28 mm lenses, especially by press photographers, and many pictorially minded amateurs have come down from 50 mm to 35 mm. Long focus lenses are naturally still popular with portraitists and sports photographers, but where the latter are not forced to use them because of the distance from the subject, they seem to prefer wide-angle lenses.

The third noticeable trend is confined to black and white work. It is an emphasis on low key and very rich blacks, often coupled with a lot of grain. Even jet black backgrounds, once condemned, seem to have become *de rigueur*. This even applies to portraiture. They were usually employed only for low key male portraits, but now even glamorous subjects are often given this treatment. Surprisingly, black backgrounds seem to project an even more glamorous look than the high key "souffles" of the past.

Landscapes in very low key, from low viewpoints and taken with wide-angle lenses have become popular and are very effective because they are more powerful in their impact than those lighter prints which formerly graced our pages. Bill Brandt originated the approach that is typified by men in flat caps pushing bikes up grimy cobbled streets, and this theme is well in evidence these days.

A by-product of the trend towards frankness in photography has been a wide acceptance of humour. An exhibition of funny pictures staged by Kodak in 1976 was very popular and it has obviously encouraged more people to submit work of this type to exhibitions and publications. Most of it is of a whimsical nature and those we have reproduced show that such photographs can also be artistic and well composed.

This year we saw a large number of prints depicting rear views of people and animals, some humorous, but mostly of the "walking-into-the-distance" variety. They were reminiscent of the endings of old movies. They also explode the myth that rear views are not so interesting as frontals—in some cases they are better, especially in the context of the modern presentation already mentioned.

Sir Joshua Reynolds, the first president of the Royal Academy, once said "A painter has but one sentence to utter, one moment to exhibit", but Sir Hugh Casson, a more recent president of the R.A. said that the artist's desire to shock and provoke was even more tedious than the despised desire to please. "Natural curiosity," he said, "tempted people to ask not how they could make something better, but how they could make it different. For an artist to make every picture a manifesto would only encourage the willing eccentric, the charlatan and the peacock." His words are worth thinking about because that same desire to shock is evident in a lot of modern photography. There is room for every type of approach and the best annual or exhibition is always the one that shows all schools of work. Too many magazines and exhibitions in recent years have been dominated by the ultra-modernists with a "shock or hit-'em-in-the-eye" approach and the result is boredom or monotony because they cancel each other out and thus lose the impact they were intended to create.

It has always been my view that black and white work gives more scope for originality in presentation because of the greater scope for modification in the darkroom, and the modern trend for low key and lots of grain makes it even easier to get away from the realism of the snapshot or factual record.

True, one can modify colour to some extent, but colour itself is one step nearer to realism than black and white. Nevertheless, in the hands of the true artist, creative pictures are possible and I hope that those in this book will give as much pleasure and interest as the black and white plates.

Unfortunately, the popularity of 35 mm cameras and the growing use of motor drives cause a lot of people to use them like Sten guns, but often not one shot hits the target. It is a strange fact that these "gunmen" will submit a lot of misses and near-misses; sometimes as many as thirty of them, whereas in black and white they are quite selective and only submit their best!

In previous decades we have seen a lot of pictures that were copies of successful exhibits in previous years, but never so good. They appear to have been produced more for the sake of fashion than for genuine art. They attempt to give a spurious authenticity to undistinguished subject matter by means of derivations or "darkroom gymnastics". Perhaps it is another by-product of the candid approach to all forms of modern art that is reducing the numbers of copyists.

Oscar Wilde wrote that only an auctioneer should attempt to appreciate every school of art, and likewise I would not expect the reader to like every picture in this book. I can only hope that those plates which do not find favour will at least stimulate the imagination and that, taken as a whole, the collection will give pleasure as well as a new interest on every page, together with an hour or two's happy browsing. There should be plenty of food for thought, even controversy.

Readers are welcome to submit the best of their work for the 1982 edition of *Photography Year Book* and a leaflet giving details of requirements will be found in this volume. Failing that, a copy can be obtained by writing to Fountain Press. Please make sure that technical data are included with your photographs because they are so useful for beginners as well as interesting to all.

R. H. Mason

Inleiding Door de Samensteller

Het streven van de samensteller van dit jaarboek (de eerste editie van de Engelse uitgave verscheen bijna vijftig jaar geleden) is altijd geweest representatief te zijn voor het beste werk van het jaar. Aanvankelijk ging het grotendeels om werk van professionele fotografen op allerlei gebied, maar in de loop der jaren werden steeds meer amateurfoto's opgenomen, hoewel de nieuws- en journalistieke foto's bleven overheersen.

In de uitgave van 1980 werd de basis verbreed teneinde alle richtingen in de fotografie te kunnen omvatten. De verhouding tussen amateurbijdragen en professioneel werk was ruwweg 50:50.

Foto's van oorlogen, geweld en baldadigheid zijn niet opgenomen. Dit zijn eendagsvliegen die in de pers of andere media voldoende aandacht kregen. Ook foto's over het leed in onderontwikkelde gebieden krijgen in dit boek geen plaats; er zijn andere geschiktere media voor.

Anderzijds zijn er wel een aantal uitstekende nieuwsfoto's opgenomen met als onderwerp sport of andere plezierige aspecten van het leven, die zich kwalificeerden door hun originaliteit of kunstzinnigheid.

Het criterium voor selectie was een hoge mate van originaliteit of een duidelijke uiting van creatief kunnen en onderscheidings vermogen. De inzendingen werden beoordeeld zonder dat de auteurs bekend waren. Het gevolg is dat sommige fotografen meer dan eens voorkomen, ondanks de enorme totale hoeveelheid werk die werd ingezonden.

Er zijn ook namen bij die in vorige jaarboeken reeds voorkwamen, hetgeen wijst op een continu hoog peil. Ook veel nieuwe namen zult u in de lijst van fotografen tegenkomen, waarin 29 landen vertegenwoordigd zijn. Dat het grootste aantal afkomstig is uit Engeland heeft te maken met het feit dat het aantal inzendingen uit dat land een veelvoud was dan die uit andere landen.

Het is gewoonte in een jaarboek conclusies te trekken over nieuwe trends in de fotografie die in het afgelopen jaar konden worden bespeurd. Naar mijn mening is zo'n periode veel te kort om een nieuwe richting te herkennen en het lijkt me verstandiger naar de laatste tien jaren te kijken.

Drie dingen komen mij dan op de lippen. Ten eerste dat er een grotere oprechtheid is in de benadering en dat de candid-foto algemeen geaccepteerd wordt. Bijvoorbeeld: portretten opgenomen in formele studio's met statische poses, pseudo-klassieke achtergronden en licht uit alle richtingen zijn grotendeels verdreven door spontane opnamen van de personen ·in de buitenlucht of in passende of karakteristieke omgeving. Er is een meer open benadering van de figuurfotografie en de dagen van de kuise pose aan de oever van een meer onder de titel "september morgen" zijn voorbij. Vandaag kijken de modellen recht in het objectief; zij lijken van de situatie te genieten. Ook landschappen kregen een verfrissend nieuw uiterlijk en de romantische softfocus scénes zijn weer bijna verdwenen.

De tweede meest opvallende trend in de laatste jaren is het gebruik van groothoekobjectieven. Vroeger werden zij voornamelijk gebruikt voor interieurfoto's, maar nu hebben zij in hoge mate de taak van de standaardobjectieven (50 mm) op kleinbeeldcamera's overgenomen. Een blik door de technische gegevens achterin dit boek toont de frequente toepassing aan van 24 en 28 mm objectieven, vooral door persfotografen. Veel creatief ingestelde amateurs gingen terug van 50 naar 35 mm. Objectieven met langere brandpuntsafstanden zijn vanzelfsprekend nog steeds populair bij portret- en sportfotografen, doch ook deze laatste categorie neigt – indien teleobjectieven niet per sé noodzakelijk zijn door de afstand tot het motief – vaak over naar het gebruik van groothoek.

De derde opmerkelijke trend heeft alleen met zwartwit te maken. Hier ligt duidelijk de nadruk op lowkey en diepe zwarten, vaak gekoppeld aan grove korrel. Zelfs gitzwarte achtergronden, eens verguisd en veroordeeld, schijnen in zwang te zijn gekomen. Dit geldt ook voor de portretfotografie. Vroeger werden zij alleen toegepast bij lowkey portretten van mannen, maar nu vaak ook bij "glamour"-foto's. Merkwaardig genoeg lijken zwarte achtergronden meer aan de uitstraling van deze foto's bij te dragen dan de vroeger gebruikelijke highkey – achtergronden.

Landschappen in sterk lowkey, uit lage standpunten gefotografeerd met groothoekobjectieven zijn populair geworden en zijn sterker in hun impact dan de lichtere foto's die vorige jaarboeken sierden.

Een bijverschijnsel van de trend naar eerlijkheid in de fotografie is een bredere acceptatie van de humor. Aanzienlijk meer mensen zenden tegenwoordig dergelijk werk in voor tentoonstellingen en publikaties. Het meeste is van luchtige aard; wat wij in dit jaarboek bieden toont aan dat zulke foto's ook artistiek en goed opgebouwd kunnen zijn.

Dit jaar zagen wij een groot aantal foto's van achteraanzichten van mens en dier; sommige humoristisch, maar meestal van de "in-de-verte-verdwijnende" soort. Zij doen denken aan het slot van oude filmdraken. Zij rekenen ook af met het sprookje dat achteraanzichten niet zo interessant zouden zijn als vooraanzichten. In sommige gevallen zijn ze zelfs beter, vooral in het kader van de eerder genoemde moderne presentatie.

Ik ben altijd van mening geweest dat zwartwit werk meer ruimte geeft voor originaliteit in presentatie wegens de mogelijkheden voor manipulatie in de donkerekamer. De moderne trend naar lowkey en grove korrel maken het nog gemakkelijker te ontsnappen uit het realisme van het snapshot of de feitelijke registratie. Het is waar, men kan ook met kleur tot op zekere hoogte spelen, maar kleur op zich is een stap dichterbij de realiteit dan zwartwit. Neittemin, in de handen van een echt kunstenaar zijn creatieve foto's mogelijk en ik hoop dan ook dat de kleurenfoto's in dit boek met evenveel genoegen en belangstelling zullen worden bekeken als de zwartwitfoto's.

Helaas is de populariteit van de kleinbeeldreflex camera en het groeiende gebruik van motoraandrijving voor velen aanleiding de camera als een soort stengun te gaan gebruiken, echter vaak zonder een enkele treffer te behalen. Het is een merkwaardig feit dat veel fotografen een groot aantal mislukte of bijna mislukte kleurenfoto's inzendt – soms wel dertig! – terwijl ze bij zwartwit bijzonder selectief te werk gaan en uitsluitend het allerbeste inzenden!

In vorige decennia hebben we veel foto's gezien die kopieën waren van succesvolle opnamen uit de jaren daarvoor, maar altijd wat minder goed. Zij lijken meer te zijn gemaakt vanwege de kunst. Zij pogen een valse authenticiteit te geven aan oninteressante motieven door middel van vervreemdingen of "donkerekamer-gymnastiek".

Wellicht is het een ander bijverschijnsel van de eerlijke benadering in alle vormen van kunst dat leidt tot vermindering van het aantal na-apers.

Oscar Wilde schreef eens dat alleen een veilingmeester moet proberen alle richtingen in de kunst te appreciëren. Ik verwacht dan ook niet dat elke lezer alle foto's in dit boek zal waarderen. Ik hoop slechts dat de platen die niet voor 100% worden gewaardeerd toch de verbeelding zullen stimuleren en dat als geheel genomen het *Focus Elsevier Fotojaarboek 1981* op elke pagina veel genoegen zal bieden en belangstelling zal wekken. De met deze uitgave doorgebrachte uurtjes zullen voldoende stof tot nadenken geven.

Zowel amateur- als vakfotografen worden gaarne uitgenodigd hun beste werk in te zenden voor de uitgave 1982 van dit jaarboek. Inlichtingen geeft de uitgeefster, Uitgeversmaatschappij Elsevier Focus B.V. te Amsterdam.

Voeg aan uw inzendingen steeds zoveel mogelijk technische gegevens toe. Zij zijn nuttig voor beginners en belangwekkend voor alle andere lezers.

R. H. Mason

Einführung des Redakteurs

Das *Jahrbuch der Fotografie* war stets, seit seiner Einführung vor nahezu 50 Jahren, als Sammlung der besten fotografischen Leistungen des Jahres gedacht. Anfänglich beschränkte es sich weitgehend auf kommerzielle, journalistische und Werbeaufnahmen von Berufsfotografen, doch allmählich hielten auch von Amateuren gelieferte Fotografien darin Einzug, obgleich die Sektoren der Nachrichtenfotografie und der Fotojournalistik nach wie vor vorherrschen.

Die weiter gespannte Ausgabe 1980 erstreckte sich auf alle Schulen und Arten der Fotografie mit Ausnahme der spezialisierten medizinischen, wissenschaftlichen und rein kommerziellen bzw. dokumentarischen Bereiche. Die Amateure und Berufsfotografen waren zu annähernd gleichen Teilen vertreten.

Nach den Absätzen und Rezensionen zu schliessen, erfreute sich diese Politik allgemeiner Beliebtheit. Die einzige ablehnende Kritik kam von dem *technischen Redakteur* einer fotografischen Wochenschrift, der Teile meiner Einführung falsch zitierte und verkehrt auslegte, um einen fragwürdigen Einwand zu beweisen!

Aufnahmen, deren Themen Krieg, Gewalttaten und unmenschliches Verhalten sind, wurden ausgelassen, da ihr Interesse flüchtig ist und sie bereits weite Verbreitung in der Presse oder durch das Fernsehen gefunden haben. Auch Bilder der Not in Ländern der dritten Welt haben in diesem Werk keine Aufnahme gefunden, da bereits andere Sammlungen dafür bestehen. Andererseits bringen wir eine Anzahl ausgezeichneter journalistischer Aufnahmen, die sportliche Ereignisse bzw. die angenehmeren Aspekte des Lebens veranschaulichen und sich durch Originalität oder künstlerischen Wert auszeichnen. Die meisten davon stammen von Pressefotografen in der Provinz und wurden aus dem einen oder anderen Grunde nicht allgemein veröffentlicht.

Den Prüfstein für die Auswahl bildeten durchwegs hochgradige Originalität oder Beweise schöpferischen Könnens und schöpferischer Errungenschaft. Den Prüfern war nicht bekannt, von wem die einzelnen Fotografien stammten, und dies hat zur Folge gehabt, dass trotz der riesigen Teilnahme gewisse Fotografen durch mehr als ein Bild vertreten sind.

Die Werke gewisser Künstler wurden bereits in früheren Jahren veröffentlicht – ein Beweis für die erstaunliche Konsistenz und hohe Güte ihrer Arbeit. Die Methode der Auswahl hat auch sichergestellt, dass viele neue Namen – aus insgesamt 29 verschiedenen Ländern – vertreten sind. Erwartungsgemäss reichten jedoch britische Fotografen viel mehr Aufnahmen ein, so dass die Anzahl ihrer Bilder auch entsprechend grösser ist.

In Jahrbüchern ist es üblich, über neue Strömungen der Fotografie zu berichten, die während des Jahres in Erscheinung getreten sind. Meiner Ansicht nach kann sich eine neue Bewegung in einer so kurzen Zeitspanne nicht deutlich abzeichnen, und es mag weiser sein, das ganze Jahrzehnt "unter die Lupe zu nehmen". Dabei fallen uns drei Dinge auf: Erstens ist die Fotografie viel ehrlicher geworden, und unbemerkte Aufnahmen sind heute allgemein annehmbar. So sind zum Beispiel in förmlichen Ateliers aufgenommene Porträts, die durch statische Posen, pseudoklassische Hintergründe und vielseitige Beleuchtung gekennzeichnet waren, weitgehend durch im Freien aufgenommene Porträts verdrängt worden, die die Personen in Aktion und in entsprechender oder charakteristischer Umgebung

zeigen. Auch unter dem Titel "Septembermorgen" gebotene Aktaufnahmen von schüchtern am Ufer eines Sees bebenden Modellen gehören der Vergangenheit an. Heute blicken sie unentwegt in die Kamera und scheinen an der Situation Vergnügen zu finden. Auch Landschaften werden heute auf erfrischend neue Weise dargestellt, und ausser in traditionellen Kalendern findet man die einst so beliebte zuckersüss-malerische Romantik praktisch nicht mehr.

An zweiter Stelle unter den in den letzten Jahren stattgefundenen Entwicklungen wäre die Verbreitung der Weitwinkelobjektive zu nennen. Einst war ihre Anwendung hauptsächlich auf Innenarchitektur beschränkt, doch nun werden sie bei 35 mm Kameras oft anstelle der normalen 50 mm Objektive verwendet. Ein Blick auf die technischen Seiten am Ende dieses Buches zeigt, wie beliebt 24 und 28 mm Objektive heute sind, besonders bei Pressefotografen. Auch viele an bildmässiger Fotografie interessierte Amateure sind von 50 auf 35 mm übergegangen. Selbstverständlich sind langbrennweitige Objektive auch heute noch bei Porträt- und Sportfotografen beliebt, doch auch die letzteren scheinen Weitwinkelobjektive zu bevorzugen, wenn sie aus Entfernungsgründen nicht unbedingt von langbrennweitigen Objektiven Gebrauch machen müssen.

Die dritte interessante Tendenz betrifft nur Schwarzweissfotografien. Sie besteht in der Betonung überwiegend dunkler Bildtöne und sehr kräftiger Schwarztöne in Verbindung mit erheblicher Körnigkeit. Selbst kohlschwarze Hintergründe, die einst als unannehmbar galten, scheinen heute *de rigueur* zu sein. Dies gilt sogar für Porträts. Früher waren sie in der Regel auf dunkel getönte Porträtaufnahmen von Männern beschränkt, doch nun werden auch erotisch ansprechende Themen auf diese Weise behandelt. Erstaunlicherweise scheinen schwarze Hintergründe in erotischer Hinsicht effektvoller zu sein als die überwiegend hellen "Soufflés" der Vergangenheit.

In sehr dunklen Farbtönen, von niedrig gelegenen Gesichtspunkten aus mit Weitwinkelobjektiven aufgenommene Landschaftsbilder sind zur Zeit beliebt und ausserordentlich wirksam, da sie einen viel stärkeren Eindruck hinterlassen als jene leichter beschwingten Aufnahmen, die wir einst zu bevorzugen pflegten. Für diese Tendenz sind z.B. Aufnahmen von Männern in Schirmmützen typisch, die Fahrräder entlang schmutziger gepflasterter Gassen schieben – ein Thema, das heute stark vertreten ist. Übrigens war Bill Brandt ein Pionier dieser Kunstrichtung.

Ein Nebenprodukt der zunehmenden Aufrichtigkeit der Fotografie bildete die allgemeine Annahme des Humors. Eine von Kodak 1976 veranstaltete Ausstellung spassiger Aufnahmen erfreute sich sehr grosser Beliebtheit und hat offensichtlich mehr Leute dazu ermutigt, entsprechende Arbeiten zur Ausstellung und Veröffentlichung anzubieten. Weitgehend handelt es sich dabei um schrullige Bilder, doch erweisen die von uns veröffentlichten Aufnahmen, dass auch sie künstlerisch und gut geplant sein können.

Dieses Jahr wurden zahlreiche Kopien unterbreitet, die Hinteransichten von Menschen und Tieren zeigen. Einige davon waren humoristischer Art, doch die meisten gehörten der "Weg in die Ferne"-Sorte an. Sie erinnerten an die Schlussaufnahmen alter Filme. Übrigens erweisen sie, dass der alte Mythos, demzufolge ein Rücken

weniger interessant ist als eine Vorderansicht, keineswegs berechtigt ist. In gewissen Fällen sind solche Aufnahmen sogar besser, besonders bei Gebrauch der bereits erwähnten modernen Techniken.

Sir Joshua Reynolds, der erste Präsident der Royal Academy, sagte einmal: "Ein Maler kann nur eine einzige Festellung machen, nur einen einzigen Augenblick veranschaulichen," doch Sir Hugh Casson, ein neuerer Präsident der R.A., erklärte, der Wunsch des Künstlers zu schockieren und zu provozieren sei noch langweiliger als der verpönte Wunsch zu gefallen. "Natürliche Neugier," sagte er, "liegt der Frage zugrunde, wie etwas anders gemacht werden kann – und nicht, wie man es besser machen könte." "Wenn jedes Werk eines Künstlers ein Bekenntnis sein müsste, so würde dies nur fanatische Eigenbrötler, Scharlatane und eitle Laffen ermutigen." Diese Worte sollten auch wir uns zu Herzen nehmen, denn einem Grossteil der modernen Fotografie liegt der gleiche Wunsch zu schockieren zugrunde. Es führen viele Wege zur Kunst, und das beste Jahrbuch bzw. die interessanteste Ausstellung vereinigt stets alle künstlerischen Strömungen. In den letzten Jahren befanden sich zuviele Zeitschriften und Ausstellungen im Banne der Ultramodernen, die um jeden Preis schockieren wollten, und das Ergebnis war Langeweile bzw. Eintönigkeit, da sie einander neutralisierten und somit die angestrebte Wirkung vernichteten.

Ich habe stete die Ansicht vertreten, dass Schwarzweissfotografie mehr Raum für Originalität der Darstellung bietet, da die Möglichkeiten zur Modifikation in der Dunkelkammer grösser sind. Auch ist es dank der modernen Tendenz dunkel getönter Aufnahmen mit starker Körnigkeit besonders leicht, dem Realismus des Schnappschusses und der sachlichen Aufnahme den Rücken zu kehren. Zwar stimmt es, dass sich auch Farbe in gewissem Masse modifizieren lässt, doch ist Farbe an und für sich dem Realismus um einen Schritt näher als Schwarz und Weiss. Trotzdem kann der wahre Künstler auch bei Farbfotografie wertvolle und interessante Aufnahmen erzielen, und ich hoffe, dass die in diesem Buch enthaltenen Beispiele ebenso viel Vergnügen und Interesse erregen werden wie die Schwarzweissaufnahmen.

Leser können ihre besten Aufnahmen für die Ausgabe 1982 einreichen, und wir fügen eine Druckschrift mit Einzelheiten hinsichtlich der Erfordernisse bei. Auf Wunsch ist diese aber auch von der Fountain Press erhältlich. Bitte geben Sie bei jeder Aufnahme auch die technischen Einzelheiten an, da diese für Anfänger besonders nützlich und für jeden Leser von Interesse sind.

R. H. Mason

Introduction du Rédacteur en Chef

Depuis que le *Photography Year Book* a fait pour la première fois son apparition il y a près de cinquante ans, il n'a eu d'autre but que de se montrer représentatif des meilleurs travaux de l'année. A ses débuts, il était essentiellement limité à la photographie commerciale, journalistique et publicitaire des professionnels, mais progressivement des photographies d'amateurs y trouvèrent place, bien qu'il y eût toujours une certaine prédominance des photographies de reportage et de photojournalisme.

Dans l'édition de 1980, la base a été élargie de manière à représenter toutes les écoles et tous les types en dehors des domaines spécialisés de la médecine, de la science et des applications purement commerciales ou à caractère historique. La rapport entre les travaux d'amateurs et les travaux de professionnels était d'environ 50:50.

Le chiffre des ventes qu'il a atteint et les commentaires qu'il a suscités sont la preuve que cette politique a été bien accueillie, la seule analyse critique dont il ait été l'objet étant due au rédacteur technique d'un magazine photographique hebdomadaire, qui a cité, d'ailleurs de manière inexacte, mon introduction en la déformant pour en faire un point spécieux.

Les images de guerre, de violence et de mutilation ont été omises en raison de leur caractère éphémère et parce qu'elles ont été largement publiées ou présentées à la télévision. De même, les images de la souffrance dans les pays en voie de développement n'ont pas leur place dans un tel ouvrage parce qu'il en existe d'autres qui leur sont consacrés. En revanche, il s'y trouve un certain nombre d'excellentes photographies de reportage donnant une vision du sport ou des aspects les plus agréables de la vie, et qui méritent d'y figurer parce qu'elles sont originales ou artistiques. La plupart d'entre elles, généralement prises par des reporters de province, n'ont pas, pour telle ou telle raison, reçu une diffusion très large.

Le critère général de sélection retenu a été un haut degré d'originalité ou la marque d'une capacité créatrice et d'une originalité affirmées. Toutes les photographies ont été examinées sans tenir compte des auteurs, d'où il résulte que certains photographes sont représentés par plusieurs de leurs oeuvres, en dépit de la masse considérable des photographies que nous avons reçues. Il est même des photographes qui ont vu certains de leurs travaux publiés dans des éditions précédentes, ce qui est la preuve d'une qualité remarquablement constante. La méthode de sélection a également eu pour effet de faire sortir de l'ombre bon nombre de noms nouveaux, représentatifs de vingt-neuf pays. Toutefois, comme on pouvait s'y attendre, la part nettement prédominante des images envoyées par des photographes britanniques s'est traduite par une part proportionnellement plus importante de reproductions des oeuvres de ces photographes.

Dans toute publication annuelle, il est d'usage de tirer des conclusions sur les nouvelles tendances de la photographie observées au cours de l'année. A mon avis, c'est là une période beaucoup trop courte pour pouvoir distinguer un mouvement nouveau, et il serait peut-être plus avisé de jeter un regard rétrospectif sur la dernière décennie. Trois constatations s'imposent immédiatement. La première est que l'approche traduit une beaucoup plus grande sincérité et que la photographie prise sur le vif est aujourd'hui universellement acceptable. Par exemple, les portraits pris dans un décor de studio avec des poses statiques, des arrière-plans pseudo-classiques et un éclairage multidirectionnel ont été largement dépassés par les portraits en extérieur de sujets en action évoluant dans un environnement approprié et caractéristique. On constate également une approche beaucoup plus franche dans la photographie des personnes, et l'époque de la pose timide ou frissonnante au bord d'un lac, sous le titre "Matin de septembre", appartient maintenant au passé. Aujourd'hui, les modèles regardent directement l'appareil photographique et semblent s'en féliciter. Les paysages aussi apparaissent sous un jour nouveau rafraîchissant, et la sérénité romantique des scènes légèrement floues qui illustraient jadis les boîtes de chocolat a presque disparu, sauf sur les calendriers traditionnels.

La deuxième tendance remarquable de ces dernières années est l'utilisation des grands angles. Il fut un temps où leur emploi était principalement limité aux intérieurs architecturaux, mais aujourd'hui ils ont dans une large mesure pris le relais des objectifs standard de 50 mm sur les appareils de 35 mm. Un coup d'oeil sur les pages de caractéristiques techniques regroupées à la fin du présent album montre que les objectifs de 24 mm et de 28 mm ont été largement adoptés, en particulier par les photographes de presse, et que de nombreux amateurs ayant un sens aigu de la photographie ont abandonné les objectifs de 50 mm pour ceux de 35 mm. Les téléobjectifs sont naturellement toujours très populaires chez les portraitistes et chez les photographes sportifs, mais lorsque ces derniers ne sont pas contraints de les utiliser en raison de l'éloignement du sujet, ils semblent préférer les grands angles.

La troisième tendance remarquable est limitée aux photographies en noir et blanc. Elle traduit l'accent mis sur les noirs très sombres et sur les noirs très riches, qui vont souvent de pair avec un grain très marqué. Même les arrière-plans noir de jais, naguère condamnés, semblent être aujourd'hui de rigueur. Cela s'applique même aux portraits. Ils étaient généralement utilisés pour les portraits d'hommes en sombre, mais, aujourd'hui, même les sujets de mode bénéficient souvent du même traitement. De manière assez surprenante, les arrière-plans noirs semblent créer une ambiance encore plus envoûtante que les "soufflés" lumineux du passé.

Les paysages très sombres pris en contre-plongée avec de grands angles sont devenus très populaires et sont très parlants parce qu'ils ont une force d'impact plus grande que les images qui autrefois embellissaient nos pages. Bill Brandt est à l'origine de la photographie dont l'exemple le plus typique représente un groupe d'hommes en casquette noire poussant des bicyclettes et remontant des rues pavées noircies, et ce thème s'est aujourd'hui nettement affirmé.

Un sous-produit de la tendance à la franchise en matière de photographie est la large place faite à l'humour. Une exposition de photographies amusantes organisée par Kodak en 1976 a remporté un franc succès et a manifestement encouragé nombre de photographes à présenter des travaux de cette nature tant dans les expositions que dans les publications. La plupart de ces photographies sont de nature bizarre, et celles que nous avons reproduites montrent qu'elles peuvent aussi être artistiques et bien composées.

Cette année, nous avons vu un grand nombre de photographies décrivant des vues de dos de personnes et d'animaux, certaines humoristiques, mais la plupart du temps du genre "qui se perd dans le lointain". Elles rappellent la fin des vieux films. Elles font également éclater le mythe selon lequel les vues de dos ne sont pas aussi intéressantes que les vues de face: or, dans certains cas, elles sont meilleures, en particulier dans le contexte de la présentation moderne déjà mentionnée.

Sir Joshua Reynolds, premier président de la Royal Academy, a dit qu' "Un peintre n'a qu'une phrase à dire, un seul moment à présenter", mais Sir Hugh Casson, l'un de ses successeurs plus proches de nous à la présidence de la Royal Academy, a déclaré que le désir de l'artiste de choquer et de provoquer était encore plus fastidieux que le désir méprisé de plaire. "La curiosité naturelle, a-t-il dit, a incité les gens à demander non pas comment ils pourraient faire quelque chose mieux, mais comment ils pourraient le faire de manière différente". "Pour un artiste, faire de chaque tableau un manifeste ne pourrait qu'encourager l'excentrique, le charlatan et le paon." Ses mots méritent réflexion parce que ce même désir de choquer est évident dans nombre de photographies modernes. Il y a place pour toutes les formes d'approche et le meilleur annuaire ou la meilleure exposition sont toujours ceux qui présentent toutes les écoles. Trop nombreux sont les magazines et les expositions qui, ces dernières années, ont été dominés par les ultra-modernistes, défenseurs du choquant, d'où résultent l'ennui ou la monotonie parce qu'ils s'annulent l'un l'autre et perdent ainsi l'impact qu'ils avaient pour but de créer.

J'ai toujours estimé que les travaux en noir et blanc ouvrent un plus vaste champ à l'originalité de la présentation en raison des plus larges possibilités de modification en chambre noire qu'ils permettent, et la tendance moderne aux teintes sombres et au grain très marqué fait qu'il est même plus facile de s'affranchir du réalisme de l'instantané ou de l'enregistrement des faits. Sans doute est-il possible, dans une certaine mesure, de modifier la couleur, mais la couleur elle-même est plus proche du réalisme que le noir et blanc. Néanmoins, entre les mains d'un véritable artiste, les photographies créatrices sont possibles, et j'espère que celles que contient le présent album procureront autant de plaisir et susciteront autant d'intérêt que celles en noir et blanc.

Les lecteurs qui souhaiteraient envoyer leurs meilleures réalisations pour l'édition 1982 du *Photography Year Book* sont cordialement invités à le faire, et une brochure donnant tous les détails à fournir à cette fin est encartée à la fin du présent album. A défaut, on peut s'en procurer un exemplaire en écrivant à Fountain Press. Mais veillez à ce que les caractéristiques techniques accompagnent vos photographies, car elles sont éminemment utiles pour les débutants et intéressantes pour tous.

R. H. Mason

Introducción del editor

Desde su primera aparición, hace ya casi cincuenta años, se ha procurado convertir al *Photography Year Book* en una muestra representativa de las mejores fotografías producidas durante el año. En las primeras ediciones se incluyeron, prácticamente en exclusiva, instantáneas inscritas en los campos del comercio, la publicidad o la información obtenidas por profesionales, pero poco a poco se fueron introduciendo fotografías tomadas por aficionados, sin dejar, sin embargo, de dar preponderancia a las primeras.

En la edición de 1980 se ensancharon las "puertas" de admisión para dar entrada a todas las escuelas y tipos de fotografía con la única excepción de las esferas extremadamente especializadas tales como la fotografía científica o médica y la de fines puramente comerciales. La proporción entre obras de profesionales y aficionados fue aproximadamente de 50:50.

Si nos atenemos al volumen de ventas y a las críticas que se nos han dedicado, esta nueva orientación ha sido muy bien recibida y todavía hay que decir que el único comentario desfavorable lo escribió el responsable de la *sección técnica* de una revista fotográfica semanal a base de desvirtuar unos párrafos de mi introducción para utilizarlos en contra nuestra.

Hemos omitido las imágenes de guerra, violencia y desastres porque su propio tema las convierte en efímeras y porque, por otra parte, la televisión se cuida ya de llevarlas a todos los hogares. Tampoco las imágenes que recogen los sufrimientos que desgraciadamente han de soportar todavía los habitantes de muchos países subdesarrollados encuentran aquí un espacio, debido a que existen otras publicaciones que les otorgan especial prominencia. Pero sí se incluyen imágenes de grandes acontecimientos deportivos o centradas en la captación de otros aspectos agradables de la actividad humana cuando poseen una fuerte originalidad y evidentes virtudes artísticas. La mayoría de ellas, por otra parte, han sido tomadas por fotógrafos de periódicos de provincias y no se las ha difundido excesivamente.

El criterio de selección utilizado ha sido el de juzgar las fotos recibidas en base a su originalidad y a la evidencia proporcionada de la capacidad creativa de su autor. El examen de las fotografías se ha llevado a cabo sin conocer la identidad de sus autores, lo que viene demostrado por el hecho de que se hayan incluido varias obras de algunos fotógrafos a pesar de la enorme cantidad de trabajos recibidos. Una parte de estos fotógrafos vieron ya sus obras introducidas en ediciones anteriores, con lo que demuestran mantenerse a un inspirado nivel artístico. Pero también aparecen muchos nombres nuevos, procedentes de veintinueve países distintos. De todas formas, y como era de esperar, Gran Bretaña continúa siendo la nación más representada, ya que de ella nos han llegado bastantes más fotografías que de los demás países.

En las recopilaciones fotográficas anuales resulta de rigor el sacar conclusiones sobre las características generales que han prevalecido durante el año. Yo estoy convencido, sin embargo, de que se trata de un período excesivamente corto para detectar nuevos movimientos, por lo que me parece más indicado extender el examen a toda la década anterior. Son tres los rasgos más característicos. El primero es la general aceptación de la necesidad de reflejar los temas de la forma más sincera posible. Así, por ejemplo, los retratos tomados en el estudio en poses estáticas, con fondos clásicos e iluminación multidireccional han sido desplazados por los retratos exteriores de modelos en movimiento y situados en un ambiente apropiado o característico. Hoy en día el fótógrafo se encara a las figuras humanas con mucha más franqueza y las poses recatadas en las orillas de un lago tituladas "Mañana de Septiembre" o algo parecido parecen haber desaparecido para siempre. Ahora las modelos miran directamente a la cámara y parecen pasárselo bien. También los paisajes han sufrido variaciones y la serenidad romántica de las escenas habituales en las cajas de bombones ha desaparecido también por completo, excepto en los calendarios más tradicionales.

El segundo rasgo típico de estos últimos años ha sido el gran incremento experimentado por el uso de los objetivos gran angular. Antiguamente su uso estaba confinado a la captación de interiores arquitectónicos monumentales, pero actualmente han llegado a desplazar a los objetivos de 50 mm como los más habituales incorporados a las cámaras de 35 mm. Una rápida ojeada a las páginas de este libro en las que constan los detalles técnicos de las fotografías incluidas nos muestra claramente la gran difusión experimentada por los objetivos de 24 y 28 mm, especialmente entre los fotógrafos de prensa, mientras que muchos aficionados han sustituido los de 50 mm por los de 35 mm. Los objetivos de foco largo son todavía utilizados con profusión por los retratistas y los fotógrafos deportivos, pero estos últimos tienden también a sustituirlos por objetivos gran angular en los casos en que no se ven obligados a servirse de los primeros por motivo de la distancia.

El tercer rasgo característico afecta solamente a los trabajos en blanco y negro. Se trata del énfasis puesto en los tonos bajos, con negros muy densos a menudo combinados con la introducción del grano. Los fondos en negro azabache, rechazados hace poco, parecen ser hoy en día *de rigor*, incluso en los retratos. Todavía recientemente se los utilizaba tan sólo en los retratos masculinos de tonos bajos, pero ahora se da muy a menudo este tratamiento a los sensuales retratos de beldades femeninas. Lo sorprendente es que estos fondos negros proporcionan al retrato mayor espectacularidad que los acentuados "soufflés" utilizados normalmente hasta ahora.

También se han popularizado los paisajes en tonos muy apagados, tomados desde puntos de vista bajos con objetivos gran angular, y hay que reconocer que resultan realmente eficaces porque producen mayor impacto que las instantáneas mucho más claras que tanto abundaban antiguamente en nuestras páginas. Por otra parte, Bill Brandt fue el creador de un tipo de temas muy popular en estos últimos años que podríamos tipificar en la visión de hombres con la cabeza cubierta con gorras aplanadas empujando bicicletas a lo largo de tristes calles empedradas. Quedará sorprendido al ver la abundancia de imágenes de esta clase en las páginas siguientes.

Un rasgo derivado de la visión más realista adoptada últimamente por los fotógrafos ha sido la introducción del humor en las instantáneas. El gran éxito obtenido por la exposición sobre temas humorísticos organizada por Kodak en 1976 ha animado a los fotógrafos a enviar trabajos de este tipo a las publicaciones y exposiciones. Muchos de estos trabajos llevan incorporados detalles fantásticos o caprichosos; pero ello no es óbice para que su composición y calidad artística resulten excelentes.

Este año hemos recibido gran número de instantáneas con personas y animales vistos desde atrás; en algunas el autor ha perseguido un objetivo humorístico y en casi todas los protagonistas aparecen alejándose de la cámara, lo que nos lleva a asociar estas imágenes con los finales de las películas producidas en los primeros tiempos del cine. Por otra parte, los autores se apoyan, para causar más impacto, en el hecho de que se haya popularizado la creencia de que las vistas posteriores no son tan interesantes como las frontales, mostrándonos que en realidad pueden llegar a resultar en múltiples casos mucho más eficaces.

Sir Joshua Reynolds, el primer presidente de la Royal Academy, dijo en cierta ocasión: "Un pintor sólo tiene una frase que proferir, un momento que ofrecer," pero Sir Hugh Casson, otro presidente de la venerable institución, dijo que el deseo de provocación en un artista era todavía más criticable que el deseo de gustar a toda costa. "La curiosidad natural," continuó, "nos lleva a menudo a preguntarnos no cómo podríamos desarrollar mejor cierta actividad, sino cómo podríamos desarrollarla de forma diferente." "Si los artistas estuvieran obligados a convertir a cada una de sus obras en un manifiesto, sólo los excéntricos, los charlatanes y los *pavos reales* podrían dedicarse a la producción de obras de arte." Merece la pena tener en cuenta estas palabras porque el deseo de commocionar al espectador se hace a menudo aparente en la fotografía actual. Ello motiva que muchas revistas se excedan en la cantidad de instantáneas chocantes seleccionadas para su publicación con el resultado de aburrir a los lectores con su insoportable monotonía. A nostros nos parece, en cambio, que en una publicación deben caber todas las tendencias, sin favoritismos para ninguna.

Siempre he pensado que los trabajos en blanco y negro ofrecen al fotógrafo mayores posiblidades de ser original en su presentación ya que se pueden introducir modificaciones más variadas en el cuarto oscuro; ello se ha visto confirmado en las fotografías recibidas este año y hay que decir que la popularidad de los tonos bajos y de los efectos obtenidos mediante la introducción del grano ha facilitado todavía más a los artistas el desmarcarse del realismo fácil de la pura instantánea descriptiva. Y no es que resulte imposible introducir modificaciones en el color, pero de hecho éste se halla ya de por sí más cerca de la realidad que el blanco y negro. El verdadero artista, sin embargo, es perfectamente capaz de manejar el color de un modo creativo y espero que las fotografías en color reproducidas en el libro le resulten tan agradables de ver como las que están en blanco y negro.

Quiero invitar finalmente a todos los lectores de este libro a que nos envíen sus fotografías para su posible inclusión en el *Photography Year Book de 1982*; aténganse, por favor, a las instrucciones indicadas en el folleto que acompaña a este libro. Si no lo encontraran, escriban a Fountain Press y les mandaremos una copia. No dejen de hacer constar los detalles técnicos relativos a sus instantáneas, ya que además de ser útil para los principiantes resulta de interés para todos los lectores.

R. H. Mason

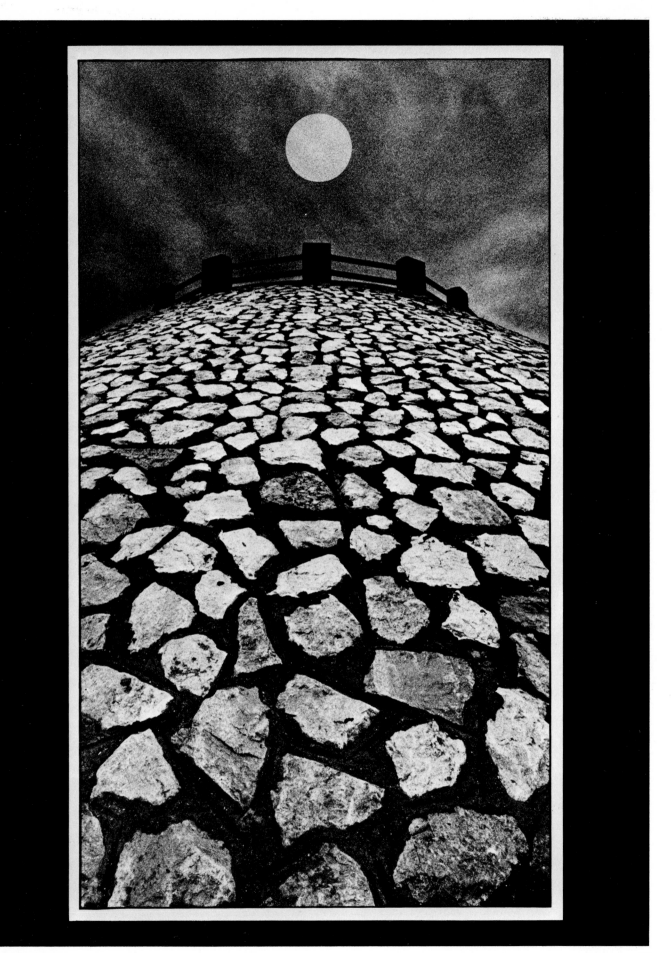

Patrick Trevor

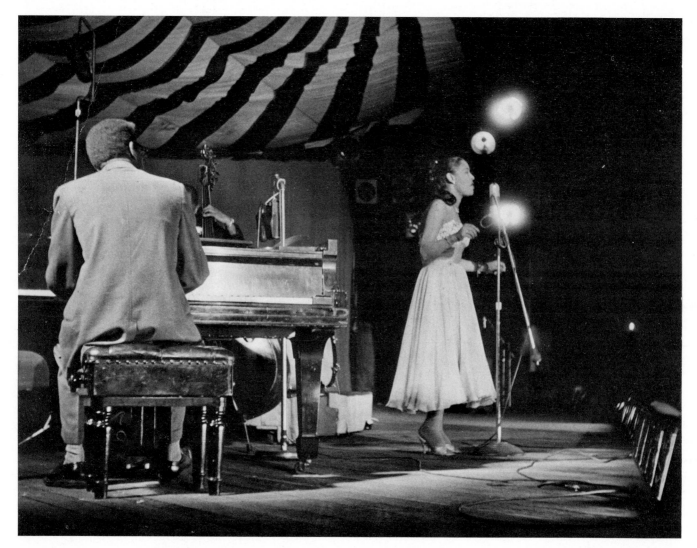

George W. Martin

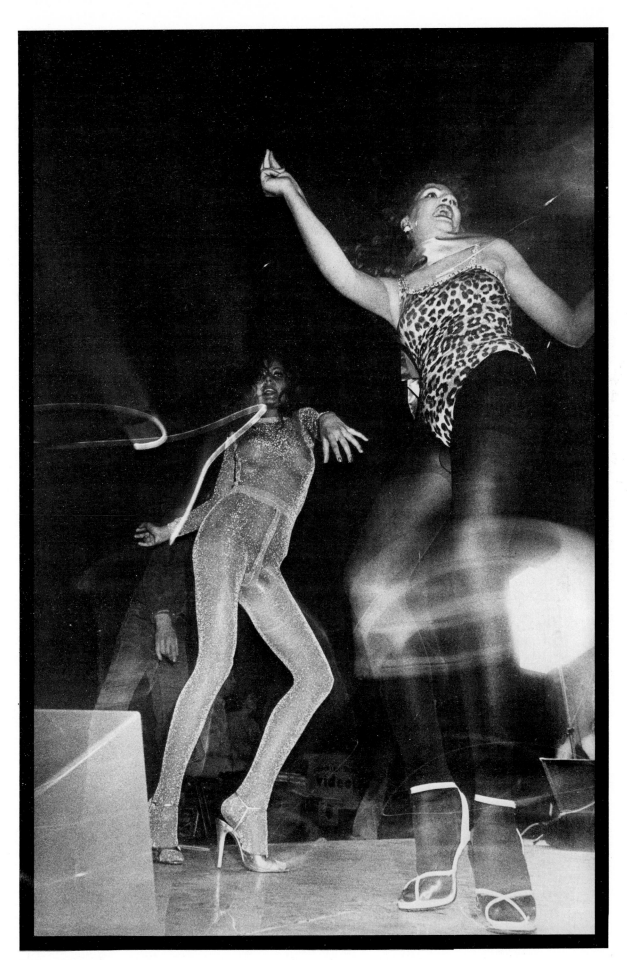

Peter Hense

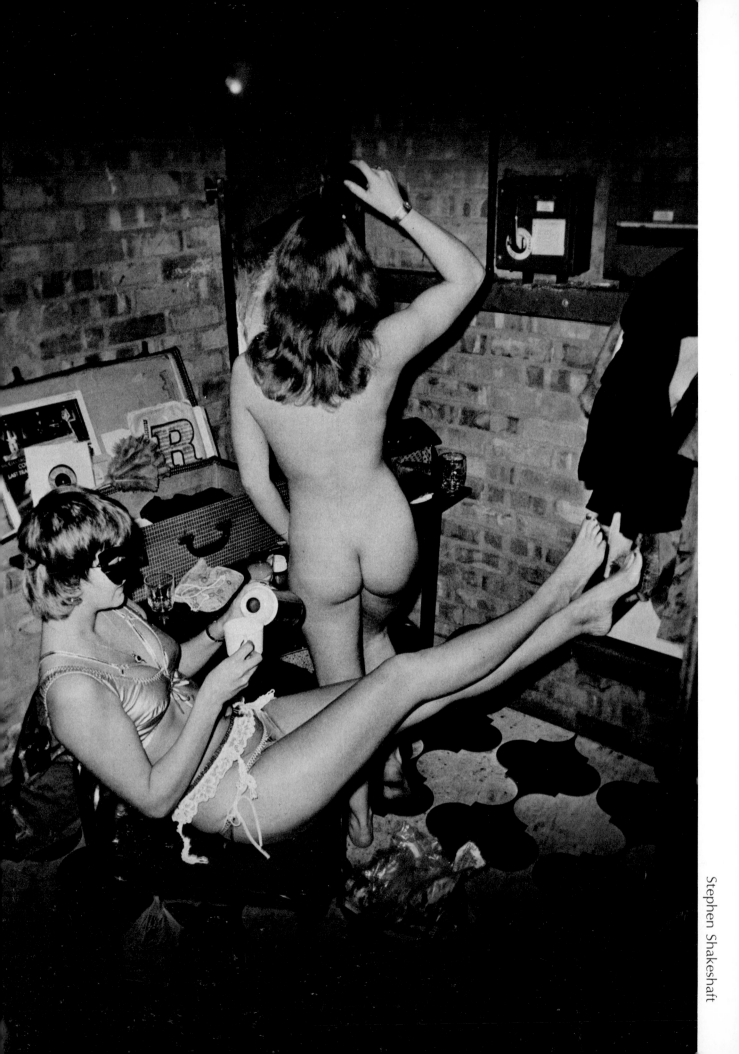

Stephen Shakeshaft

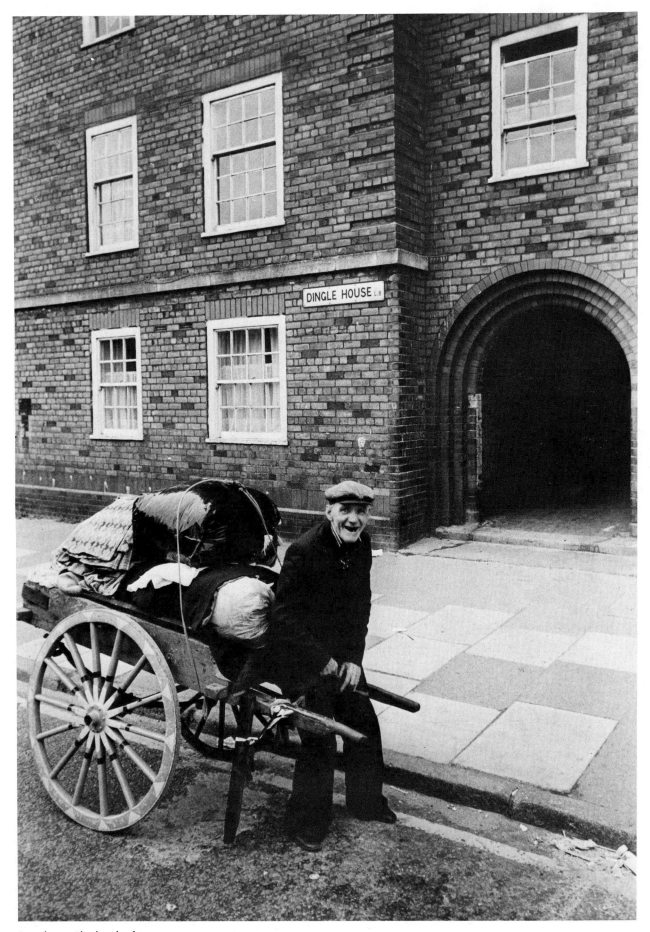

Stephen Shakeshaft

Rainer Kemper

Iain R. Smith

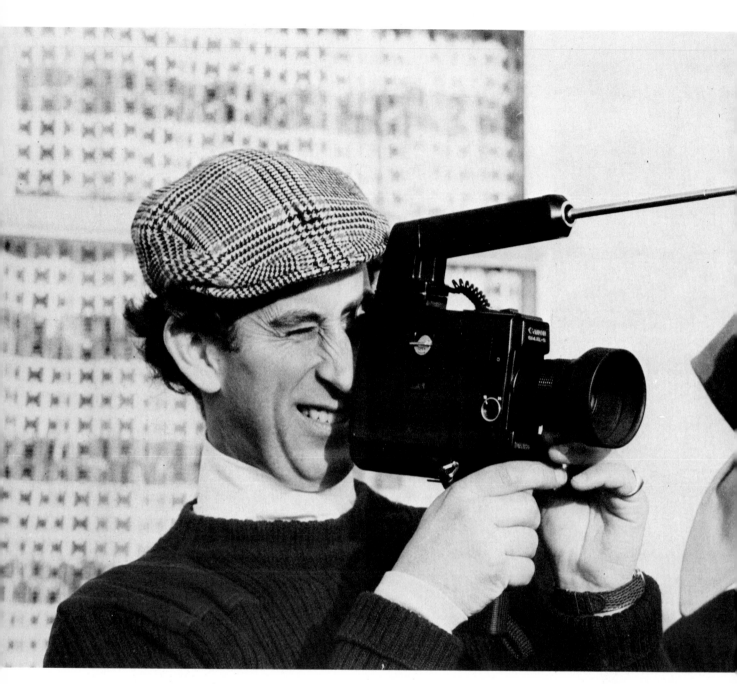

John Walker

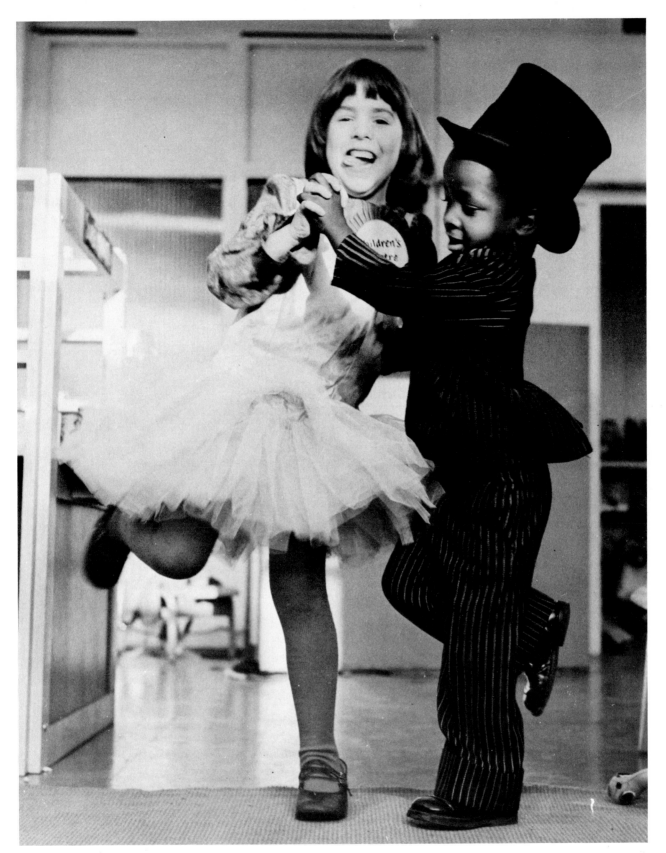

John Walker

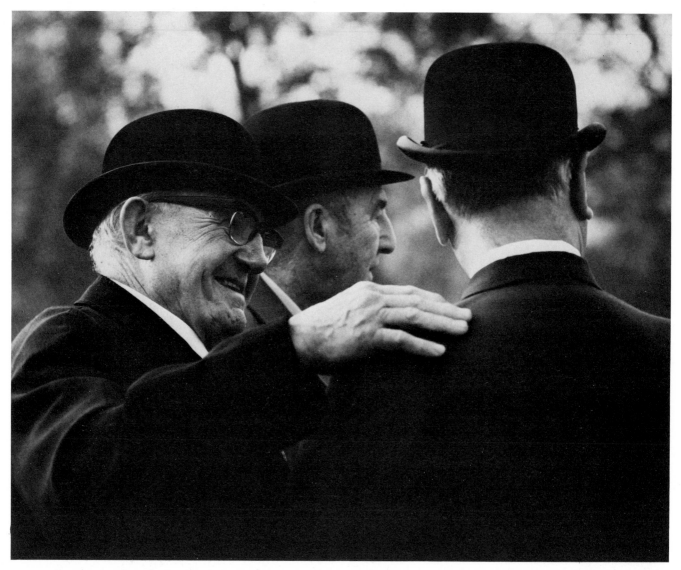

Norman Eve

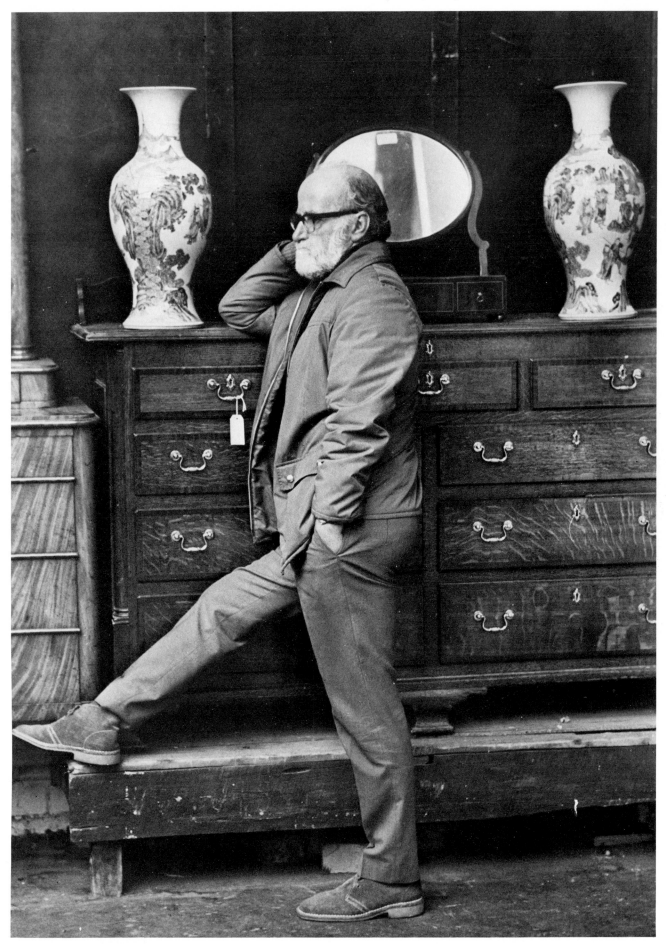

Stephen Shakeshaft

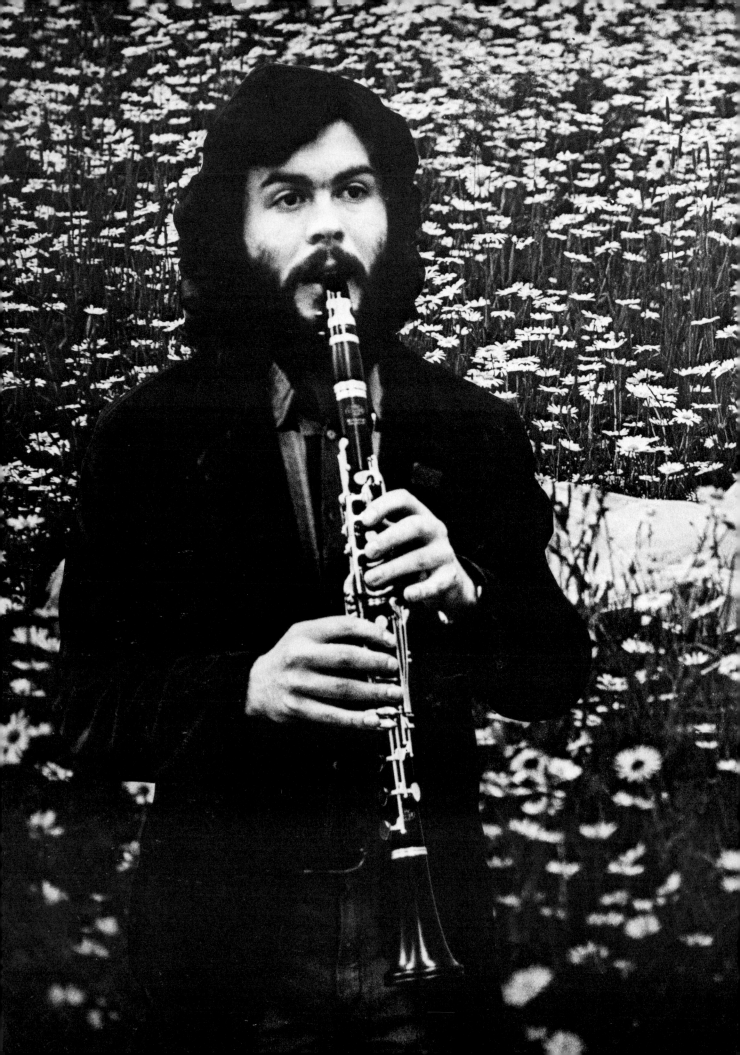

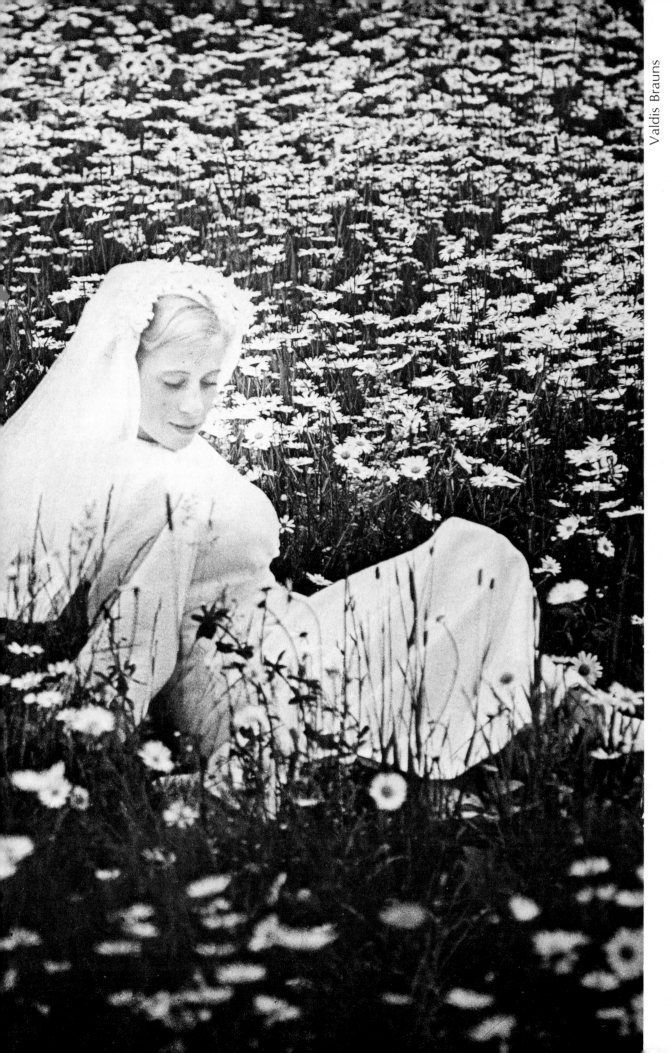

Valdis Brauns

25

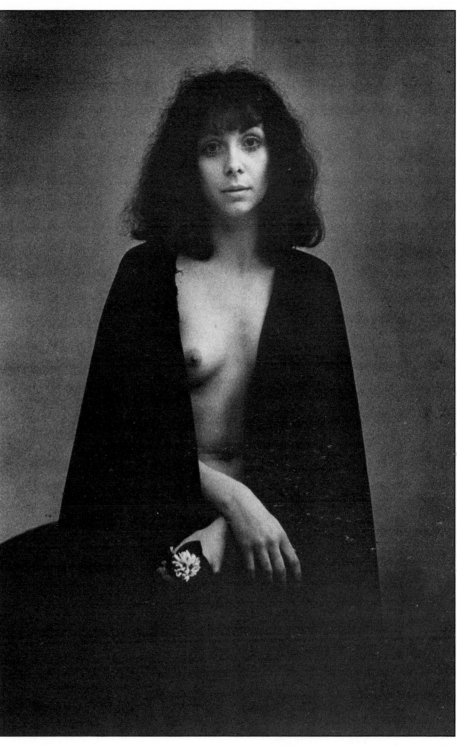

Harald Hirsch Rostislav Kõstál

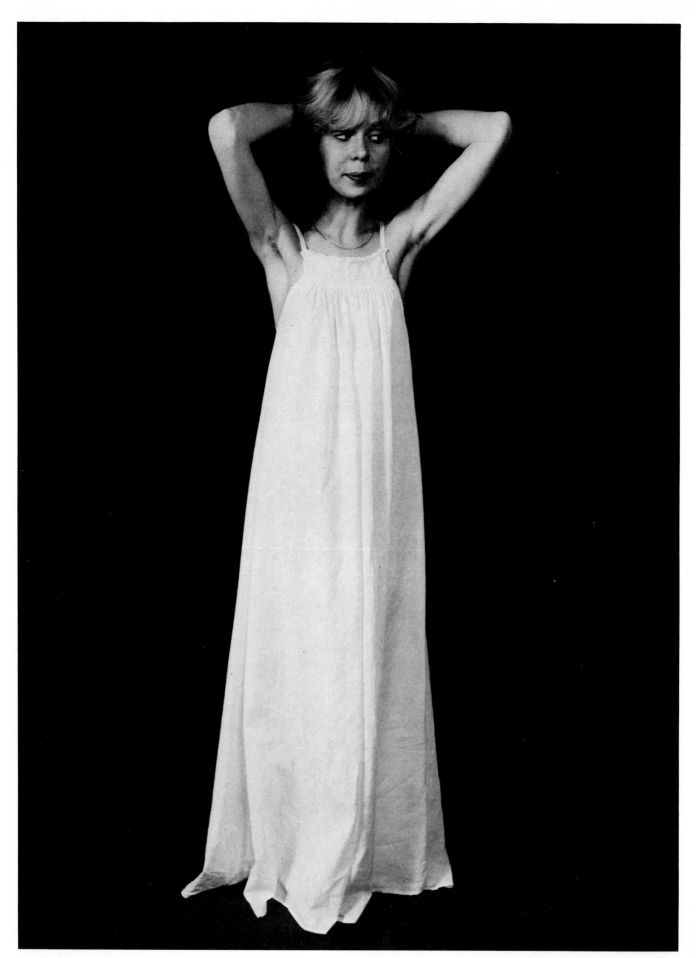

Hans-Peter Bogdahn

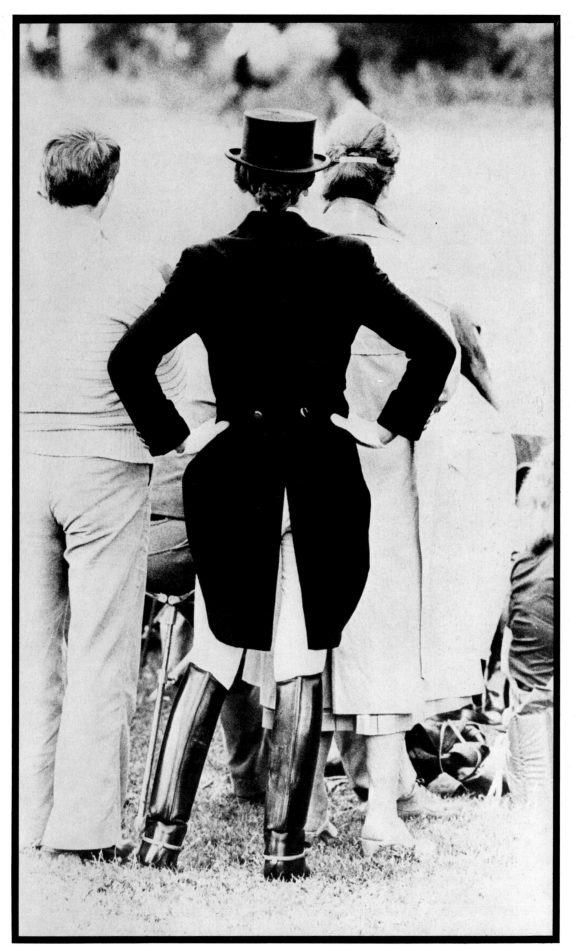

Ole Sand

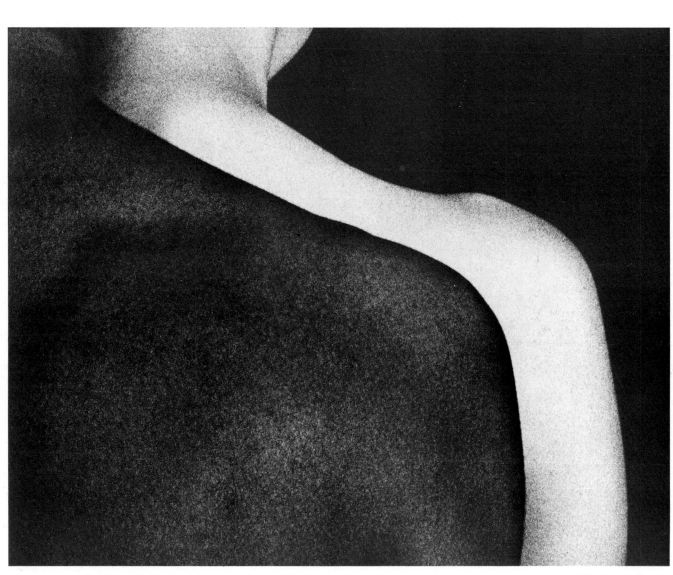

Vladimir Birgus

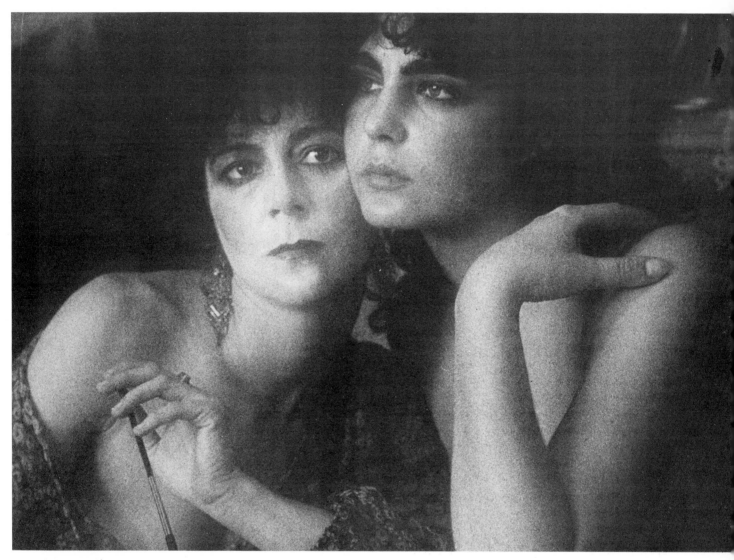

Josep Maria Ribas I Prous

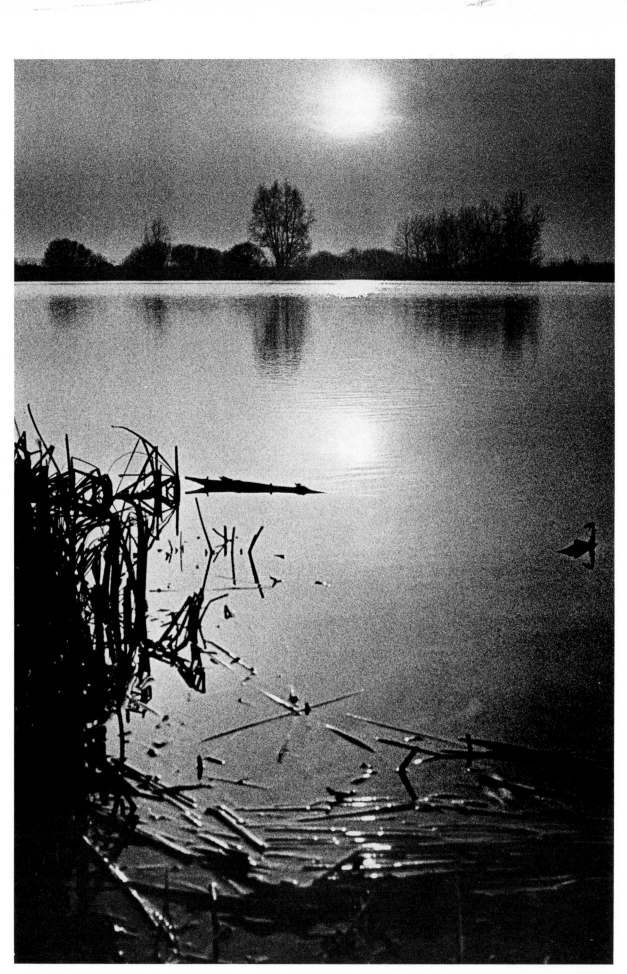

Harald Hirsch

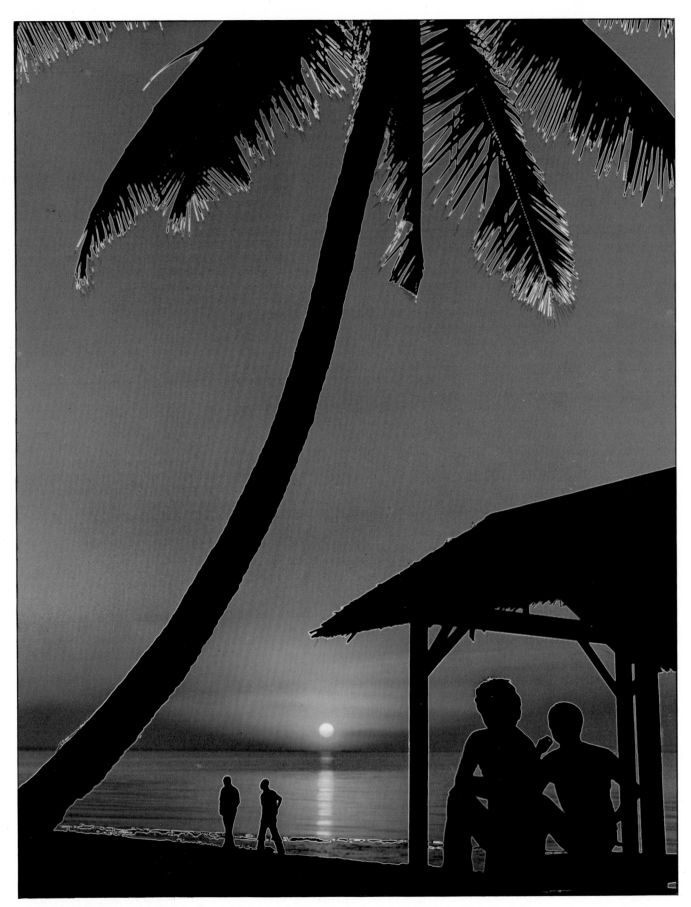

Leo K.K. Wong

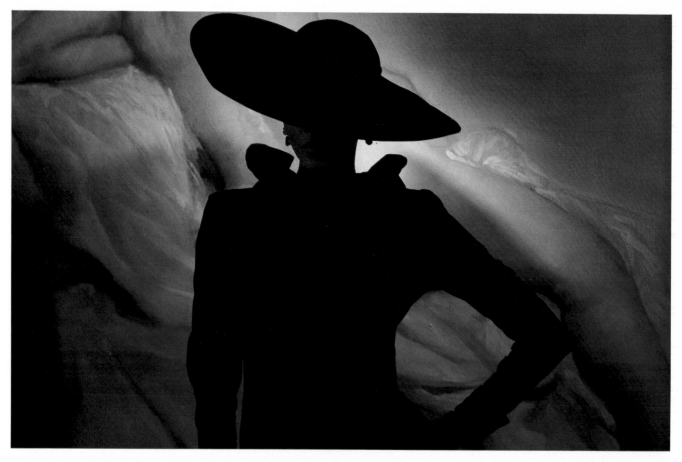

Michel Arnaud

Ole Yssing

C.J. Stratmann

35

J.L. Cawthra

Tony Duffy

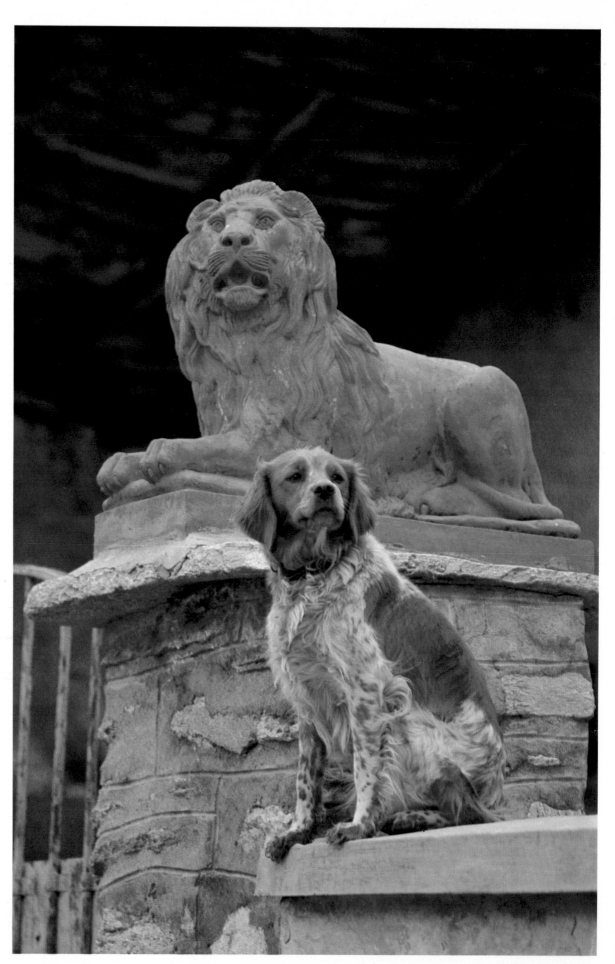

Giuseppe Balla

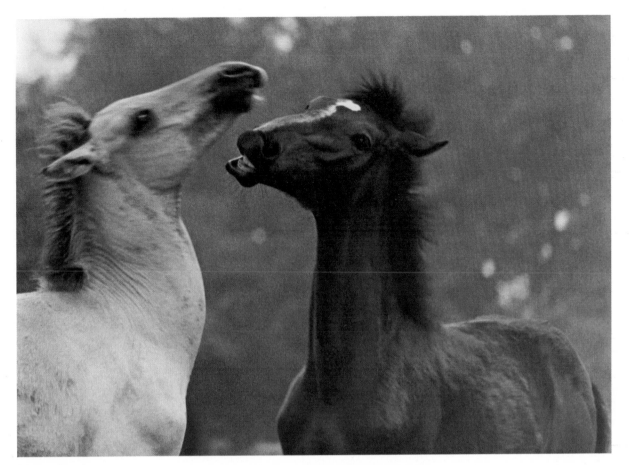

Dieter Rockser

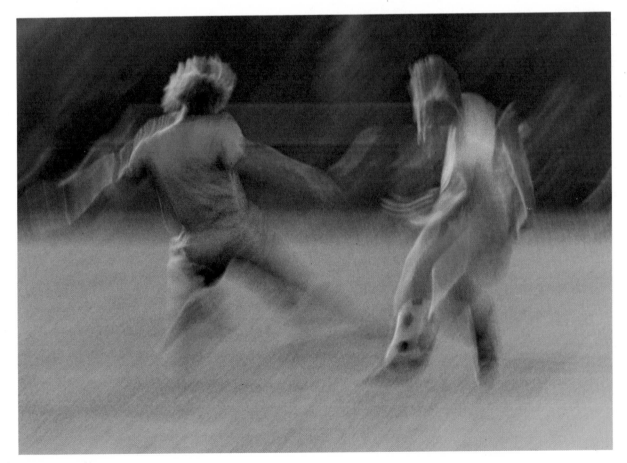

Dieter Rockser

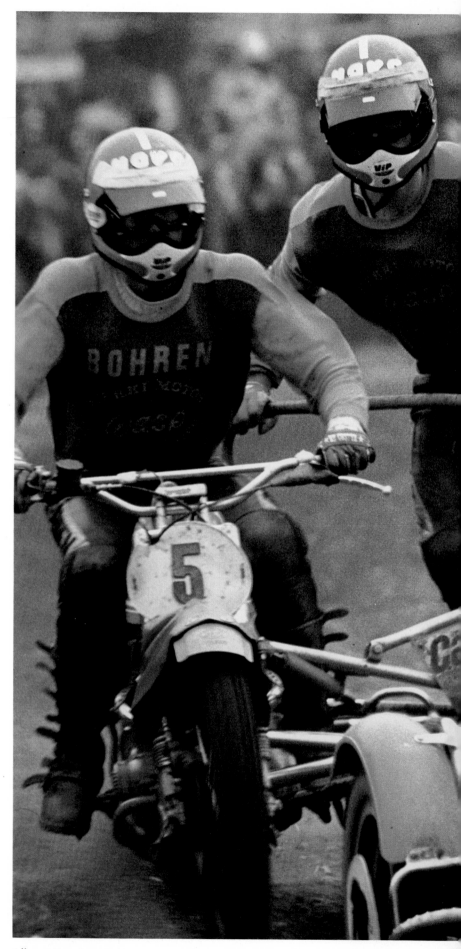

Albert Bernhard

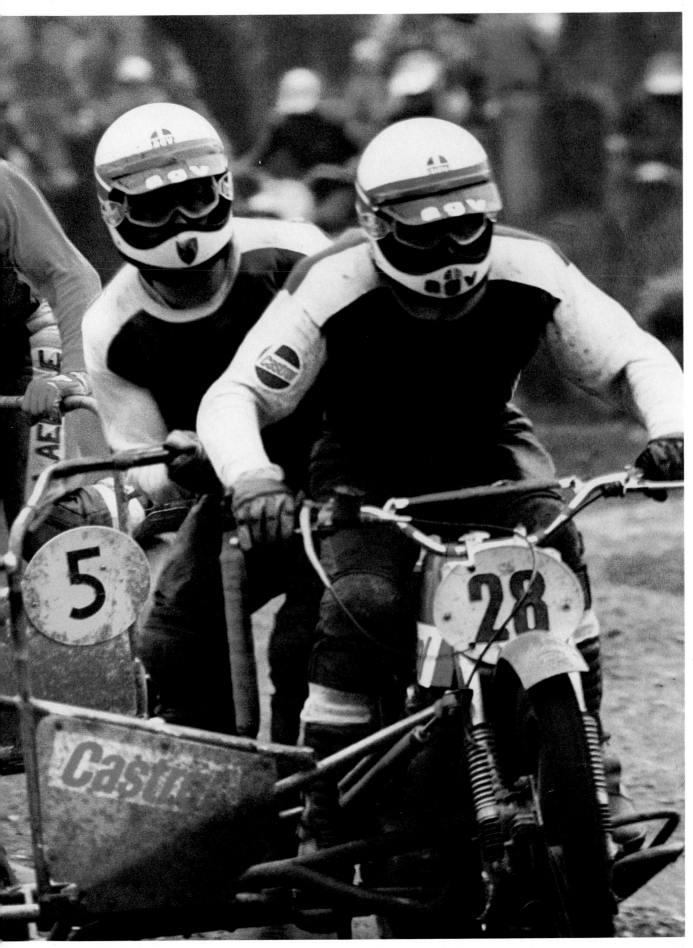

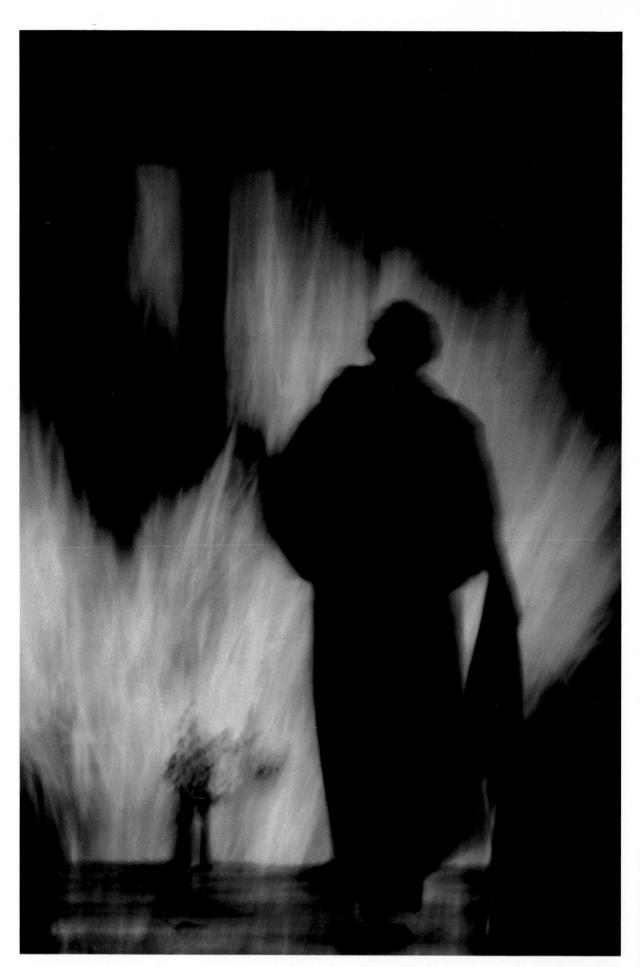

Peter Gant

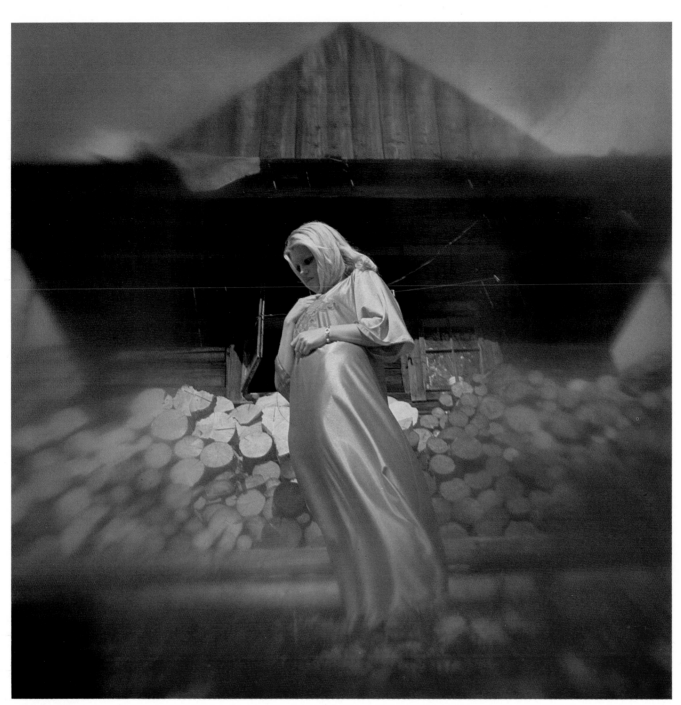

Vlado Báča

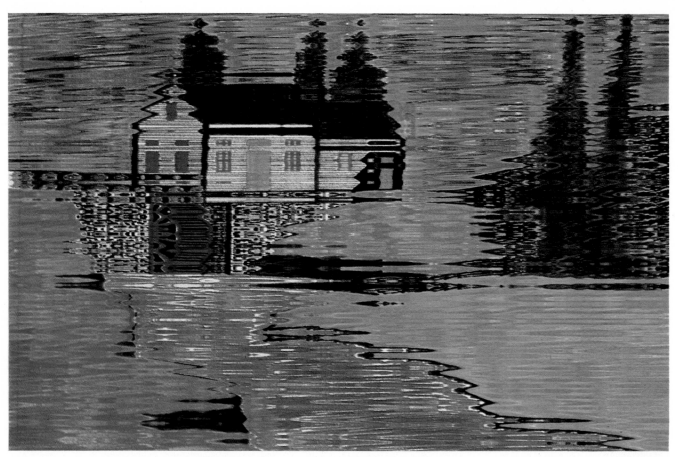

Al Bridel

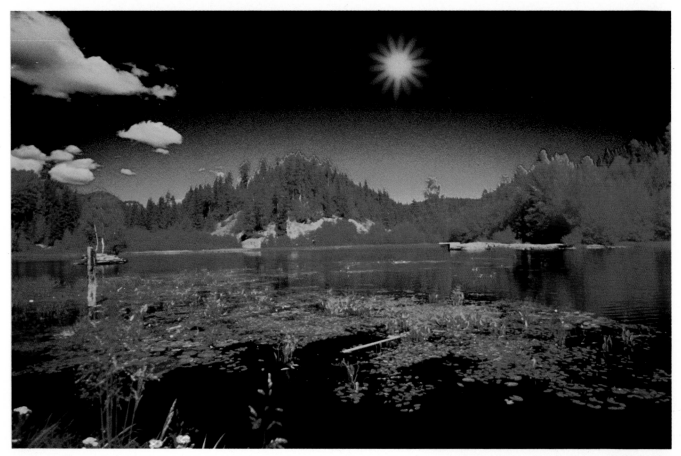

Erik Steen

Erik Steen

Stephen Dalton

T. Norman Tait

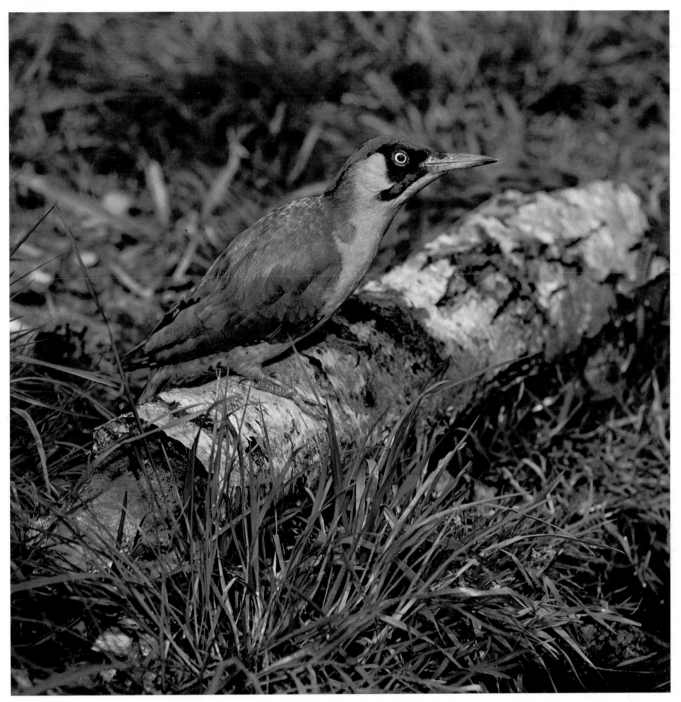

E.A. Janes

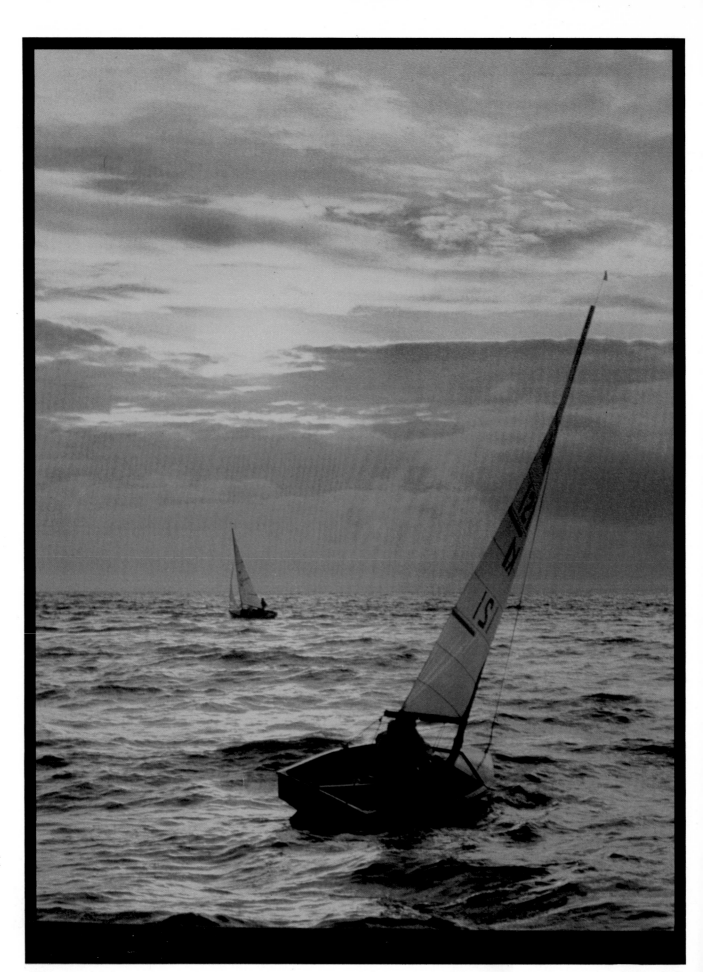

W.G. Gale

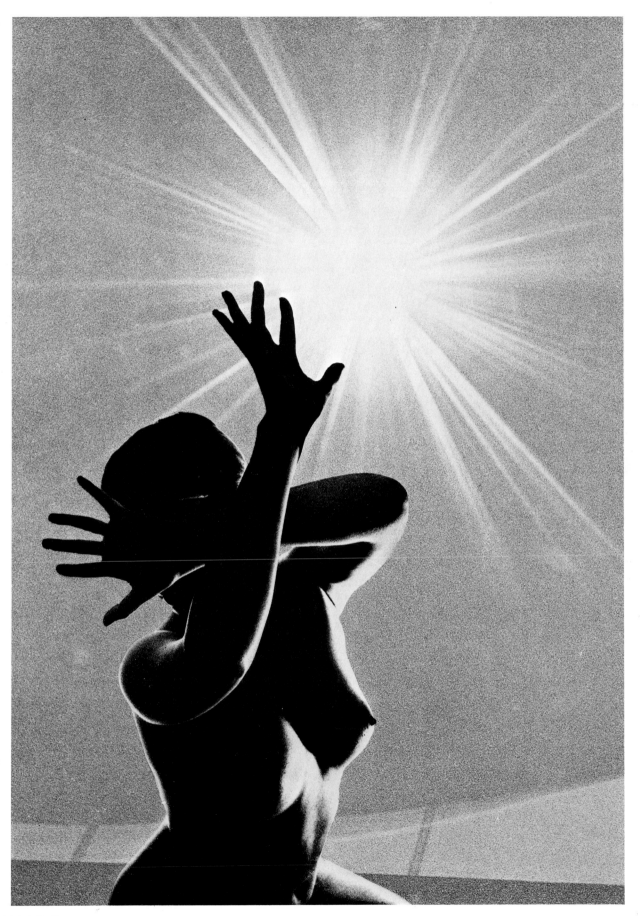

Valdis Brauns

Brian Duff

50

Brian Duff

Kent Bailey

John Jones

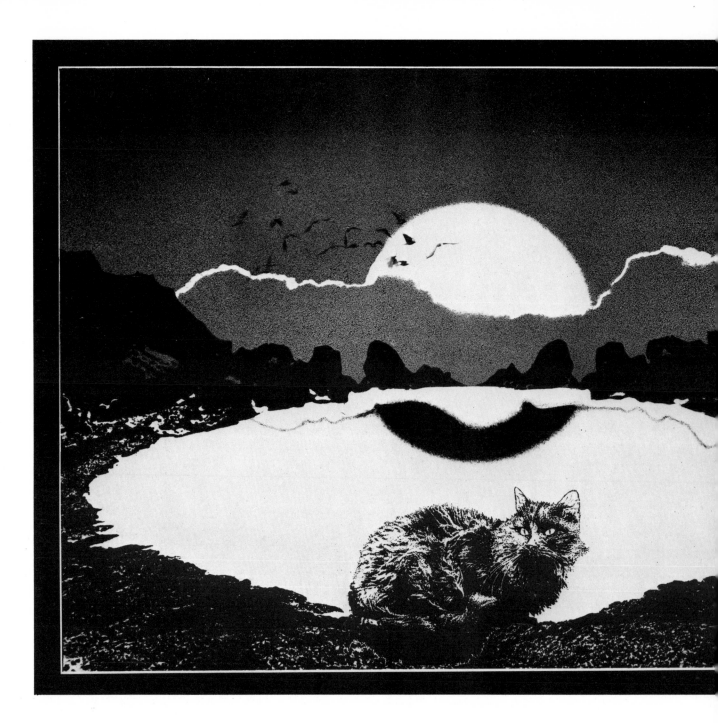

Vladimir Filonov

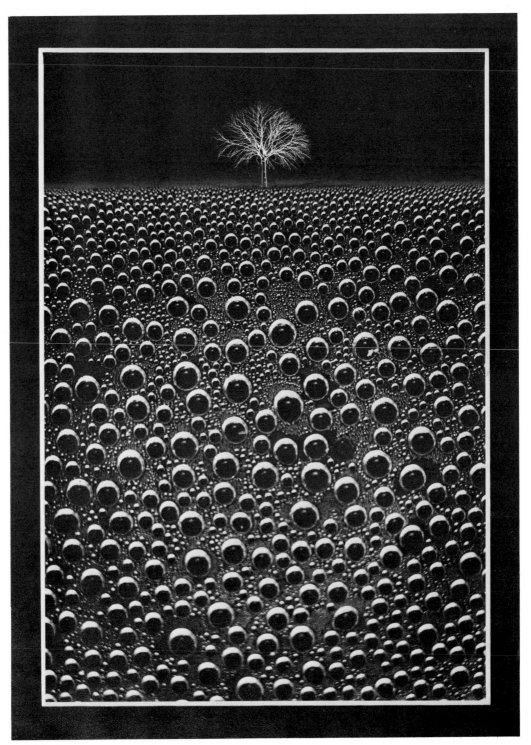

Jiri Bartos

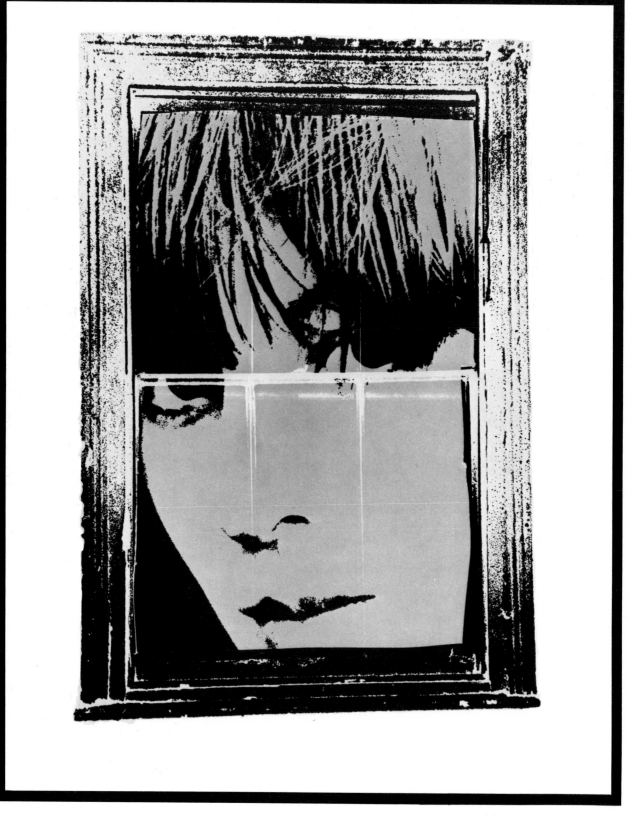

Francis Fernandez

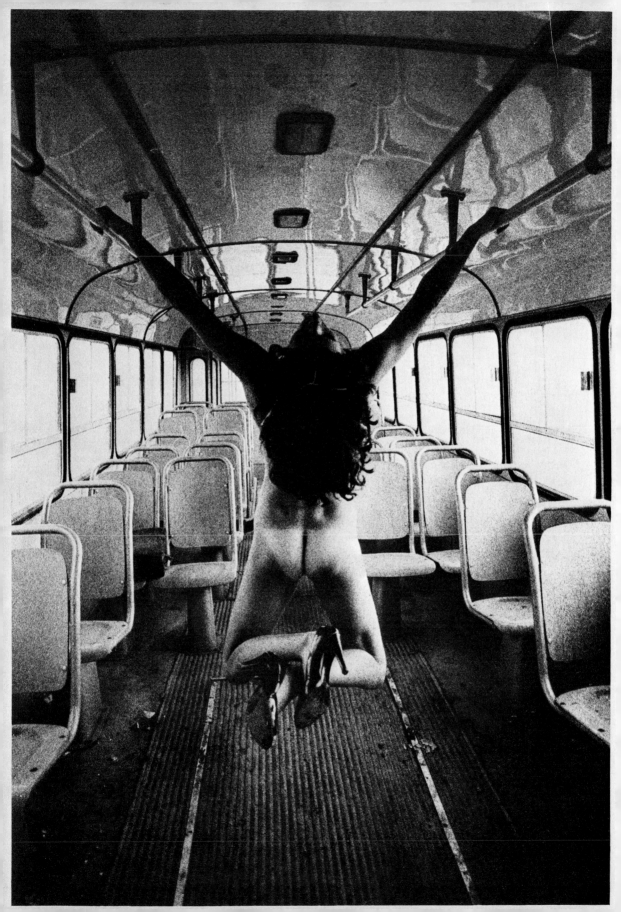

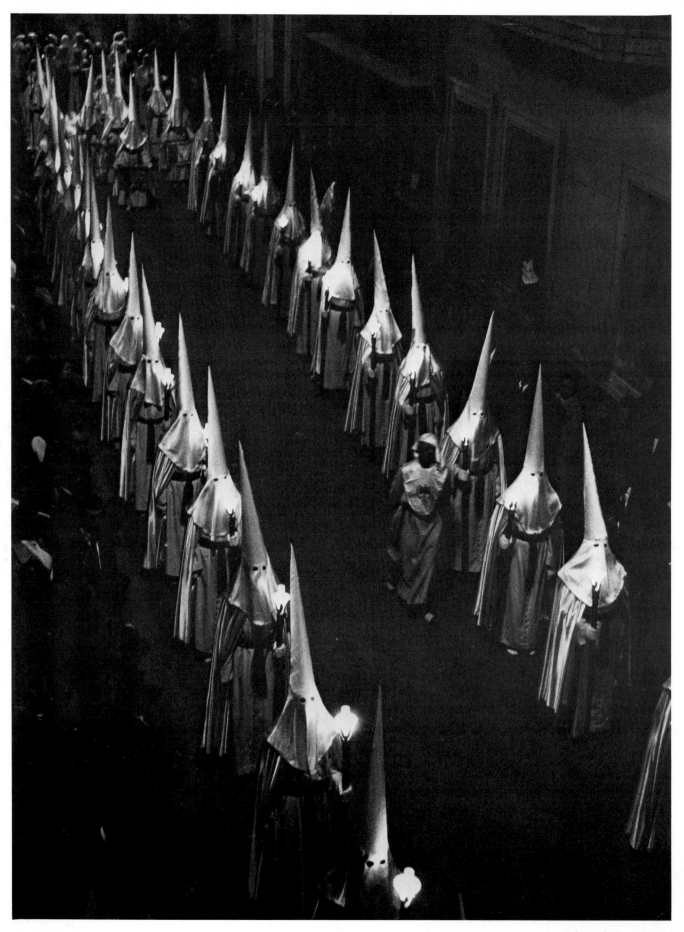

Jose Miguel de Miguel

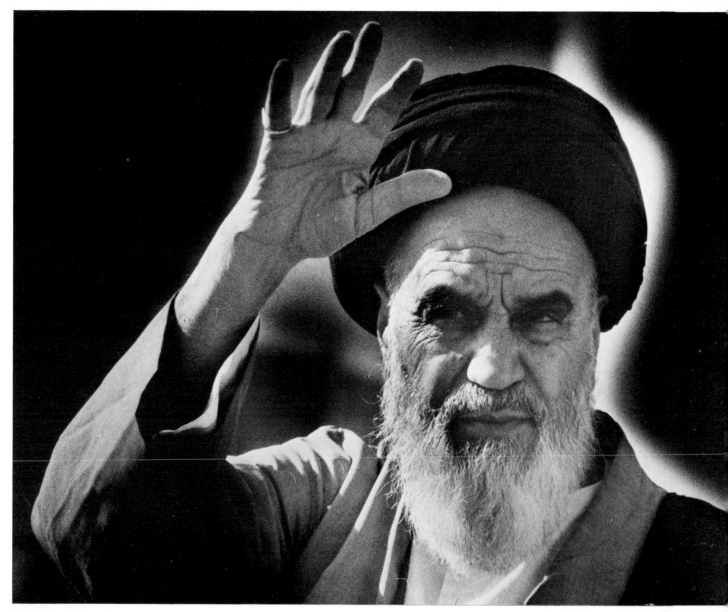

Rolf M. Aagaard

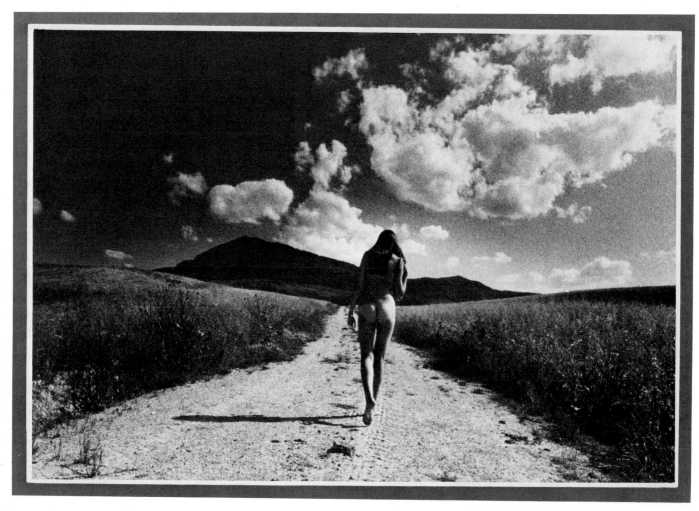

Jose Torregrosa

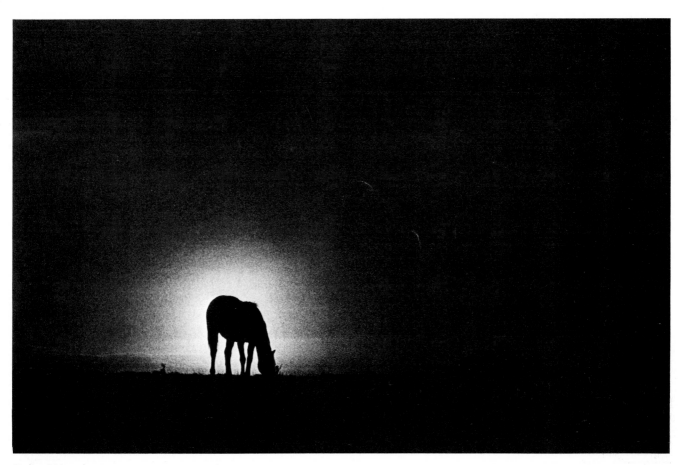

Colin Westgate

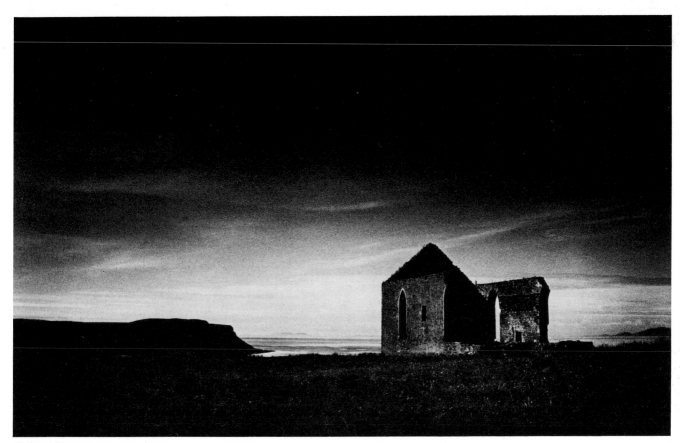

Colin Westgate

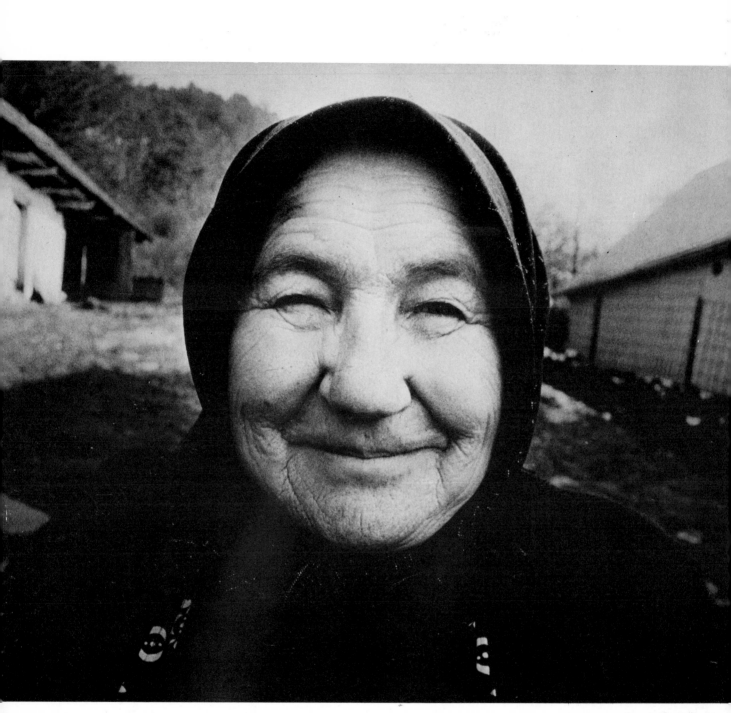

Juraj Fleischer

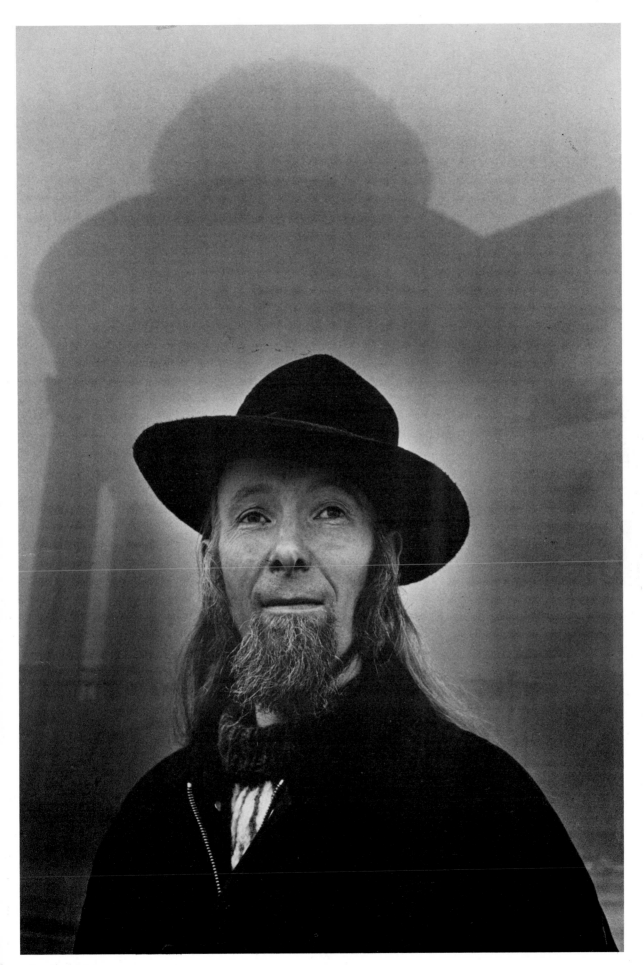

John Davidson

63

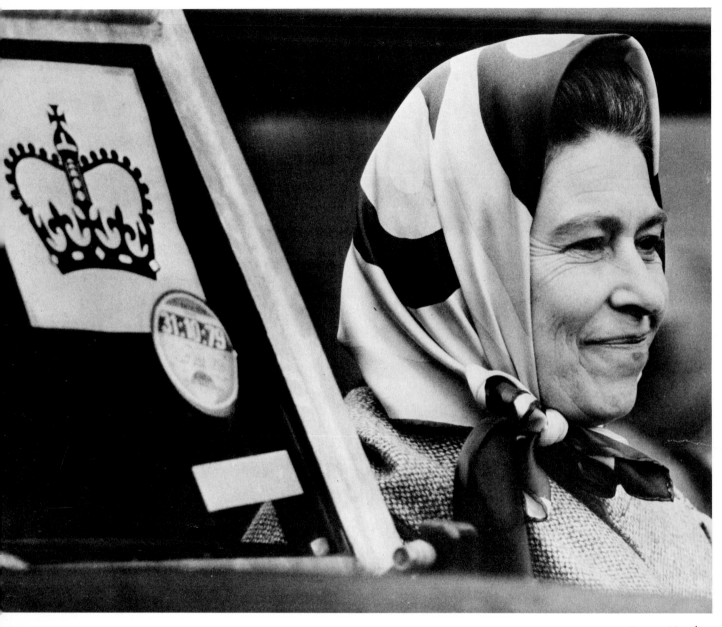

Steve Hartley

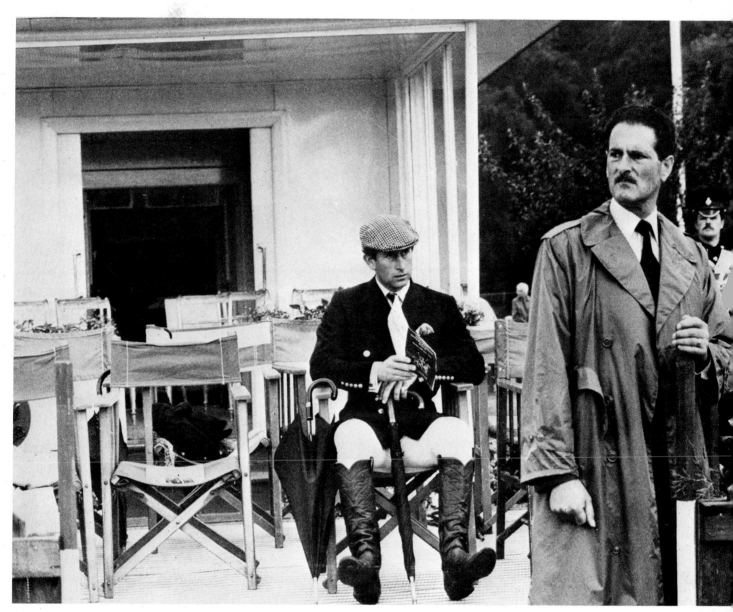

Jenny J. Goodall

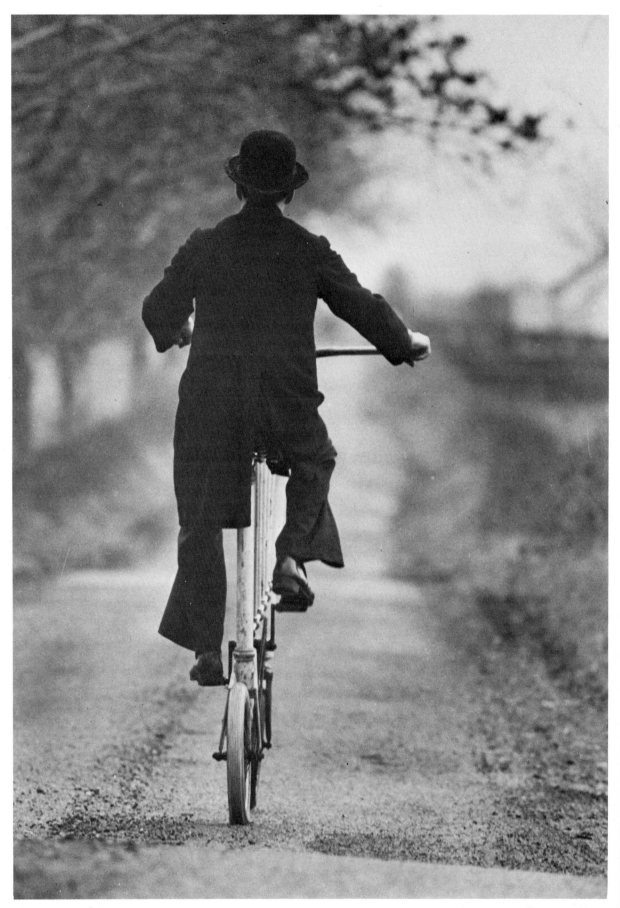

Stanley Matchett

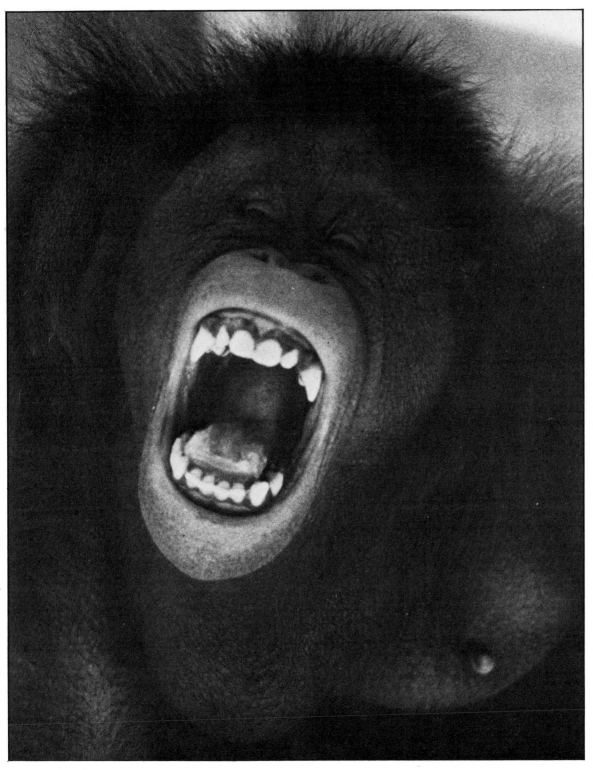

Forrest Smyth

David Burrows

Joan Wakelin

Arijs Klavinskis

Arijs Klavinskis

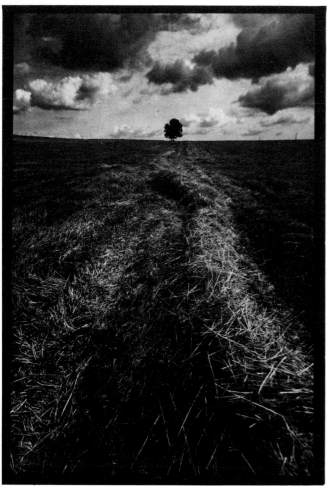

Jan Aṇděl

Jan Aṇděl

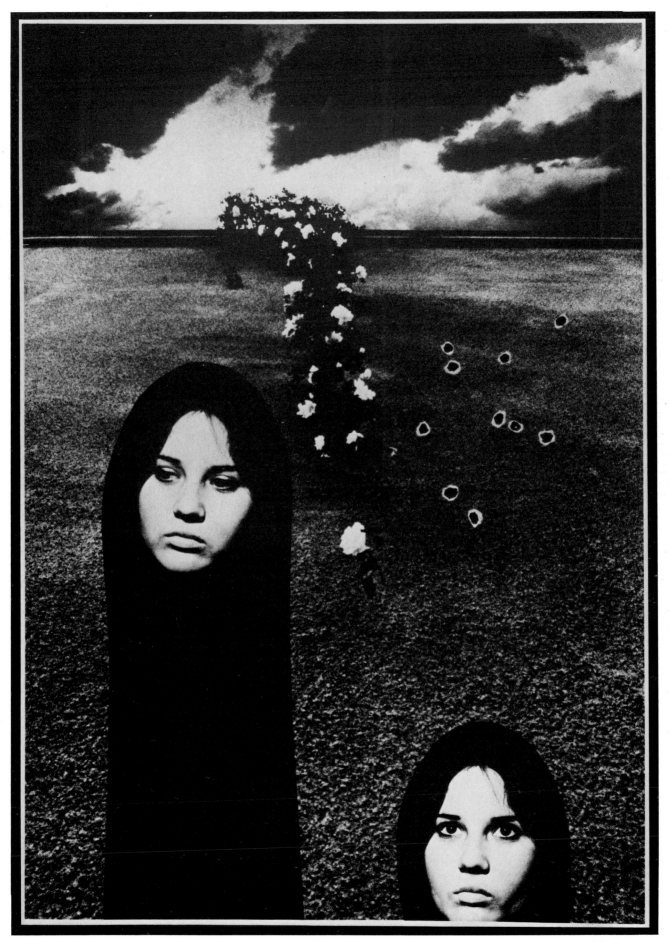

Witaly Butyrin

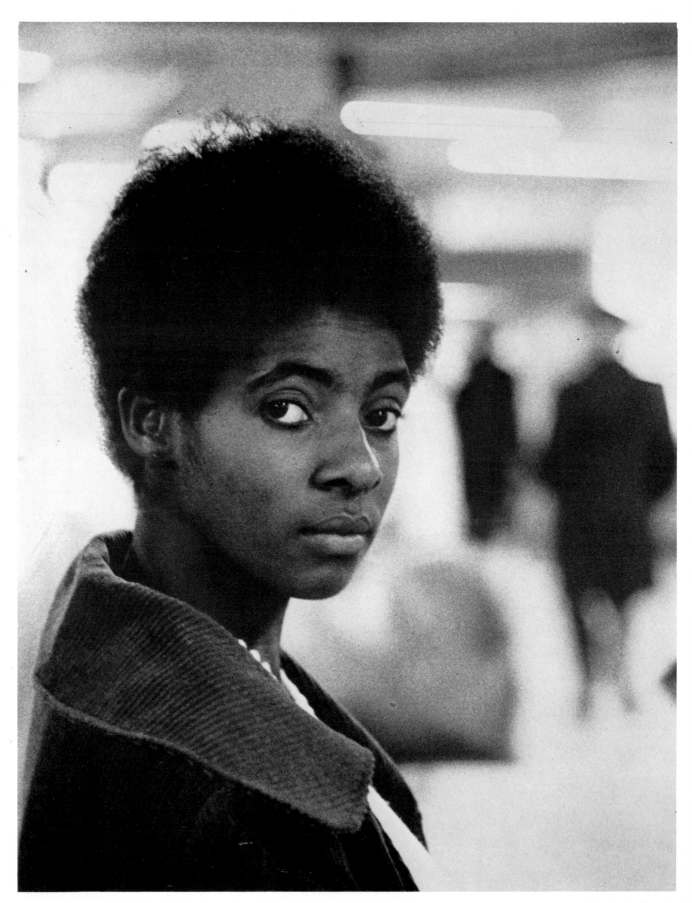

Michael Gnade

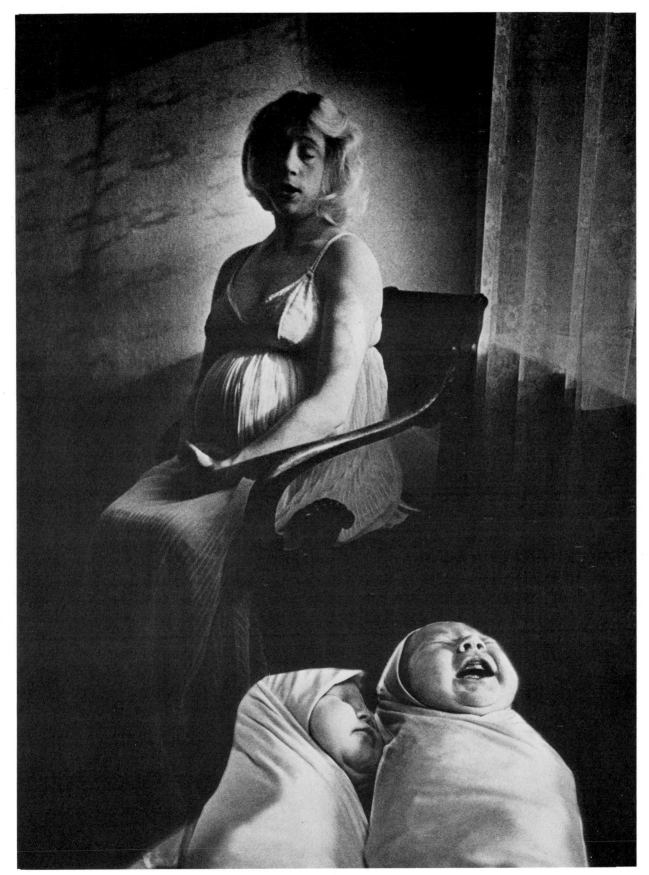

Valdis Brauns

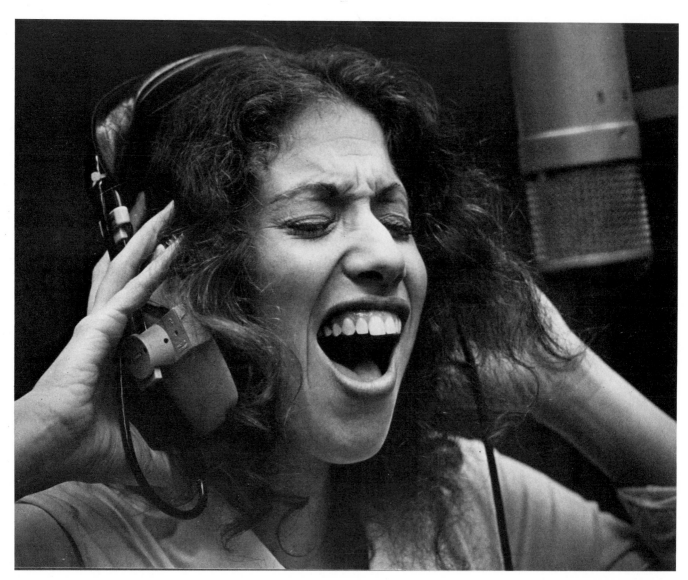

Martin Wolmark

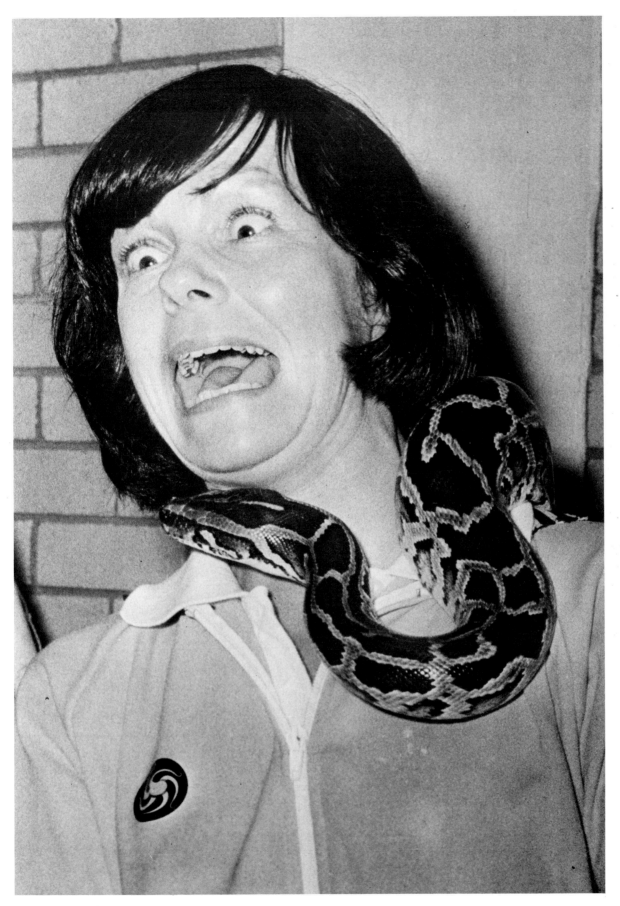

Stanley Matchett

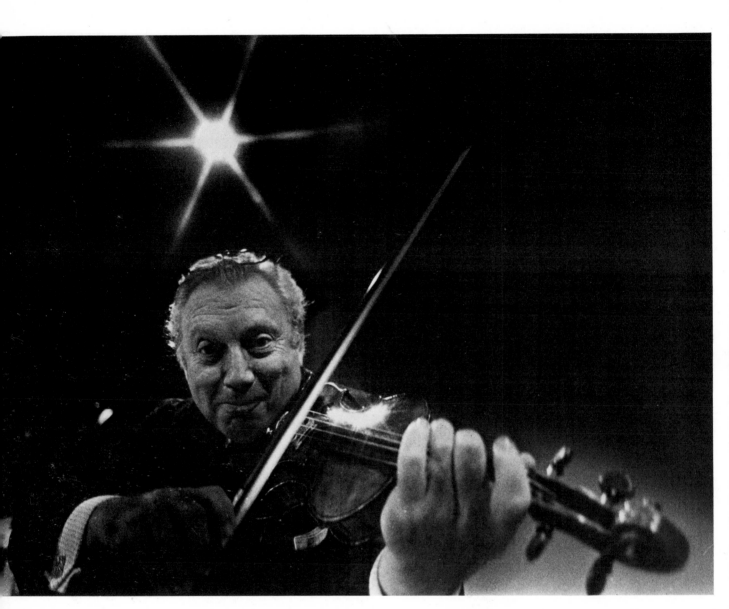

Rolf M. Aagaard

Jens O. Hagen

Don McPhee

Jim Hart

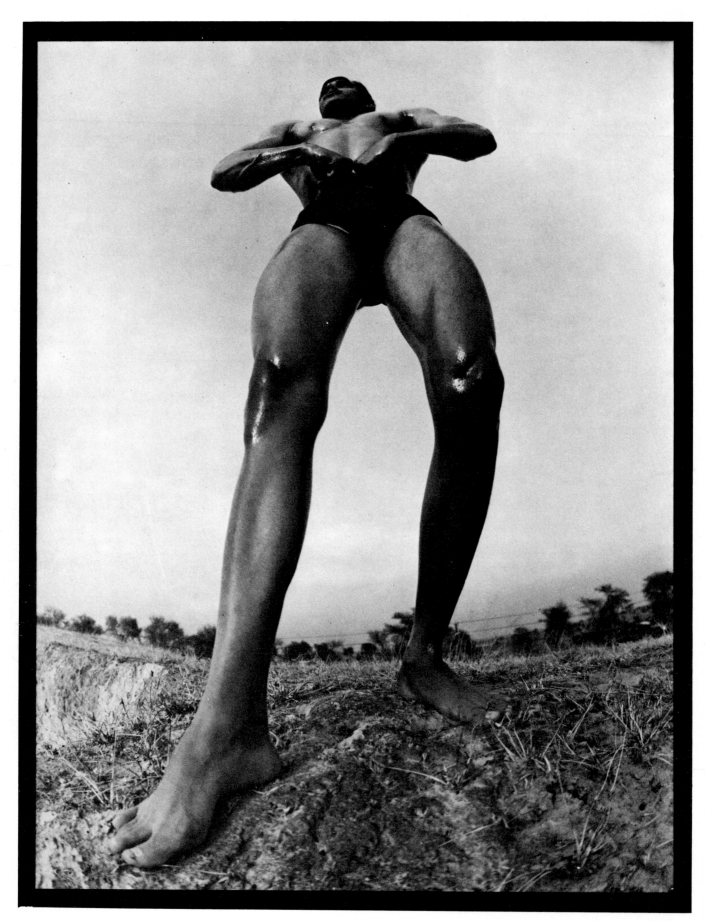

M.R. Owaisi

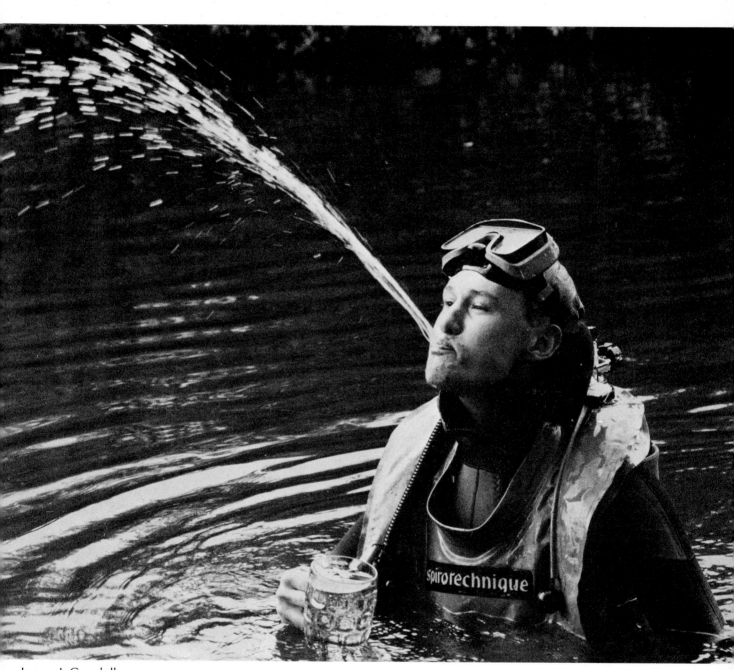

Jenny J. Goodall

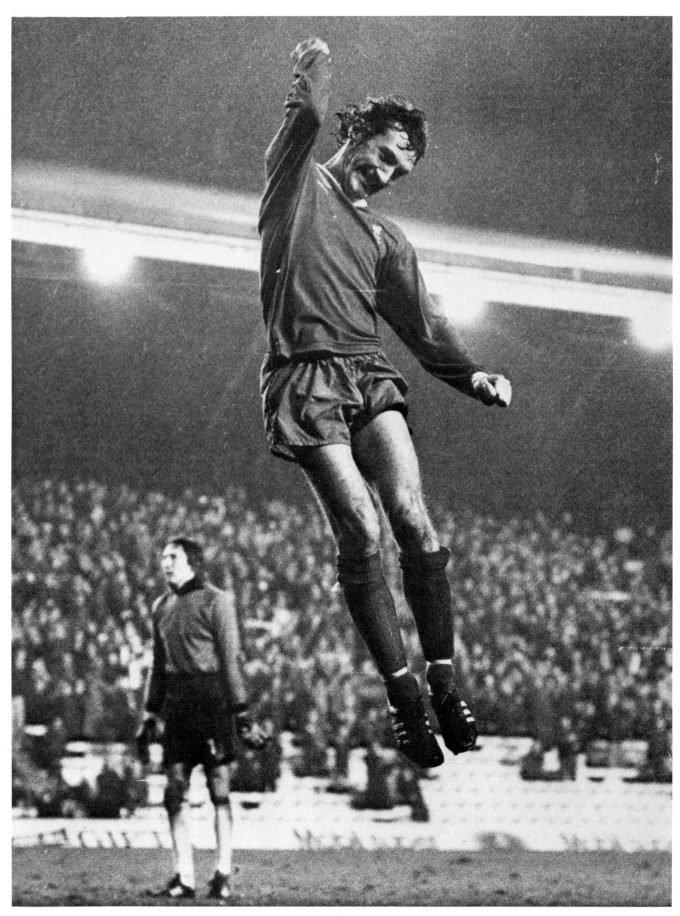

Steve Hale

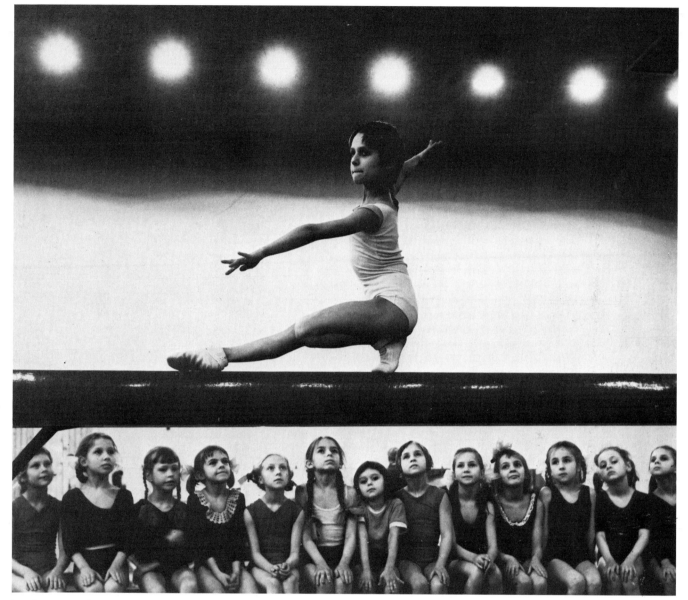

M. Barananskas

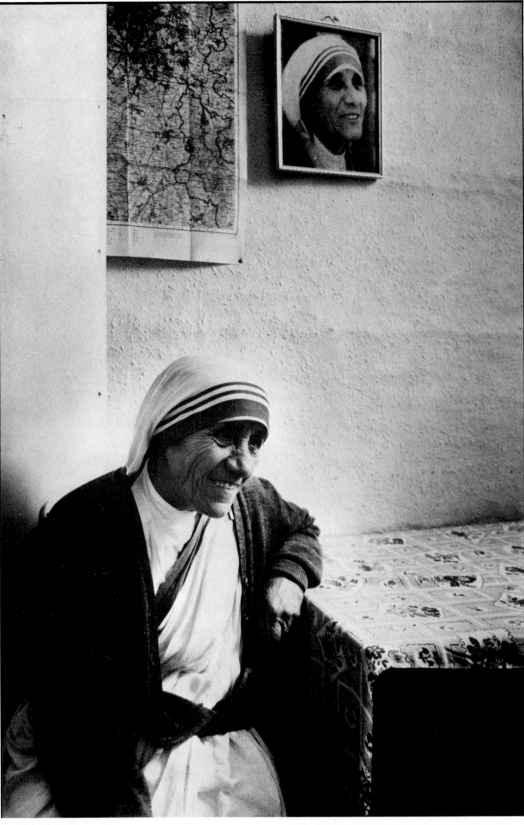

Denis Thorpe

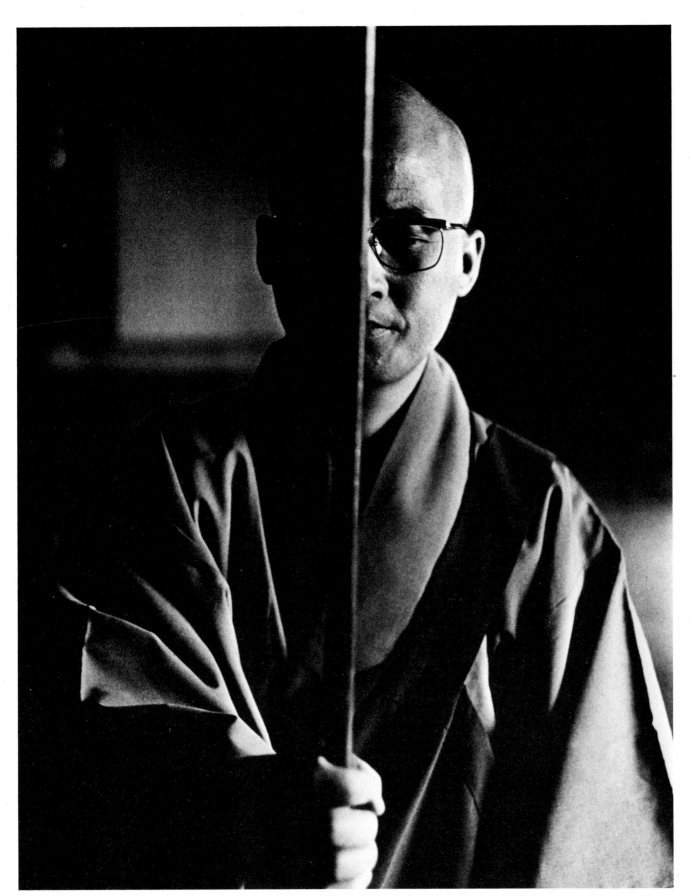

Kwanjo Lee

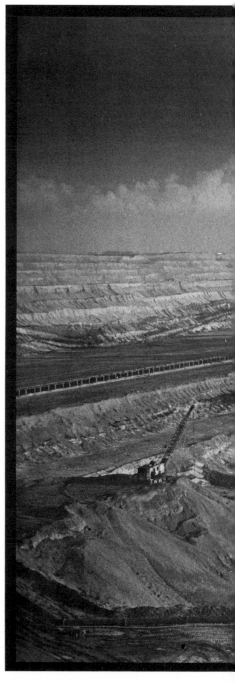

Wolfgang Volz

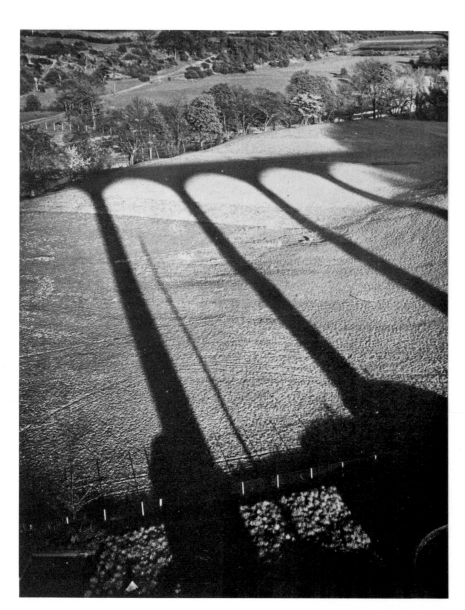

E. Chambré Hardman

Rostislav Kǒstál

Harald Hirsch

Hans J. Anders

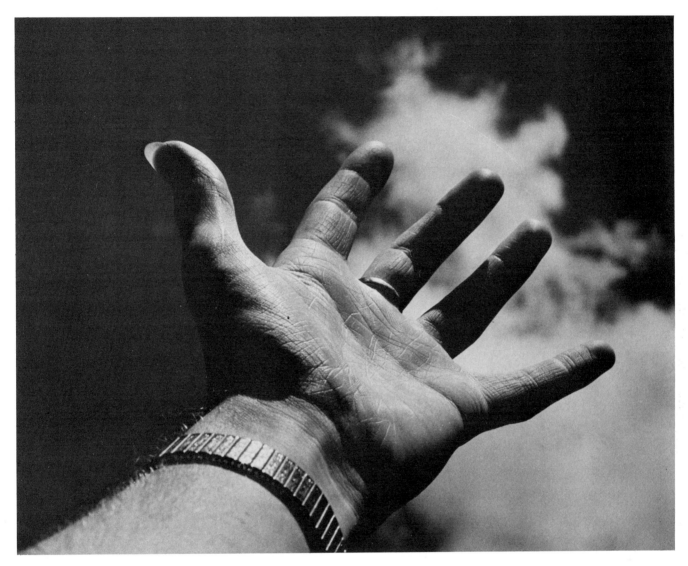

Johnathan C. Pitt

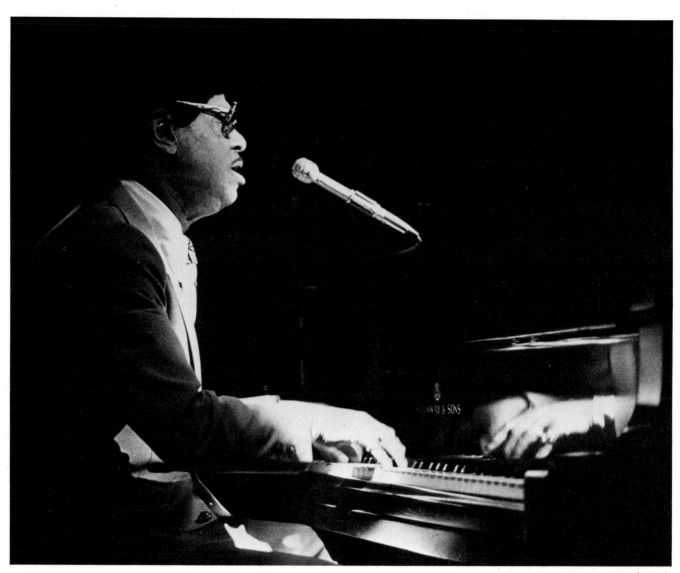

Martin Wolmark

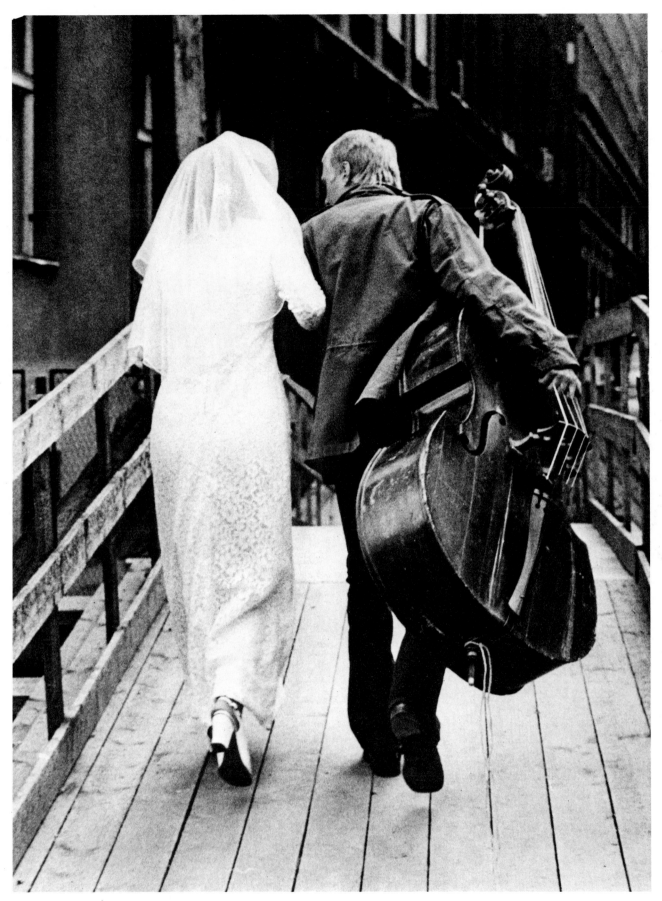

František Dostál

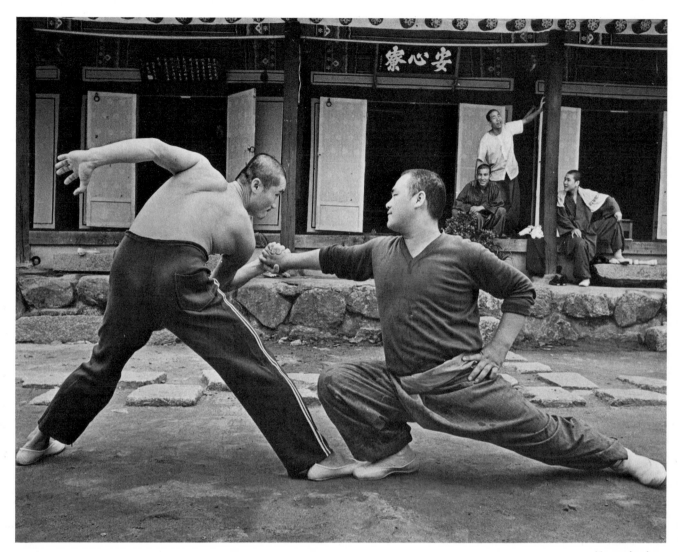

Kwanjo Lee

F. Reavey

R. Dexter

Gary Radchik

Al Bridel

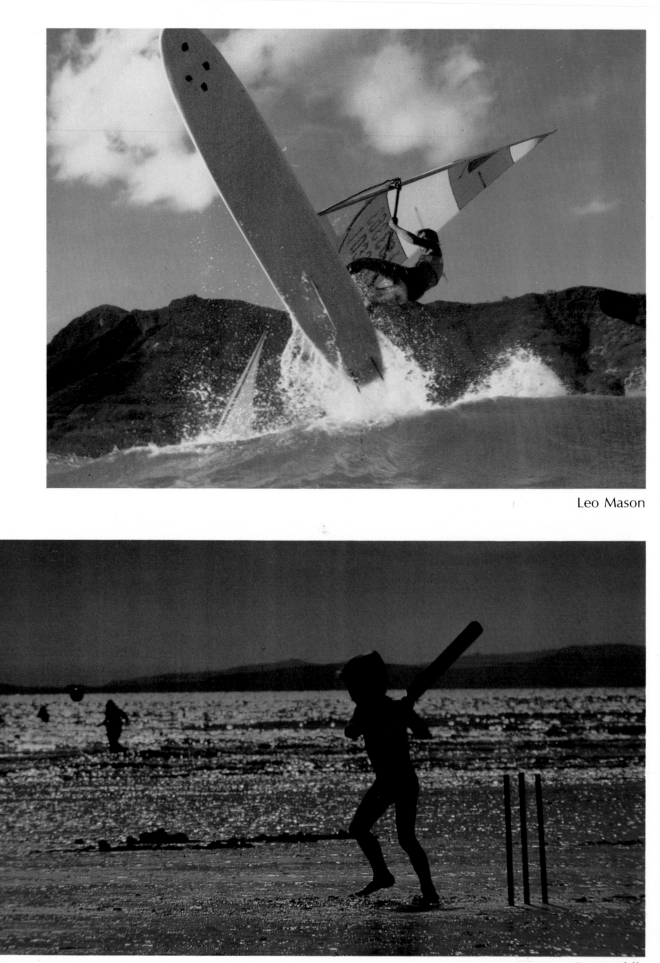

Leo Mason

G.I. Ratcliffe

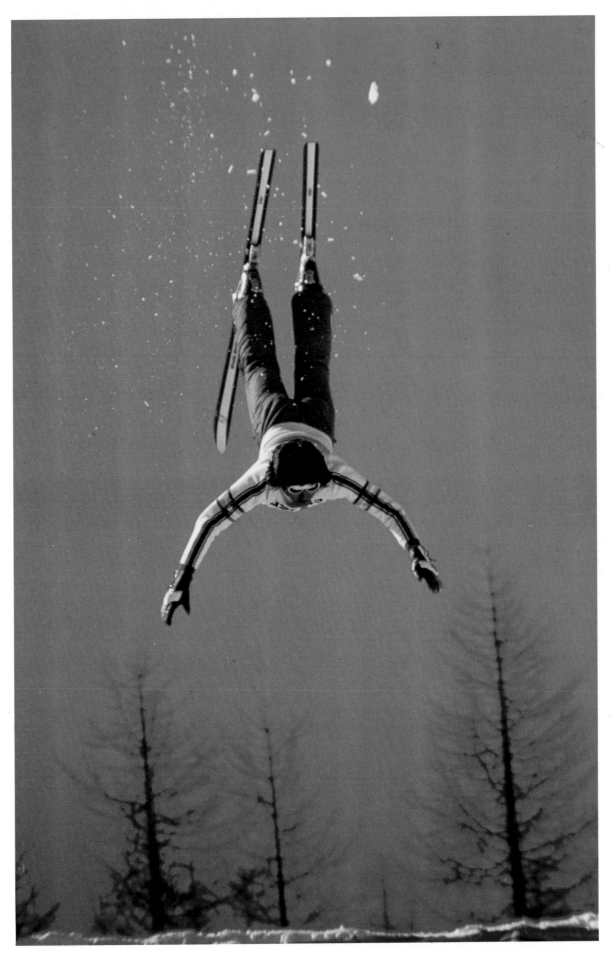

Giuseppe Balla

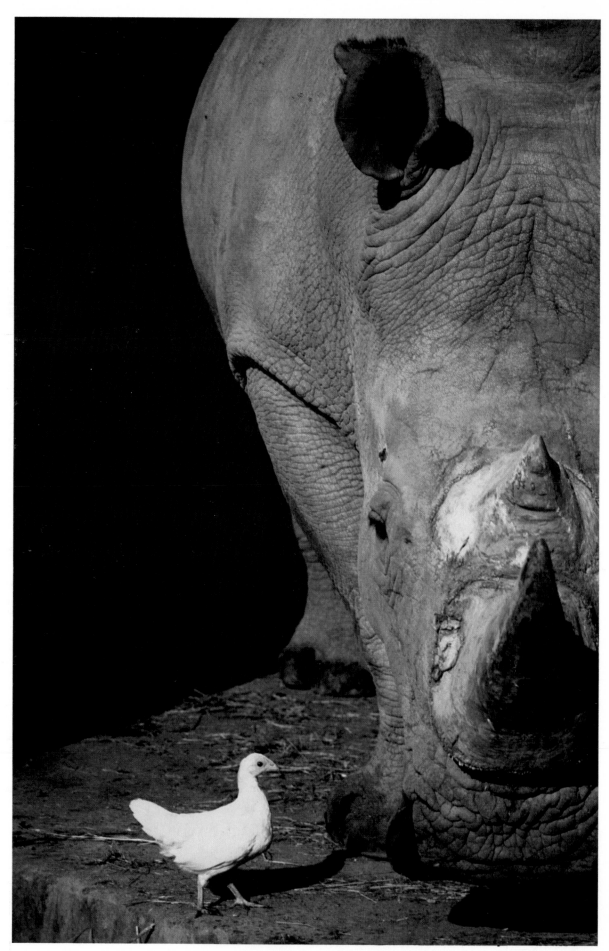

Peter Gant

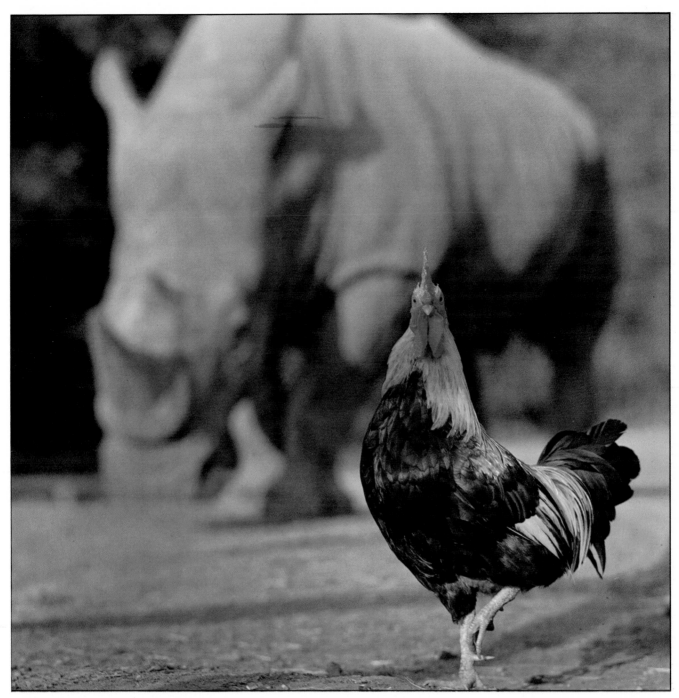

Robert Hallmann

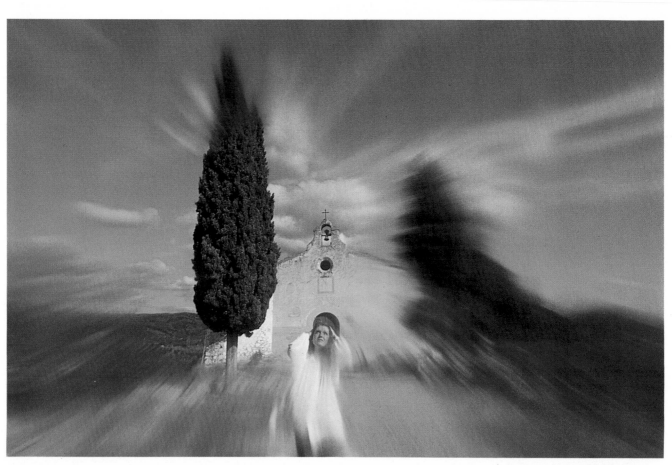

Josep Maria Ribas I Prous

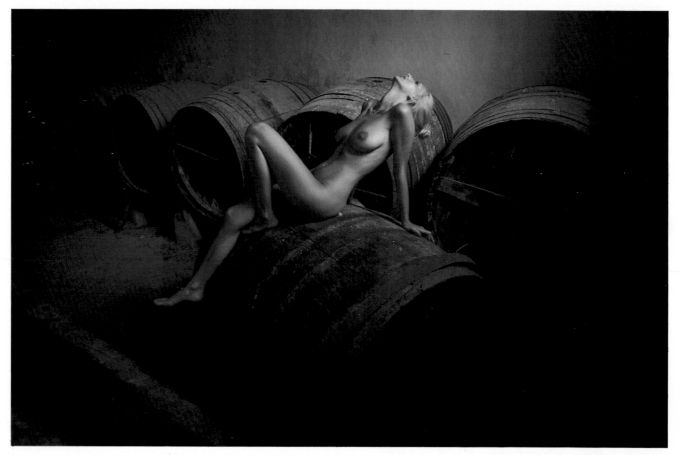

Josep Maria Ribas I Prous

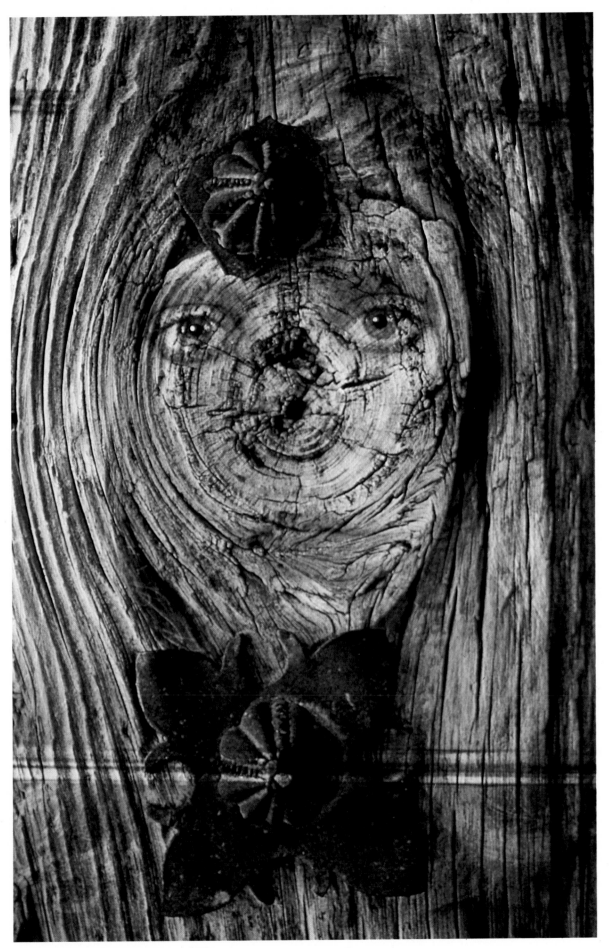

Albert Bernhard

E. Oscar Gustafson

Trevor Fry

G. Leighton

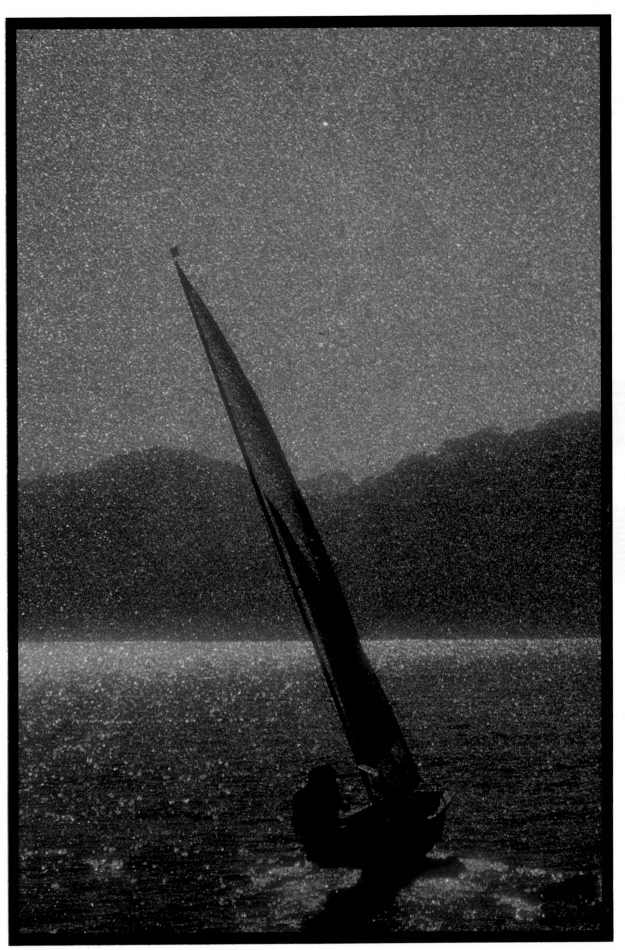

Michael Barrington-Martin

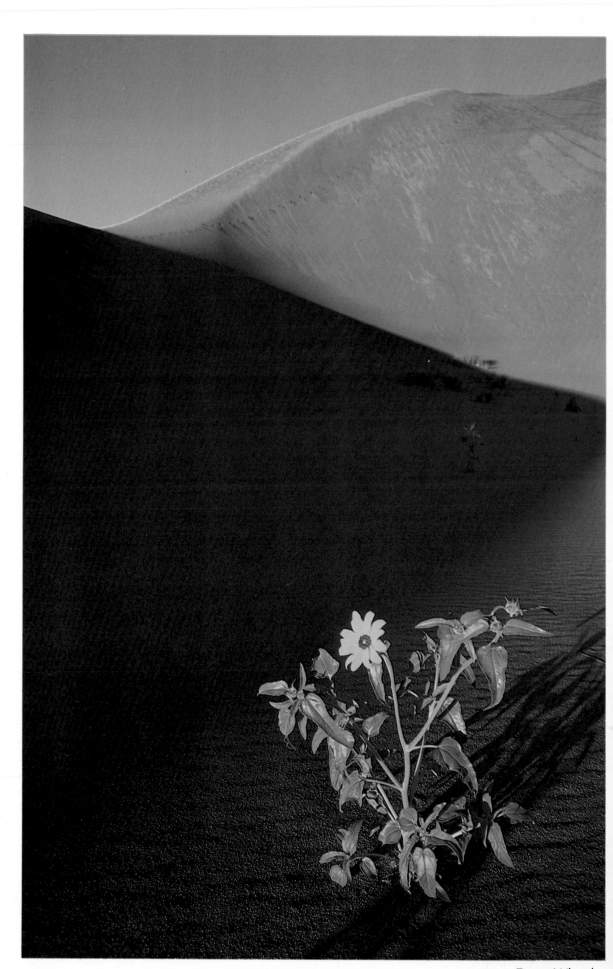

Dave Wheeler

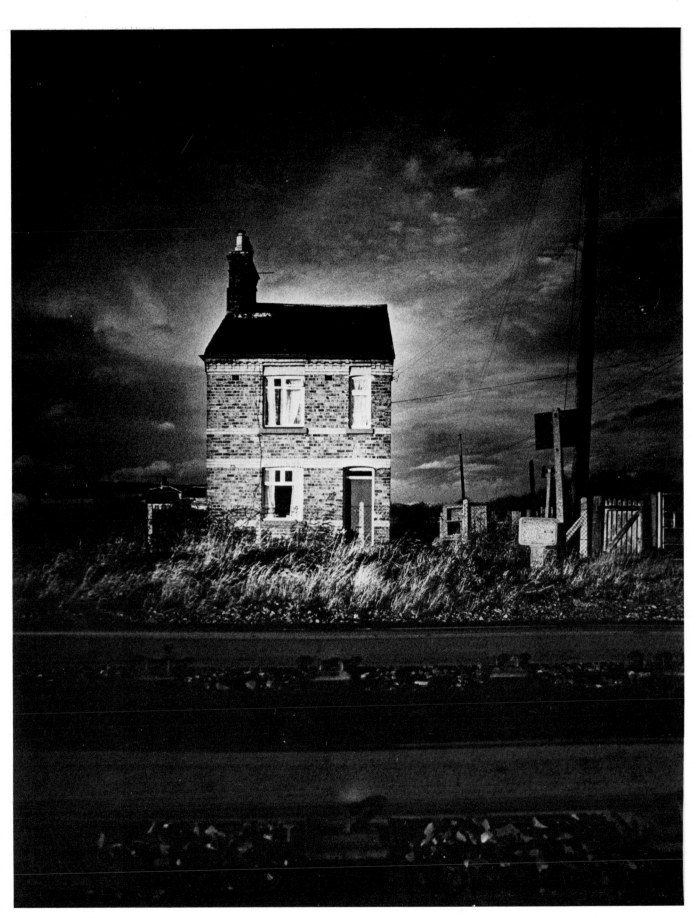

Margaret Salisbury

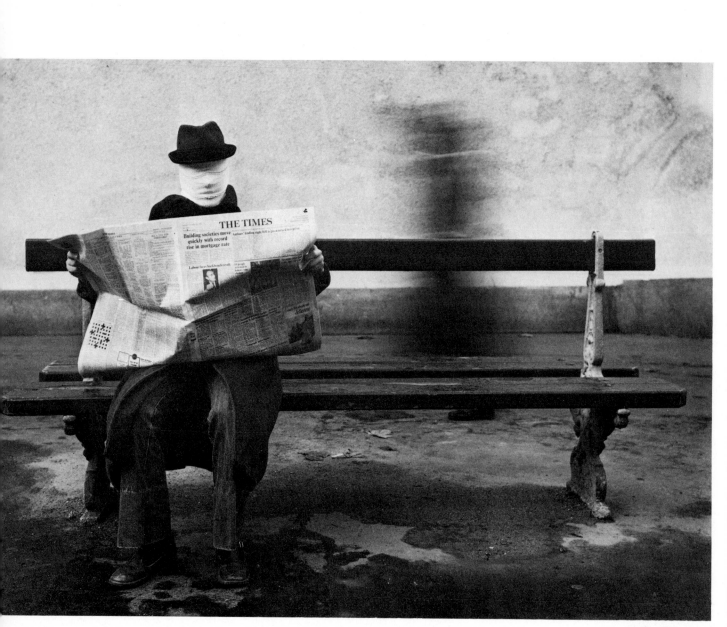

Philip Bernard

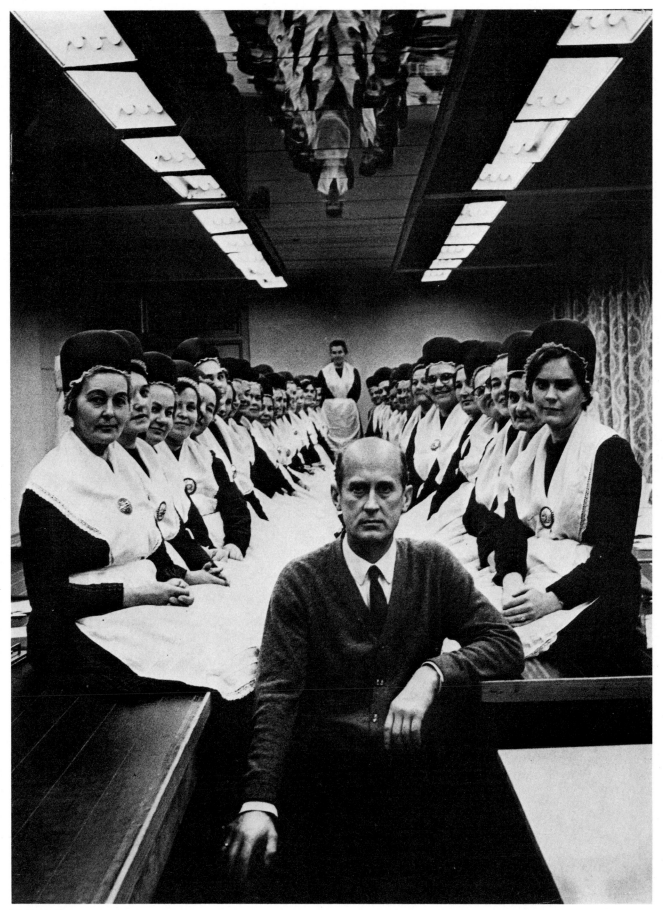

V. Koreškov

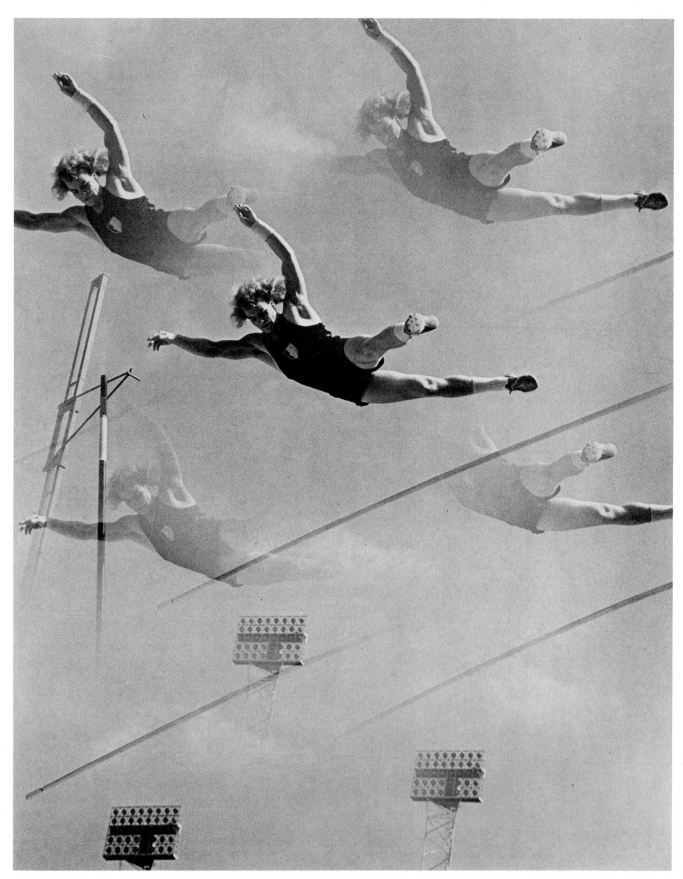

Mervyn Rees

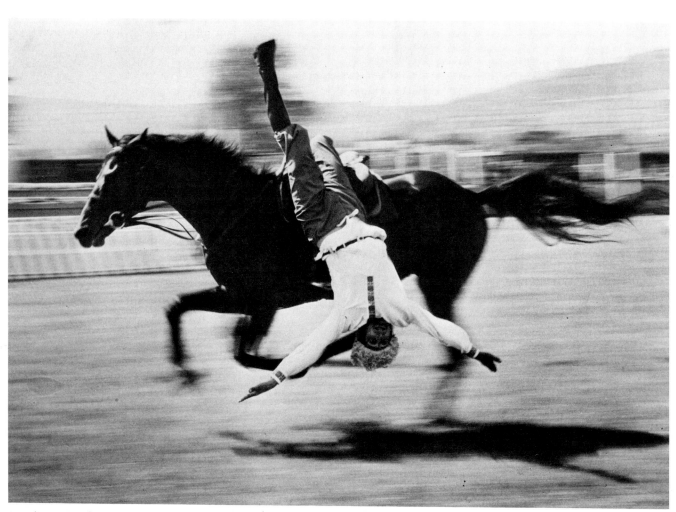

Stanley Matchett

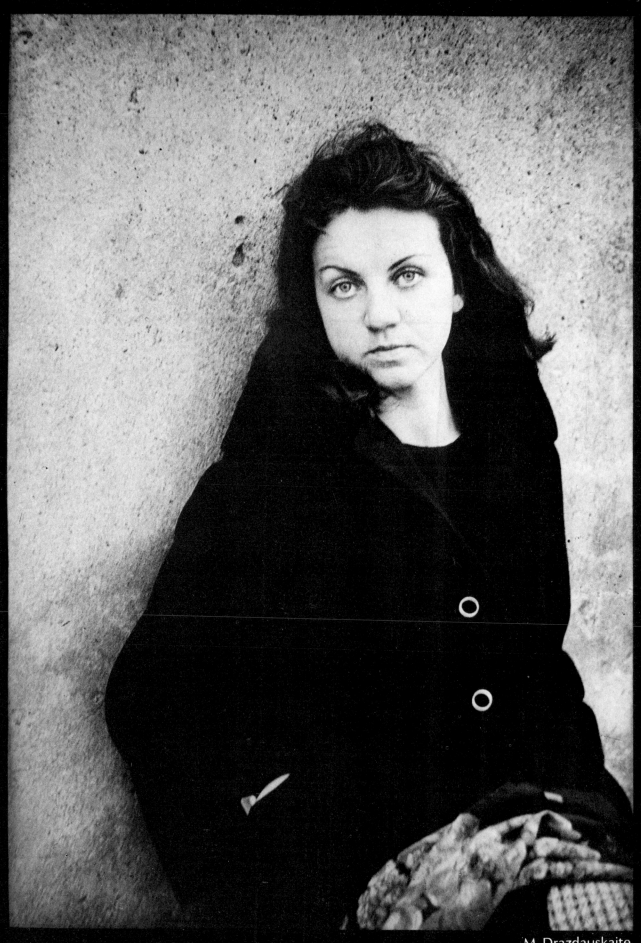

M. Drazdauskaite

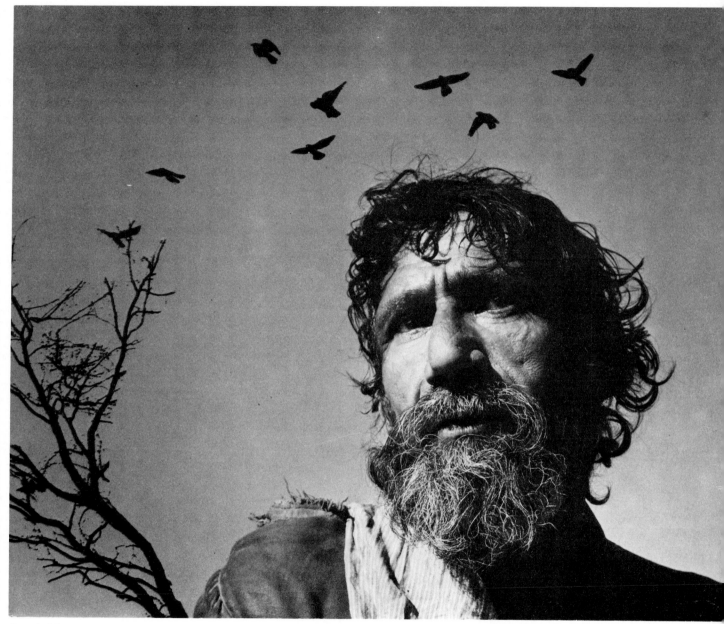

Asad Ali

Stephen Shakeshaft

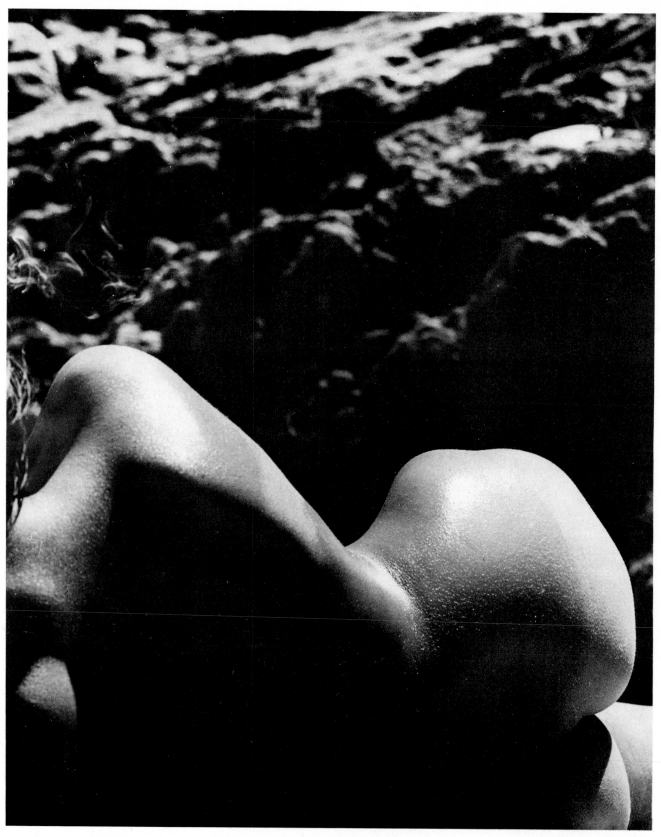

Michael Gnade

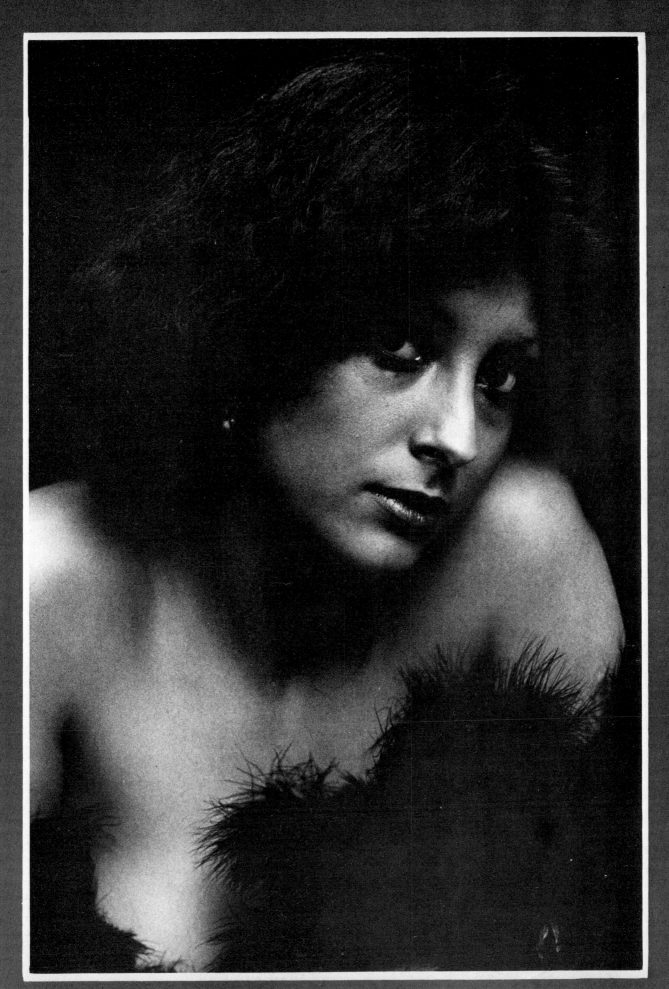

Jose Torregrosa

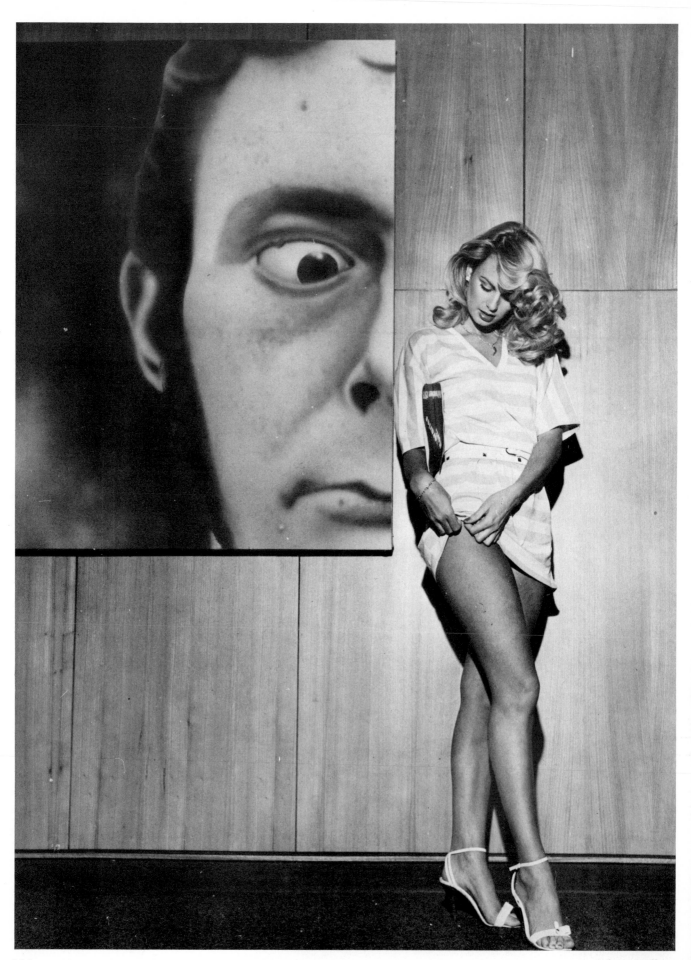

124

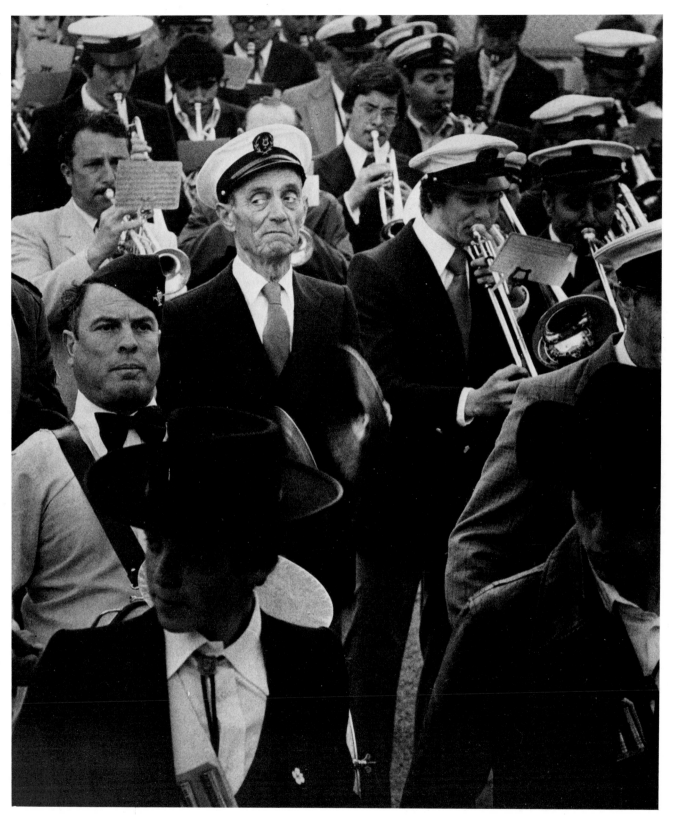

John Pattenden

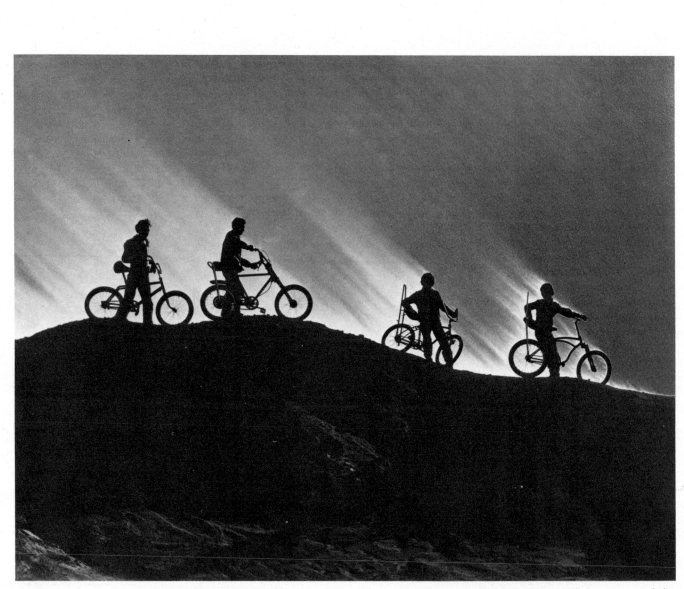

Jason Apostolidis

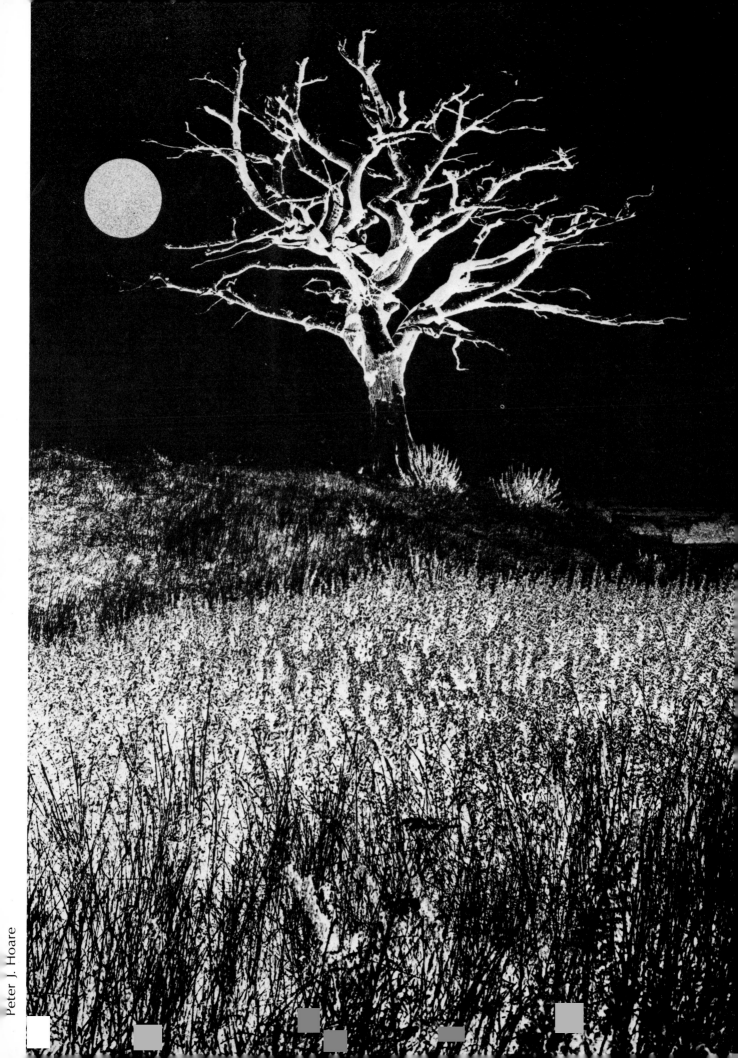

Peter J. Hoare

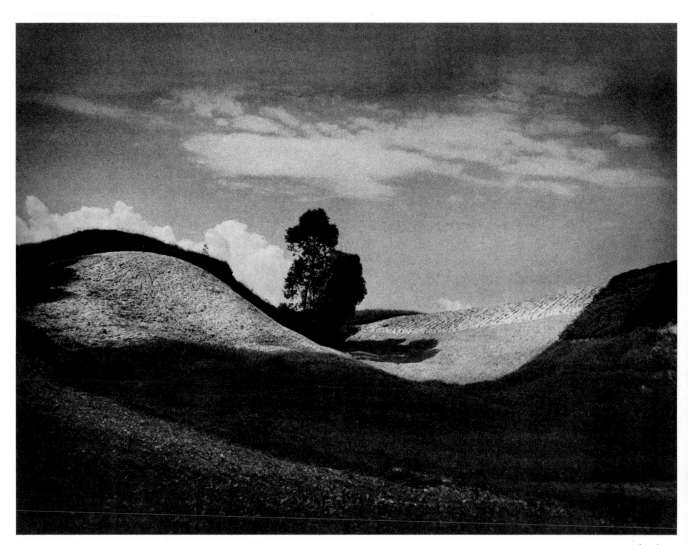

Pawel Pierściński

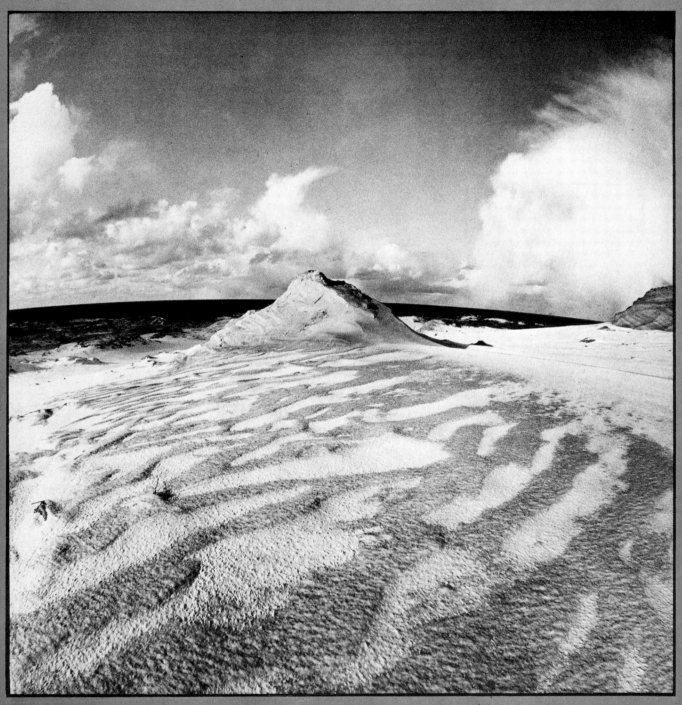

V. Straukas

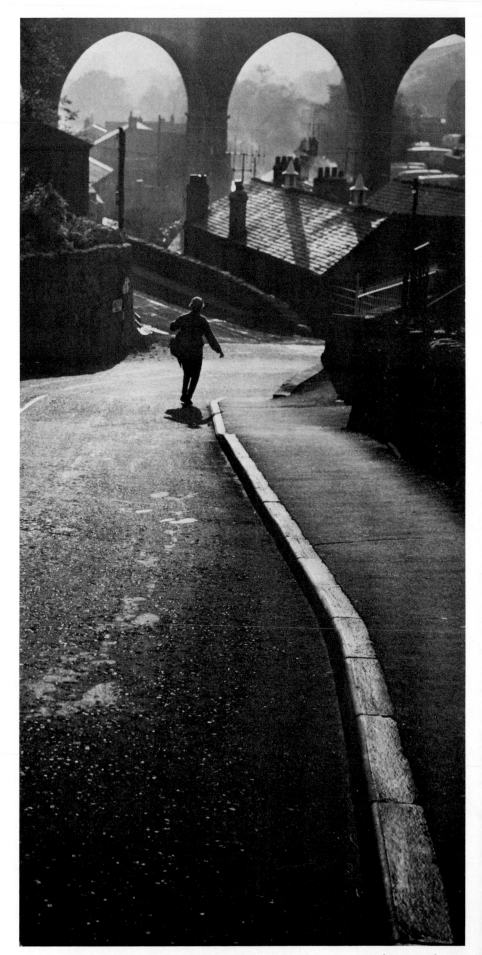

John P. Delaney

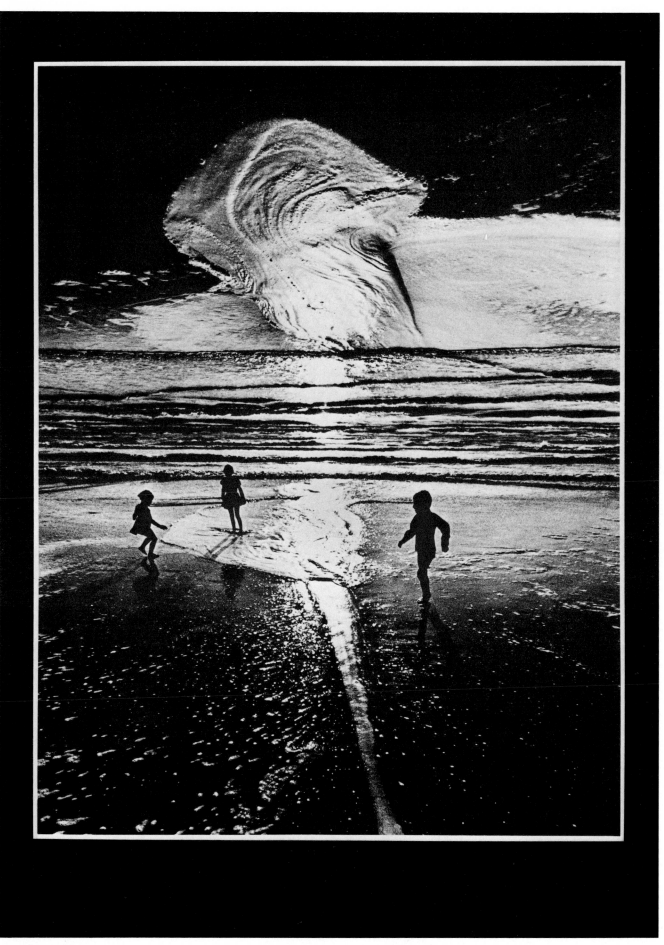

Witaly Butyrin

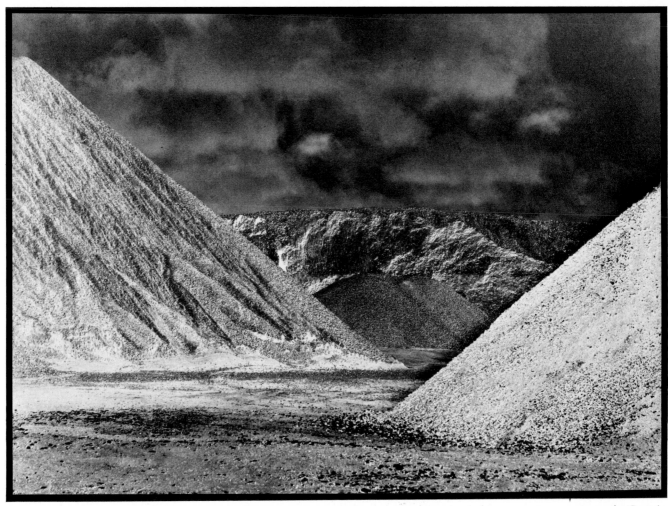

Joseph Cascio

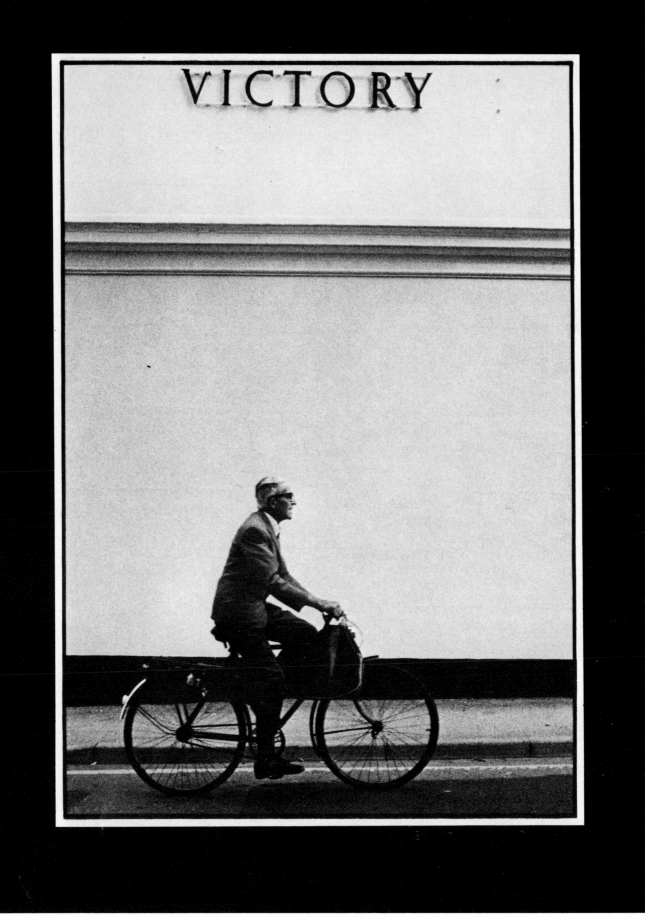

Miguel Bergasa

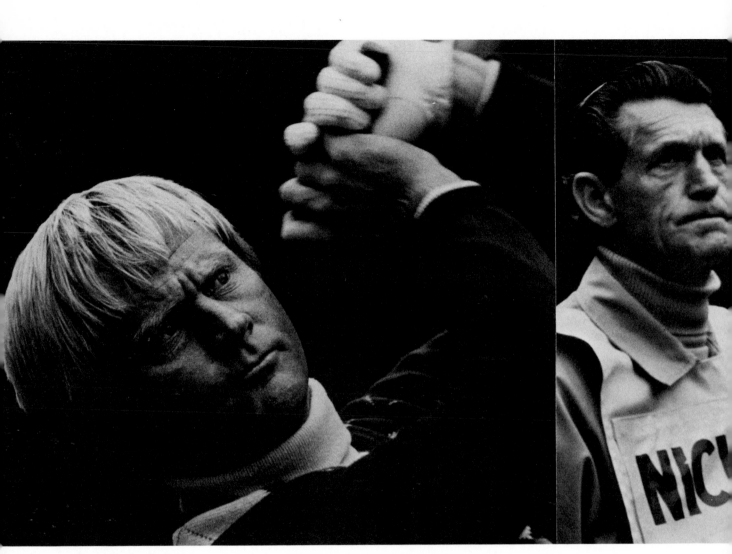

Stephen Shakeshaft

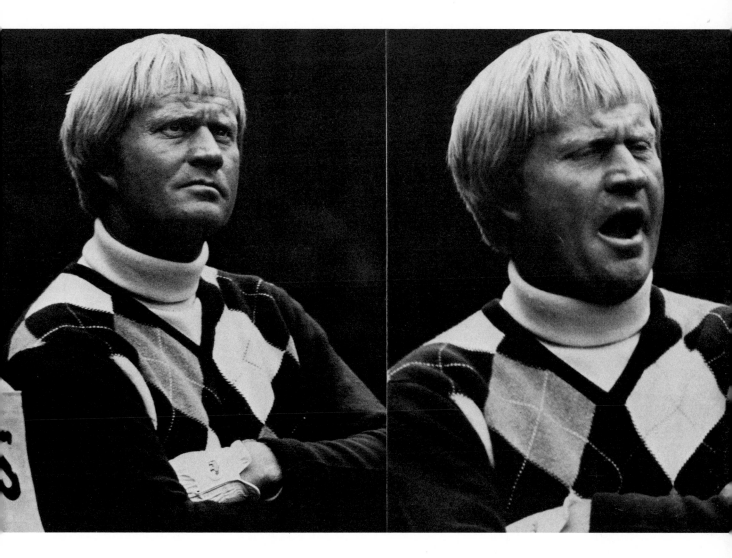

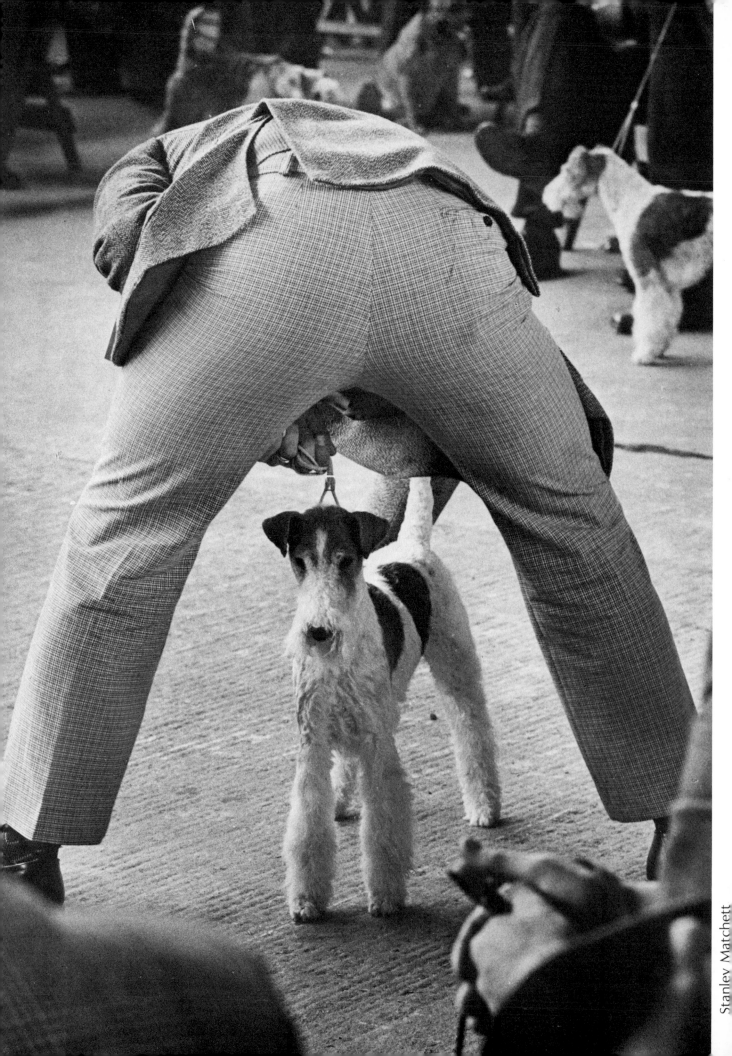

Stanley Matchett

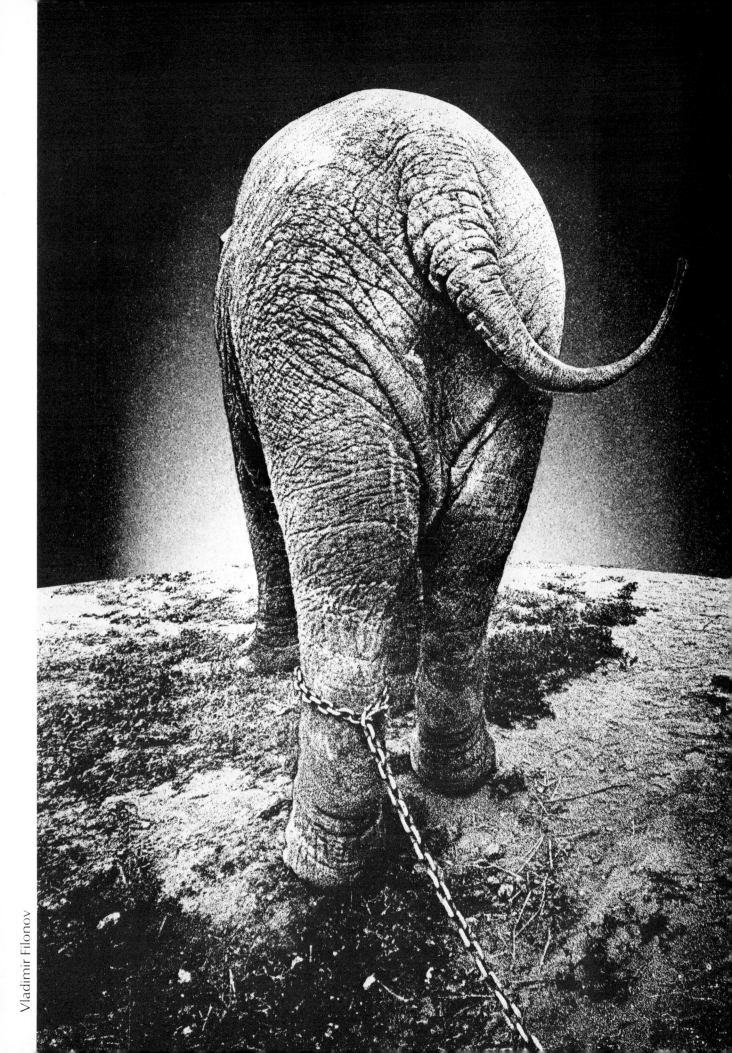

Vladimir Filonov

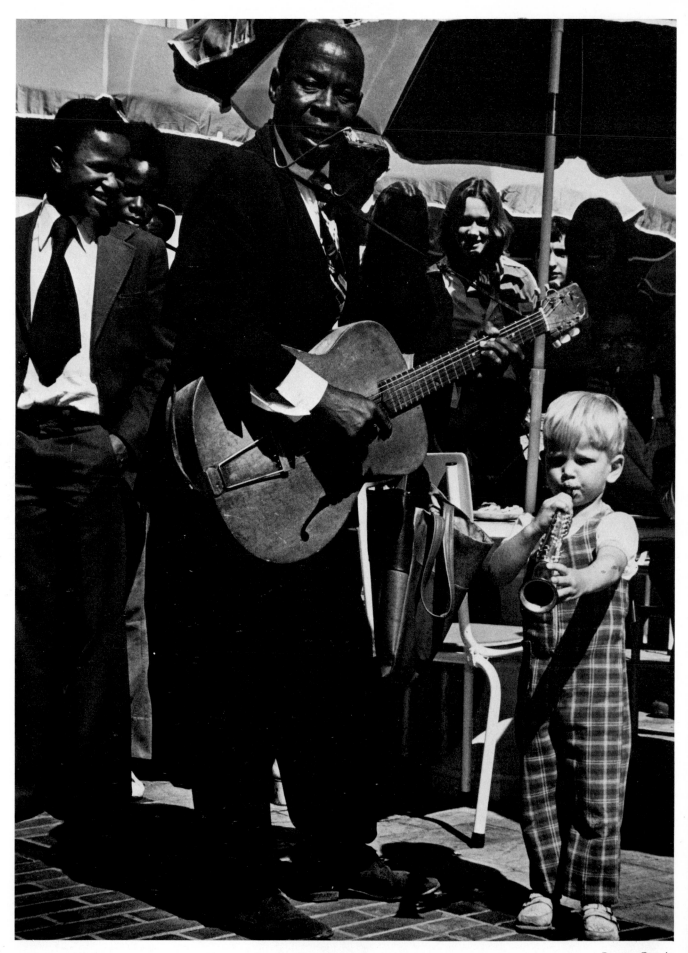

Bryan Petrie

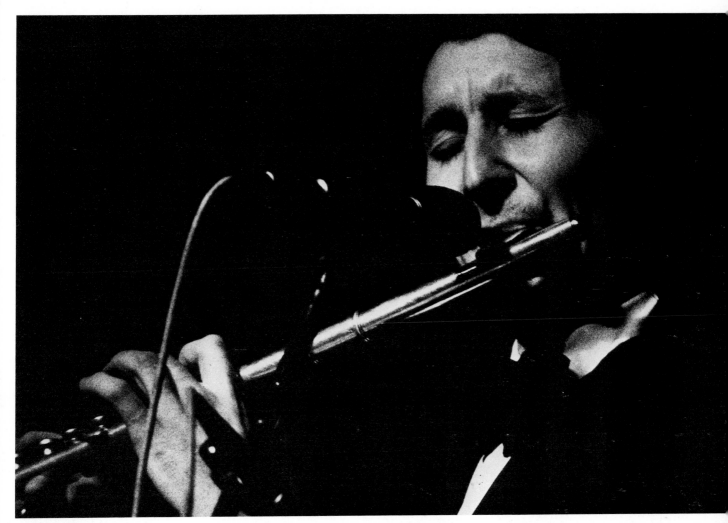

Rudolf Bieri

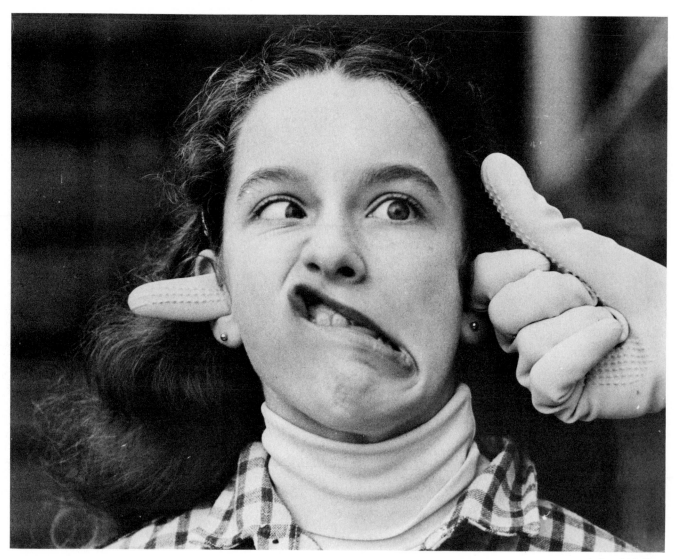

John Walker

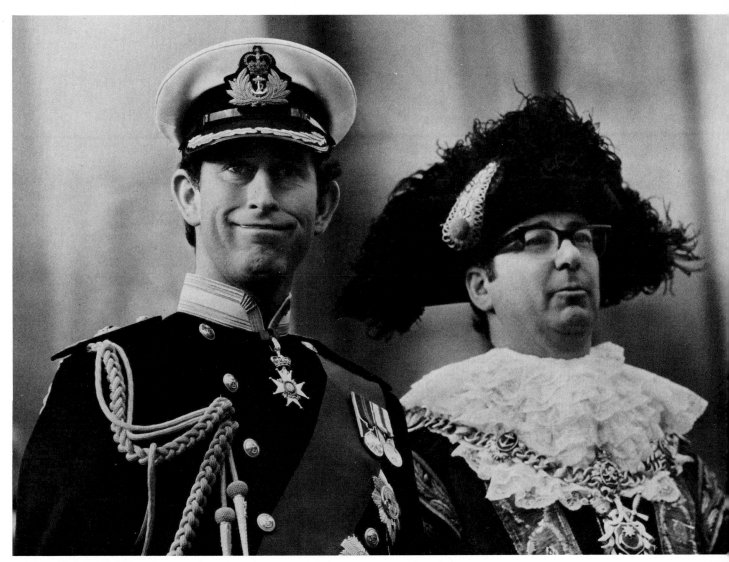

Arthur Edwards

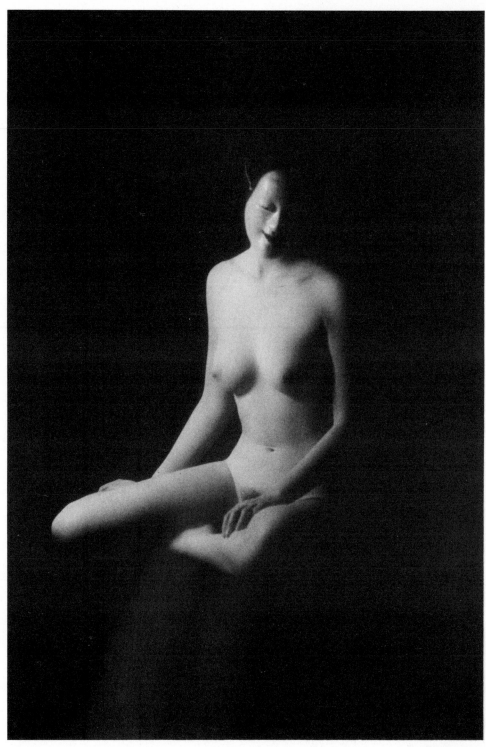

Hideki Fujii

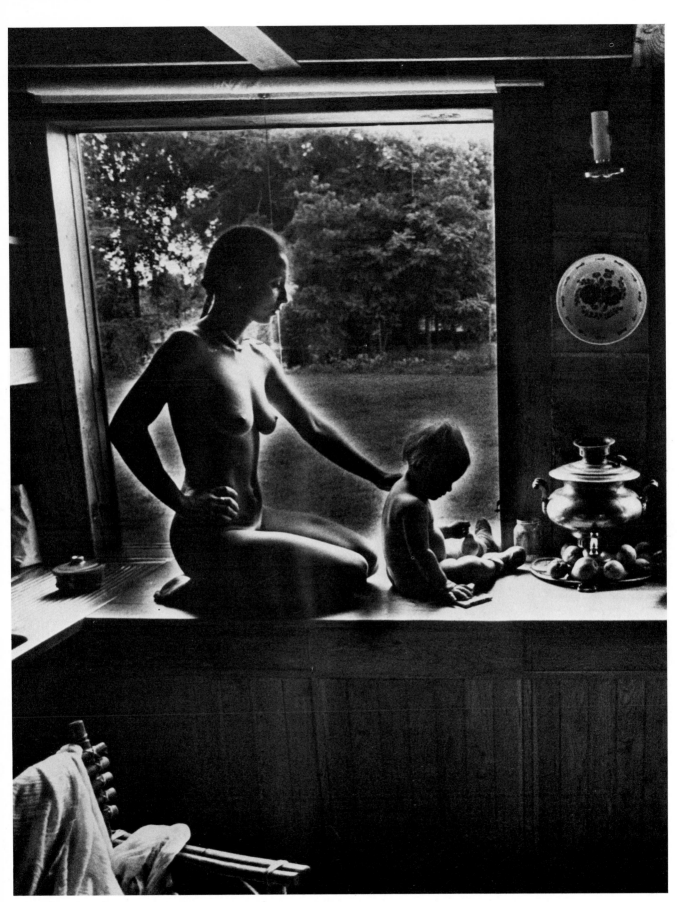

Stanislav Trzaska

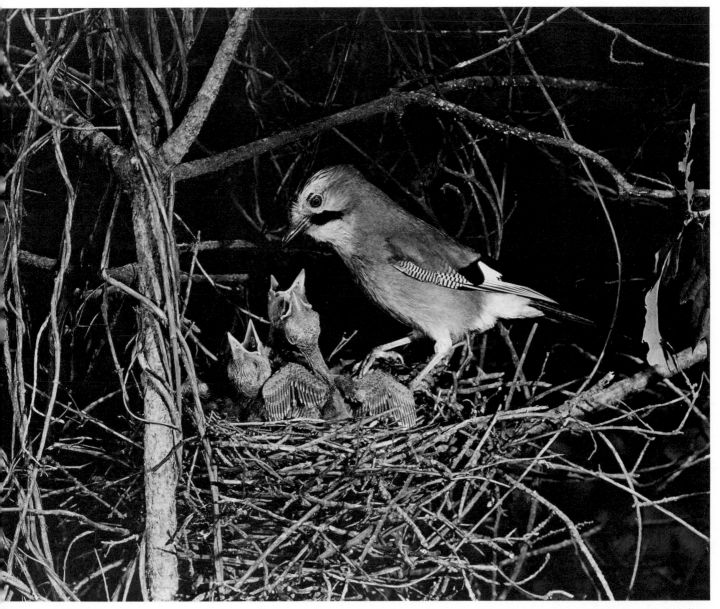

Maurice K. Walker

144

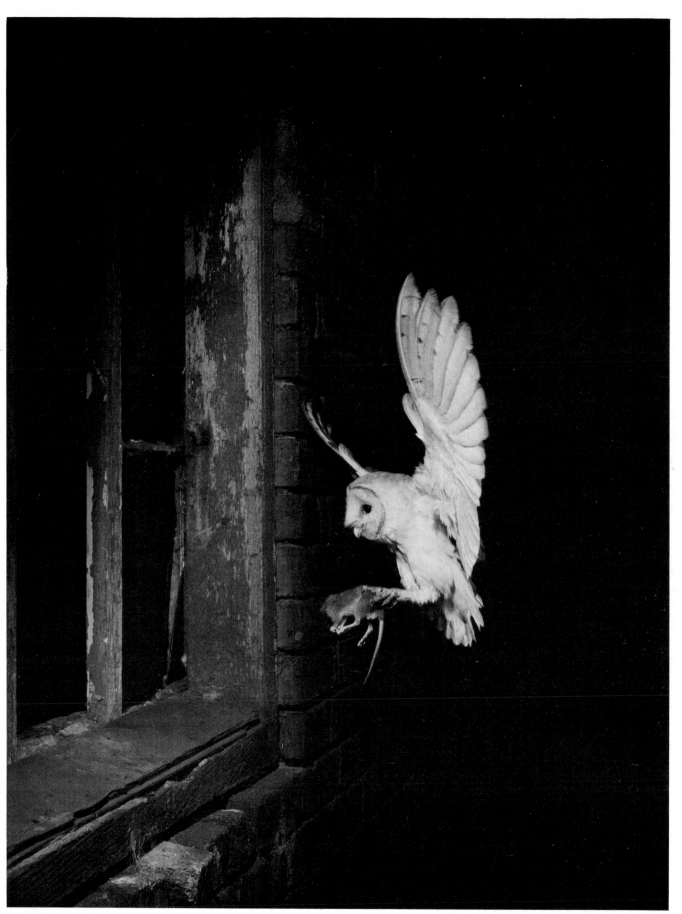

Anthony J. Bond

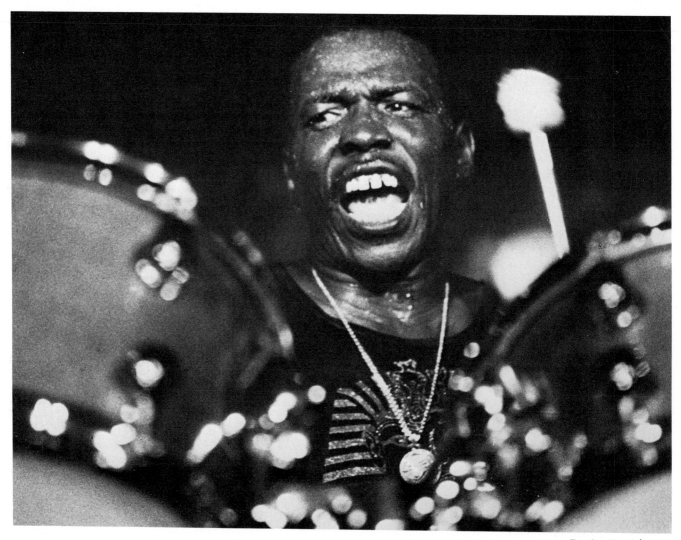

Erwin Kneidinger

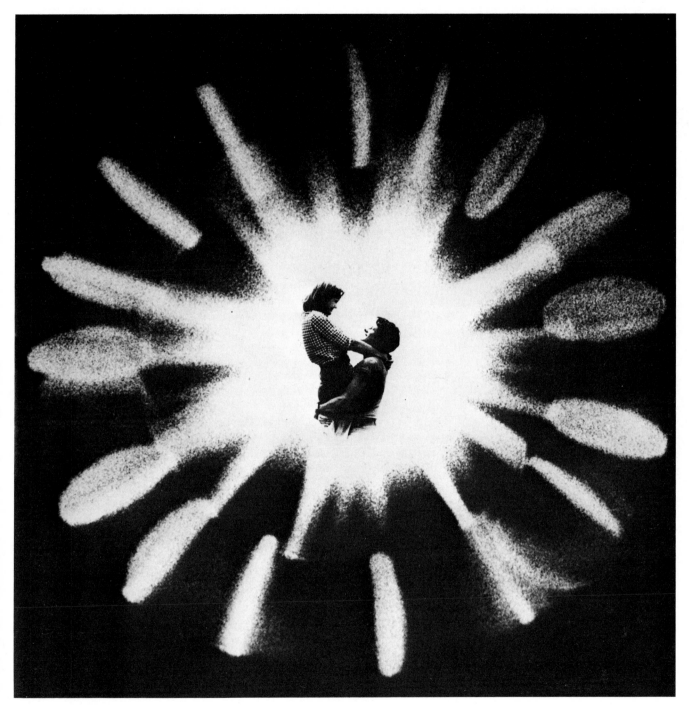

Pavol Schramko

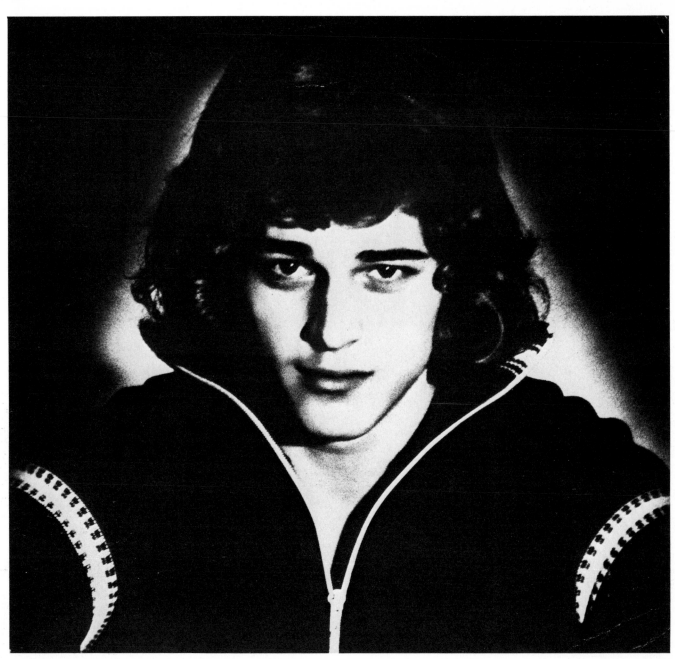

Oleg Burbowskij

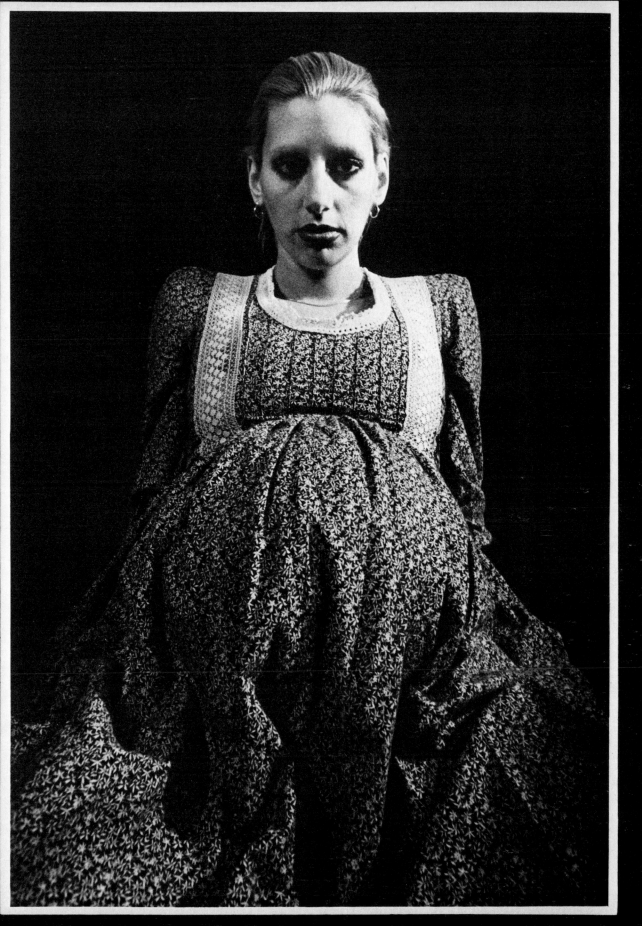

David Balsells

Joyce Newcombe

John O'Reilly

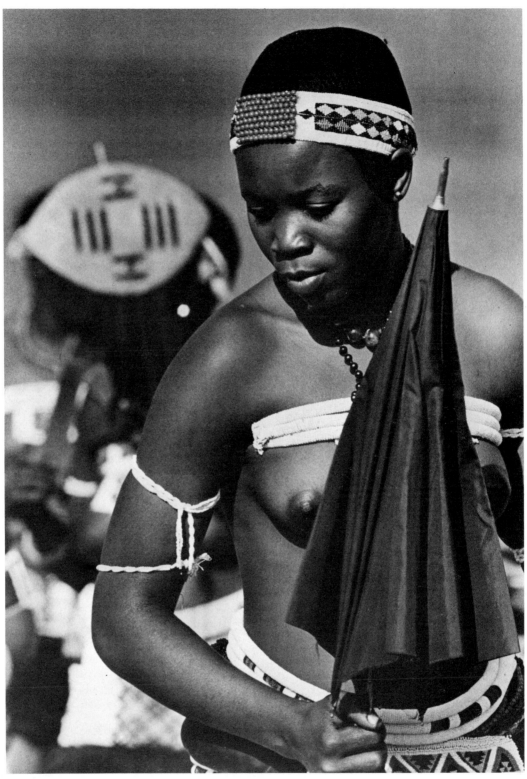

Andrej Krynicki Andrzej Sawa

153

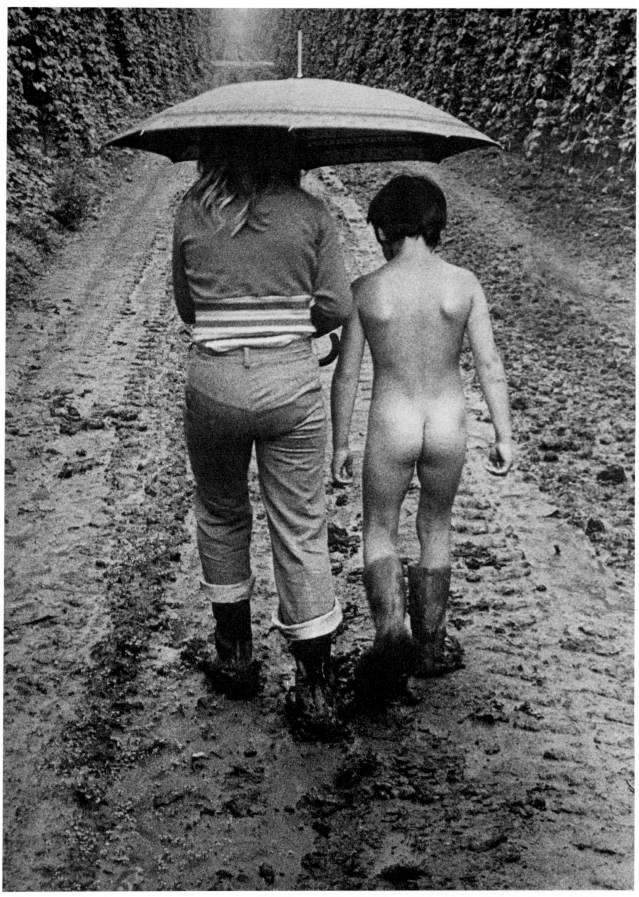

L.B. Feresovi

Mike Hollist

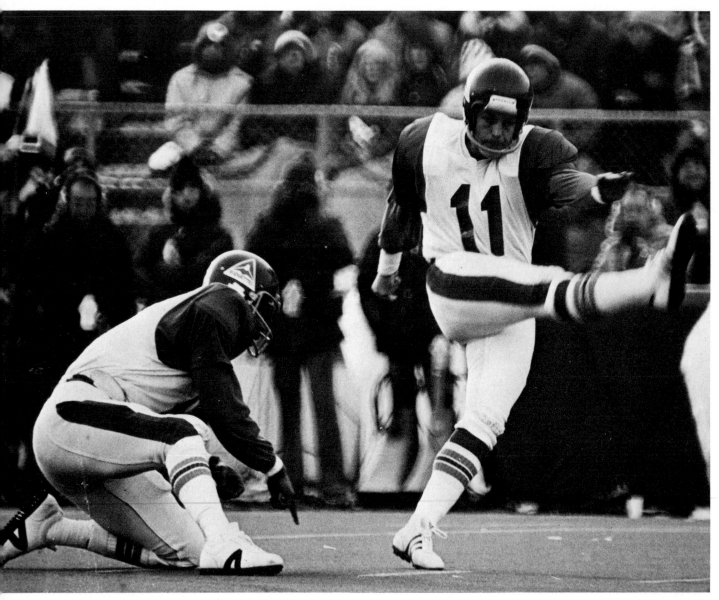

W.H. Murenbeeld

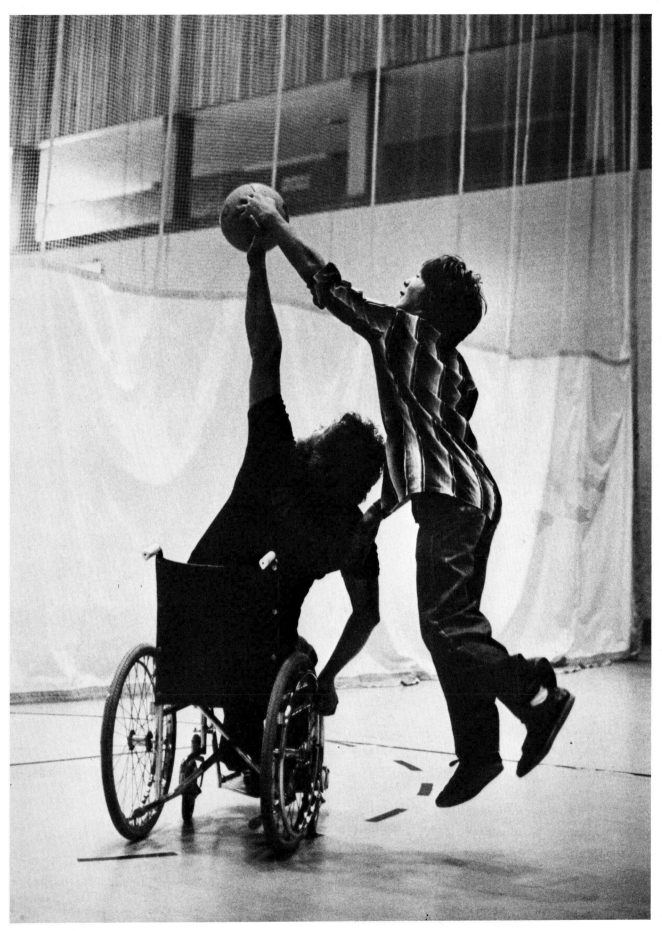

Dave Hartley

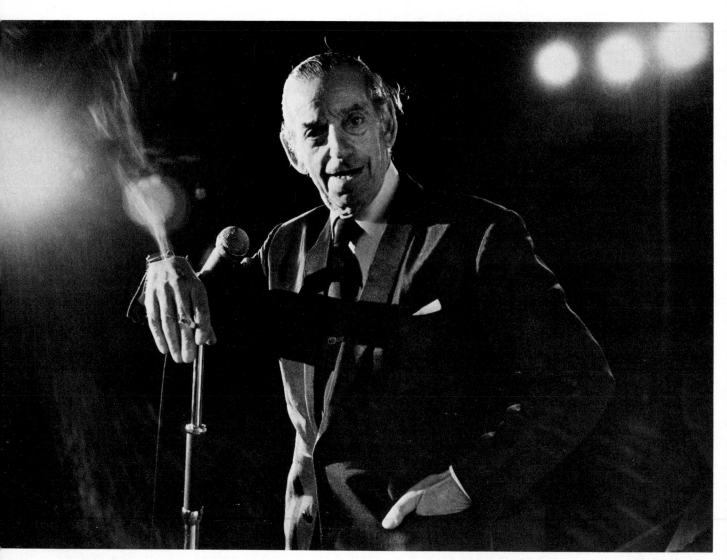

John Davidson

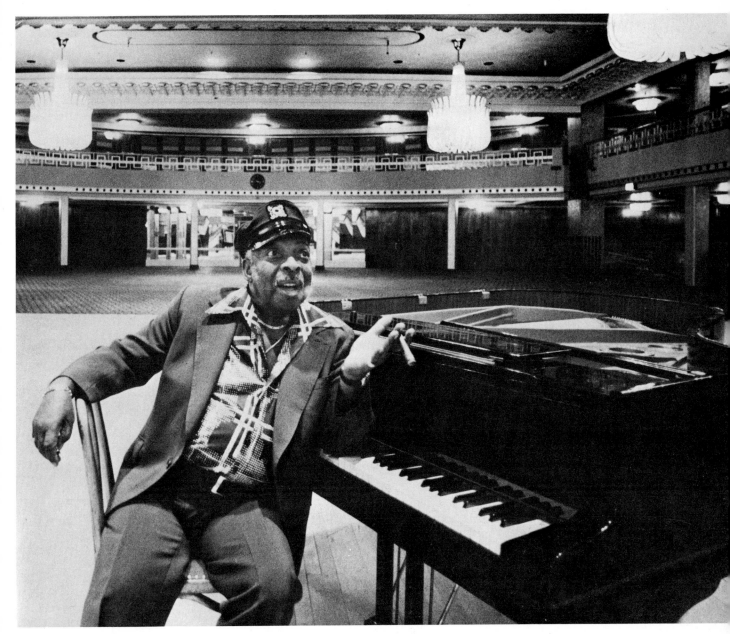

Mike Hollist

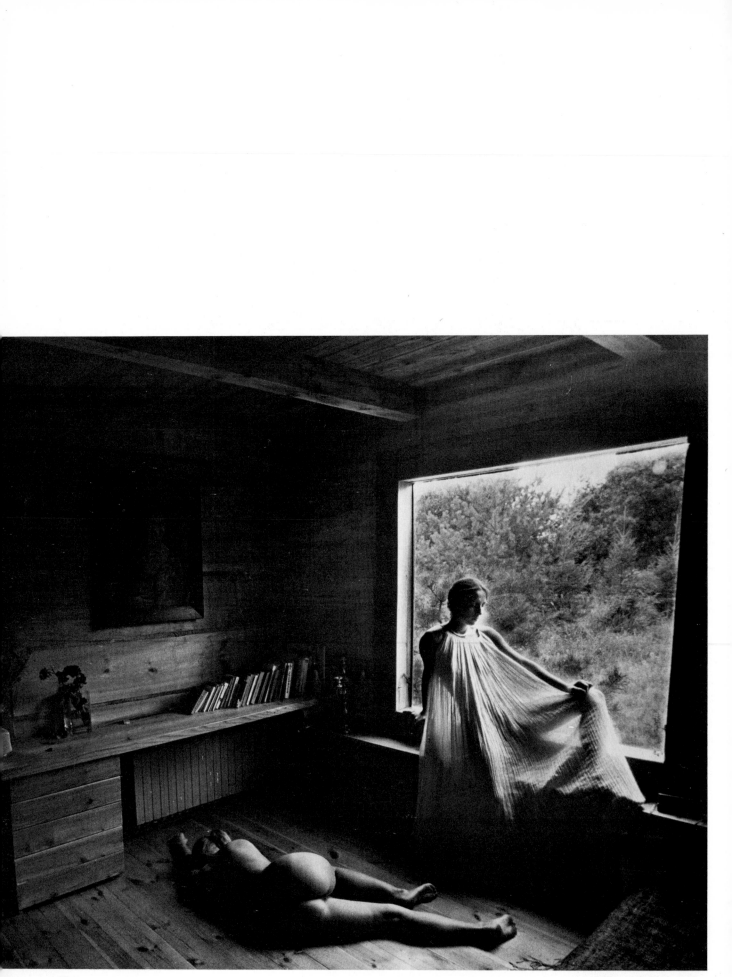

Stanislav Trzaska

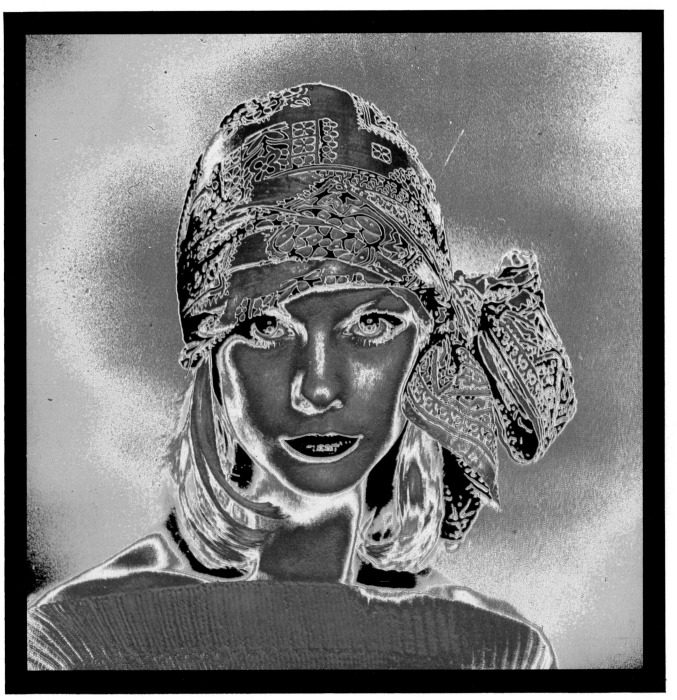

Michael Barrington-Martin

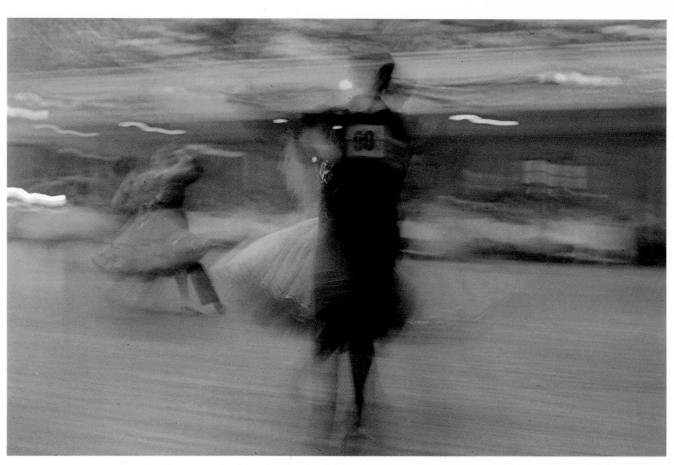

Alan Coats

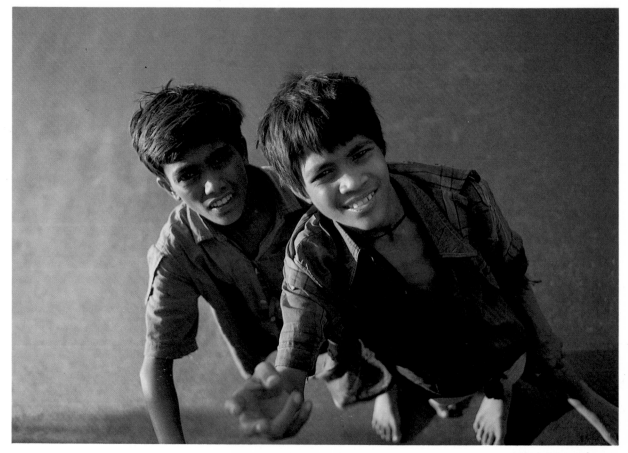

W.H. Humphreys

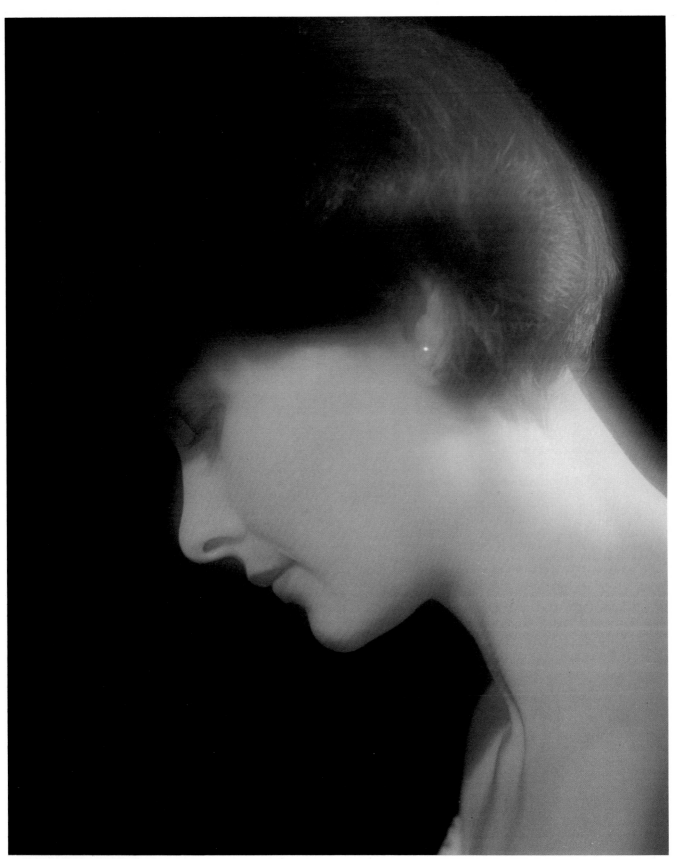

Vlado Bača

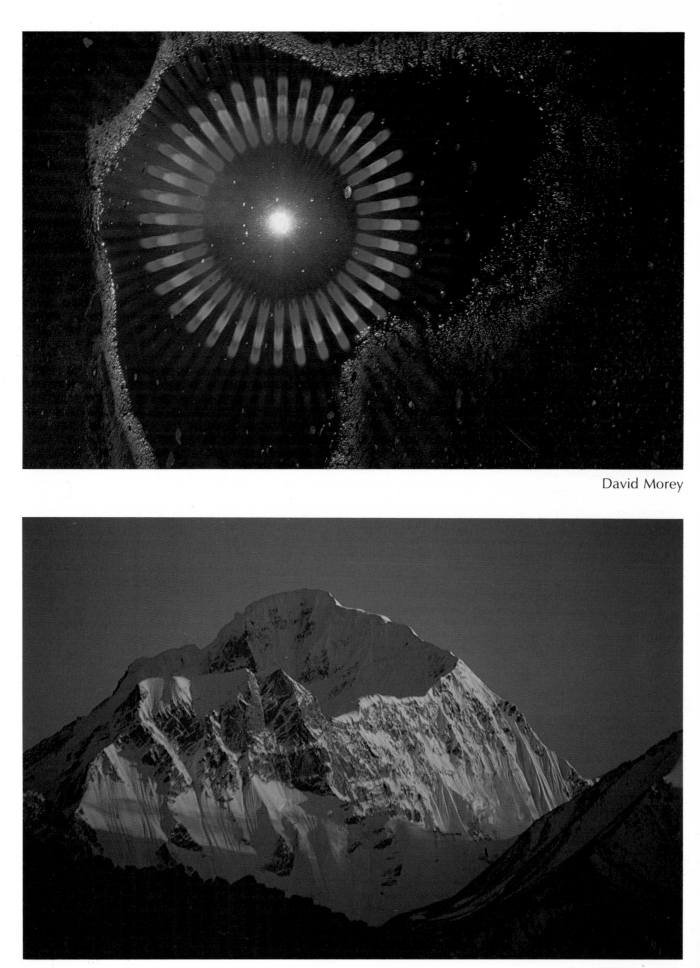

David Morey

Frank Martin

Robert Hallmann

Phil Mahre

Lee Jenn Shyong

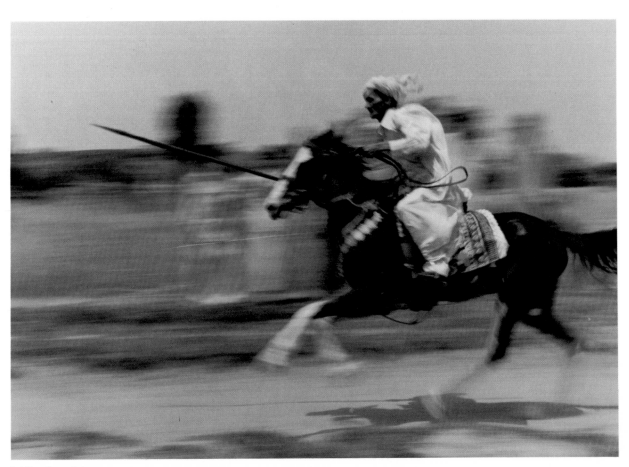

M.R. Owaisi

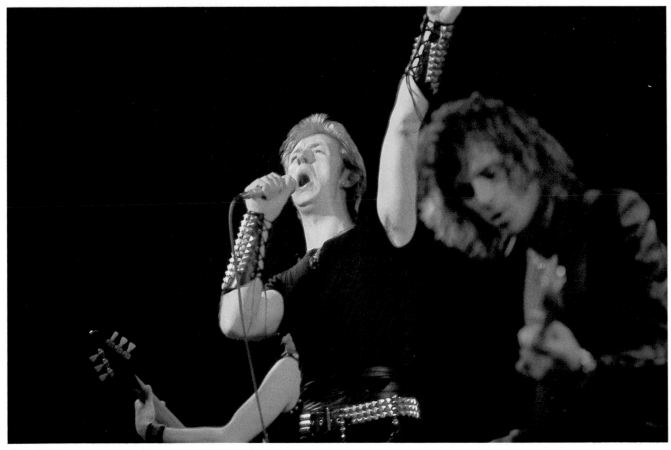

G. Leighton

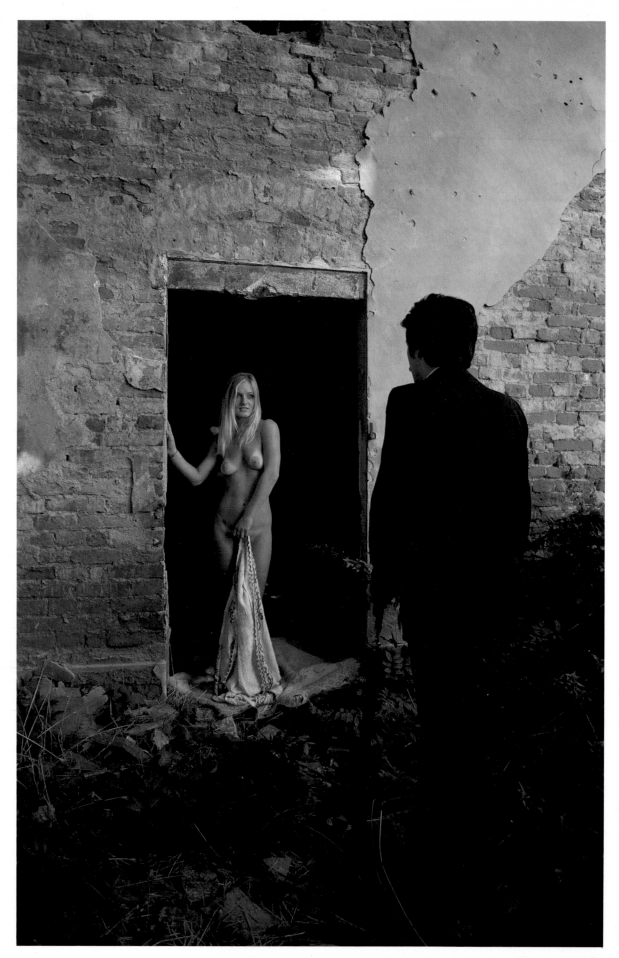

Giuseppe Balla

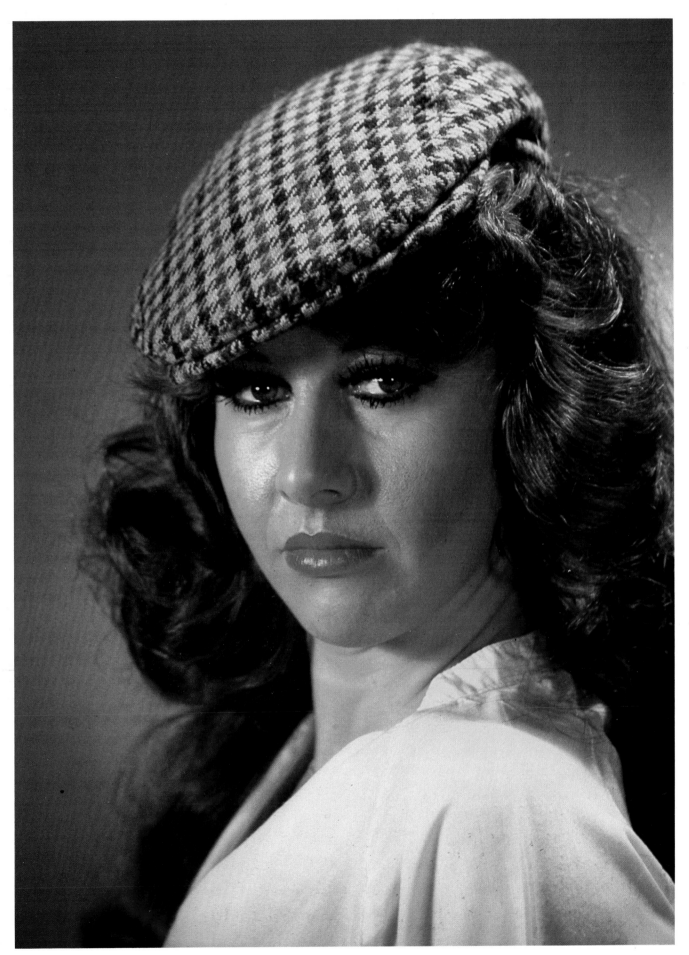

Leslie Thompson

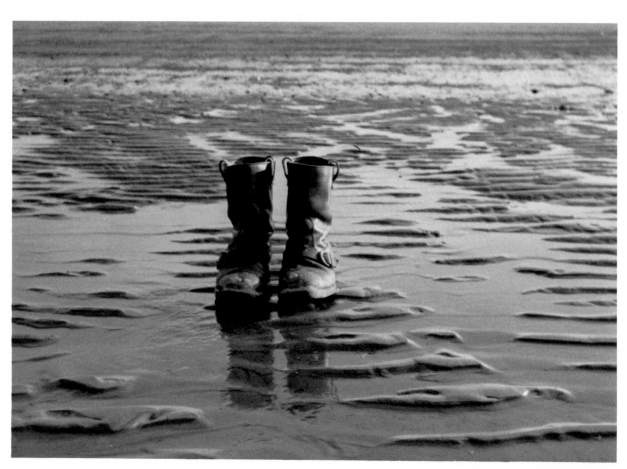

Wendy Alldis

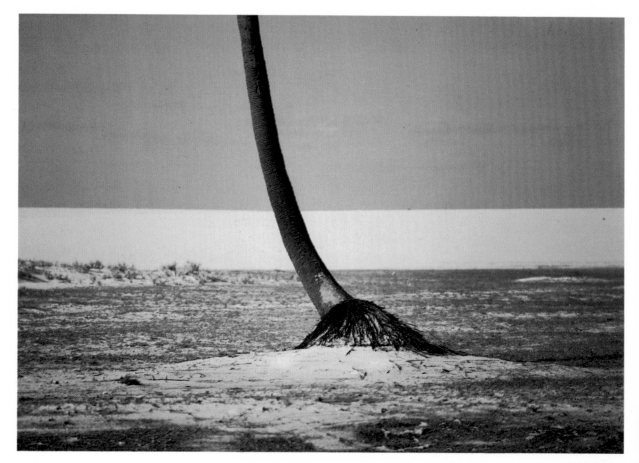

Joan Wakelin

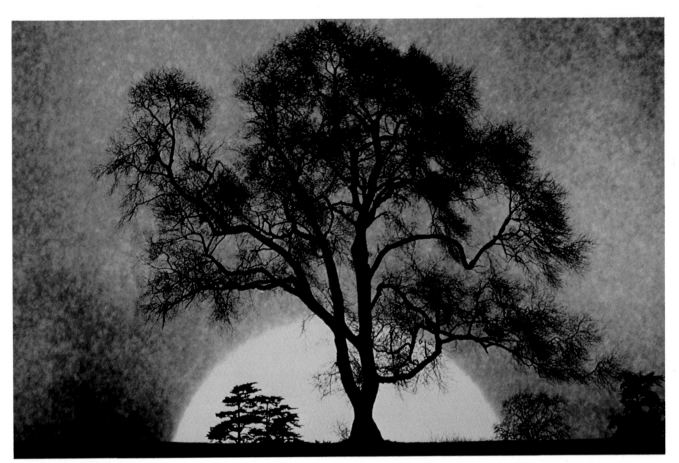

Derek Gould

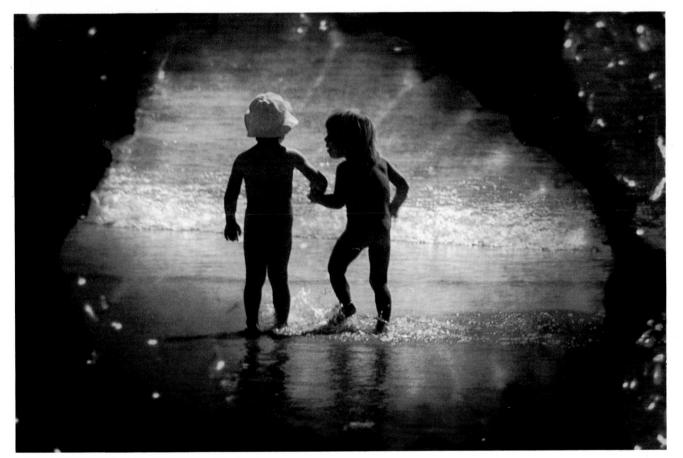

Dr M.D. Constable

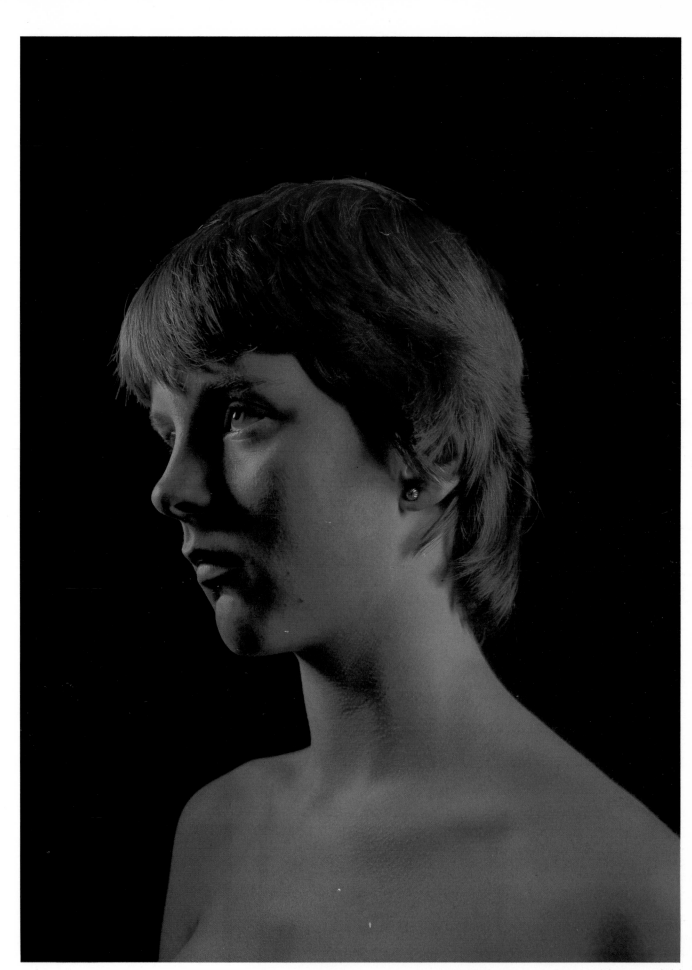

Lars Oddvar Løvdahl

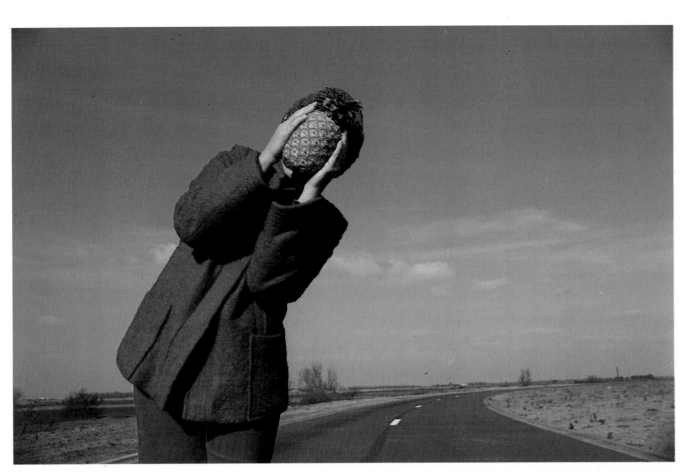

Frank Peeters

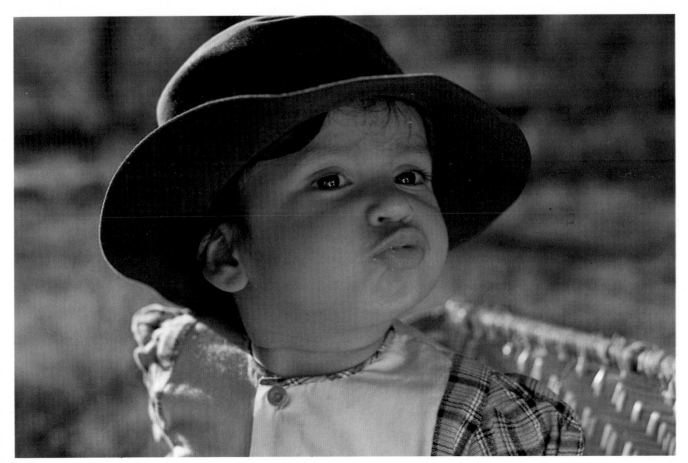

R.K. Paul

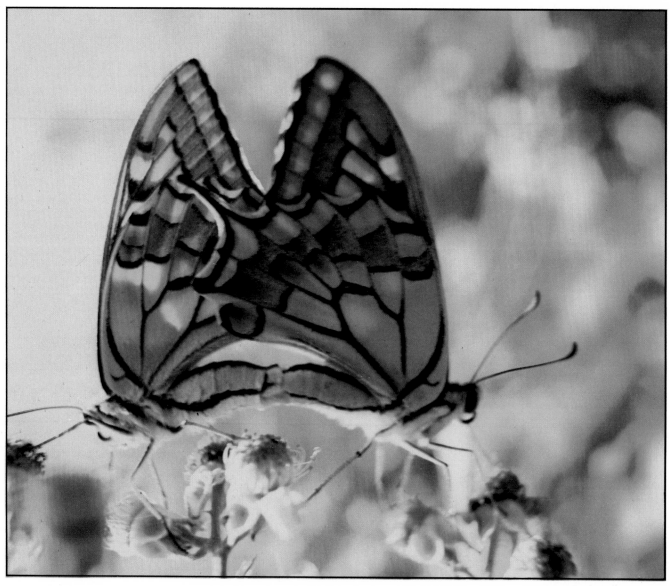

Richard Hewins

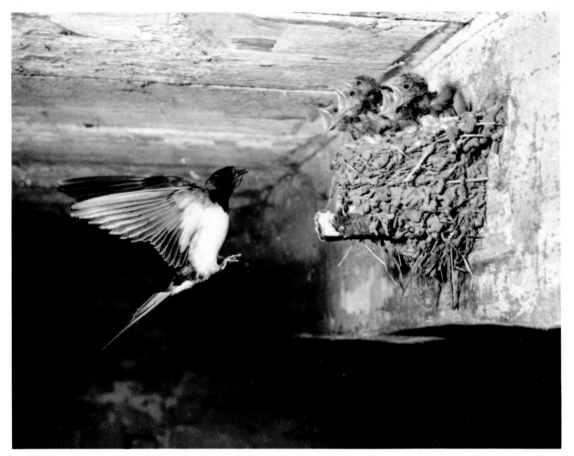

Anthony J. Bond

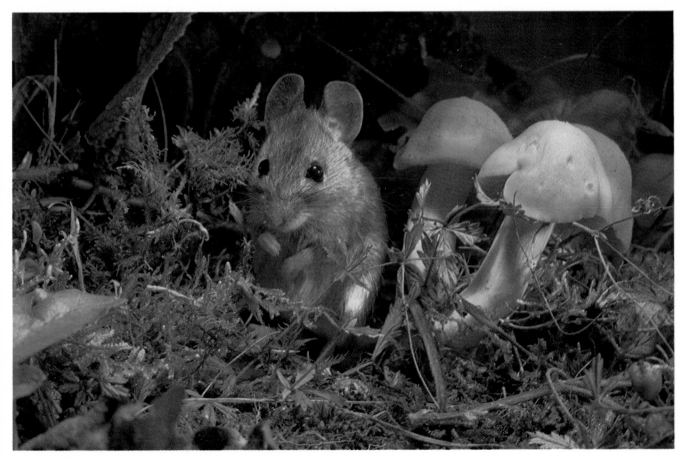

Jane Craik

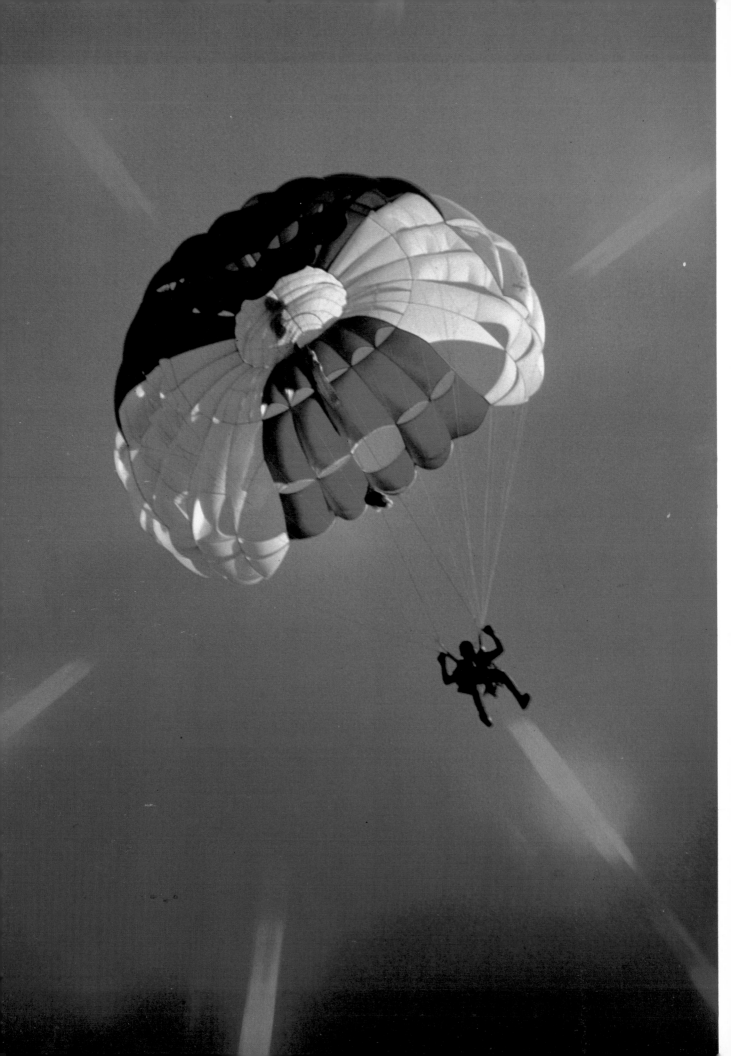

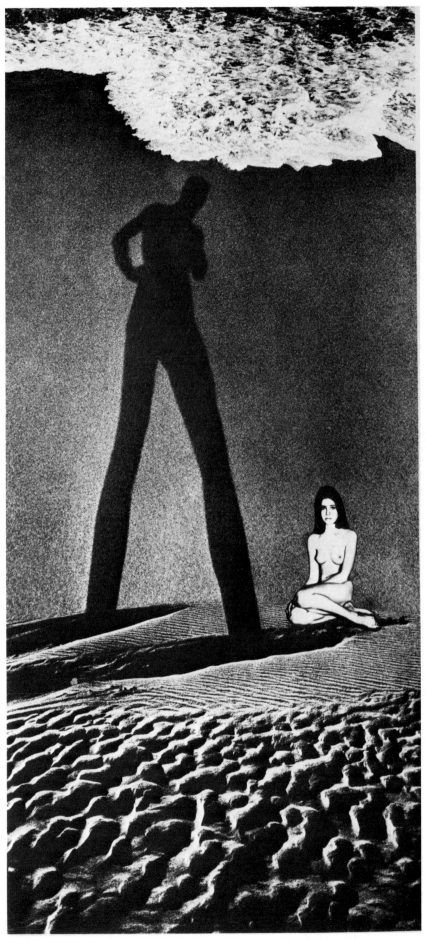

Witaly Butyrin 177

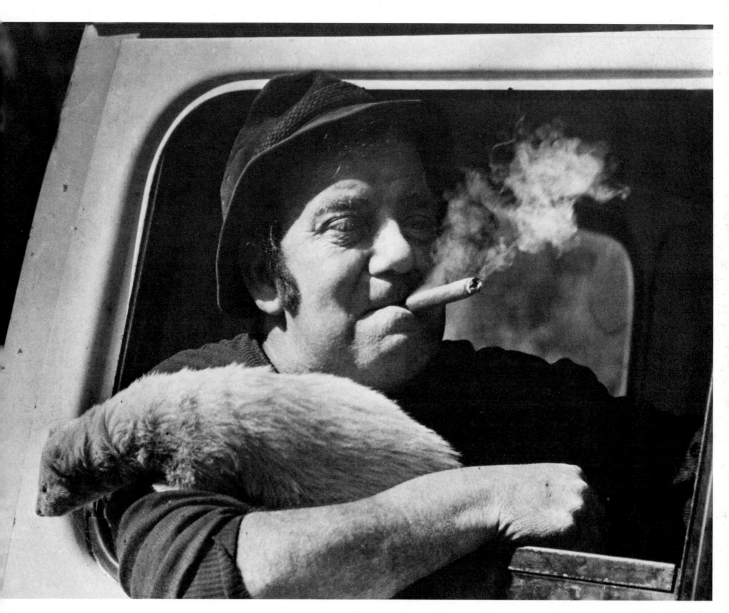

Joan Wakelin

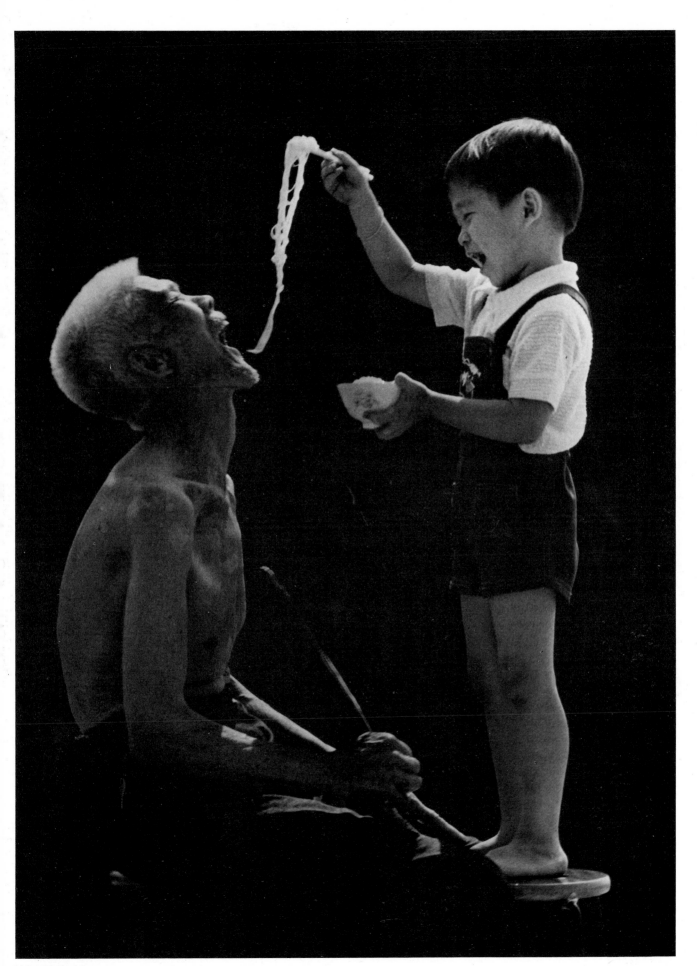

Wu Chih Hung

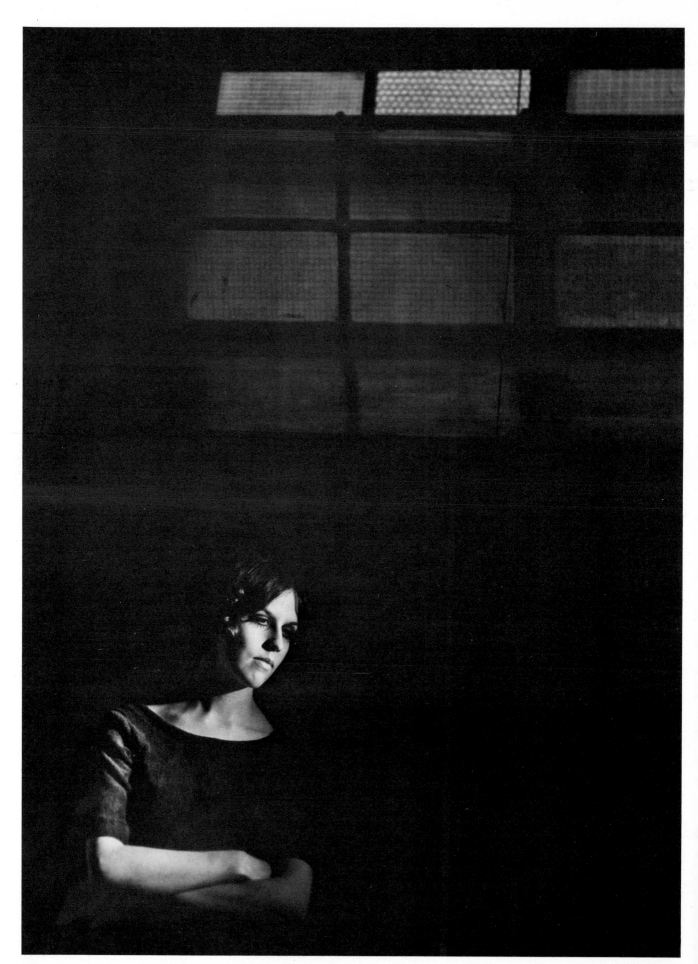

Jeanine M. Sarll

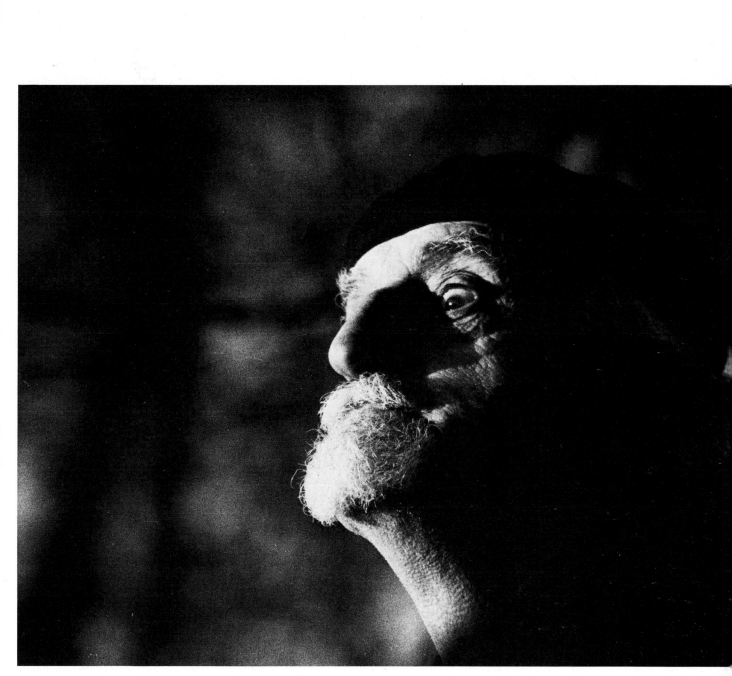

Neale Davison

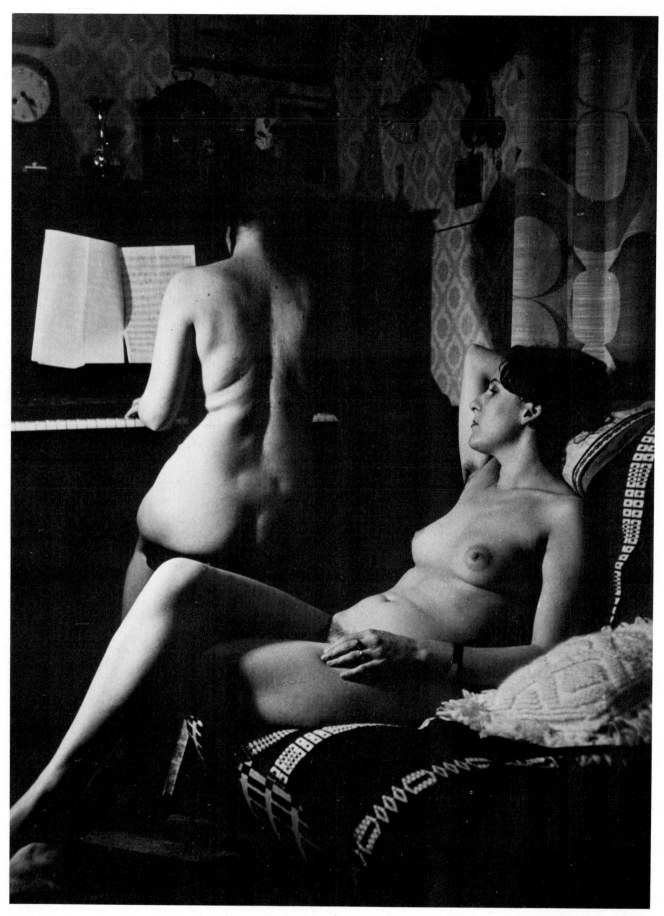

Lamberto Lamberti

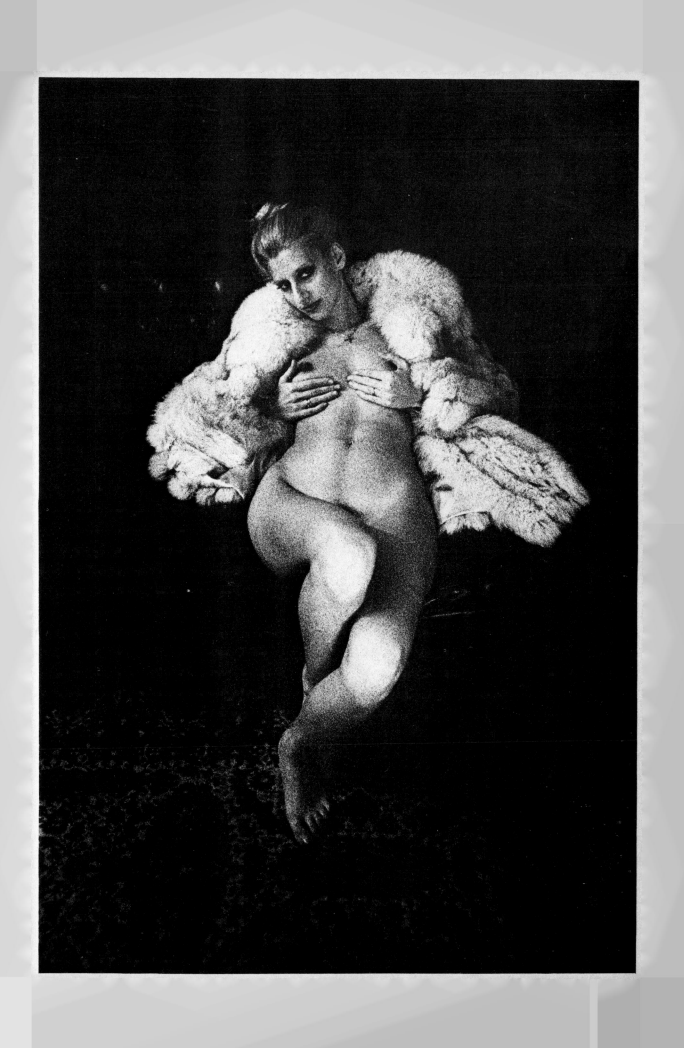

Alan Millward

184

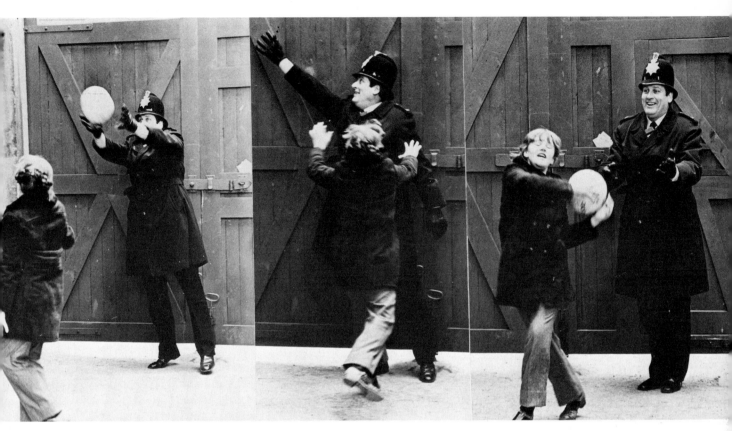

Stephen Shakeshaft

S.T.U. Fairlamb

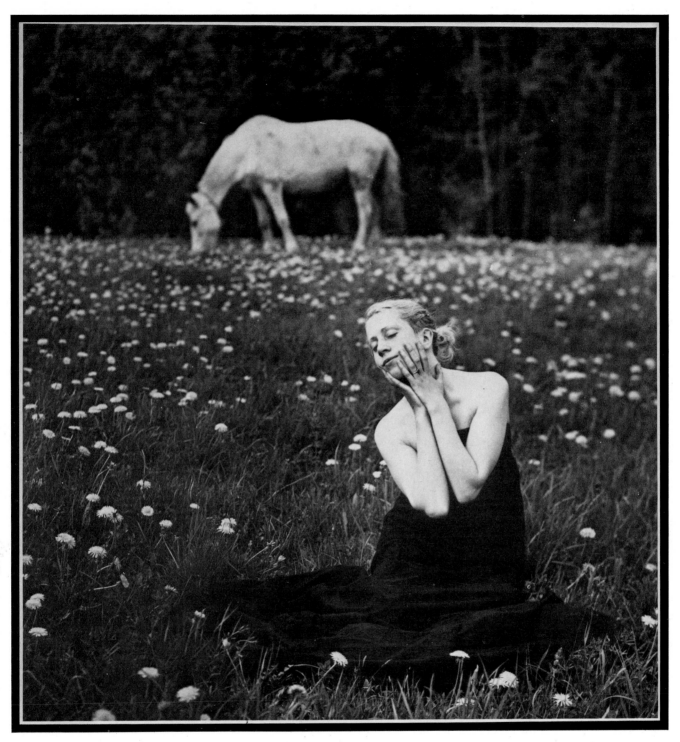

Valdis Brauns

Ārijs Klavinskis

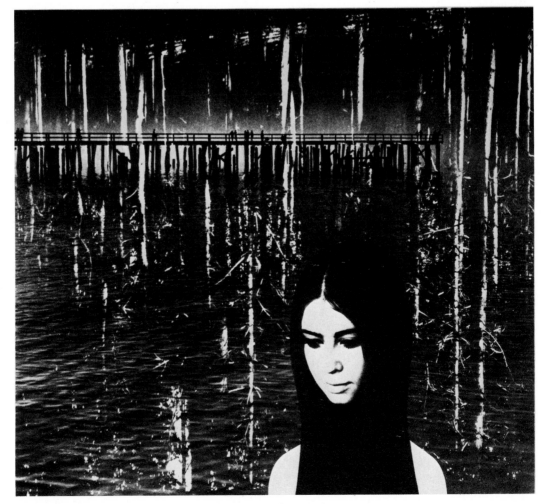

Witaly Butyrin

Jos Janssens

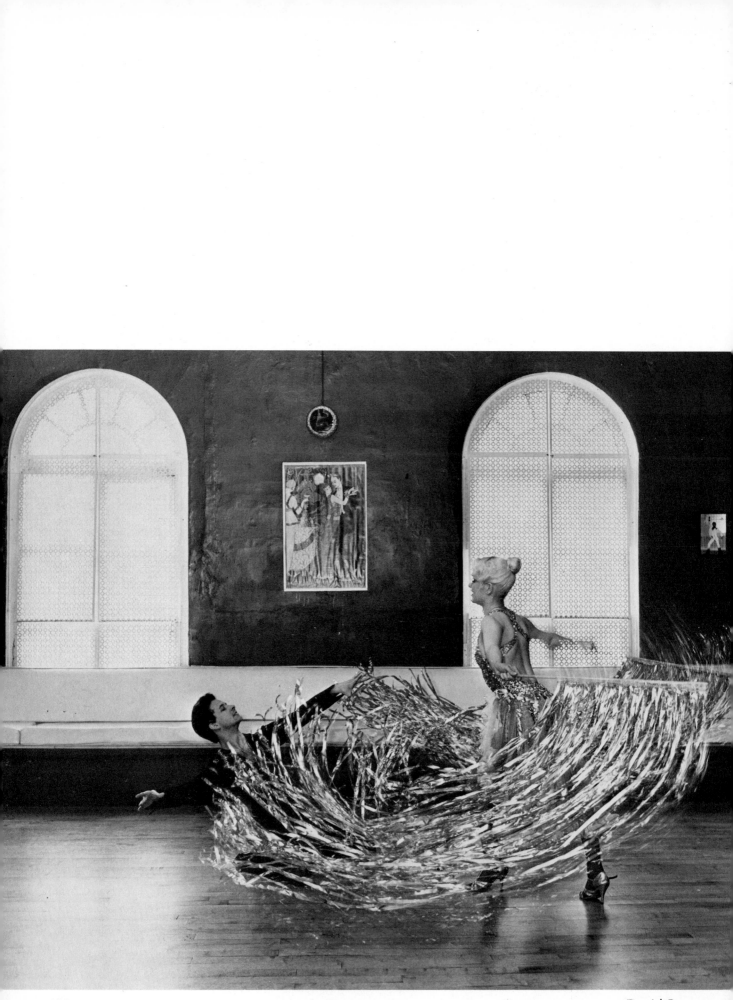

192

David Burrows

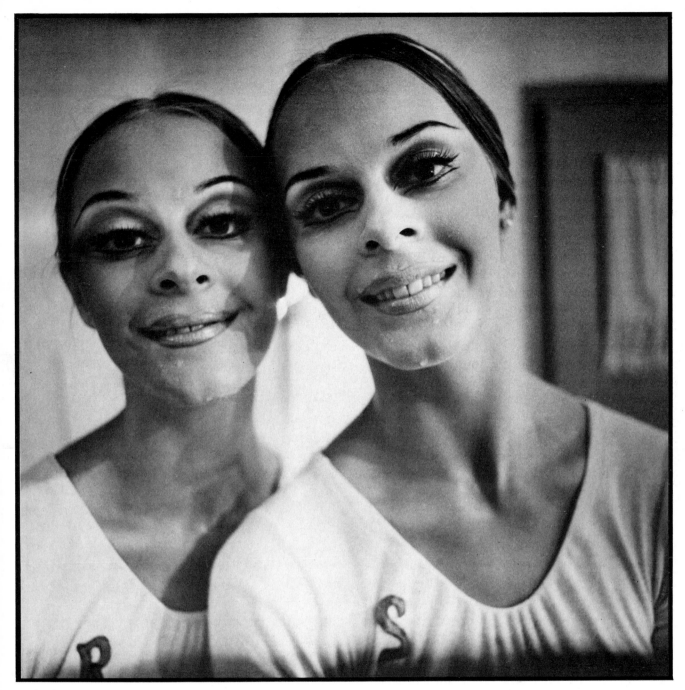

A. Sutkus

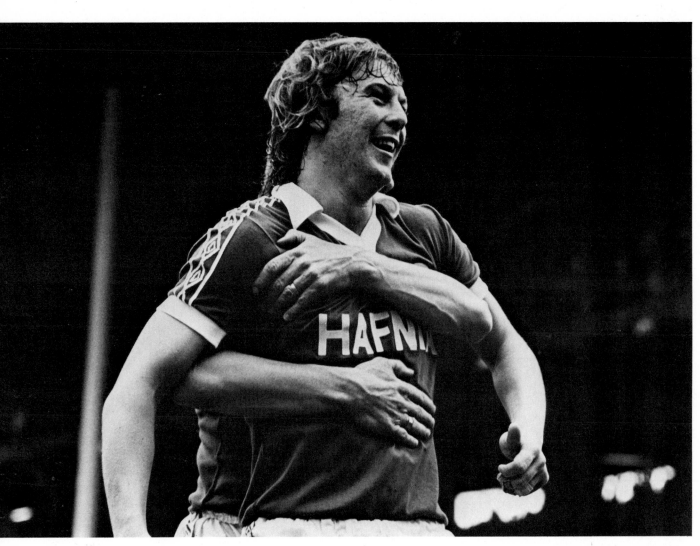

John Davidson

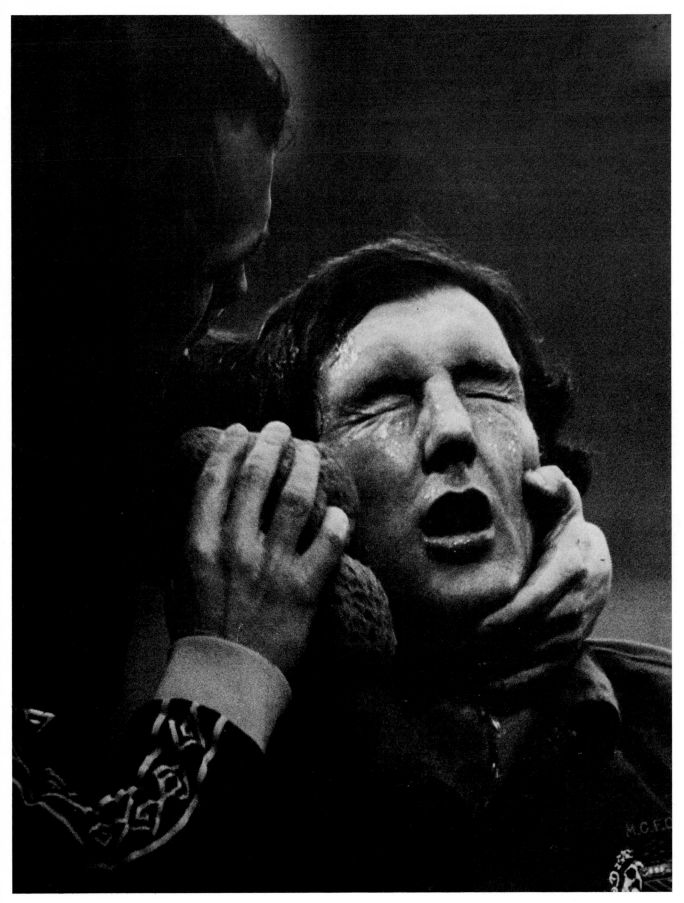

Howard Walker

Witaly Butyrin

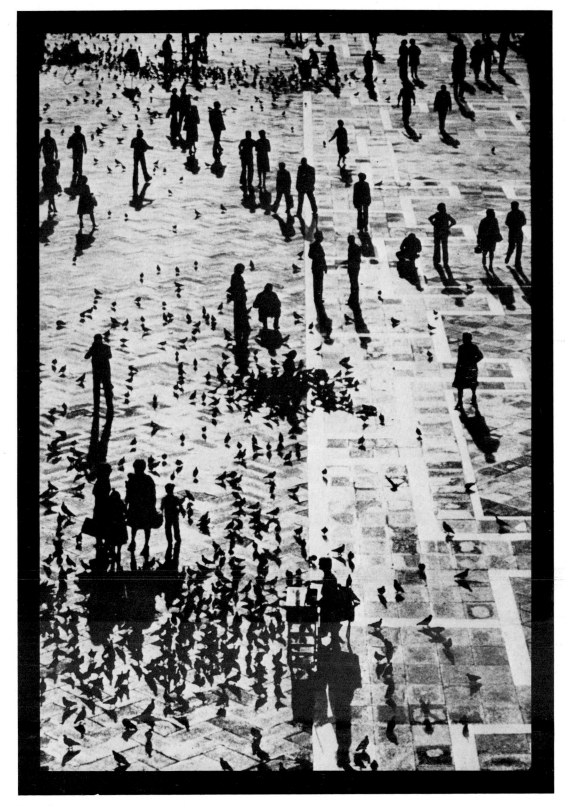

Jean Berner

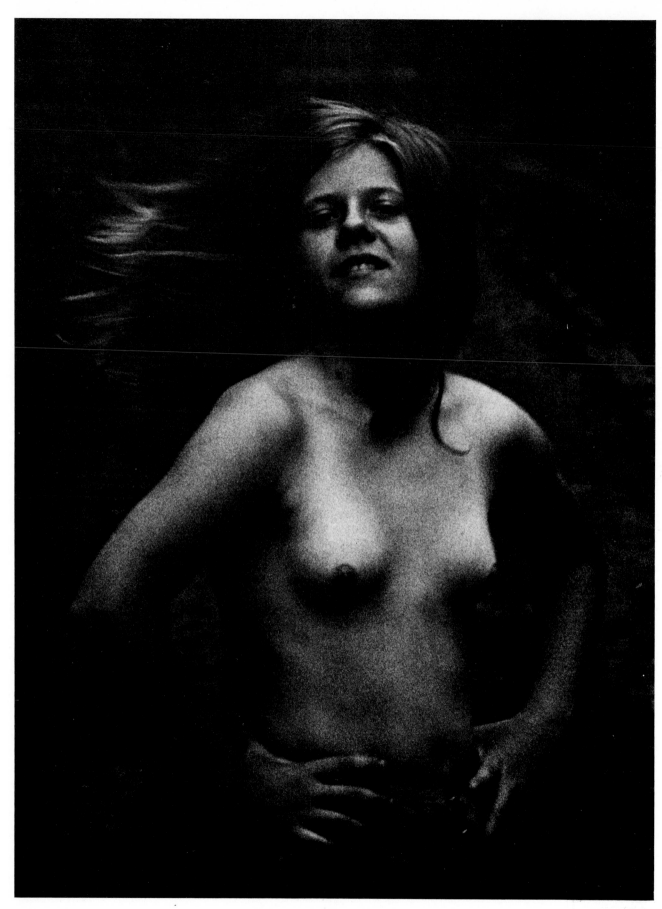

L.B. Ferešovi

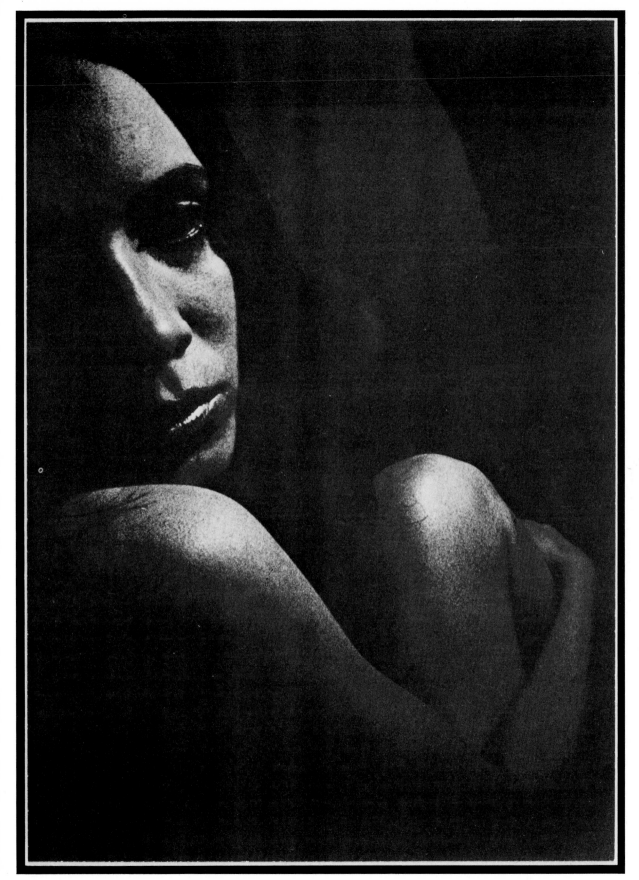

Peeter Tooming

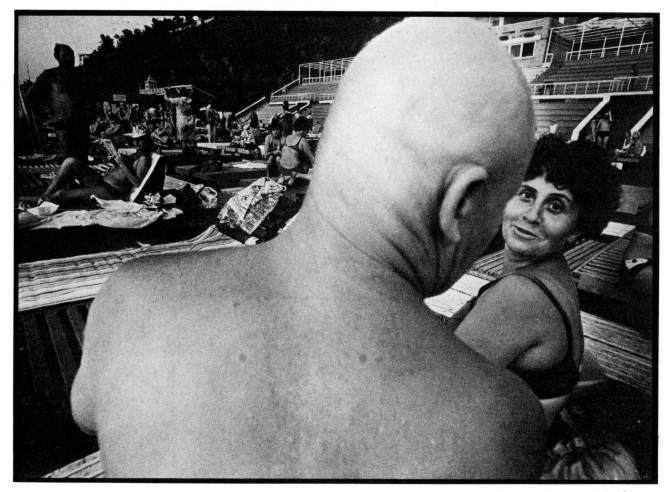

V. Shonta

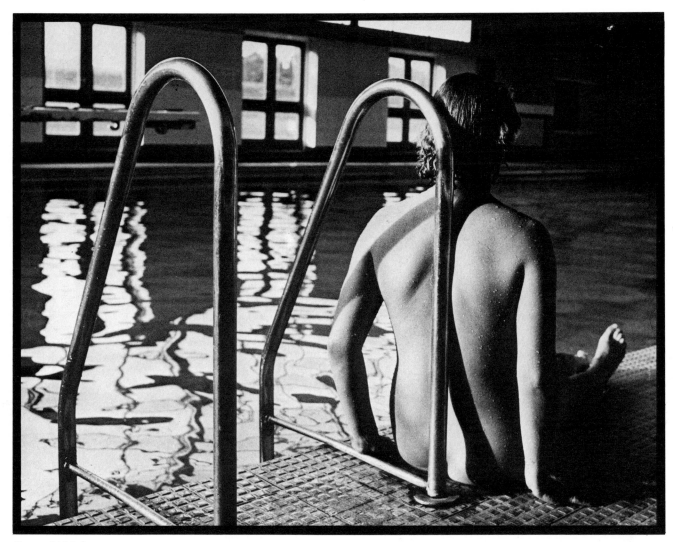

Corry Wright

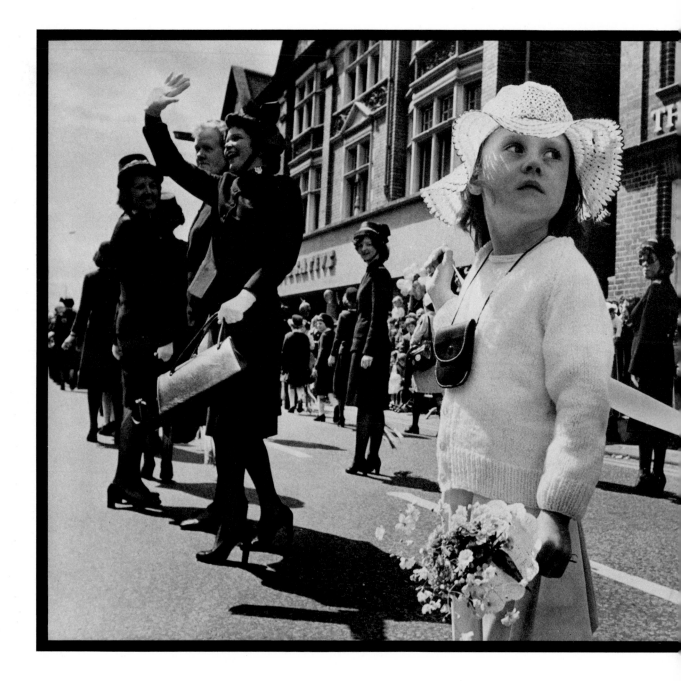

John Davidson Douglas Corrance

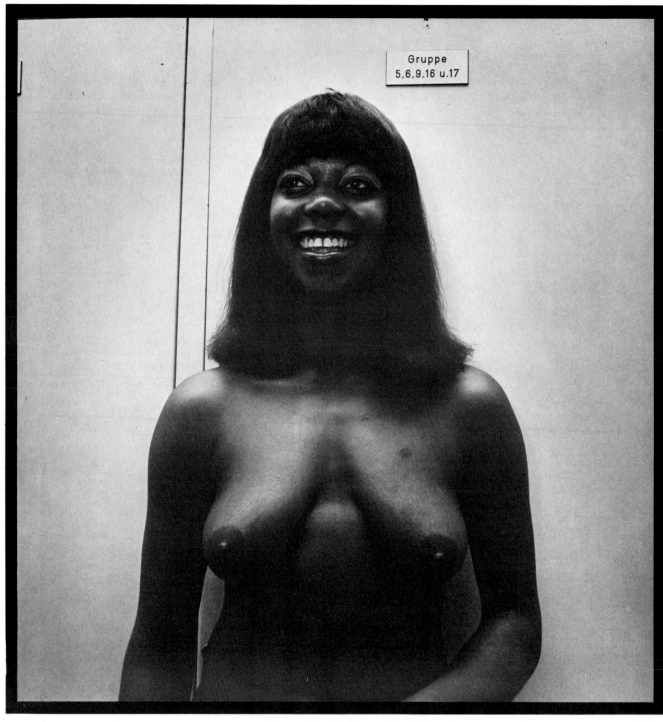

Peter Hense

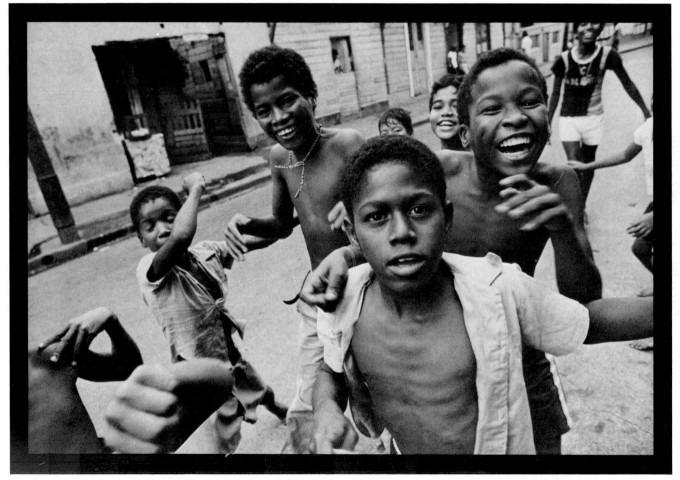

Luc Chessex

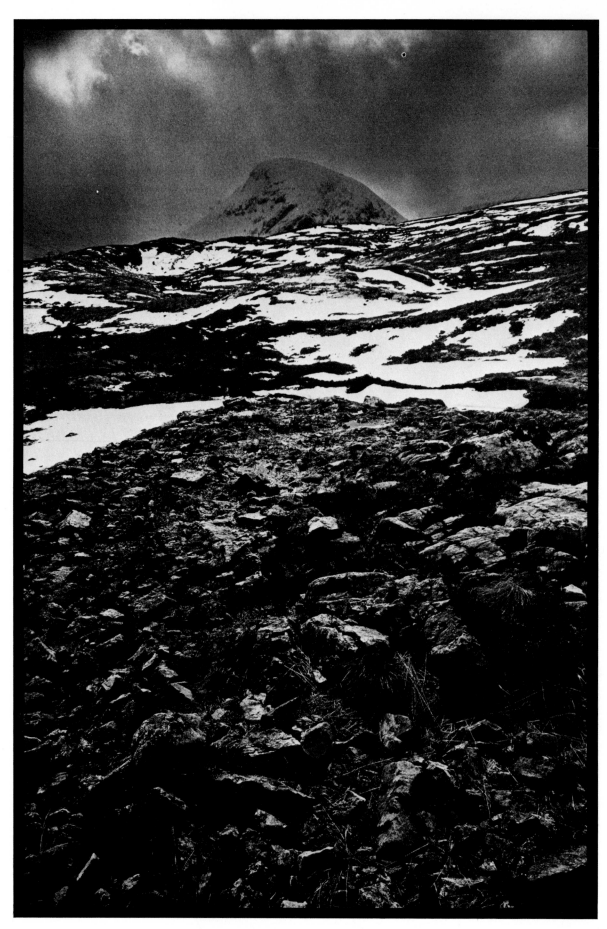

Trevor Fry

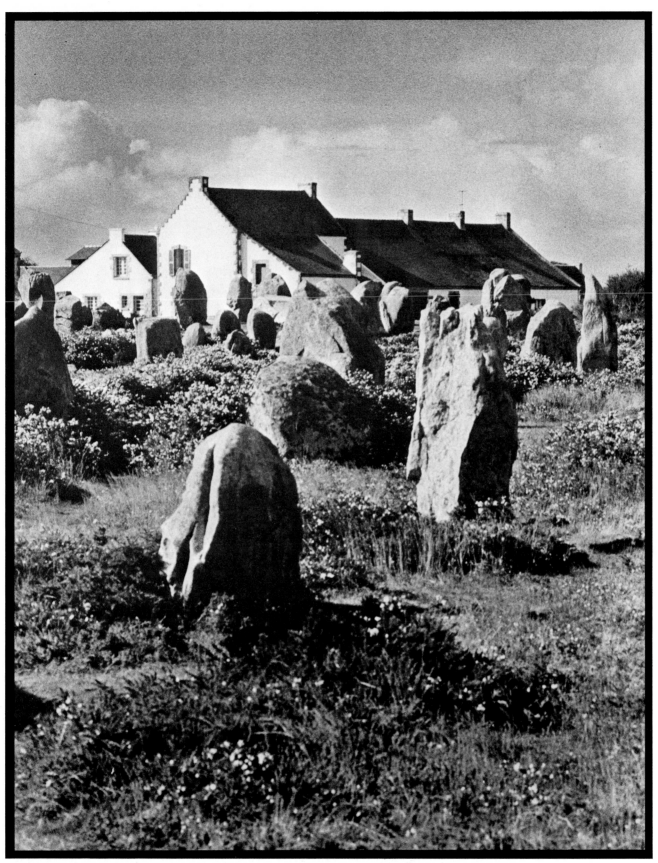

Jean Berner

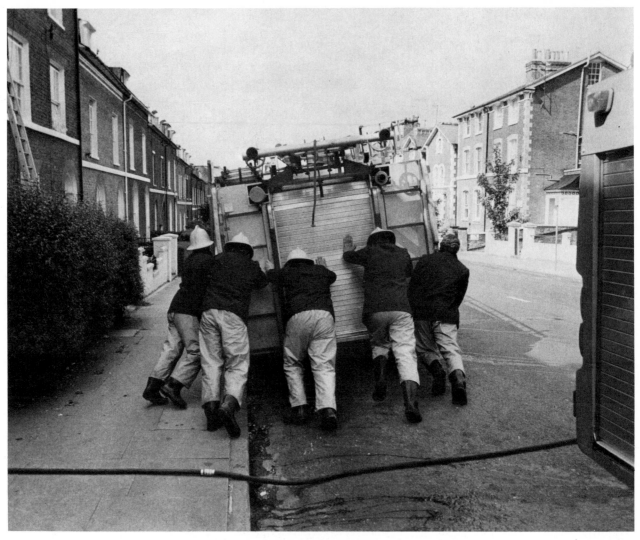

Jim Hart

R. Požerskis

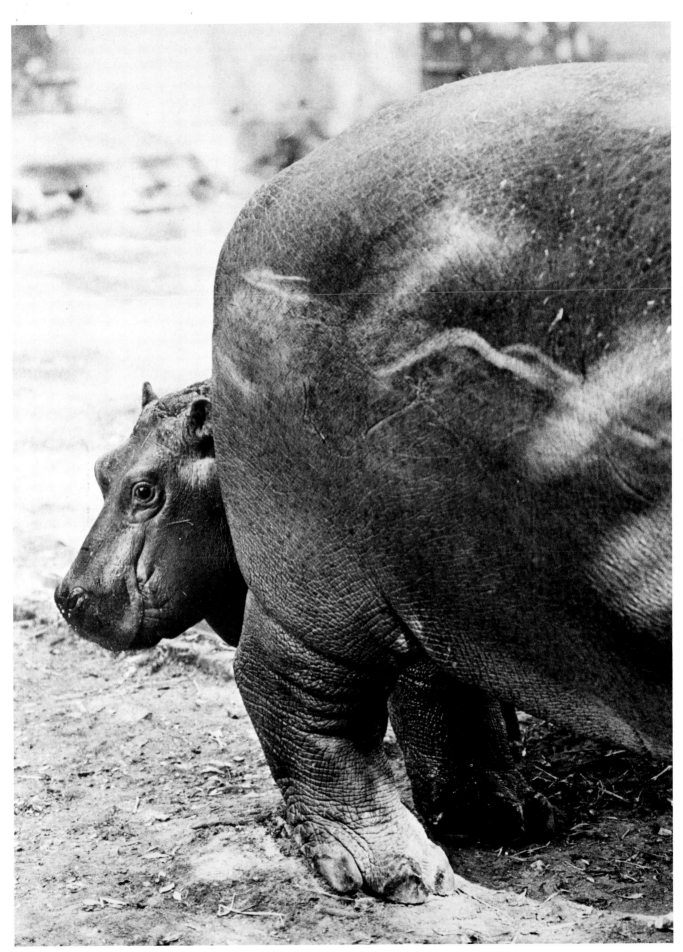

Mike Hollist

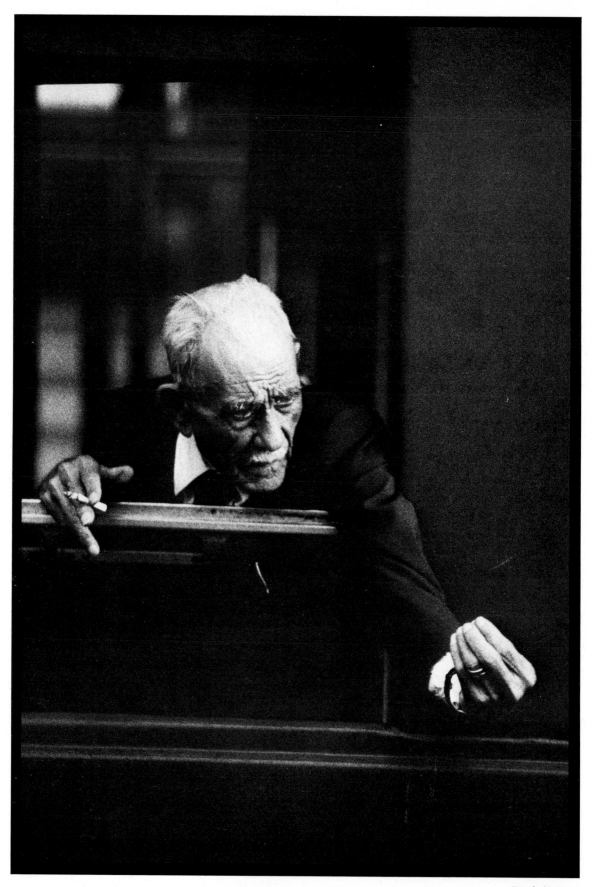

Rudolf Bieri

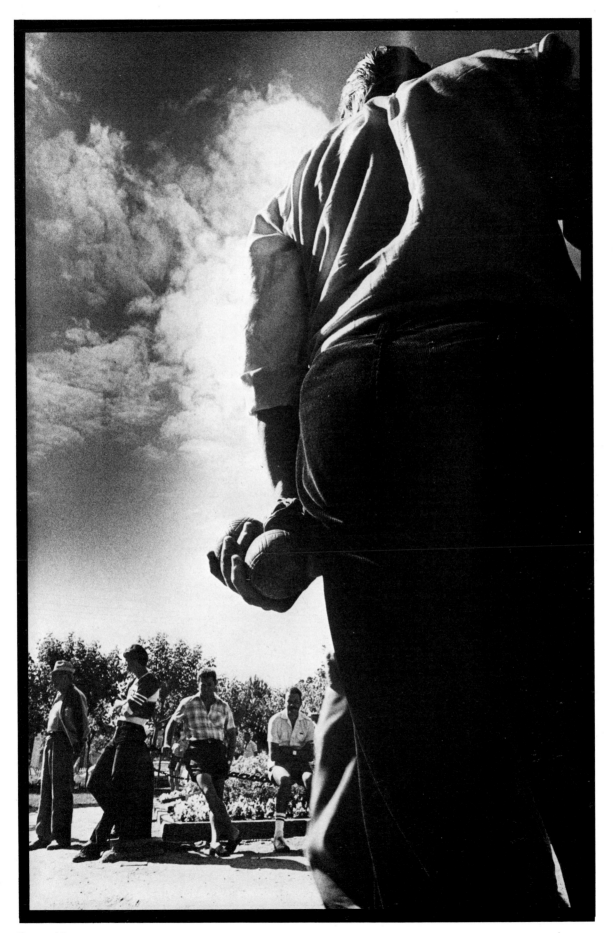

Peter Hense

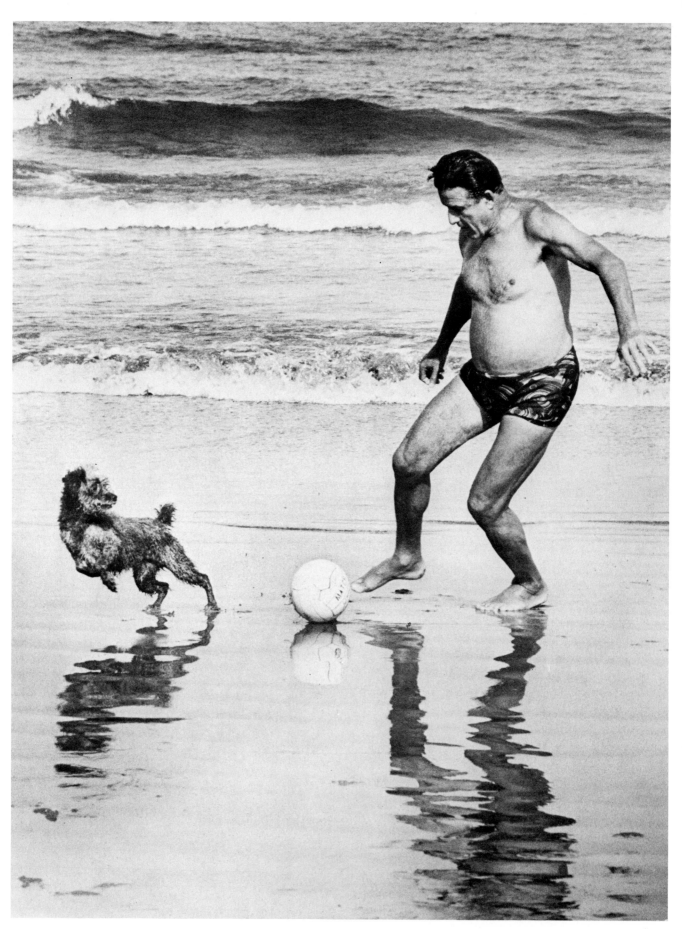

Hartmut Rekort

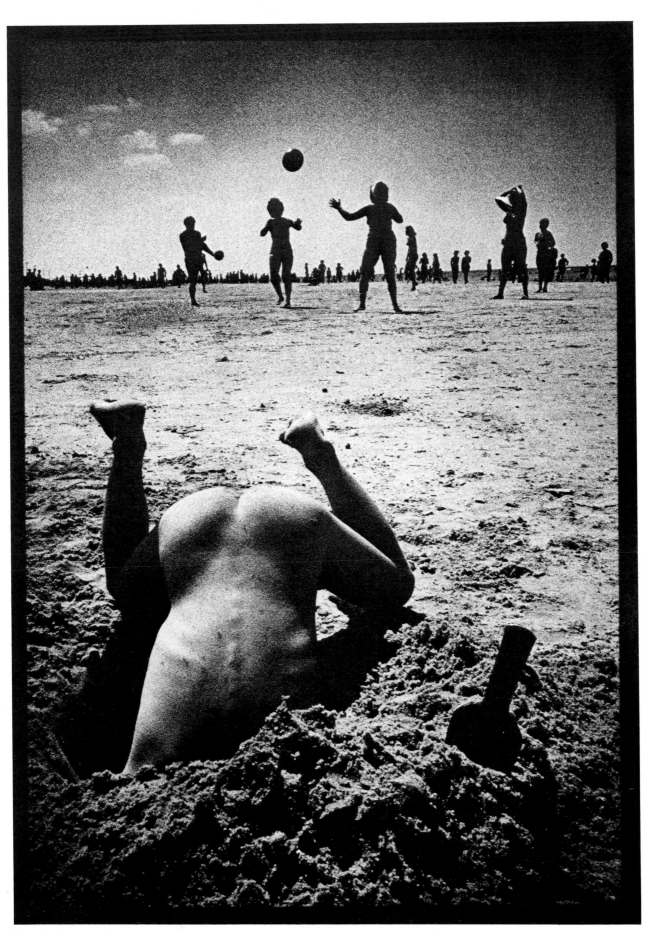

Peteris Jaunzems

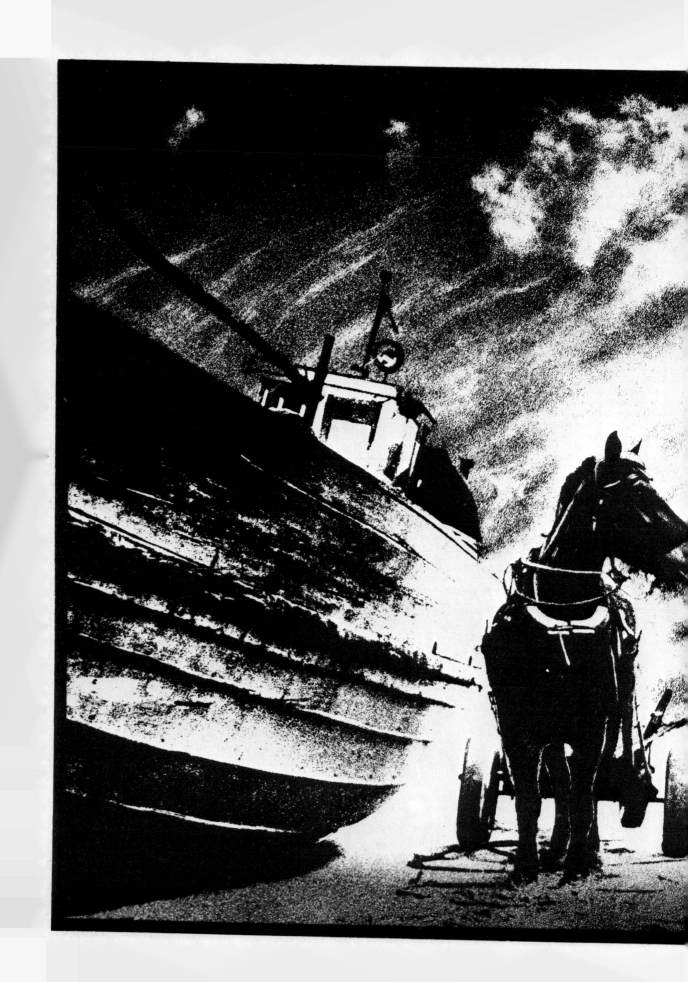

PERSONNEL
IN NON-PROTECTIVE CLOTHING
ONLY

Stephen Shakeshaft

216

Steve Butler

Vlado Bača

Stephen Shakeshaft

Peteris Jaunzems

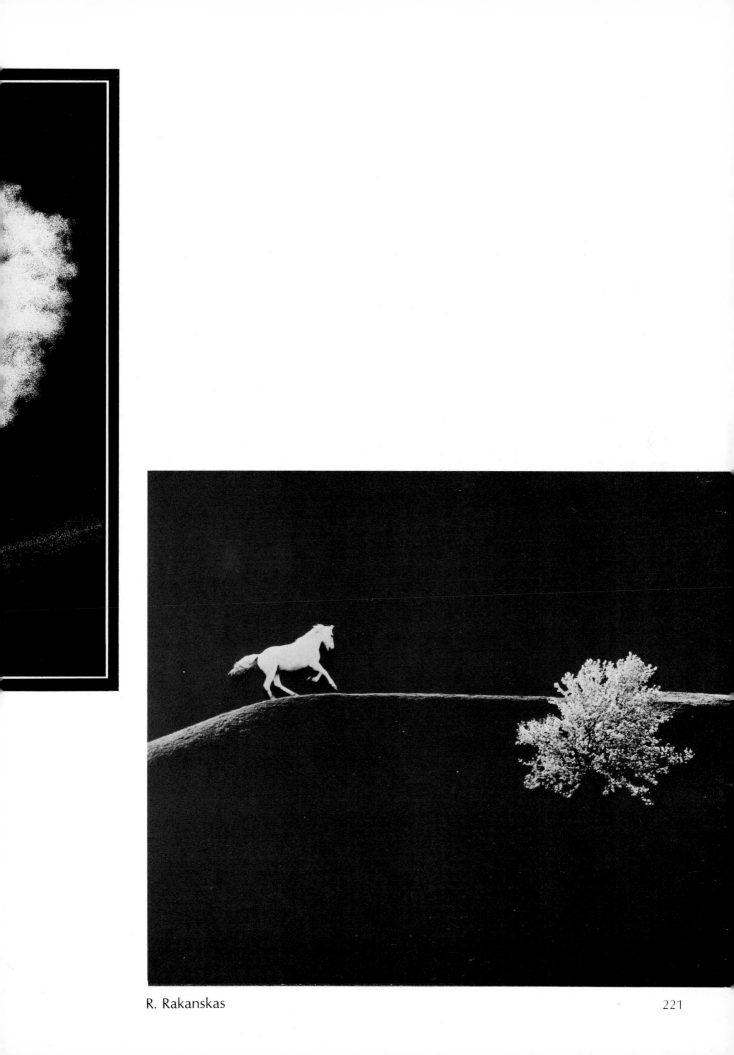

R. Rakanskas

Frank Peeters

Jose Torregrosa

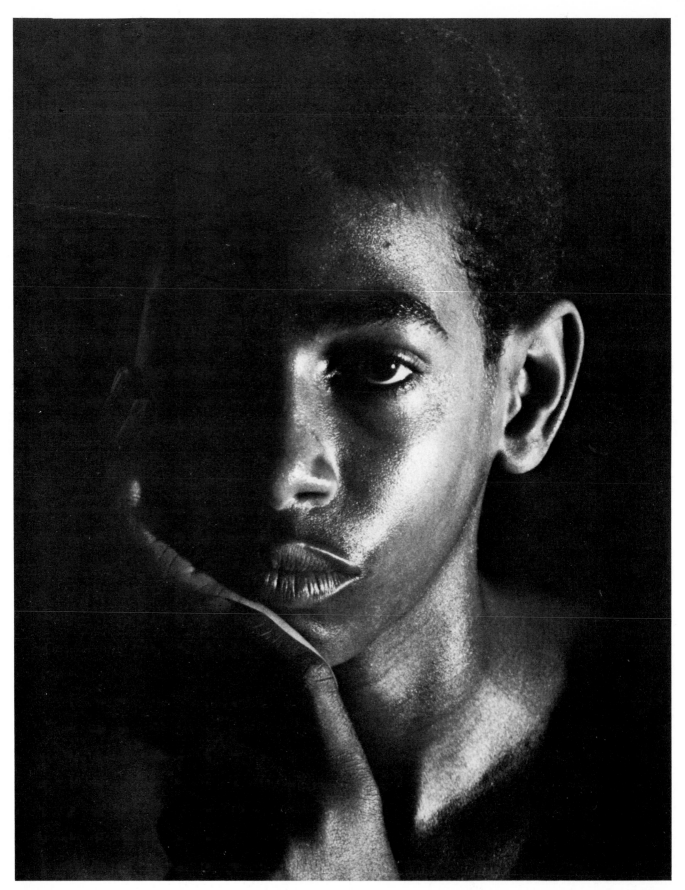

Domingo Batista

Technical Data

Jacket

Photographer Josep Maria Ribas I Prous
Camera Nikon F2
Lens 105mm
Exposure 1/125 at f/5.6
Film Orwo

A very artistic studio portrait which has been reproduced from a very fine colour print. The original was a 35 mm transparency.

Ein sehr künstlerisches Studioporträt, das aufgrund einer sehr feinen Farbkopie wiedergegeben wurde. Das Original war ein 35 mm Diapositiv.

Een bijzonder artistiek studioportret dat werd gereproduceerd van een erg mooie kleurvergroting. Het origineel was een kleinbeelddia.

Retrato de estudio de gran calidad artística reproducido a partir de una excelente copia en color. El original era una diapositiva de 35 mm.

Très artistique portrait en studio, qui a été reproduit à partir d'un tirage en couleur très fin. L'original était une diapositive de 35 mm.

Front End Paper

Photographer K. Stevens
Camera Pentax 1000
Lens 150mm

Entitled "May Day" this is a very happy picture of country life centering on the Maypole dance. It is full of action and youthful vitality, and is a good montage of three negatives.

Diese Aufnahme, die den Titel "1.Mai" trägt und um einen Maibaum tanzende Menschen zeigt, bietet einen sehr frohen Eindruck ländlichen Lebens. Bewegung und jugendliche Vitalität – das sind die Hauptmerkmale dieser gut geglückten Montage von drei Nagativen.

Deze foto die de titel 'May Day' draagt geeft een blij beeld van het leven op het platteland dat zich concentreert op de dans rondom de meiboom. De foto is vol actie en jeugdige vitaliteit, en is een goede montage van drie negativen.

Con el título de Primero de mayo se recoge aquí la desinhibida felicidad de la vida rural, centrada en este caso en la típica danza alrededor del poste engalanado. Se trata de una imagen llena de acción y vitalidad juvenil, constituida por un montaje de tres negativos.

Intitulée "May Day" (le premier mai), cette photographie est une image réussie de la vie campagnarde centrée autour de la danse du "Maypole" (arbre de mai). Elle est pleine d'action et de vitalité, et c'est un montage parfait de trois négatifs.

13

Photographer Patrick Trevor
Camera Olympus OM-1
Lens 21mm Zuiko
Film Tri-X at 1000 ASA

An excellent example of a low viewpoint with a wide angle lens producing a dramatic interpretation of a familiar subject. It also emphasises texture when required.

Ein ausgezeichnetes Beispiel dafür, wie sich ein alltägliches Thema durch Gebrauch eines Weitwinkelobjektivs und Aufnahme von einem niedrigen Standpunkt dramatisch erfassen lässt. Wo erforderlich ist auch die Struktur hervorgehoben.

Een schitterend voorbeeld van een laag standpunt met een groothoekobjectief, waarmee een dramatische interpretatie werd gegeven van een alledaags onderwerp.

Dramática interpretación de un tema familiar obtenida con un objectivo gran angular y un punto de vista bajo. La textura está acentuada en los puntos requeridos.

Excellent exemple de photographie en contre-plongée, prise avec un objectif grand angle, qui donne une interprétation saisissante d'un sujet familier. De plus, cette image met la texture en relief aux endroits voulus.

14

Photographer George W. Martin
Camera Nikon F
Lens 50mm Nikkor
Exposure 1/125 at f/8
Film Tri-X

An action portrait of Billie Holliday taken during one of her last performances in New York. It is full of atmosphere and a fitting tribute to a great singer. The title "God Bless the Child" is taken from one of the songs she made famous.

Ein Aktionsporträt von Billie Holliday, das während ihrer letzten Vorführung in New York aufgenommen wurde. Es ist sehr atmosphärisch und eine angemessene Anerkennung einer grossen Sängerin. Der Titel "God Bless the Child" ist der eines der Lieder, die sie berühmt gemacht hat.

Een actieprotret van Billie Holliday, opgenomen tijdens een van haar laatste optredens in New York. Do foto bevat veel sfeer en vormt een passende hommage aan een groot zangeres. De titel 'God Bless the Child' werd ontleend aan een van de door haar beroemd gemaakte liederen.

Aquí vemos a Billie Holliday en una de sus últimas actuaciones en Neuva York. El fotógrafo ha captado a maravilla la atmósfera del local, obteniendo así un perfecto homenaje a la memoria de la protagonista. El título de la instantánea, Dios bendiga al niño, corresponde al de una de las canciones que Billie popularizó.

Portrait d'action de Billie Holliday, pris durant l'une de ses dernières représentations à New York. Il est plein d'atmosphère et constitue un hommage mérité à une grande chanteuse. Le titre "God Bless the Child" (Dieu bénisse l'enfant) est emprunté à l'une de ses plus célèbres chansions.

15

Photographer Peter Hense
Camera Nikon F2A
Lens 24mm Nikkor
Film Tri-X

The fast movement of these disco dancers has been emphasised by the extremely low angle, presumably from below the stage, and by the use of a wide angle lens. Although taken by flash with an aperture of f/16 this picture shows little sign of the unpleasant shadows usually associated with it.

Die schnelle Bewegung dieser Discotänzerinnen wurde durch den ausserordentlich niedrigen Aufnahmestandpunkt – wahrscheinlich von unterhalb der Bühne – und durch den Gebrauch eines Weitwinkelobjektivs betont. Obgleich dieses Bild unter Anwendung von Blitzlicht und bei Blende 16 aufgenommen wurde, merkt man wenig von den unter diesen Bedingungen üblichen unangenehmen Schatten.

De snelle beweging van deze disco-danseressen werd benadrukt door het bijzonder lage standpunt – waarschijnlijk van onder het toneel – en door het gebruik van een groothoekobjectief. Hoewel opgenomen met flitslicht toont de foto weinig van de onplezierige schaduwen die daarmee gewoonlijk gepaard gaan.

Los rápidos movimientos de los protagonistas de esta instantánea han sido acentuados a través de la utilización de un objectivo gran angular y un punto de vista bajo, probablemente situado por debajo del escenario. Aunque se tomó con un flash con abertura f/16, la imagen está libre de las desagradables sombras que suelen aparecer en estos casos.

Le mouvement rapide de ces danseuses de discothèque a été mis en relief par l'angle de prise de vue extrêmement bas, probablement à partir d'un point situé au-dessous de la scène, et par l'utilisation d'un objectif grand angle. Bien qu'elle ait été prise au flash, avec une ouverture de diaphragme de f/16, cette photographie ne présente pratiquement aucune de ces ombres, si déplaisantes, très courantes en pareil cas.

16

Photographer Stephen Shakeshaft
Camera Nikon F2
Lens 28mm
Film Tri-X

A flash shot by a well-known photographer from the Liverpool Post and Echo which captures the crowded and rather frenzied atmosphere of a backstage dressing room.

Diese Blitzlichtaufnahme wurde von einem bekannten Fotografen der Zeitung Liverpool Post and Echo gemacht und vermittelt einen Eindruck von der Beengtheit und etwas hektischen Atmosphäre eines Hinterbühnen-Ankleideraums.

In deze flitsfoto wordt de drukke en gehaaste sfeer van een kleedkamer achter het toneel op treffende wijze weergegeven.

En esta instantánea, tomada con flash por un conocido fotógrafo del Liverpool Post and Echo, aparece perfectamente captado el ambiente tenso y recargado de un camerino de teatro.

Photographie prise au flash par un photographe bien connu du Liverpool Post and Echo, qui traduit bien l'encombrement et l'atmosphère assez survoltée d'une loge d'artiste.

17

Photographer Stephen Shakeshaft
Camera Nikon F2
Lens 28mm
Film Tri-X

A "slice of life" picture depicting a "character" in his normal environment. It will no doubt raise a smile, especially when seen in conjunction with the author's picture on the opposite page.

Ein Bild "aus dem Leben", das ein "Original" in seiner normalen Umgebung zeigt. Man kann nicht umhin darüber zu lächeln, besonders wenn man es gleichzeitig mit dem von demselben Künstler stammenden Bild auf der gegenüberliegenden Seite betrachtet.

'Uit het leven gegrepen' wordt deze figuur weergegeven in zijn normale omgeving. De foto zal ongetwijfeld een glimlach opwekken, speciaal als men let op de tegenstelling met de foto van dezelfde fotograaf op de tegenoverliggende bladzijde.

En esta imagen, "tan real como la vida misma", se ha captado a un "personaje" en su ambiente normal. Dificilmente puede uno dejar de sonreír al contemplarla, y en especial si se la asocia con la fotografía de la página opuesta.

Photographie qui restitue une "tranche de vie" en présentant un personnage très typique dans son cadre habituel. Elle appellera sans aucun doute un sourire, en particulier si on la compare avec la photographie, du même auteur, reproduite sur la page opposée.

18

Photographer Rainer Kemper
Camera Pentax 6 × 7
Lens 150mm
Film Tri-X at 200 ASA

A fairly straightforward profile portrait given movement and extra interest by the smoke, the relaxed pose, and impeccable technique.

Ein recht einfaches Profilporträt, das durch den Rauch, die entspannte Haltung und überlegene Technik lebensvoll und besonders interessant wirkt.

Een rechttoe-rechtaan portret, waaraan beweging en extra elementen werden toegevoegd door de rook, de ontspannen houding en de perfecte techniek.

Perfecto retrato de perfil cuyo interés se ha subrayado mediante la pose relajada, la impecable ténica del autor y la introducción del humo.

Portrait de profil assez naturel, auquel le photographe a su donner du mouvement et un intérêt supplémentaire grâce à la fumée, à la pose détendue et à une technique impeccable.

19

Photographer Iain R. Smith, ARPS
Camera Mamiya C33
Film FP4

An interesting contrast to the picture opposite. It is stylized and very obviously posed, but the strong texture lighting and superb technique has turned it into a good portrait and character study.

Ein interessanter Kontrast zu dem gegenüber befindlichen Bild. Bei dieser stilisierten Aufnahme handelt es sich ganz offensichtlich um eine künstliche Pose, doch dank der kräftigen Texturbeleuchtung und der hervorragenden Technik ist dies ein gutes Porträt, das die Persönlichkeit des Modells ausgezeichnet zum Ausdruck bringt.

Een interessant contrast met de foto op de tegenoverliggende bladzijde. Duidelijk geposeerd, maar door de uitstekende verlichting en de goede techniek een fijn portret.

Esta instantánea proporciona un interesante contraste en relación con la de la página opuesta. Es evidente que se ha hecho posar artificialmente a la modelo, pero la enérgica iluminación utilizada por el fotógrafo y el perfecto dominio de la técnica de que hace gala convierten a la imagen en un excelente estudio de carácter.

Intéressant contraste avec la photographie de la page opposée. Elle est stylisée et de toute évidence posée, mais le vif éclairage de la texture et la technique parfaite en ont fait un portrait et une étude de personnage excellents.

20

Photographer John Walker
Camera Nikon F
Lens 85mm
Exposure 25 sec at f/4
Film Tri-X

A pleasing news picture showing that Prince Charles has at least one photographic interest and employs it on informal occasions.

Ein nettes Pressebild, das zeigt, dass Prinz Charles wenigstens an einer Form der Fotografie interessiert ist und bei zwanglosen Anlässen gelegentlich von einer Kamera Gebrauch macht. Aufgenommen während eines Querfeldein-Rennens in Beeston, Cheshire.

Een plezierige nieuwsfoto die aantoont dat de Engelse kroonprins Charles ten minste in één richting fotografisch geïnteresseerd is en daarvan bij informele gelegenheden ook gebruik maakt. Opgenomen gedurende een cross country in Beeston in het Engelse graafschap Cheshire.

Agradable instantánea periodística que nos muestra que al príncipe Carlos de Inglaterra le gusta por lo menos un uso de la fotografía, en ocasiones informales. Instantánea tomada durante un concurso hípico de salto a campo traviesa en Beeston, condado de Cheshire.

Agréable photographie de reportage, qui montre que le Prince Charles s'intéresse en tout cas à la photographie et sait utiliser ce penchant en dehors des manifestations officielles. Photographie prise lors d'une épreuve de cross-country à Beeston, Cheshire.

21

Photographer John Walker
Camera Rolleiflex 2.8
Lens 85mm
Exposure 25 sec at f/2.8
Film Tri-X

A very lively picture entitled "Putting on the Style" which has captured all the vitality and joy of children's parties where apartheid is an unknown word.

Eine sehr lebendige Aufnahme mit dem Titel "Putting on the Style", die der ganzen Vitalität und Freude von Kinderparties, auf denen man nichts von Apartheid weiss, Ausdruck verleiht. Bei vorherrschendem Licht aufgenommen.

Een levendige opname, gemaakt bij available light, waarin de levendigheid en het plezier zijn vastgelegd van kinderfeestjes waar apartheid een onbekend woord is.

He aquí una instantánea llena de vida, titulada Dando el toque definitivo, en la que se ha captado fidedignamente la vitalidad y alegría de las fiestas infantiles donde la separación racial es totalmente desconocida.

Très vivante photographie intitulée "Putting on the Style" (Le Roi n'est pas leur cousin!), qui a saisi toute la vitalité et la joie propres aux fêtes enfantines là où l'apartheid est un mot inconnu. Prise à la lumière ambiante.

22

Photographer Norman Eve, FRPS
Camera Mamiyaflex C33
Lens 180mm Sekor
Film FP4 rated 200 ASA

This shot, entitled "Remembrance", could almost be a documentation of a dying breed – the officers of the last war who cling to the bowler hats which were, in effect, their undress uniform. The grouping is good and the friendly gesture of the hand raises the picture out of the ordinary.

Diese Aufnahme, die den Titel "Erinnerung" trägt, könnte fast zur bleibenden Erinnerung an einen dahinschwindenden Menschenschlag gemacht worden sein, und zwar an die Offiziere des letzten Krieges, deren Melonen eine Art Ziviluniform bilden. Die Gruppierung ist gut, und die freundliche Geste der Hand verleiht dem Bild ein ungewöhnliches Interesse.

Deze opname, getiteld 'Herinneringen', is bijna een documentatie van een uitstervend ras: Britse officieren uit de Tweede Wereldoorlog die nog steeds vasthouden aan de bolhoeden die in feite hun burgeruniform waren. De opstelling is goed en het vriendschappelijke gebaar van de hand tilt de foto uit boven het gemiddelde.

A esta instantánea, titulada Recuerdo, se la puede considerar un documento gráfico sobre una especie que desaparece: los oficiales ingleses que lucharon en la última gran guerra, para los cuales el sombrero hongo formaba parte simbólica de su traje civil. La agrupación es perfecta y el ademán amigable de la mano proporciona a la imagen unas dimensiones excepcionales.

Cette photographie intitulée "Remembrance" (Souvenir) pourrait presque illustrer une espèce en voie d'extinction: les officiers de la dernière guerre, fidèles adeptes du chapeau melon, qui faisait, en effet, partie de leur tenue civile. Le groupement est bon, et le geste amical de la main fait que cette photographie sort de l'ordinaire.

23

Photographer Stephen Shakeshaft
Camera Nikon F2
Lens 50mm
Film Tri-X

The relaxed attitude of a dealer in a sales room waiting to bid for the item that he wants when it comes up. A little bored, a little impatient – the picture expresses it all, and against an interesting background.

Dieser Händler wartet in einem Auktionsraum in entspannter Haltung darauf, dass der Gegenstand, an dem er interessiert ist, an die Reihe kommt. Er ist ein wenig gelangweilt und ein wenig ungeduldig. All dies und mehr geht aus dem Bilde, in dem der Hintergrund übrigens sehr ansprechend ist, deutlich hervor.

De ontspannen houding van de handelaar in het veilinglokaal waar hij wacht op het moment dat hij kan bieden op het nummer waarvoor hij is gekomen. Enigszins verveeld, wat ongeduldig – de foto drukt het allemaal uit, en dat tegen een interessante achtergrond.

En esta imagen se ha captado cabalmente la actitud relajada de uno de los asistentes a una subasta, que espera con tranquilidad el momento en que le llegue el turno a la pieza que desea adquirir. El aburrimiento, la pequeña dosis de impaciencia . . . La imagen recoge todas las sensaciones que se acumulan en el comprador, contrastándolas con un fondo no desprovisto de interés.

Attitude détendue d'un acheteur dans une salle de ventes attendant de soumettre une offre pour l'objet qu'il convoite, lorsqu'il sera mis aux enchères. Un brin d'ennui, une légère impatience: c'est tout cela qu'illustre la photographie, et sur un arrière-plan intéressant.

24/25

Photographer Valdis Brauns

One of the many intriguing situation pictures to come from the USSR. The clarinettist has apparently been printed in to the background of the bride in the field of daisies, thus creating a very romantic story and an artistic interpretation.

Eine von vielen mysteriösen Situationsaufnahmen aus der Sowjetunion. Der Klarinettenspieler wurde offensichtlich über den Hintergrund mit der Braut auf einer Wiese mit Margeriten überlagert, was eine sehr romantische Wirkung und eine künstlerische Interpretation ergibt.

Eén uit een serie intrigerende genrefoto's uit Rusland. De clarinettist is kennelijk in de donkerekamer ingedrukt in de foto van de bruid tussen de madeliefjes, waardoor een romantisch verhaal en een kunstzinnige interpretatie werden gecreëerd.

Setting up your own darkroom isn't exactly a cheap exercise. And choosing the wrong enlarger won't make it any cheaper.

Which is why we thought we had better warn you about five of ours.

Which five they are, though, depends on you.

For instance, it would be foolish to lash out on our M605 if you're not likely to need all the advanced features. (Each enlarger in the 'M' range comes in two versions, b+w or colour.)

And equally foolish to buy our B30 if it's likely you'll want to up-grade it after a few months. But whichever model you decide on, you'll find it's backed by the unique Durst Care two year warranty.

To help you with your choice, we've produced a 50 page booklet that takes you through everything from setting up a darkroom, right through to the finer points of printing and, of course, the detailed specifications of every Durst product.

If you'd like a copy, send us the coupon. We'd hate you to waste your money on one of our enlargers.

Please send me your home darkroom guide.

Name: _____

Address: _____

Post to Durst Consumer Service Division, Eumig (UK) Ltd., 14 Priestley Way, London NW2 7TN. Tel: 01-450 8070.

Durst®
Don't be afraid of the dark.

FIVE OUT OF SIX DURST ENLARGERS ARE A WASTE OF MONEY.

THE B30 B/W, A WASTE OF £80?

THE C35 COLOUR, A WASTE OF £130?

THE M302 COLOUR, A WASTE OF £190?

THE M305 COLOUR, A WASTE OF £230?

THE M605 COLOUR, A WASTE OF £340?

THE M705 B/W, A WASTE OF £290?

De la URSS nos han llegado esta vez varias imágenes de tema ligeramente intrigante. Al parecer se ha agregado el clarinetista durante el copiado de la instantánea original, en la que aparecía solamente la novia en el campo de margaritas. Con ello se ha obtenido una atmósfera de agradables connotaciones románticas.

Il s'agit là d'une photographie parmi un grand nombre d'autres, représentant toutes des situations intrigantes, qui nous viennent d'URSS. Le clarinettiste semble avoir été rapporté sur l'arrière-plan constitué par le dos de la mariée assise dans le champ de marguerites, créant ainsi une scène très romantique et une interprétation artistique.

26

Photographer Harald Hirsch
Camera Praktica LTL
Lens Flektogon 20mm
Film Orwo NP27

This picture is typical of the treatment employed in much of the work received from East Germany — very strong contrasts with rich blacks and plenty of grain. It has given an evocative atmosphere to a conventional outdoor portrait of a pretty girl.

Dieses Bild mit seinen sehr kräftigen Kontrasten, satten Schwarztönen und hoher Körnigkeit ist typisch für einen Grossteil der aus der DDR erhaltenen Arbeiten. Durch diese Behandlung wurde einem herkömmlichen Freiluftporträt eines hübschen Mädchens eine geheimnisvolle Stimmung verliehen.

Deze foto is typerend voor de benadering in veel van het uit de DDR ontvangen werk: sterke contrasten met rijke zwarten en veel korrel. Dit verleende een bijzondere sfeer aan een anders conventioneel portretje van een aardig meisje.

En esta imagen podemos apreciar el tratamiento dado a los temas en la mayor parte de las fotografías que hemos recibido de Alemania Oriental: fuertes contrastes con negros enérgicos y grano perceptible. Este tratamiento ha proporcionado una atmósfera evocativa al retrato convencional de una bella joven.

Cette image est caractéristique du traitement appliqué à bon nombre des photographies qui nous sont parvenues d'Allemagne de l'Est: des contrastes très accusés avec des noirs riches et un grain très marqué. Il a donné une atmosphère évocatrice à ce classique portrait en extérieur d'une jolie fille.

27

Photographer Rostislav Kõstál
Camera Minolta SRT 101
Lens 28mm Rokkor
Film Orwo NP27

A moody portrait of tremendous appeal. The low key treatment is somewhat similar to the outdoor portrait on the opposite page with which it makes an interesting contrast.

Ein stimmungsvolles Porträt, das ausserordentlich ansprechend wirkt. Die dunkle Tönung erinnert ein wenig an das Freiluftporträt auf der gegenüberliegenden Seite, zu dem es einen interessanten Kontrast bildet.

Een stemmig portret met een enorme uitstraling. De lowkey-uitwerking komt enigszins overeen met het daglichtportret op de tegenoverliggende bladzijde, waarmede het overigens een interessant contrast vormt.

He aquí un retrato que posee un encanto fuera de lo común. El tratamiento de tonos bajos es similar al utilizado en el retrato de la página opuesta, lo que proporciona un agradable contraste.

Portrait d'état d'âme, remarquablement séduisant. Le traitement en sombre n'est pas sans rappeler le portrait en extérieur de la page opposée, avec lequel il offre un contraste saisissant.

28

Photographer Hans-Peter Bogdahn
Camera Hasselblad
Lens 50mm Distagon
Exposure 1/125 at f/5
Film Agfa 25

A very unusual composition and dynamic contrast has made a striking full length portrait without any tricks of treatment in the darkroom.

Eine sehr ungewöhnliche Komposition und dynamischer Kontrast haben ohne besondere Behandlung in der Dunkelkammer ein eindrucksvolles Ganzporträt ergeben.

Een ongewone compositie en het dynamische contrast leidden tot een frappante portretopname zonder enige manipulatie in de donkerekamer.

La insólita composición y el dinámico contraste proporcionan un gran empaque a este retrato de cuerpo entero, para cuya obtención no se ha utilizado ningún truco de laboratorio.

Une composition très insolite et un contraste violent sont à l'origine de ce saisissant portrait en pied, obtenu sans aucun artifice de traitement en chambre noire.

29

Photographer Ole Sand
Camera Nikon F
Lens 200mm Nikkor
Exposure 1/1000 at f/8
Film HP5

A candid outdoor picture which typifies the scene at English Country events. The riding habit makes a striking contrast to the casual clothes and high key of the figures in front.

Dieses unbemerkt aufgenommene Freiluftbild vermittelt einen typischen Eindruck von ländlichem Sport in England. Das Reitkostüm und die Reitstiefel kontrastieren auf interessante Weise mit der legeren Kleidung und der hellen Tönung der Personen im Vordergrund.

Een ongedwongen foto die de situatie typeert tijdens gebeurtenissen op het Engelse platteland. Het rijkostuum vormt een sterk contrast met de vrijetijdskleding en de highkeyweergave van de figuren ervoor.

Ingenua instantánea en la que se recoge con fidelidad la atmósfera típica de las competiciones celebradas en las zonas rurales inglesas. El traje de montar contrasta con la forma informal de vestir y los tonos altos de las personas situadas a su alrededor.

Photographie d'extérieur prise sur le vif, qui restitue merveilleusement l'ambiance des manifestations rurales anglaises. La tenue d'équitation contraste vigoureusement avec les vêtements ordinaires et la luminosité des personnages situés devant.

30

Photographer Vladimir Birgus
Camera Pentax Spotmatic
Lens 28mm Takumar
Film Orwo NP27

A picture which achieves success because of its utter simplicity. The contrast of tones and the "echoing" lines create rhythm and an attractive design. The original is sepia toned.

Ein Bild, dessen Erfolg auf seiner absoluten Einfachheit beruht. Der Kontrast der Töne und die harmonische Linienführung ergeben Rhythmus und eine ansprechende Komposition. Das Original ist Sepia getont.

Het succes van deze foto ligt ongetwijfeld in zijn eenvoud. Het toonwaardencontrast en de herhaling van de lijnen zorgen voor ritme en voor een aantrekkelijk patroon. Het origineel was sepia getint.

En esta imagen destaca sobre todo su gran sencillez. El contraste tonal y las líneas dispuestas paralelamente crean un ritmo agradable y unas formas atractivas. El original era de tono sepia.

Photographie réussie en raison de son extrême simplicité. Le contraste des tons et les lignes qui lui font écho engendrent le rythme et une composition séduisante. L'original est dans un ton sépia.

31

Photographer Josep Maria Ribas I Prous ARPS
Camera Nikon F2
Lens 105mm Nikkor
Exposure 1/30 at f/5.6
Film Tri-X

A traditional and romantic picture given a modern touch by the use of soft focus achieved with Vaseline on a UV filter, plus the introduction of grain by extreme enlargement. The pose and arrangement show the touch of an artist.

Eine traditionelle, romantische Aufnahme mit einer modernen Note, die auf durch Bestreichen eines UV-Filters mit Vaseline bedingter Unschärfe und durch extreme Vergrösserung bewirkter Körnigkeit beruht. Die Prose und die Anordnung sind meisterhaft.

Een traditioneel, romantisch dubbelportret waaraan een modern accent werd gegeven door de toepassing van softfocus, verkregen met Vaseline op een UV-filter, en door het inbrengen van een grove korrel door de extreme uitvergroting. Pose en arrangement duiden op de hand van een kunstenaar.

He aquí una imagen de corte romántico tradicional a la que se ha añadido un toque moderno por medio de un foco suave, obtenido untando con vaselina un filtro UV y a través de la introducción del grano conseguida con una gran ampliación. En la pose y la composición general se refleja claramente la capacidad artística del fotógrafo.

Photographie traditionnelle et romantique, légèrement modernisée par le recours au flou, obtenu par application de Vaseline sur un filtre à rayons ultraviolets, et par la formation d'un grain dû à un agrandissement extrême. La pose et la composition sont la marque d'un artiste.

32

Photographer Harald Hirsch
Camera Praktica LTL
Lens 50mm Pentacon
Exposure 1/60 at f/8
Film Orwo NP27

Sunset pictures in black and white are usually less successful than in colour, but this example puts over the mood and atmosphere very well, largely due to the still water with the reflected sun and the sparkle on the reeds in the foreground.

In der Regel sind Sonnenuntergänge in Schwarz und Weiss weniger erfolgreich als in Farbe, doch dieses Bild gibt die Stimmung — hauptsächlich durch die Stille des Wassers, in dem sich die Sonne spiegelt, und die Glanzlichter an dem Schilf im Vordergrunde — sehr gut wieder.

Kodak cares

Zonsondergangen zijn in zwartwit doorgaans minder succesvol dan in kleur, maar in deze opname worden stemming en sfeer uitstekend overgebracht, grotendeels te danken aan het stille water met de daarin gereflecteerde zon en de glinstering op het riet in de voorgrond.

Las puestas de sol captadas en blanco y negro suelen resultar mucho menos efectivas que las obtenidas en color, pero en este caso la imagen es excelente y su atmósfera evocativa está subrayada por el reflejo del sol en el agua en reposo y por los destellos captados en las cañas del primer plano.

Les couchers de soleil en noir et blanc sont généralement moins réussis qu'en couleur, mais cet exemple restitue parfaitement le ton et l'atmosphère, ce qui est dû dans une large mesure à la surface sans ride de l'eau, au soleil qui s'y reflète et au scintillement sur les roseaux du premier plan.

33

Photographer	Dr Leo K. K. Wong, FRPS
Camera	Hasselblad
Lens	80mm
Exposure	1/125 at f/8
Film	Kodacolor II

Reproduced from a beautiful 20 × 16 in colour print entitled "Manila Sunset" which is enhanced by the line treatment of the silhouetted foreground.

Wiedergabe einer schönen 50 × 40 cm Farbkopie mit dem Titel "Sonnenuntergang in Manila". Die Konturen der Silhouetten im Vordergrund verleihen dem Bild eine eigene Note. Aufgenommen am Jalee-Strande der Manila-Bucht an einem Nachmittag im Sommer.

Gereproduceerd van een prachtige 40 × 50 cm kleurvergroting waarvan het effect duidelijk werd versterkt door de lijnuitwerking van de silhouetten in de voorgrond. De opname werd gemaakt op een zomerse namiddag in de Baai van Manilla.

Esta imagen es una reproducción de una extraordinaria copia en color de 20 × 16 pulgadas titulada *Puesta de sol en Manila*, cuya calidad composicional se acentúa por el tratamiento lineal de las siluetas del primer plano.

Photographie reproduite à partir d'un magnifique tirage en couleur de 20 × 16 pouces intitulé "Manila Sunset" (Coucher de soleil à Manille), rehaussé par le traitement ligné du premier plan profilé.

34 (Upper)

Photographer	Michel Arnaud
Camera	Nikon F2
Lens	85mm
Film	200 ASA Ektachrome

A fashion shot, taken for "Image" magazine, which has enhanced the attractive semi silhouette by adding an unusual and almost abstract background until one realises that it is actually subjective. The contrast of diagonal movement with the static and vertical silhouette is stimulating.

Eine Modeaufnahme für die Zeitschrift *Image*. Die ansprechende Halbsilhouette ist durch einen ungewöhnlichen, nahezu abstrakten Hintergrund, der sich jedoch als subjektiver Art herausstellt, betont. Der Kontrast zwischen der diagonalen Bewegung und der statischen, senkrechten Silhouette ist anregend.

Een modefoto gemaakt voor het tijdschrift 'Image', waarin het effect van het aantrekkelijke halfsilhouet werd versterkt door de toevoeging van een ongewone, bijna abstracte achtergrond, totdat men zich realiseert dat deze in feite subjectief is. Het contrast van de diagonale beweging met het statische verticale silhouet is stimuulerend.

En esta imagen, tomada para la revista *Image*, se ha acentuado la fuerza de la atractiva semisilueta añadiéndosele un fondo abstracto que evoca características absolutamente subjetivas. Resulta, por otra parte, estimulante el contraste entre el movimiento en diagonal y la silueta estática y vertical.

Photographie de mode, prise pour le magazine *Image*, sur laquelle l'auteur a rehaussé la séduisante demi-silhouette en ajoutant un arrière-plan insolite et presque abstrait jusqu'à ce qu'on se rende compte qu'il est en fait subjectif. Le contraste du mouvement diagonal avec la silhouette verticale est stimulant.

34 (Lower)

Photographer	Ole Yssing
Camera	Mamiya DSX 1000
Lens	14mm
Film	Kodachrome 64

A wide angle lens from a high viewpoint has given an unusual touch to this outdoor figure study. The juxtaposition of earth and flesh tints make a pleasing colour harmony and the composition is almost symmetrical, but entirely acceptable. Like many good pictures it breaks the so-called "rules" to good effect.

Die ungewöhnliche Wirkung dieser im Freien aufgenommenen Akstudie beruht auf dem Gebrauch eines Weitwinkelobjektivs und einem hohen Aufnahmestandpunkt. Das Nebeneinander der Erd- und Hauttöne ergibt eine ansprechende Farbharmonie, und die Komposition ist nahezu symmetrisch, doch durchaus annehmbar. Wie dies bei vielen guten Aufnahmen der Fall ist, werden die sogenannten "Regeln" mit Vorteil gebrochen.

Het groothoekobjectief en het hoge standpunt verleenden een ongewoon accent aan deze figuurstudie. De combinatie van de aarde en de huidtinten vormt een plezierige kleurenharmonie; de compositie is bijna symmetrisch, maar volkomen acceptabel. Zoals vele goede foto's doorbreekt deze de zogenaamde 'compositieregels' met veel succes.

La combinación de un objetivo gran angular con un punto de vista alto ha proporcionado un toque insólito a este estudio efectuado al aire libre. La yuxtaposición de los colores de la tierra y la carne proporciona una agradable armonía cromática, y la composición es casi simétrica pero totalmente aceptable. Al igual que otras buenas imágenes, también ésta deja de respetar las "reglas" habituales, con resultados plenamente positivos.

Un objectif grand angle utilisé en plongée a donné une touche insolite à cette étude de nu en extérieur. La juxtaposition de la terre et de la carne engendre une plaisante harmonie de couleurs et la composition est presque symétrique, mais parfaitement acceptable. Comme nombre de bonnes photographies, celle-ci rompt avec les "règles" du bon effet.

35

Photographer	Dr C. J. Stratmann, ARPS
Camera	Exacta VXIIb
Lens	Pancolor 50mm f/2
Exposure	1 sec at f/8
Film	Kodachrome 64

Entitled "The Evil Eye" this picture shows how a star screen can be used to create an evocative picture. All too often they are used on unsuitable subjects but here the effect is essential to the message. It was done by gluing a sequin to the eye of a polystyrene bust to provide a highlight from the photoflood light. An 80B filter was used.

Dieses Bild — sein Titel lautet "Das böse Auge" — zeigt, wie sich mit einem Sternvorsatz ein interessanter Effekt erzielen lässt. Zu oft werden Spezialvorsätze am falschen Ort benutzt, doch in

diesem Falle war er unerlässlich. Der Künstler erzielte den gewünschten Effekt dadurch, dass er auf das Auge einer Polystyrol-Büste ein Flitterteilchen aufklebte, das das Breitstrahlerlicht intensiv reflektierte. Er machte von einem 80B-Filter Gebrauch.

Onder de title 'Het boze oog' toont deze foto aan hoe een stereffectlens kan worden toegepast om een veelzeggende foto te creëren. Maar al te vaak worden stereffectlenzen gebruikt bij allerlei ongeschikte onderwerpen, maar hier is het effect essentieel voor het overbrengen van de boodschap. In dit geval werd een lovertje gelijmd op het oog van een kop uit polystyreen. Daarin reflecteerde het licht van een fotolamp. Voor de juiste kleurweergave werd een Wratten 80B-filter gebruikt.

Titulada *El ojo maligno*, esta instantánea nos muestra cómo se puede utilizar una trama en estrella para crear una atmósfera evocativa. De estas tramas se hace uso demasiado a menudo con temas poco adecuados; pero en este caso el efecto es esencial para la formulación del mensaje. Se obtuvo pegando una lentejuela al ojo de un busto de poliestireno, con lo que se obtuvo un punto de reflejo del alumbrado con el flood. Se utilizó asimismo un filtro 80B.

Intitulée "The Evil Eye" (Le mauvais oeil), cette photographie montre comment un écran étoilé peut être utilisé pour créer une image évocatrice. Trop souvent, les écrans sont utilisés sur des sujets inappropriés, mais ici l'effet est indispensable au message. Elle a été réalisée en collant une paillette sur l'un des yeux d'un buste en polystyrène pour rehausser l'éclairage du spot. Interposition d'un filtre 80B.

36

Photographer	J. L. Cawthra
Camera	Canon AT I
Lens	300 mm Tamron
Exposure	1/250 at f/8
Film	Kodachrome 64

Motorcycling sport is a very popular subject with many photographers but, to be successful, very accurate timing, and anticipation which allows for the slight delay in the camera between pressing the release and the actual exposure, is required. This example is well timed and the low angle has produced a dramatic impact.

Der Motorradsport bildet ein beliebtes fotografisches Thema, doch lassen sich erfolgreiche Aufnahmen nur bei sehr genauem Zeitgefühl erzielen, d.h. es muss die leichte Verzögerung zwischen dem Druck auf den Auslöser und der eigentlichen Belichtung berücksichtigt werden. Diese Aufnahme wurde mit ausgezeichnetem Zeitgefühl ausgeführt, und infolge der Froschperspektive hat man den dramatischen Eindruck, dass das Motorrad fliegt. Der Titel des in Sedgefield aufgenommenen Bildes lautet "Start".

Motorsport is bij veel fotografen in trek. Om succes te hebben is echter een nauwkeurige timing nodig, alsmede een voorgevoel waarmee de lichte vertraging tussen het drukken op de ontspankop en de feitelijke belichting kan worden opgeheven. In deze foto draagt het lage standpunt bij aan het effect.

El motociclismo es un tema tratado con gran profusión por los fotógrafos, a pesar de que para obtener buenas instantáneas es preciso saber pulsar el disparador en el instante oportuno, debiéndose tener en cuenta que transcurre cierto tiempo entre dicho instante y el momento en que se produce la exposición. En este caso la sincronización ha sido perfecta y el ángulo bajo ha proporcionado un dramático impacto.

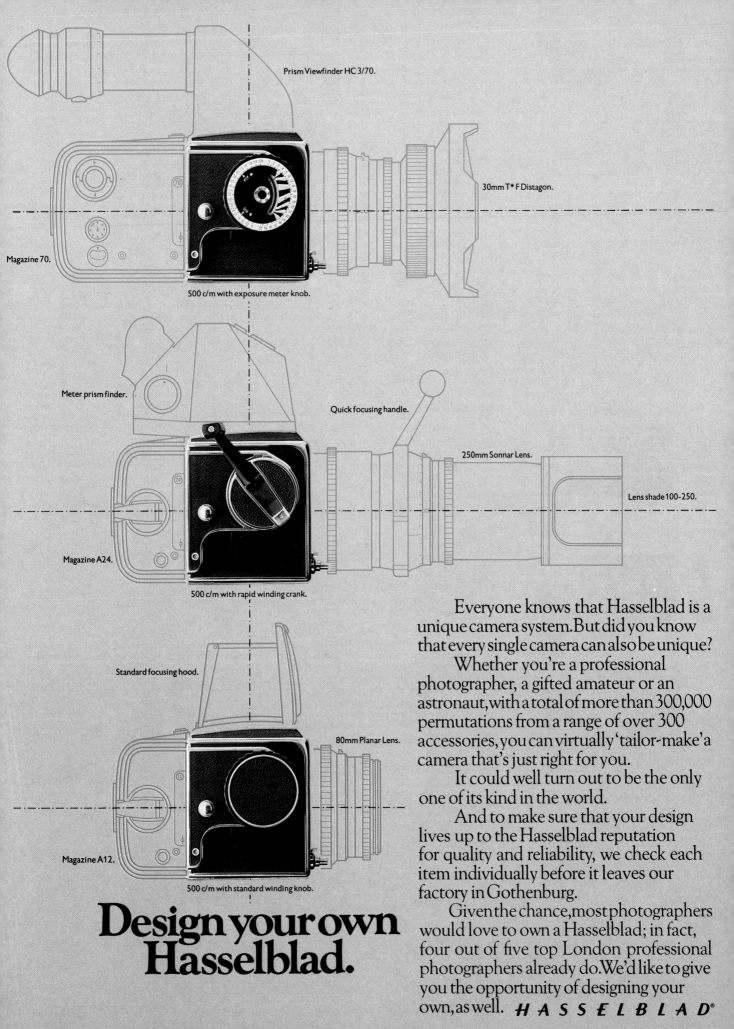

Prism Viewfinder HC 3/70.

30mm T* F Distagon.

Magazine 70.

500 c/m with exposure meter knob.

Meter prism finder.

Quick focusing handle.

250mm Sonnar Lens.

Lens shade 100-250.

Magazine A24.

500 c/m with rapid winding crank.

Standard focusing hood.

80mm Planar Lens.

Magazine A12.

500 c/m with standard winding knob.

Design your own Hasselblad.

Everyone knows that Hasselblad is a unique camera system. But did you know that every single camera can also be unique?

Whether you're a professional photographer, a gifted amateur or an astronaut, with a total of more than 300,000 permutations from a range of over 300 accessories, you can virtually 'tailor-make' a camera that's just right for you.

It could well turn out to be the only one of its kind in the world.

And to make sure that your design lives up to the Hasselblad reputation for quality and reliability, we check each item individually before it leaves our factory in Gothenburg.

Given the chance, most photographers would love to own a Hasselblad; in fact, four out of five top London professional photographers already do. We'd like to give you the opportunity of designing your own, as well. *HASSELBLAD*®

IF YOU WOULD LIKE FURTHER DETAILS ON THE WORLD'S LARGEST MEDIUM FORMAT CAMERA SYSTEM AND INFORMATION ABOUT OUR EXCLUSIVE SILVER SERVICE CARD WARRANTY, WE'LL BE HAPPY TO SEND YOU A COLOUR BROCHURE. JUST WRITE TO: DEPT. PYB, HASSELBLAD (GB) LTD, YORK HOUSE, EMPIRE WAY, WEMBLEY, MIDDLESEX HA9 0QQ. OR TELEPHONE 01-903 3435.

Le motocyclisme est un sujet très populaire auprès de nombreux photographes, mais, pour donner de bons résultats, il exige un minutage et une avance très précises pour tenir compte du très court décalage qui se produit dans l'appareil entre le moment où l'on presse le bouton de déclenchement et celui de l'exposition proprement dite. Cet exemple est bien minuté et la prise de vue en contre-pongée a donné ce saisissant impact aérien. La photographie est intitulée "Take Off" (Décollage) et a été prise à Sedgefield.

37

Photographer Tony Duffy
Camera Nikon F2 with motor drive
Lens 35mm
Film Kodachrome 64

A picture taken at the opening ceremony of the Sportakiade Games in Moscow by the Managing Director of the "All Sport" photo agency. The ability of this leading sports photographer to catch the right moment of the action is well known but this picture also demonstrates artistic ability. He has chosen a viewpoint which avoids monotony by including a team dressed in a different colour.

Dieses Bild wurde von dem geschäftsführenden Direktor der Fotoagentur "All Sport" während der Eröffnungszeremonie der Sportakiade in Moskau aufgenommen. Dieser führende Sportfotograf ist dafür bekannt, das er Vorgänge stets im richtigen Moment erfasst, doch diese Aufnahme beweist auch sein künstlerisches Können. Er hat den Aufnahmestandpunkt so gewählt, dass durch ein in einer anderen Farbe gekleidetes Team Eintönigkeit vermieden wird.

Deze foto werd gemaakt tijdens de openingsceremonie van de Sportakiade Spelen in Moskou. De auteur is bekend vanwege zijn vaardigheid het juiste moment te kiezen, maar in deze foto demonstreert hij ook zijn artistieke inzicht. Hij koos een standpunt waarmee hij dankzij de kleuren eentonigheid vermeed.

Esta fotografía la tomó el director de la agencia fotográfica *All Sport* durante la ceremonia de inauguración de la Sportakiade de Moscú. Conocíamos la capacidad de este conocido fotógrafo para captar el momento culminante de las actuaciones deportivas, pero en esta imagen revela poseer también sobresalientes cualidades artísticas. La inclusión, a través de la elección de un punto de vista adecuado, de equipos vestidos en colores diferentes le ha permitido desterrar totalmente la monotonía.

Photographie prise lors de la cérémonie d'ouverture des Spartakiades de Moscou par le directeur de l'agence photographique All Sport. L'aptitude de ce remarquable photographe sportif à saisir le bon moment de l'action est bien connue, mais cette image montre aussi son savoir-faire artistique. Il a choisi un point de vue qui élimine la monotonie par la présence d'une équipe de sportifs portant des couleurs différentes.

38

Photographer Giuseppe Balla

Humour in photography is more often seen in black and white than in colour. Its success must be in spotting situations such as this and having the camera at the ready. This example is called "L'Emulo", and it will give pleasure to the viewer without necessarily being great art.

Humor trifft man öfter in Schwarzweissfotografien an als in Farbe. Dabei muss der Fotograf ein Auge für Situationen wie diese haben und sofort mit der Kamera bereit sein. Dieses Bild, "L'Emulo", ist nicht gerade grosse Kunst, bereitet aber Spass.

Humor in de fotografie ziet men vaker in zwartwit dan in kleur. Het succes ervan ligt in het zien van situaties als deze. Het spreekt vanzelf dat men dan ook nog snel zijn camera gereed moet hebben. Deze opname zal vele kijkers bevallen zonder nu direct kunst te kunnen worden genoemd.

El humor suele estar presente más a menudo en las fotografías en blanco y negro que en las de color. En estos casos lo importante es tener la cámara a punto para captar situaciones como la que aquí vemos. El título de la instantánea es *L'Emulo* y su contemplación resulta un verdadero placer aunque no posea un extraordinario mérito artístico.

L'humour en photographie est plus souvent représenté en noir et blanc qu'en couleur. Son succès doit tenir à la capacité de saisir des situations comme celle-ci et d'avoir son appareil toujours prêt. Cet exemple, intitulé "L'Emulo" (L'émule), ne manquera pas de plaire sans être nécessairement du grand art.

39 (Upper)

Photographer Dieter Rockser
Camera Minolta SRT 101
Film Agfa CNS

Another photograph by the author of "Zweikampf" This one is much more subjective but nevertheless capturing a lot of movement as well as having an emotional impact which will have a strong appeal to all horse lovers.

Eine weitere Aufnahme des Künstlers, der "Zweikampf" (unten) fotografiert hat, doch ist dieses Bild viel subjektiver. Trotzdem ist es sehr lebensvoll und übt eine emotionale Wirkung aus, der sich kein Pferdefreund entziehen kann.

Deze opname, die niet alleen op treffende wijze de beweging invangt maar ook een sterk emotionele aantrekingskkracht heeft, zal veel paardenliefhebbers aanspreken.

Otra fotografía del autor de *Zweikampf*. Esta resulta mucho más subjetiva, aunque en ella se refleja perfectamente el movimiento y el impacto emocional que los caballos suelen ejercer en el espectador.

Autre photographie due à l'auteur de "Zweikampf" (Duel), ci-dessous, mais cette fois beaucoup plus subjective. Néanmoins, elle saisit beaucoup de mouvement tout en ayant un impact qui ne manquera pas d'émouvoir tous les amoureux des chevaux.

39 (Lower)

Photographer Dieter Rockser
Camera Minolta SRT 101
Film Agfa CNS

A picture which makes no attempt at a subjective projection of the footballers but has used them to produce a symphony of movement and beautifully harmonised colour. Reproduced from a 15 × 12 in Agfacolor print entitled "Zweikampf".

Mit dieser Aufnahme wird kein Versuch einer subjektiven Darstellung der Fussballer unternommen, sondern vielmehr eine Symphonie der Bewegung und schön harmonisierter Farben geboten. Die ursprüngliche Agfacolor-Kopie, die den Titel "Zweikampf" trägt, misst 38 × 30 cm.

Een opname van dezelfde maker als de vorige, nu echter veel minder subjectief. De voetballers werden gebruikt om een symfonie van beweging en harmonieuze kleuren te creëren. Gereproduceerd van een 30 × 40 cm vergroting op Agfacolorpapier. De titel is 'Tweekamp'.

En este caso el autor no ha tratado de obtener una proyección subjetiva de los futbolistas, sino que los ha utilizado para producir una sinfonía de movimiento y color perfectamente armonizados. El original era una copia Agfacolor de 15 × 12 pulgados titulada *Zweikampf*.

Photographie qui ne vise pas à donner une projection subjective des joueurs de football, mais qui les a utilisée pour engendrer une symphonie de mouvement et une couleur magnifiquement harmonisée. Reproduite à partir d'un tirage en couleur sur Agfacolor en 15 × 12 pouces intitulé "Zweikampf" (Duel).

40/41

Photographer Albert Bernhard

Motor cycling photography is popular so it is not easy to get a shot which is really different from the average. This print has achieved a dramatic impact by the use of a long focus lens to "bunch up" the riders and throw the background out of focus. There is also an excellent composition and a fine impression of speed.

Motorradfotografien sind beliebt, und es ist daher nicht leicht, eine Aufnahme zu erzielen, die sich von den durchschnittlichen Leistungen wesentlich unterscheidet. Die dramatische Wirkung dieses Bildes wurde durch Gebrauch eines langbrennweitigen Objektivs erzielt, das die Fahrer einander "näher" und gleichzeitig den Hintergrund unscharf erscheinen lässt. Die Komposition ist hervorragend, und die Geschwindigkeit kommt sehr gut zur Geltung.

Het is niet zo gemakkelijk om bij een populair onderwerp als motorsport met resultaten te komen die boven het gemiddelde uitkomen. Hier is dit wel gelukt dankzij de lange brandpuntsafstand, de uitstekende compositie en de indruk van snelheid.

Resulta realmente difícil obtener una instantánea motociclística que se aleje de lo normal. Hay que reconocer, por tanto, la habilidad del autor, que ha conseguido un efecto dramático a través de la "compresión" de los corredores y el desenfoque del fondo mediante la utilización de un objetivo de foco largo. La composición es excelente y la velocidad está perfectamente reflejada.

La photographie représentant des scènes de motocyclisme est très populaire, de sorte qu'il n'est pas facile d'obtenir une image qui soit vraiment différente de la moyenne. Ce tirage a un impact saisissant grâce à l'utilisation d'un téléobjectif destiné à "regrouper" les motocyclistes et à rendre flou l'arrière-plan. C'est aussi une excellente composition, qui donne une remarquable impression de vitesse.

42

Photographer Peter Gant, ARPS
Camera Olympus OM-1

A fantasy entitled "Spanish Inquisition" made by a sandwich of two transparencies taken at a priory in Kent. The reproduction is from a magnificent colour print made from this sandwich.

Eine Fantasie mit dem Titel "Spanische Inquisition", erzielt durch Überlagerung von zwei in einer Priorei in Kent aufgenommenen Diapositiven. Der Reproduktion lag eine hervorragende Farbkopie – das Ergebnis der Überlagerung – zugrunde.

Een fantasie getiteld 'Spaanse inquisitie', gemaakt via een sandwich van twee dia's opgenomen in een priorij in Kent. Gereproduceerd van een kleurvergroting van deze sandwich.

Fantasía titulada *La inquisición española* y obtenida mediante un sandwich de dos diapositivas tomadas en un convento de Kent. La copia resultante presenta una magnífica calidad cromática.

Fantaisie intitulée "Spanish Inquisition" (Inquisition espagnole), due à la mise en sandwich de deux diapositives prises dans un prieuré du Kent. La reproduction provient d'un magnifique tirage en couleur obtenu à partir du sandwich.

Photocolor.
The easiest way to process colour at home.

Colour processing and printing for the amateur has never been as popular as it is today.

And we at Photo Technology have helped to make it easier than ever before.

Whether you shoot colour slides or colour negatives and make your own prints, there's a Photocolor kit to help you do it faster, simpler, and cheaper.

Negs and prints. The original Photocolor II chemical kit lets you process your own colour negatives and prints in the same two solutions. Colour negatives take only 5¾ minutes, prints only 3½ minutes.

Colour print paper. Superb new Photocolor RC paper is specially produced and packed for us. It's the perfect partner for Photocolor II. Bright colours, clean whites, incredible sharpness. Available in glossy and lustre, 5 x 7in. and 8 x 10in.

Colour slides. Chrome-Six is our new four-bath process, including chemical reversal, for E6 type colour slide films. Gives you perfect colour slides in less than half an hour at a truly low cost.

Prints from slides. Photochrome R is the least expensive way to make colour prints from slides. And without excessive contrast. A new fast, simple chemical reversal process for use with Kodak 'Ektachrome' 14 RC paper.

Colour retouching. Give your colour prints and transparencies that professional finish by spotting with transparent Photocolor Retouching Dyes. They actually become part of the emulsion. Twelve bottles of liquid packed in a strong protective box with full instructions.

For further information about Photocolor products, write for free literature, enclosing SAE, please.

Photo Technology Limited
Potters Bar, Hertfordshire EN6 3JN.

Photocolor
Making good photography easier.

43

Photographer Vlado Bača
Camera Pentacon Six
Lens Flektogon
Exposure 1/50 at f/4
Film Agfachrome Professional 50L

An interesting combination of varied elements made into a cohesive composition by a good choice of viewpoint, coupled with a softening around the figure to concentrate the interest. The colour scheme is very exciting.

Eine interessante Kombination unterschiedlicher Elemente, die durch geschickte Wahl des Standpunkts und Unschärfe der Bereiche rings um die Person zwecks Konzentrierung des Interesses zu einer geschlossenen Komposition vereinigt wurden. Die Farbwirkung ist sehr ansprechend.

Een interessante combinatie van verschillende elementen, tot een samenhangende compositie samengevoegd door een goede keuze van standpunt, alsmede een concentratie van de aandacht op het midden dankzij het softfocus-effect eromheen. Het kleurenschema is bijzonder aantrekkelijk.

He aquí una interesante combinación de variados elementos convertida en una composición coherente a través de la elección de un punto de vista adecuado, suplementada con la suavización del entorno para concentrar el interés en la figura. La calidad cromática es excelente.

Intéressante combinaison de différents éléments rassemblés en une composition cohérente par un choix judicieux du point de vue, joint à la création d'un certain flou autour du sujet pour concentrer l'intérêt. La palette de couleurs est des plus séduisante.

44 (Upper)

Photographer Al Bridel
Camera Nikomat EL
Lens Nikkor 55mm
Film Ektachrome X

Appropriately titled "Country Fantasy" this is another example of the use of ribbed glass to make a conventional subject more interesting. To be successful a bold and colourful scene is essential. This picture fulfils the requirement and makes a pleasing composition. It was made by projecting a number of slides on to white paper and then photographing the composite through glass.

Dieses Bild, das den treffenden Titel "Ländliche Fantasie" trägt, ist ein Beispiel dafür, wie sich das Interesse eines herkömmlichen Motivs durch geripptes Glas erhöhen lässt. Für den Erfolg ist eine kühne, farbenprächtige Szene unerlässlich. Dieses Bild entspricht dieser Forderung und ergibt eine ansprechende Komposition. Es wurde durch Projizieren mehrerer Diapositive auf weisses Papier und Fotografieren des Ergebnisses durch Glas erzielt.

In deze opname werd geribbeld glas toegepast om een conventioneel onderwerp interessanter te maken. In dit geval werd een aantal dia's op wit papier geprojecteerd en daarna door het glas heen gefotografeerd.

Apropiadamente titulada *Fantasía rural* esta instantánea constituye otra muestra excelente de cómo se puede utilizar el vidrio estriado para dar mayor interés a un tema convencional. En estos casos es esencial trabajar con una escena de formas atrevidas y gran riqueza cromática. El fotógrafo obtuvo la imagen proyectando una serie de diapositivas sobre papel blanco y fotografiando el conjunto con placa de vidrio intercalada.

Judicieusement intitulèe "Country Fantasy" (Fantaisie provinciale), cette photographie est un autre exemple de l'utilisation du verre strié en vue d'obtenir un sujet classique plus intéressant. Pour

que le résultat soit bon, il est indispensable de partir d'une scène hardie et colorée. Cette photographie répond à cette exigence et forme une plaisante composition. Elle a été obtenue en projetant sur du papier blanc un certain nombre de diapositives et en photographiant la composition après interposition d'une plaque de verre.

44 (Lower)

Photographer Erik Steen
Film Infra Red Ektachrome

The best of many slides on Infra Red Ektachrome seen this year. An apparently peaceful scene has been overlaid with mood and drama by the false but powerful colours, while the star halation around the sun adds to the fantasy.

Das beste von vielen Diapositiven auf Infra-Red Ektachrome, die dieses Jahr eingereicht wurden. Eine scheinbar friedliche Szene wurde durch die falschen aber kräftigen Farben stimmungsvoll und dramatisch gestaltet, und der sternförmige Lichthof rings um die Sonne erhöht die fantastische Wirkung.

Het beste van een groot aantal dia's op infraroodfilm die dit jaar werden ingezonden. Een schijnbaar vredig landschap werd overtrokken met stemming en dramatiek door de krachtige 'valse' kleuren. Het stereffect rondom de zon draagt bij tot de fantasie.

Esta es quizá la mejor de las diapositivas obtenidas con película Ektachrome infrarroja recibidas este año. A la pacífica escena que constituye el tema de la imagen se le agrega gran fuerza dramática por medio de los enérgicos colores introducidos por la película, mientras que el halo estrellado que rodea al sol pone unas gotas de fantasía.

La meilleure d'une longue série de diapositives en Ektachrome infrarouge vues cette année. Une scène apparemment paisible a été empreinte d'atmosphère et de drame – si l'on fait abstraction des fausses mais vives couleurs – tandis que le halo d'étoiles qui entoure le soleil ajoute à la fantaisie.

45

Photographer Erik Steen

A very atmospheric landscape produced by a combination of a low viewpoint, wide angle lens and a differential colour filtering. The use of these lens attachments is often indiscriminate and overdone but this is an example of an already good picture being made more exciting still.

Eine sehr stimmungsvolle Landschaftsaufnahme, das Ergebnis einer Kombination von niedrigem Standpunkt, Weitwinkelobjektiv und differentiellen Farbfilter. Vorsätze dieser Art werden oft wahllos und übermässig benutzt, doch hier haben wir einen Fall, in dem das Interesse eines an und für sich guten Bildes zusätzlich erhöht wurde.

Een sfeervol landschap ontstaan door een combinatie van een laag standpunt, groot-hoekobjectief en een verlopend kleurfilter. Dergelijke filters worden vaak te pas en te onpas gebruikt, maar dit is een voorbeeld van een op zich reeds goede foto die er nog aantrekkelijker door werd.

Paisaje profundamente sugestivo captado con un objetivo gran angular, un punto de vista bajo y un filtro cromático diferencial. A menudo la utilización de este accesorio resulta injustificada, pero en este caso hay que reconocer que juega un importante papel.

Paysage tout empreint d'atmosphère grâce à la combinaison d'une prise de vue en contre-plongée, d'un grand angle et de différents filtres de couleur. L'utilisation de ces accessoires est souvent peu judicieuse et excessive, mais nous avons là un exemple d'une photographie intrinsèquement bonne qui a été rendue encore plus séduisante.

46 (Upper)

Photographer Stephen Dalton, FRPS

Taken by one of the world's foremost insect photographers who specialises in taking them in full flight using special electronic apparatus. This is a remarkable example of a Green Heliconid (*Phylaethria dido*) in flight taken on 9 × 12 cm film in Venezuela. The author was awarded the gold progress medal of the Royal Photographic Society for his pioneer work in insect photography.

Diese Aufnahme stammt von einem der führenden Insektenfotografen der Welt, der sich auf Flugbilder unter Anwendung spezieller elektronischer Geräte spezialisiert. Dies ist ein interessantes Bild einer im Flug befindlichen Phylaethria dido, das auf 9 × 12 cm Film in Venezuela aufgenommen wurde. Der Künstler wurde für seine Pionierarbeit auf dem Sektor der Insektenfotografie mit der "Gold Progress Medal" der Royal Photographic Society ausgezeichnet.

Deze opname werd gemaakt door een van de meest vooraanstaande insektenfotografen van de wereld die zich specialiseert op het vastleggen van insekten in volle vlucht, met gebruikmaking van een speciale elektronenflitsapparatuur. Dit is een opmerkelijk voorbeeld van een *Phylaethria dido* in de vlucht opgenomen in Venezuela op 9 × 12 cm film.

Stephen Dalton es uno de los mejores fotógrafos especializados en insectos, que acostumbra captar en pleno vuelo mediante la utilización de un sofisticado equipo electrónico. A este heliconido verde (*Phylaethria dido*) lo fotografió en Venezuela con una película de 9 × 12 cm. La Royal Photographic Society le ha otorgado una medalla de oro por los adelantos que ha logrado en el campo de la fotografía de insectos.

Photographie prise par l'un des plus célèbres photographes d'insectes du monde, qui s'est donné pour spécialité de les prendre en plein vol au moyen d'un appareil électronique spécial. Le sujet est un remarquable exemple d'*héliconie verte* (*Phylaetria dido*) en vol, prise au Venezuela sur une pellicule de 9 × 12 cm. L'auteur s'est vu décerner la médaille d'or du progrès par la Société Royale de Photographie de Grande-Bretagne pour ses travaux de pionnier dans le domaine de la photographie des insectes.

46 (Lower)

Photographer T. Norman Tait, AIIP, ARPS
Camera Nikkormat EL
Lens 55mm Micro Nikkor at f/11
Film Kodachrome 64

A dark green fritillary (Mesoacidalia aglaja) photographed on the Isle of Jura, Scotland, early in the morning when the subject was not very active because of the low air temperature. Fill-in flash was used with the flashgun on the camera.

Ein grosser Perlmutterfalter (Mesoacidalia aglaja), aufgenommen auf der Insel Jura in Schottland. Da es früh am Morgen und die Lufttemperatur niedrig war, verhielt sich dieser Falter nicht sehr aktiv. Der Künstler machte von einem Aufhellblitzlicht Gebrauch, und das Blitzgerät war auf der Kamera angeordnet.

Een donkergroene Mesoacidalia aglaja gefotografeerd op het eiland Jura bij Schotland, vroeg in de morgen toen de vlinder niet erg actief was ten gevolge van de lage temperatuur. Invvulflits werd toegepast met de flitser op de camera.

He aquí una Mesoacidalia aglaja de color verde oscuro fotografiada en la isla de Jura (Escocia) a primeras horas de la mañana, cuando aún estaba quieta por causa de la baja temperatura reinante. Se utilizó un flash de relleno.

Damier vert foncé (Mesoacidalia aglaja) photographié sur l'île de Jura, en Ecosse, tôt le matin alors que le sujet n'était pas encore très actif en raison de la basse température de l'air. L'éclairage a été renforcé au moyen d'un flash monté sur l'appareil.

QUARTZ

Meet the new Contax—the Contax 139 Quartz. It has the very latest in optical design from Zeiss (West Germany) and the perfection of ergonomics in Porsche styling. From Yashica (the leaders in electronics) comes yet another first—QUARTZ timing of ALL time related functions. Not only for the shutter but for the supreme accuracy of all the functions from the exposure meter to the electronic self timer. To these tremendous advances are added totally new concepts in flash photography, data recording, remote control etc. It is a full SYSTEM camera that sets the pace for the Eighties.

CONTAX
139 QUARTZ

You will want to know more—so write for full specifications and explanatory literature to:—

Photax Eastbourne East Sussex
London Showroom: 59 York Road SE1
Republic of Ireland: 1 George Place Dublin 1

47

Photographer E. A. Janes, ARPS
Camera Mamiyaflex C 330
Lens 180mm Sekor
Exposure 1/60 at f/8
Film Ektrachrome 120

This picture of a male Green Woodpecker, taken from a hide, must have required a lot of patience to obtain. Apart from an excellent arrangement and very good technique the author has captured the alert expression of this attractive, but watchful, species. Taken by daylight augmented by flash just above the camera.

Dieses aus einem Versteck aufgenommene Bild eines männlichen Grünspechts muss viel Geduld erfordert haben zur Schau gestellt wurden. Abgesehen von der ausgezeichneten Komposition und der sehr guten Technik hat der Künstler den aufmerksamen Ausdruck dieses hübschen Vogels erfasst. Aufgenommen bei Tageslicht und mit einem Blitzlicht unmittelbar über der Kamera.

Deze opname van de groene mannetjesspecht, opgenomen uit een schuilhut, moet veel geduld hebben gevraagd. Afgezien van de perfecte compositie en de goede techniek wist de fotograaf de oplettende uitdrukking vast te leggen van deze aantrekkelijke, maar waakzame vogelsoort. Opgenomen bij daglicht, versterkt met flitslicht van juist boven de camera.

Para captar a este pito real macho el fotógrafo tuvo que armarse de gran dosis de paciencia. Además de obtener una excelente composición ejecutada con gran dominio técnico, el autor ha conseguido reflejar la expresión vigilante de esta atractiva especie. El fotógrafo utilizó luz natural suplementada con un flash situado sobre la cámara.

Cette photographie d'un pic-vert mâle, prise à partir d'une cache et qui a dû demander beaucoup de patience à son auteur. En plus de son excellente composition et d'une technique parfaite, l'auteur a saisi l'expression alerte de cette espèce séduisante mais vigilante. Photographie prise à la lumière du jour renforcée par la lumière d'un flash situé au-dessus de l'appareil.

48

Photographer W. G. Gale
Camera Olympus OM-1
Film Kodachrome

A pleasing seascape has been given a strong impression of sunset by copying the original transparency through an orange filter. Thus an almost classic composition has been given an added atmosphere.

Bei diesem schönen Meeresbild hat man einen starken Eindruck von Sonnenuntergang, was durch Kopieren des ursprünglichen Diapositivs durch ein Orangefilter erzielt wurde. Einer nahezu klassischen Komposition wurde auf diese Weise eine besondere Stimmung verliehen.

Dit fijne zeegezicht kreeg een sterke impressie van een zonsondergang door het originele dia te reproduceren via een oranjefilter. Op deze wijze werd extra sfeer toegevoegd aan een bijna klassieke compositie.

A este agradable paisaje marino se le ha añadido una atmósfera de anochecer mediante la reproducción de la diapositiva original a través de un filtro naranja en papel de copia. De este modo se ha acentuado la riqueza cromática de una composición que muy bien podemos definir como clásica.

Séduisant paysage marin auquel le photographe a conféré une impression de soleil couchant en copiant la diapositive originale au travers d'un filtre orange, rehaussant ainsi l'atmosphère d'une composition presque classique.

49

Photographer Valdis Brauns

A very striking nude study in which the figure is used to tell a story which stimulates the imagination. The impact is further emphasised by the bold lighting on the body in contrast with the almost blinding effect of the sun.

Eine sehr eindrucksvolle Aktstudie, in der die Gestalt einen die Fantasie anregenden Eindruck bedingt. Die Wirkung ist auch durch die kühne Beleuchtung des Körpers im Kontrast zu der nahezu blendenden Sonne hervorgehoben.

Een frappante naakstudie waarin de figuur wordt gebruikt om een verhaal te vertellen dat de verbeelding stimuleert. De expressie wordt verder benadrukt door de harde verlichting van het lichaam in contrast met het bijna verblindende effect van de zon.

Impresionante desnudo en el que la figura humana se ha utilizado para estimular la imaginación del observador. El impacto se acentúa por el contraste entre la atrevida iluminación del cuerpo y el efecto, casi cegador, del sol.

Etude de nu très frappante dans laquelle le personnage est utilisé pour raconter une histoire qui stimule l'imagination. L'impact est en outre renforcé par l'éclairage cru qui tombe sur le corps en contraste avec l'effet presque éblouissant du soleil.

50

Photographer Brian Duff, ARPS
Camera Nikon F2
Lens 24mm Nikkor
Film FP4

A wonderful action shot of "Big Daddy" (Shirley Crabtree), a very popular British wrestler. Taken during a training session. To catch a 24 stone man floating in the air is quite a technical feat!

Eine wunderbare Aktionsaufnahme von "Big Daddy" (Shirley Crabtree), einem sehr beliebten britischen Ringkämpfer. Sie wurde während einer Trainingssitzung gemacht. Es ist gar nicht so einfach einen 150 kg wiegenden Mann beim Flug durch die Luft aufzunehmen.

Een schitterende actiefoto van 'Big Daddy', een bekend Brits worstelaar, opgenomen tijdens de training. Het valt niet mee om een 150 kilo wegende man zwevend in de lucht weer te geven!

Excelente instantánea en la que vemos en acción durante un entrenamiento al luchador británico "Gran papá" (Shirley Crabtree). Hay que reconocer que la captación de una "mole" de 150 kilos flotando en el aire resulta una verdadera hazaña.

Magnifique photographie d'action de "Big Daddy" (Shirley Crabtree), lutteur britannique très connu. Prise durant une séance d'entraînement. Saisir au vol un homme de quelque 115 kg, voilà qui est une prouesse technique!

51

Photographer Brian Duff, ARPS
Camera Mamiya RB67
Lens 180mm Sekor
Film FP4

Like the plate opposite, this shows another very popular figure, Charlie Cairoli, an internationally famous clown. Taken by flash just before his retirement he couldn't resist "clowning it up" for the photographer.

Ebenso wie das Bild gegenüber zeigt diese bei Blitzlicht aufgenommene Studie eine sehr prominente Persönlichkeit, den nun verstorbenen weltberühmten Clown Charlie Cairoli, kurz bevor er in den Ruhestand trat. Er konnte der Versuchung nicht widerstehen, sich auch bei diesem Anlass als Komiker zu gebärden.

Net als de foto op de tegenoverliggende bladzijde geeft ook deze opname een populaire figuur weer, namelijk de inmiddels overleden, internationaal bekende clown Charlie Cairoli, die ook in deze foto, met flitslicht gemaakt vlak voordat hij zijn carrière stopte, niet kon nalaten voor de fotograaf de clown uit te hangen.

También en esta imagen aparece una figura popular: Charlie Cairoli, payaso de fama internacional. Cairoli no pudo resistir la tentación de obsequiar al fotógrafo con una de sus celebradas "payasadas".

Comme la photographie de la page opposée, celle-ci présente un autre personnage très populaire, le défunt Charlie Cairoli, clown de renommée internationale. Pris au flash juste avant son départ en retraite, il n'a pas pu résister au désir d'une nouvelle facétie pour le photographe.

52

Photographer Kent Bailey
Camera Nikkormat
Film Tri-X

A very funny picture entitled "Lear Jet with Jet Lag". Many people would have passed by without seeing the humour of the situation which the author has successfully portrayed by using a low viewpoint and a wide angle lens.

Ein sehr spassiges Bild mit dem Titel "Strahlflugzeug – erschöpft". Viele wären daran vorbeigegangen, ohne sich der Komik dieses Anblicks bewusst zu sein, die Kent Bailey mit Erfolg von einem niedrigen Standpunkt aus und unter Anwendung eines Weitwinkelobjektivs wiedergegeben hat.

Veel mensen zouden hier langs zijn gelopen zonder het humoristische van deze situatie te herkennen, die door de fotograaf met succes werd vastgelegd vanuit een laag camerastandpunt en met een groothoekobjectief.

He aquí una graciosa imagen en la que se refleja una situación que tal vez habría pasado inadvertida para muchas personas. El fotógrafo, en cambio, la ha captado a la perfección valiéndose de un objetivo gran angular y un punto de vista bajo.

Très amusante photographie intitulée "Lear Jet with Jet Lag" (Avion d'affaires à réaction Lear épuisé par d'incessants changements de fuseau horaire). Bien des gens seraient passés sans percevoir l'humour de cette situation, que l'auteur a magnifiquement saisi en photographiant en contre-plongée avec un grand angle.

53

Photographer John Jones
Camera Canon Ftb
Lens 35mm
Exposure 1/125 at f/8
Film Tri-X

Eric Morecambe, Britain's most popular comedian, is laughingly supported by sports commentator, Dickie Davis, at a charity golf tournament. A very pleasing news picture.

Eric Morecambe, der beliebteste britische Komiker, wird hier während eines Wohltätigkeits-Golfturniers lachend von dem Sportkommentator Dickie Davis gestützt. Eine sehr ansprechende Presseaufnahme.

HOW TO TAKE A WIDE ANGLE SHOT WITH A STANDARD LENS.

TURN THIS

Please send me details of the Tamron Adaptall-2 28-50mm f 3.5/4.5. The wide angle zoom that's the size of a standard lens. And the world's first with 'minimum object distance' selector system, giving different MOD at each focal length – right down to 0.25m at 50mm.

Name_____

Address_____

PYB/81

ost to: Tamron Customer Service Division, Eumig (UK) Ltd., 14 Priestley Way, London NW2 7TN. Tel: 01-450 8070.

TAMRON®

Eric Morecambe, een populaire Engelse toneelspeler, wordt lachend ondersteund door sportverslaggever Dickie Davis tijdens een liefdadigheids golftoernooi. Een amusante nieuwsfoto.

Vemos aquí a Eric Morecambe, quizás el cómico británico más popular, acompañado por el comentarista deportivo Dickie Davis durante la disputa de un torneo de golf organizado con fines caritativos. Una agradable noticia gráfica.

Eric Morecambe, le comédien le plus populaire de Grande-Bretagne, joyeusement soutenu par le commentateur sportif Dickie Davis, lors d'un tournoi de golf organisé au profit d'une oeuvre de charité. Très séduisante photographie de reportage.

54

Photographer Vladimir Filonov

Another example of a very simplified line treatment which makes multiple printing and re-arrangement of elements comparatively simple. The title "Through the Looking Glass" gives pause for thought.

Noch ein Beispiel sehr vereinfachter Behandlung der Linien, die Mehrfachkopieren und das Umordnen der Elemente relativ einfach macht. Der Titel "Im Spiegelreich" stimmt nachdenklich.

Weer eens een voorbeeld van een sterk vereenvoudigende lijnuitwerking van een onderwerp, waardoor bij het vergroten meervoudige belichtingen en een hergroepering van de elementen betrekkelijk gemakkelijk worden.

En esta imagen el simplificado tratamiento lineal ha facilitado el copiado múltiple y la reordenación de los elementos constitutivos. El título, A través del espejo, pone en seguida en funcionamiento a nuestra imaginación.

Autre exemple d'un traitement simplifié des lignes, qui rend la multi-impression et le réarrangement relativement simples. Le titre "Through the Looking Glass" (Au travers du miroir) laisse pensif.

55

Photographer Jiri Bartos
Camera Pentax SP 1000
Lens 35mm Flektogon
Film Orwo NP20

A very original and imaginative picture presumably made from a shot of bubbles printed with one of a tree and then reversed to a negative. One of many excellent "darkroom gymnastics" to come from Czechoslovakia.

Ein sehr originelles, fantasiereiches Bild, das wohl durch Aufnahme von Blasen, Überdrucken mit der Aufnahme eines Baumes und Rückverwandlung in ein Negativ erzielt wurde. Eine der vielen ausgezeichneten ''Dunkelkammer-Trickaufnahmen'' aus der Tschechoslowakei.

Een originele en van veel fantasie getuigende foto, waarschijnlijk een combinatie van een opname van zeepbellen en een van een boom, waarvan door omkeren een nieuw negatief werd gemaakt. Eén uit een serie perfecte donkerekamer-trucages uit Tsjechoslowakije.

Instantánea muy original e imaginativa probablemente obtenida mediante el copiado simultáneo de la imagen de unas burbujas y la de un árbol, tras lo cual se invirtió el resultado para convertirlo en un negativo. Su título es Jardín y constituye una nueva prueba de la habilidad con que los fotógrafos checos efectúan sus "ejercicios gimnásticos" de laboratorio.

Photographie très originale et tout empreinte d'imagination, résultant probablement du tirage simultané d'un cliché représentant des bulles et

d'un cliché représentant un arbre, reconverti en suite en négatif. Remarquable exemple de cette excellente "gymnastique de chambre noire" qui nous vient de Tchécoslovaquie.

56

Photographer Francis Fernandez

One of a number of striking pictures produced by young students trained by Roger Darker, FRPS, and exhibited at an exhibition of students' work at the Royal Photographic Society. The enlarged head in relation to the window gives an imprisoned feeling which is underlined by the two tone treatment.

Eine von mehreren bemerkenswerten Aufnahmen, die von jungen Studenten des Künstlers Roger Darker, FRPS, angefertigt und in einer Ausstellung von Studentenarbeiten der Royal Photographic Society zur Schau gestellt wurden. Im Verhältnis zu dem Fenster erregt der vergrösserte Kopf ein klaustrophobisches Gefühl, das durch die zweitönige Behandlung betont wird.

Een opname uit een serie frappante opnamen geproduceerd door jonge studenten, getraind door Roger Darker, FRPS, en tentoongesteld op een exposition van werk van studenten bij de Royal Photographic Society. Het in verhouding met het venster uitvergrote hoofd geeft een gevoel van gevangenschap dat wordt onderstreept door de uitwerking in twee toonwaarden.

Esta instantánea forma parte de una serie producida por los alumnos de Roger Darker, miembro de la Royal Photographic Society, la cual se exhibió en una exposición desarrollada en las instalaciones de dicha sociedad. La impresión de encierro proporcionada por la relación existente entre los tamaños de la cabeza y la ventana se ve acentuada por el tratamiento bitonal.

Bon exemple d'une série de remarquables photographies dues à de jeunes étudiants formés par Roger Darker, membre de la Société Royale de Photographie de Grande-Bretagne (FRPS), et présentées lors d'une exposition de travaux d'élèves-photographes à la Société Royale de Photographie. La tête agrandie par rapport à la fenêtre donne une impression d'emprisonnement, qui est renforcée par le traitement en deux tons.

57

Photographer David Balsells
Camera Nikon F2
Lens 20mm Nikkor
Film HP5

A situation picture which arouses memories of what many of us liked to do when we were young but there is one added touch of comedy because the "gymnast" is nude. Many good photographs are copied but anyone copying this situation should be careful!

Eine Situationsaufnahme, die daran erinnert, was viele von uns so gerne taten, als wir noch jung waren, doch ist dieses Bild besonders komisch, weil die "Turnerin" nackt ist. Viele gute Aufnahmen werden nachgeahmt, doch wäre in diesem Falle besondere Vorsicht geboten.

Een genrefoto die herinneringen oproept aan wat velen van ons graag taten toen we jong waren. Het verschil is dat de 'gymnaste' hier naakt is.

Esta imagen nos recuerda una de las actividades que nos gustaba desarrollar a muchos de nosotros cuando éramos jóvenes, aunque la desnudez de la figura añade un toque humorístico y, en cierta forma, distanciador. Sí, como sucede con muchas buenas fotografías, otros autores deciden copiar la situación descrita tendrán que andarse evidentemente con mucho cuidado.

Photographie de situation qui ravive les souvenirs de ce que nombre d'entre nous aimions faire lorsque nous étions jeunes, mais avec une touche d'humour supplémentaire due au fait que la

"gymnaste" est nue. Nombre de bonnes photographies sont des copies, mais quiconque se risquerait à copier cette situation devrait agir avec prudence!

58

Photographer Jose Miguel de Miguel
Camera Nikon F
Lens 50mm Nikkor
Film Plus X

A dramatic photograph of a procession of penitents on a saints day in Spain. The author very wisely shot solely by the light of the torches thus preserving the air of mystery at night, while the diagonal composition from a high viewpoint gives a feeling of movement.

Eine dramatische Aufnahme einer Büsserprozession am Festtag eines Heiligen in Spanien. Der Künstler handelte sehr weise, als er sich mit dem von den Fackeln abgegebenen Licht begnügte, da dadurch die mysteriöse Nachtstimmung gewahrt bleibt. Andererseits verleiht die diagonale Komposition von einem hohen Aufnahmestandpunkt aus dem Bild ein Gefühl der Bewegung.

Een dramatische foto van een processie van boetelingen in Spanje. De maker deed er verstandig aan de opname uitsluitend bij het licht van de toortsen te maken, waardoor de mysterieuze nachtelijke sfeer werd behouden. De diagonale compositie vanuit het hoge standpunt geeft een gevoel van beweging.

Dramática instantánea en la que vemos a una procesión de penitentes celebrada en España durante la semana santa. Al servirse únicamente de la luz de las hachas el autor ha conseguido conservar la atmósfera de misterio que rodea a estas celebraciones, mientras que la composición diagonal obtenida desde un punto de vista alto proporciona una impresión de movimiento.

Saisissante photographie d'une procession de pénitents le jour de la fête d'un saint en Espagne. L'auteur a très sagement pris sa photographie à la seule lumière des flambeaux, conservant ainsi l'air de mystère propre à la nuit, tandis que la composition en diagonale prise en plongée donne une impression de mouvement.

59

Photographer Rolf M. Aagaard
Camera Nikon F2
Lens 360mm
Film Tri-X

This face is so well known that no title is needed. However this photograph portrays more character and is better presented than the thousands that have appeared in the press throughout the world. The "halo" introduced during printing may not appeal to many viewers but it has helped to balance a strong composition.

Dieses Gesicht ist so bekannt, dass kein Titel nötig ist. Die Aufnahme bringt die Persönlichkeit jedoch viel deutlicher zum Ausdruck und die Präsentation ist besser als bei den tausenden Aufnahmen, die in der Presse der ganzen Welt erschienen sind. Der Lichthof im Hintergrund, der eine Art "Heiligenschein" bildet, mag von vielen Betrachtern abgelehnt werden, verleiht der starken Komposition aber das nötige Gleichgewicht.

Deze man is zo bekend geworden dat vermelding van zijn naam niet nodig is. Deze foto toont echter meer karakter en is beter gepresenteerd dan de duizenden portretten die in de wereldpers verschenen. De lichtkring rondom zijn hoofd zal niet iedereen aanspreken, maar hij leidde wel tot een evenwichtige, sterke compositie.

Take your wife, seriously.

The Nikon FM and FE Compacts.
Made to perfectionist standards by the world's greatest camera-makers.
For photographers with a serious interest in improving their image.

Nikon One word that's worth a thousand pictures.

For further details, write to: Dept. P.Y. Nikon UK Limited, 20 Fulham Broadway, London SW6 1AA.

Este rostro es tan conocido que no hace falta decir a quién pertenece. Sin embargo, en la instantánea se refleja el carácter del modelo mucho más fidedignamente que en la mayor parte de las que han aparecido en las publicaciones de todo el mundo. Puede que el "halo", introducido en el copiado, no sea del agrado de algunos lectores, pero de hecho ayuda a equilibrar la enérgica composición.

Ce visage est si connu qu'il n'appelle aucun titre. Toutefois, cette photographie accentue le caractère du sujet et est mieux présentée que les milliers d'autres qui ont été publiées dans la presse du monde entier. Le "halo" rapporté lors du tirage ne sera peut-être pas du goût de tous, mais il a contribué à équilibrer une forte composition.

60

Photographer Jose Torregrosa
Camera Nikon F
Lens 24mm Nikkor
Film Tri-X

The marks left by the removal of a bikini used to be regarded as a drawback but it does not seem to matter in rear view nudes, especially with a contrasty treatment. (See also plate 57.) Walking into the distance always has the dramatic touch seen at the end of many films and it is well exploited here.

Die Spuren, die ein Bikini hinterlässt, pflegten als ein Nachteil erachtet zu werden, doch spielen sie bei Aktaufnahmen von hinten, besonders bei kontrastreicher Behandlung, anscheinend keine Rolle (siehe auch Aufnahme 57). Der Gang in die Ferne hat immer etwas Dramatisches an sich, was an das Ende vieler Filme erinnert. Hier wurde dieser Effekt gut verwertet.
De witte bikinistrepen worden vaak als een nadeel beschouwd, maar bij achteraanzichten schijnen ze niet erg te storen, vooral niet in combinatie met een contrastrijke uitwerking.

Las señales que quedan en la piel al tomar el sol en bikini pueden resultar embarazosas en un desnudo, pero no ha sido así en esta imagen tomada desde atrás, gracias quizá al tratamiento contrastante. (Algo parecido sucede en la fotografía 57.) El fotógrafo ha explotado asimismo las connotaciones dramáticas que el cine nos ha hecho asociar con las figuras humanas que desaparecen caminando en la distancia.

Les marques laissées par l'enlèvement d'un bikini étaient généralement considérées comme un inconvénient, mais il ne semble pas que ce soit très important dans le cas de nus pris de dos, en particulier sur une image aussi contrastée. (Voir aussi la photographie 57.) Se perdre dans le lointain implique toujours cette touche saisissante que l'on voit à la fin de nombreux films, et elle est bien exploitée ici.

61 (Upper)

Photographer Colin Westgate, FRPS
Camera Konica T3
Lens 30mm Lydith
Film Tri-X

An extremely imaginative treatment of a quite ordinary subject. The overall printing-in, leaving only a halo to silhouette the horse, was a brilliant touch which would only occur to a few. Taken at sunset in February.

Eine ausserordentlich fantasiereiche Behandlung eines recht alltäglichen Themas. Dadurch dass nur ein Lichthof rings um die Silhouette des Pferdes zurückgeblieben ist, wurde ein brillanter Effekt erzielt, der nur wenigen in den Sinn gekommen wäre. Bei Sonnenuntergang im Februar aufgenommen.

Een fantasierijke behandeling van een nogal gewoon onderwerp. De wijze waarop de foto is doorgedrukt, zodat alleen een lichtkring ontstond waartegen het paard als silhouet afsteekt, is een briljante vondst waarop slechts weinigen zouden zijn gekomen. De opname werd gemaakt bij zonsondergang in februari.

Tenemos aquí un tema totalmente normal tratado de forma extremadamente imaginativa. La fotografía se tomó a la hora del crepúsculo en el mes de febrero y el positivado general, que ha dejado sólo un ligero halo para siluetear al caballo, ha introducido en la imagen un toque magistral.

Traitement plein d'imagination d'un sujet très banal. La suppression de tous les détails, à l'exception d'un halo pour faire ressortir la silhouette du cheval, était une brillante idée, qui ne serait pas venue à tous. Photographie prise au coucher du soleil, en février.

61 (Lower)

Photographer Colin Westgate, FRPS
Camera Konica T3
Lens 30mm Lydith
Film FP4

Another moody picture made by the same author as the one above. It also shows considerable shading to enhance the mood and a red filter was used to give contrast to the mid-day scene. The author states the lens cost only £4!

Ein weiteres stimmungsvolles Bild, das ebenfalls von Colin Westgate stammt. Der Effekt wurde durch erhebliche Schattierung verstärkt, und die Kontraste in dieser zur Mittagszeit ausgeführten Studie wurden durch ein Rotfilter erhöht. Der Künstler berichtet, dass das Objektiv nur £4 kostete.

Nog een stemmige foto van dezelfde auteur. Ook hier is sterk doorgedrukt om de stemming te accentueren. Een roodfilter werd toegepast om contrast te brengen in het midden op de dag gefotografeerde landschap.

Otra imagen de atmósfera muy sugestiva obtenida por el mismo fotógrafo. También en ésta se ha utilizado el sombreado para dar mayor énfasis al ambiente, mientras que se ha introducido cierto contraste en la luz del mediodía por medio de un filtro rojo. ¡El autor nos dice que el objetivo le costó solamente 4 libras!

Autre photographie tout empreinte de mélancolie, due au même auteur que la précédente. Elle résulte également d'un ombrage considérable, destiné à renforcer l'état d'âme, et de l'interposition d'un filtre rouge utilisé pour donner du contraste à cette vue prise à l'heure de midi. L'auteur indique que l'objectif ne lui a coûté que 40 francs français!

62

Photographer Juraj Fleischer
Camera Petri MF1
Lens 20mm
Film Orwo 27

A portrait of an old peasant woman has been given a lot of character by the use of a wide angle lens which has introduced perspective distortion that in a sense is caricature. This is offset by the happy smile and bold tone treatment.

Diesem Porträt einer alten Bäuerin wurde durch den Gebrauch eines Weitwinkelobjektivs eine eigene, die Persönlichkeit besonders betonende Note verliehen. Gleichzeitig wurde die Perspektive verzerrt, so dass das Bild auf eine Weise karikaturartig wirkt. Das glückliche Lächeln und die kühne Tönung schaffen jedoch den nötigen Ausgleich.

Dit portret van een oude boerenvrouw kreeg veel karakter door het gebruik van een groothoekobjectief, waardoor een perspectivische vertekening werd veroorzaakt die min of meer karikaturaal werkt. Dit wordt goedgemaakt door de blije glimlach en de sterke benadrukking van de toonwaarden.

A este retrato de una vieja campesina se le ha dado una atmósfera especial mediante la utilización de un objetivo gran angular, cuya deformación de la perspectiva constituye en cierto modo un rasgo caricaturesco. El equilibrio se consigue a través del contraste establecido por la sonrisa confiada y el atrevido tratamiento tonal.

Portrait d'une vieille paysanne, au caractère très marqué par suite de l'utilisation d'un grand angle, lequel a permis d'introduire une déformation de la perspective qui, en un sens, est caricaturale. Cette impression est contrebalancée par le sourire heureux et le traitement dans un ton hardi.

63

Photographer John Davidson

A rather moving character portrait with a most interesting composition in which the rotunda of the building behind the subject echoes the shape of his hat. The halo effect, although artificially produced, brightens up the tone pattern and isolates the figure to advantage.

Eine recht dramatische Charakterstudie und eine interessante Komposition, in der die Rotunda des Gebäudes eine Art Echo zu der Form der Hutes bildet. Die lichthofartige Wirkung wurde zwar künstlich erzielt, hellt aber das Tonbild auf und isoliert die abgebildete Person auf vorteilhafte Weise. Dies ist Bill Harp, der Vorsitzende der Merseyside Arts Association.

Een karakterportret met een bijzonder interessante compositie, waarin de ronding van het gebouw in de achtergrond wordt herhaald in de vorm van de hoed van de afgebeelde persoon. De lichtkring achter het hoofd is in de donkerekamer ingebracht, maar verheldert het toonwaardenschema en isoleert de figuur voortreffelijk.

Interesante retrato dotado de una excelente composición en la que la rotonda del edificio situado detrás del modelo reproduce la forma de su sombrero. El efecto de halo, a pesar de harberse obtenido artificialmente, alegra el esquema tonal y aísla favorablemente a la figura.

Portrait d'un personnage assez émouvant, dans une composition particulièrement intéressante où la rotonde de bâtiments qui se trouve derrière le sujet fait écho à la forme de son chapeau. L'effet de halo, bien qu'artificiel, rehausse la palette des tons et isole judicieusement le personnage à son avantage. Il s'agit de Bill Harp, président de la Merseyside Arts Association

64

Photographer Steve Hartley
Camera Nikon F2
Lens 85mm Nikkor
Exposure 1/250 at f/5.6
Film HP5

One of a number of candid portraits of members of the Royal Family taken by photographers on the *Evening Post,* Reading, which have not been widely reproduced. It was taken when the Queen was watching Prince Philip taking part in the Royal Windsor Horse Show.

Eines von mehreren Porträts von Mitgliedern der königlichen Familie, die von Fotografen der *Evening Post, Reading,* unbemerkt aufgenommen wurden und keine weite Verbreitung gefunden haben. Die Königin beobachtete gerade Prinz Philip auf der Royal Windsor Horse Show.

Eén uit een serie snapshot-portretten van leden van het Britse Koninklijke Huis, gemaakt door fotografen van de Evening Post uit Reading, die slechts in

beperkte kring zijn gepubliceerd. Deze opname werd gemaakt terwijl de Engelse koningin Prins Philip gadesloeg die deelnam aan de Royal Windsor Horse Show.

Esta instantánea forma parte de una serie de retratos de la familia real inglesa tomada por reporteros del *Evening Post, Reading* que ha sido muy poco reproducida. La reina contempla al príncipe Felipe que toma parte en el Royal Windsor Horse Show.

Photographie extraite d'une série de portraits peu diffusés de membres de la famille royale pris sur le vif par des photographes de l'*Evening Post, Reading*. Elle a été prise alors que la Reine regardait le Prince Philip participer au Royal Windsor Horse Show.

65

Photographer	Jenny J. Goodall
Camera	Olympus OM-1
Lens	50mm Zuiko
Exposure	1/250 at f/5.6
Film	HP5

Entitled "The Lonely Prince" this shows Prince Charles watching polo at Windsor Great Park. The author who is with the *Evening Post*, Reading, has captured something of the isolation in which public figures are sometimes forced to live.

Dieses Bild, das den Titel "Der einsame Prinz" trägt, zeigt Prinz Charles, wie er im Windsor Great Park einem Polo-Match zusieht. Der Fotograf, ein Mitarbeiter des *Evening Post, Reading*, hat etwas von der Einsamkeit erfasst, in der prominente Persönlichkeiten manchmal leben.

Onder de titel 'De eenzame prins' toont deze foto Prins Charles van Engeland terwijl hij kijkt naar een polowedstrijd in Windsor Great Park. De fotografe die eveneens werkt voor de Evening Post in Reading slaagde erin iets vast te leggen van de isolatie waarin publieke figuren soms noodgedwongen leven.

Titulada *El príncipe solitario*, esta instantánea nos muestra al príncipe Carlos de Inglaterra en el Parque de Windsor. La autora, que trabaja para el *Evening Post, Reading* ha captado con acierto el aislamiento en que las personalidades conocidas a menudo se ven obligadas a vivir.

Intitulée "The Lonely Prince" (Le prince solitaire), cette photographie montre le Prince Charles assistant à un match de polo dans le Windsor Great Park. L'auteur, journaliste à l'*Evening Post, Reading*, a saisi quelque chose de cet isolement dans lequel les personnalités en vue sont parfois contraintes de vivre.

66

Photographer	Stanley Matchett
Camera	Nikon F2
Lens	300mm Nikkor
Exposure	1/125 at f/4.5
Film	HP5

A very amusing picture by a *Daily Mirror* photographer which shows once again that back views are often more expressive than front views. Paddy, the rider, made this bicycle from an old brass bedstead and a child's discarded bicycle.

Ein sehr amüsantes Bild eines Fotografen des *Daily Mirror*, das wieder beweist, dass Aufnahmen von hinten oft ausdrucksvoller sind als von vorn. Paddy, der auf dem Fahrrad sitzt, machte es aus Teilen eines alten Messingbettgestells und einem nicht mehr benötigten Kinderfahrrad.

Een amusante opname door een fotograaf van de Daily Mirror die weer eens aantoont dat achteraanzichten. Vaak expressiever zijn dan vooraanzichten. De fietser maakte zijn vervoermiddel zelf van een oud koperen ledikant en een afgedankt kinderfietsje.

Divertida imagen tomada por un fotógrafo del *Daily Mirror* que de nuevo nos demuestra que las vistas desde atrás pueden resultar a menudo más interesantes que las de frente. Paddy construyó su bicicleta con una abandonada por otro niño y el armazón de una cama de latón.

Très amusante photographie due à un photographe du *Daily Mirror*, qui montre une fois de plus que les vues de dos sont souvent plus expressives que les vues de face. Paddy, le cycliste, a fabriqué cette bicyclette à partir d'un vieux châlit en laiton et d'une bicyclette d'enfant mise au rebut.

67

Photographer	Forrest Smyth
Camera	Pentax MX
Lens	Vivitar 70-210mm zoom
Film	Tri-X at 800 ASA

An orang utang in the Kuala Lumpur zoo in Malaysia who might well be laughing at Paddy on the opposite page. The author has wisely darkened most of the face in order to concentrate interest on the mouth and hence the action.

Ein Orang-Utan im Tiergarten von Kuala Lumpur in Malaysia, der aussieht, als ob er über "Paddy" auf der gegenüberliegenden Seite lachen würde. Der Künstler hat mit Erfolg den grössten Teil des Gesichtes verdunkelt, so dass das Maul des Affen und somit die Aktion im Vordergrund des Interesses steht.

Deze orang oetan in de dierentuin van Kuala Loempoer in Maleisië schijnt te lachen om de fietser op de tegenoverliggende bladzijde. De fotograaf liet het merendeel van het gezicht in het donker om de aandacht te concentreren op de mond en daarmee op de actie.

¿Estará riéndose de Paddy este orangután del Zoo de Kuala Lumpur (Malasia)? El autor ha dejado en la sombra la mayor parte de la cara para concentrar el interés en la boca del animal.

Voici un orang-outang du zoo de Kuala Lumpur en Malaysia, qui pourrait bien être en train de se moquer de Paddy sur la page opposée. L'auteur a judicieusement assombri la plus grande partie de la face de manière à concentrer l'intérêt sur la bouche, et donc sur l'action.

68

Photographer	David Burrows, AIIP
Camera	Hasselblad
Lens	80mm
Exposure	1/15 at f4
Film	Tri-X

A well composed group has been given a posterized treatment by conversion to pure black tones and then adding various tints. The result has more interest and a better balance than line alone.

Diese geglückte Komposition wurde durch Umgestaltung auf reine Schwarztöne und nachträglichen Zusatz verschiedener Tönungen plakatmässig behandelt. Das Ergebnis ist interessanter und besser ausgeglichen, als dies sonst der Fall gewesen wäre.

Een goed opgestelde groep kreeg een grafisch uiterlijk door het omwerken tot zuiver zwarte toonwaarden en het achteraf toevoegen van enkele grijstinten. Het resultaat is interessanter en evenwichtiger dan een lijnuitwerking alleen.

A este grupo, compuesto con notable eficacia, se lo ha sometido a una posterización, obteniéndose tonos negros puro luego se han convertido en distintos colores a través de la adición de tintes. El resultado posee mayor interés y equilibrio más perfecto que las instantáneas puramente lineales.

Un groupe bien composé a été "postérisé" par conversion à des tons noirs purs, puis adjonction de différentes teintes. Il en résulte une photographie présentant un intérêt accru et un meilleur équilibre que la ligne seule.

69

Photographer	Joan Wakelin, FRPS
Camera	Mamiyaflex
Lens	65 mm
Film	FP4

Entitled "Lady Clare and Friends", this is a delightful whimsy – almost a caricature of a Victorian set piece. The composition is an almost perfect arrangement and shows great artistry on the part of the photographer.

Dieses entzückende Bild, das den Titel "Lady Clare und Freunde" trägt, wirkt fast wie eine Karikatur einer viktorianischen Gruppenaufnahme. Die nahezu perfekte Komposition ist ausserordentlich kunstvoll.

Deze foto is bijna een karikatuur van een Victoriaanse situatie. De compositie wordt bepaald door een bijna perfecte opstelling en duidt op de artisticiteit van de fotografe.

Titulada *Lady Clara y sus amigos*, esta instantánea constituye una extravagante caricatura de las imágenes victorianas. Su perfecta composición da fe de la capacidad artística de la autora.

Intitulée "Lady Claire and Friends" (Lady Claire et ses amis), cette photographie est une délicieuse fantaisie, presque une caricature d'une scène victorienne. La composition est un arrangement presque parfait et traduit un grand sens artistique chez le photographe.

70

Photographer	Arijs Klavinskis

An interesting picture with an emphasis on design which has been emphasised by the simplified tone treatment and given character by introducing grain. Even on a print treated in this way, back lighting is effective.

Eine interessante Aufnahme, bei der die Betonung auf dem Design liegt. Die Wirkung wurde durch die vereinfachte tonale Behandlung und die Körnigkeit erhöht. Selbst bei einer auf diese Weise behandelten Kopie ist Gegenlicht wirksam.

Een interessante foto waarin de nadruk ligt op de compositie, die wordt versterkt door de vereenvoudigde toonwaardenbehandeling en karakter krijgt door de toevoeging van korrel. Zelfs bij een op deze wijze behandelde vergroting is het tegenlicht effectief.

Interesante instantánea en la que se ha subrayado la composición a través de la simplificación del tratamiento tonal y la introducción del grano. La iluminación a contraluz resulta efectiva, incluso combinada con este tratamiento.

Intéressante photographie où l'accent a été mis sur la conception, qui a été rehaussée par la simplification des tons et à laquelle l'auteur a conféré du caractère en lui donnant du grain. Même sur un tirage traité de cette manière, l'éclairage arrière est efficace.

71

Photographer	Arijs Klavinskis

Like the picture on the opposite page, this example shows a beautifully balanced design which is considerably enhanced by the poster treatment, and the back-lighting which has outlined the horses and separated them from the pleasing background of grain.

Wie bei dem Bild auf der gegenüberliegenden Seite haben wir hier eine wunderschön ausgeglichene Komposition, die infolge der plakatmässigen Behandlung besonders zur Geltung gelangt. Zum Teil ist die Wirkung auch auf Gegenlicht zurückzuführen, das die Pferde hervorgehoben und von dem ansprechenden körnigen Hintergrund isoliert hat.

Net als de foto op de tegenoverliggende bladzijde toont deze opname een uitgebalanceerde compositie, welke wordt versterkt door de toonscheiding, evenals door het tegenlicht dat de contouren van de paarden benadrukt en ze doet afsteken tegen de prettig aandoende korrelachtergrond.

Al igual que la de la página anterior, esta instantánea presenta también una composición perfectamente equilibrada, a la que se ha subrayado por medio de la "posterización" y la iluminación a contraluz. Esta recorta las siluetas de los caballos y los separa del agradable fondo granulado.

Comme pour la photographie de la page opposée, nous avons là un exemple d'une conception magnifiquement équilibrée, considérablement rehaussée par la "postérisation" ainsi que par l'éclairage arrière qui a eu pour effet de mettre les chevaux en relief et de les séparer du séduisant arrière-plan au grain marqué.

72 (Upper)

Photographer Jan Anděl
Camera Pentax ES II
Lens 20mm Zeiss Flektogon
Film Orwo NP55

A straightforward low angle shot of a country scene has been given drama by the use of a red filter and rich blacks in the print.

Dieser einfachen Aufnahme einer ländlichen Szene von einem niedrigen Standpunkt aus wurde durch Gebrauch eines Rotfilters und die intensiven Schwarztöne in der Kopie eine dramatische Wirkung verliehen.

Deze rechttoe-rechtaan opname van een landschap kreeg een dramatisch effect door het gebruik van een roodfilter en door de rijke zwarten in de vergroting.

A esta instantánea rural obtenida desde un ángulo bajo se le ha añadido cierto dramatismo por medio de la utilización de un filtro rojo y del énfasis proporcionado a las zonas de color negro.

Photographie très directe, prise en contre-plongée, d'un paysage champêtre, qui donne une impression saisissante par suite de l'utilisation d'un filtre rouge soutenu par les noirs riches du tirage.

72 (Lower)

Photographer Jan Anděl
Camera Pentax SP1000
Lens 200mm Pentacon
Film Orwo NP 20

This makes an interesting comparison with the picture above because, although the subject is similar, it has been taken with a long focus lens and tone simplified with a Lith film internegative.

Dieses Bild kontrastiert auf interessante weise mit der Aufnahme oben, denn obgleich das Motiv ähnlich ist, wurde hier von einem langbrennweitigen Objektiv Gebrauch gemacht und der Ton durch ein Lithofilm-Zwischennegativ vereinfacht.

Deze opname vormt aardig vergelijkingsmateriaal met de foto erboven omdat, hoewel het onderwerp gelijk is, deze werd gemaakt met een tele-objectief, terwijl de toonwaarden werden vereenvoudigd met behulp van een lith-tussennegatief. U kunt zelf kiezen waaraan u de voorkeur geeft.

Puede resultar interesante el comparar esta imagen con la de arriba porque, siendo ambas de tema parecido, han sufrido tratamientos diversos. Esta ha sido tomada con un objectivo de foco largo y una película lith internegativa, que ha simplificado la tonalidad. ¿Cuál de las dos prefiere?

Cette photographie permet une intéressante comparaison avec celle du haut parce que, bien que le sujet soit semblable, il a été pris au téléobjectif et les tons ont été simplifiés par l'emploi d'une pellicule lithographique internégative.

73

Photographer Witaly Butyrin

A picture which stimulates the imagination and is entitled "Memory". This title, plus the flowers and the hooded women would suggest an association in some way with death. It is most original in every way.

Ein Bild, das die Fantasie anregt. Es trägt den Titel "Erinnerung" und scheint, angesichts der Blumen und der Frauen mit den bedeckten Köpfen, auf eine gewisse Weise den Tod zu symbolisieren. Es ist in jeder Hinsicht sehr originell.

Een foto die tot de verbeelding spreeekt en getiteld is: 'Herinnering'. Deze titel, plus de bloemen en de vrouwen met de kappen, suggereren een of andere associatie met de dood. In elk geval is de foto wel origineel.

He aquí una imagen, titulada *Recuerdo*, que instantáneamente pone a la imaginación en funcionamiento. La combinación del título con las flores y la mujer con la cabeza cubierta presenta inevitables connotaciones mortuorias, pero el tratamiento del tema rezuma originalidad.

Photographie, intitulée "Memory" (Souvenir), qui stimule l'imagination. Ce titre, plus les fleurs et les femmes en coiffe, suggère d'une certaine manière une association avec la mort. Elle est originale à tous égards.

74

Photographer Michael Gnade
Camera 6 × 6 cm
Lens 150mm
Film 40 ASA

This well known West German photographer and writer has a gift for simplicity and a direct approach. This is one of many straightforward but striking portraits in his book *People in my Camera*. The use of a large aperture with a fairly long focus lens has isolated the head without destroying the interest of the background.

Dieser bekannte westdeutsche Fotograf und Verfasser hat ein Talent für Einfachheit und Unmittelbarkeit. Dies ist eines von vielen bemerkenswerten Porträts in dem von ihm veröffentlichten Werk. Durch Gebrauch einer grossen Blende und eines recht langweitigen Objektivs hat er den Kopf hervorgehoben, ohne gleichzeitig das Interesse des Hintergrundes zu zerstören.

Deze bekende Duitse fotograaf en auteur (*Het fotograferen van mensen* en *Fotograferen in zwartwit*) weet in zijn foto's eenvoud en directe benadering te combineren. In dit interessante portret zorgden een groot diafragma en de tamelijk lange brandpuntsafstand voor een goede isolatie van het hoofd zonder de achtergrond te verstoren.

Las producciones de este conocido fotógrafo alemán se caracterizan siempre por su sencillez. Este retrato forma parte de la colección titulada

Fotografía de gente. La combinación de un diafragma amplio con un objectivo de foco largo le ha permitido aislar la cabeza sin llegar a destruir el interés del fondo.

Ce célèbre photographe et écrivain ouest-allemand a le don de la simplicité. Nous avons ici un exemple extrait d'une série de portraits très directs mais frappants tirés de son livre "Les gens et mon appareil photo". Le recours à une grande ouverture de diaphragme et à un téléobjectif à focale relativement longue a permis d'isoler la tête sans supprimer l'intérêt de l'arrière-plan.

75

Photographer Valdis Brauns

A most evocative picture of an age old subject, but photographed in a very original way and with superb presentation. The contrast of expressions justified the obvious printing-in of the babies although it would still have been a good picture without them.

Ein ausserordentlich anregendes Bild eines uralten Motivs, doch mit sehr origineller Komposition und hervorragender Präsentation. Das offensichtliche Einkopieren der Kinder war angesichts der Kontraste in den Gesichtsausdrücken durchaus berechtigt, doch wäre dies auch ohne sie ein gutes Bild gewesen.

Een indringende foto van een eenwenoud onderwerp, weergegeven op een originele manier en voortreffelijk uitgevoerd. Het contrast ven de expressies rechtvaardigde het duidelijke inprinten van de babies, hoewel het ook zonder hen een goede foto zou zijn geweest.

He aquí una instantánea sumamente evocativa en la que un tema de siempre se presenta de forma harto original y brillante. La inclusión de los niños viene justificada por la necesidad de contrastar las expresiones, pero sin ellos la imagen continuaría siendo buena.

Photographie des plus évocatrices d'un sujet traditionnel, mais composée d'une manière très originale, et dans une présentation superbe. Le contraste des expressions justifie l'adjonction, évidente, des bébés, encore que la photographie aurait été bonne sans cela.

76

Photographer Martin Wolmark
Camera Pentax Spotmatic II
Lens 135mm Takumar
Film Tri-X

The title *Hitting the High Note* is almost unnecessary because the picture tells it all. The subject is Yvetta Moscovitz and one might almost think she is also registering dismay at the screams from the subject on the opposite page.

Der Titel 'Ganz hoch' ist beinahe überflüssig, da das Bild nichts ungesagt lässt. Dies ist Yvetta Moscovitz, und es sieht fast danach aus, als ob sie die Schreie der Dame auf der nächsten Seite missbilligte.

Het heeft nauwlijks zin deze foto een titel te geven, want hij spreekt voor zichzelf. U ziet hier is Yvetta Moscovitz en men zou denken dat ze ook haar ontzetting uit over het krijsen van de babies op de foto op de tegenoverliggende bladzijde.

El título *Llegando a la nota más alta* resulta ciertamente innecesario porque la imagen se basta por sí sola. En cierto modo parece también como si Yvetta Moscovitz mostrara su desazón al oír los gritos de la mujer que vemos en la página siguiente.

HOYA-Glass technology

Your camera's performance is judged by the quality and sharpness of its lens.

A lens is judged by the quality and image definition of its glass optics.

When it comes to glass optics HOYA are respected as the world's leading manufacturer. In fact HOYA probably had a hand in making the optics for your camera's standard lens.

So before you next buy a new lens for your camera take a close look at HOYA.

Remember HOYA only use Grade A optical glass, treated with their unique HMC Multi-coating process.

Remember HOYA's impressive 5 year guarantee, plus an inclusive carrying case.

Remember the opinions of a host of independent technical experts, who have tried, tested and recommended HOYA HMC Lenses.

All important reasons why you should match HOYA's advanced glass technology with the latest SLR cameras. A winning combination both designed to succeed in the 80's.

If you still need convincing, write to us for a copy of the new '80 Hoya lens brochure and copies of independent test reports.

Available from leading photographic stores.
Distributed in the U.K. by:-

INTROPHOTO

89 Park Street Slough SL1 1PX
Tel: Slough 37779

Universal Thread Mount.

WIDE ANGLE 24mm/F2.8, 28mm/F2.8, 35mm/F2.8. **TELEPHOTO** 135mm/F2.8, 200mm/F3.5, 300mm/F5.6, 400mm/F5.6 **NEW ZOOM** 70-150/F3.8, 80-200mm/F4. **ZOOM & MACRO** 25-42mm/F3.5, 35-105mm/F3.5. 70-210mm/F3.8, 75-260mm/F4.5, 100-300mm/F5.

for the camera of the '80 s

Le titre "Hitting the High Note" (Un haut de gamme) est presque inutile, parce que tout est dans la photographie. Le sujet est Yvetta Moscovitz, dont on pourrait presque penser qu'elle est épouvantée par les cris du sujet de la page opposée.

77

Photographer Stanley Matchett
Camera Nikon F2
Lens 50mm Nikkor
Exposure 1/60 at f/11
Film HP5

An amusing candid that has been well caught by the camera. Although the lady was probably in no danger she has acted the part well.

Eine amüsante unbeobachtete Aufnahme. Obgleich die Dame wahrscheinlich in keiner Gefahr war, spielte sie die Rolle gut.

Een leuke snapshot die goed door de camera is vastgelegd. Hoewel de dame waarschijnlijk in geen enkel opzicht gevaar liep speelde zij haar rol goed.

Divertida imagen captada con gran perfección. Aunque probablemente la mujer no corrió peligro alguno, representó su papel admirablemente.

Amusante photographie prise sur le vif, où le sujet a été bien saisi. Bien que la dame ne fût probablement pas en danger, elle a bien joué son rôle.

78

Photographer Rolf M. Aagaard
Camera Nikon F2
Lens 24mm Nikkor
Film Tri-X

A very good action picture of the famous violinist Isaac Stern which has captured a happy and characteristic expression. The star above his head formed by a spotlight is most appropriate!

Eine sehr gute Aktionsaufnahme des berühmten Geigers Isaac Stern, das einen glücklichen, für ihn charakteristischen Ausdruck erfasst hat. Der Stern über seinem Kopf, das Ergebnis eines Spotlichts, ist bestimmt sehr am Platze.

Een heel goede actiefoto van de beroemde violist Isaac Stern waarin een karakteristieke, blijde expressie werd vastgelegd. De ster boven zijn hoofd, gevormd door een spotlight, is bijzonder op zijn plaats.

El famoso violinista Isaac Stern captado en plena acción y mostrando una expresión feliz y significativa. La estrella formada sobre su cabeza por medio de un foco resulta totalmente apropiada.

Excellente photographie d'action du célèbre violoniste Isaac Stern, qui a saisi une expression heureuse et caractéristique. L'étoile située au-dessus de sa tête, due à la lumière d'un spot, est particulièrement appropriée!

79

Photographer Jens Hagen
Camera Canon F1
Lens 100mm
Film Tri-X

A well lit and well posed portrait has been given added character by transfer to lith film which has produced a rather unusual grain effect, not unlike reticulation.

Diesem gut beleuchteten und beobachteten Porträt wurde zusätzlicher Charakter durch Übertragung auf Lithofilm verliehen. Das Ergebnis ist ein recht ungewöhnlicher Korneffekt, der ein wenig an Runzelkorn erinnert.

Een uitstekend verlicht en goed geposeerd portret kreeg extra karakter door omkopiëring op lithfilm waardoor een nogal ongewoon korreleffect ontstond, min of meer gelijk aan reticulatie.

La calidad de este excelente retrato, muy bien iluminado, se ha visto subrayada por su transferencia a una película lith, que ha producido un insólito efecto de grano, bastante parecido a la reticulación.

Ce portrait, bien éclairé et bien posé, a été rehaussé par suite d'un transfert sur pellicule lithographique, ce qui a engendré un effet de grain assez inhabituel, qui n'est pas sans rappeler la réticulation.

80

Photographer Don McPhee
Camera Nikon F2
Lens Novoflex 280mm
Exposure 1/125 at f/5.6
Film HP5

A picture snatched by a *Guardian* photographer at a political party conference. Catching public figures, like William Whitelaw, in unguarded moments can sometimes be unkind, but this one is expressive and characteristic.

Dieses Bild wurde von einem Fotografen des *Guardian* auf einer politischen Parteikonferenz aufgenommen. Bilder prominenter Persönlichkeiten in entspannten Augenblicken können etwas herzlos wirken, doch diese Aufnahme von William Whitelaw ist ausdrucksvoll und bringt seine Persönlichkeit gut zum Ausdruck.

Deze opname werd gemaakt tijdens een vergadering van een politieke partij in Engeland. Het fotograferen van bekende figuren in onbewaakte momenten kan soms onvriendelijk zijn, maar ook, zoals in dit geval, expressief en karakteristiek.

Don McPhee, fotógrafo del *Guardian*, obtuvo esta instantánea en una conferencia política. Algunas personas creen que resulta poco delicado el captar a los hombres públicos en momentos de descuido, pero seguramente convendrían en que en este caso se ha obtenido una imagen de gran valor expresivo.

Photographie prise par un photographe du *Guardian* lors d'une conférence d'un parti politique. Saisir des personnalités en vue comme William Whitelaw, dans des moments où elles ne se surveillent pas, peut parfois être méchant, mais cette image est particulièrement expressive et caractéristique.

81

Photographer Jim Hart
Camera Canon FTb
Lens Tamron 70-210mm zoom
Exposure 1/250 at f/8
Film Ilford HP5

A moving portrait of Mrs Margaret Thatcher with her husband at the funeral of a murdered and much respected politician. The author chose the moment well and has achieved a good composition.

Ein ausdrucksvolles Porträt von Mrs Margaret Thatcher und ihrem Mann auf der Beerdigung eines sehr geachteten Politikers, der einem Morde zum Opfer fiel. Der Künstler wählte den Augenblick gut und hat eine wirksame Komposition erzielt.

Een aangrijpend portret van de Engelse premier Margaret Thatcher met haar echtgenoot tijdens de begrafenis van een vermoord, zeer geacht politicus. De fotograaf koos het moment goed en zorgde voor een goede compositie.

He aquí una conmovedora imagen en la que vemos a la señora Margaret Thatcher acompañada por su marido en los funerales por un político asesinado.

Emouvant portrait de Mme Margaret Thatcher accompagnée de son mari lors de l'enterrement d'un homme politique assassiné et unanimement respecté.

82

Photographer M. R. Owaisi
Camera Pentax 6 × 7
Lens 35mm Fish-eye
Film VP 120

An amusing picture entitled "Man" in which strength and masculinity are boldly emphasised by a low viewpoint and the use of a fish-eye lens. This has put the message across in an original way.

Ein amüsantes Bild mit dem Titel "Mann", in dem Kraft und Männlichkeit durch die Froschperspektive und den Gebrauch eines Fischaugenobjektivs kühn betont sind. Der Künstler, ein Pressefotograf in Pakistan, hat hier seine Absicht auf originelle Weise realisiert.

De auteur, die persfotograaf is in Pakistan, noemde deze foto simpelweg 'Man'. In deze opname wordt sterk de nadruk gelegd op de kracht en mannelijkheid door het lage standpunt en de toepassing van een fisheye-objectief.

Divertida instantánea titulada *Hombre* en la que se da énfasis a la fuerza masculina mediante la adopción de un punto de vista baja y el uso de un objectivo ojo de pez. De esta forma el mensaje nos llega de una forma harto original.

Amusante photographie, intitulée "Man" (L'homme), où la force et la masculinité sont hardiment soulignées par la prise de vue en contre-plongée et par l'utilisation d'un *fish-eye*. Cette technique a permis de transmettre le message de manière originale. L'auteur est photographe de presse au Pakistan.

83

Photographer Jenny Goodall
Camera Nikon F
Lens Vivitar 70-210 zoom
Exposure 1/250 at f/5.6
Film HP5

This picture shows a diver who has been looking for glass thrown into the river behind a "pub" in Berkshire. An amusing situation has been complemented by a good composition with plenty of movement.

Diese Aufnahme zeigt einen Taucher, der nach hinter einem Wirtshaus in Berkshire in den Fluss geworfenen Gläsern sucht. Die gute, lebensvolle Komposition betont den amüsanten Vorfall.

De opname toont een duiker die op zoek is geweest naar glazen die in de rivier zijn geworpen achter een 'pub' in Berkshire in Engeland. De op zich amusante situatie werd gecompleteerd door een goede compositie met voldoende actie.

En esta instantánea vemos a un hombre que se ha sumergido en un río de Berkshire para sacar unos vasos tirados en un zona cercana a un "pub".

Cette photographie montre un plongeur à la recherche de lunettes jetées dans la rivière derrière un "pub" du Berkshire. Cette amusante situation est rehaussée par une bonne composition et beaucoup de mouvement.

84

Photographer Steve Hale
Camera Nikon F2
Lens 85mm
Exposure 1/500 at f/2.8
Film Tri-X rated at 1600 ASA

The elation expressed by Terry McDermott after scoring against Hamburg has been well caught. The low viewpoint has exaggerated the height of his jump and the out-of-focus background sets the scene.

Ein guter Schnappschuss von Terry Mc-Dermott, nachdem dieser ein Tor gegen Hamburg erzielt hatte. Der niedrige Standpunkt betont die Höhe des Sprunges und der verschwommene Hintergrund bildet einen wirksamen Kontrast.

De vreugde na het scoren is in deze foto goed vastgelegd. Het lage standpunt overdreef de hoogte van de sprong en de onscherpe achtergrond bepaalt de omgeving.

He aquí perfectamente captado el júbilo de Terry McDermott tras marcar un gol contra el Hamburgo. La adopción de un punto de vista bajo ha exagerado la altura de su salto, a la que se ha dado todavía mayor énfasis desenfocando el fondo.

La joie qu'exprime Terry McDermott après avoir marqué un but contre Hambourg a été bien saisie. La prise de vue en contre-plongée a exagéré la hauteur de son saut, tandis que l'arrière-plan flou crée le décor.

85

Photographer M. Barananskas

Entitled *The 1st Step* this picture is full of interest. Apart from catching the apprehensive expression on the face of the principal subject, the children below are all registering different emotions. The picture would have been of passing interest without them, but their inclusion shows perception on the part of the author.

Dieses Bild, das den Titel "Der erste Schritt" trägt, ist voller Interesse. Es zeigt nicht nur den angespannten Gesichtsausdruck des turnenden Mädchens, sondern auch die verschiedenen Emotionen der sitzenden Kinder. Dies ist eine besonders gut beobachtete Szene, obgleich das Bild auch ohne die Kinder nicht uninteressant gewesen wäre.

Deze foto die de titel draagt 'De eerste stap' is vol aandacht. Afgezien van de uitdrukking op het gezicht van het hoofdmotief, weerspiegelen de kinderen onderaan in de foto alle verschillende emoties. Zonder hen zou de foto van weinig belang zijn geweest.

El interés de esta imagen titulada El primer paso se centra en la expresión de su sujeto principal, pero la captación de las emociones reveladas por los niños situados en segundo plano constituye un complemento harto interesante. Sin los niños la instantánea hubiera conservado una buena parte de su calidad, pero su inclusión pone de manifiesto la exquisita sensibilidad de su autor.

Intitulée "The 1st Step" (Le premier pas), cette photographie est pleine d'intérêt. Outre qu'elle saisit l'expression craintive que traduit le visage du sujet principal, les enfants que l'on voit au-dessous ressentent chacun une émotion différente. La photographie aurait été d'un intérêt médiocre sans eux, alors que leur présence traduit un sens aigu de la perception de la part de l'auteur.

86

Photographer	Denis Thorpe
Camera	Leica M2
Lens	35mm Summilux
Exposure	1/60 at f/2.8
Film	FP4

A portrait by available light has projected the honesty and simplicity of Mother Teresa of Calcutta who has done wonderful relief work and been unmoved by her world wide fame and acclaim. The pose is natural and the inclusion of another portrait of the lady gives an unusual touch.

Ein Porträt bei verfügbarem Licht bringt die Ehrlichkeit und Einfachheit der Mutter Therese von Kalkutta, die wunderbare Arbeit unter leidenden Menschen leistet und durch ihren grossen Ruhm in der ganzen Welt unberührt geblieben ist, voll zum Ausdruck. Die Haltung ist natürlich und die Einbeziehung eines weiteren Porträts verleiht dem Bild eine ungewöhnliche Note.

Een portret bij aanwezig licht waarin de eerlijkheid en eenvoud tot uiting komen van Moeder Teresa uit Calcutta, die haar leven wijdde aan de hulpverlening aan armen en die niet beïnvloed is door haar bekendheid over de hele wereld. De pose is natuurlijk; door het opnemen van nog een portret van dezelfde vrouw kreeg de foto een speciaal accent.

En esta retrato obtenido con luz natural se ha captado perfectamente la honestidad y sencillez de la Madre Teresa de Calcuta, que ha dedicado su vida a atender a los pobres sin ser afectada en absoluto por su popularidad mundial. La pose está totalmente desprovista de afectación y la inclusión de otro retrato de la misma persona ha añadido un "toque" muy poco usual.

Ce portrait pris à la lumière ambiante traduit toute l'honnêteté et la simplicité de Mère Teresa, de Calcutta, qui a soulagé tant de souffrances autour d'elle, et que la renommée et les honneurs dont elle est l'objet partout dans le monde n'ont pas ébranlée. La pose est naturelle et l'adjonction d'un autre portrait d'elle-même confère à cette photographie une touche insolite.

87

Photographer	Kwanjo Lee
Camera	Nikon F2
Film	Tri-X

A portrait of a Seoul monk in Korea who practises asceticism shows a bold approach produced by strong tone contrasts and side lighting. The division by the vertical line in the centre seems to express determination. It was a daring composition, but it has succeeded.

Dieses Porträt eines Mönchs in Korea, der sich in Asketik übt, ist kühn, mit starken Tonkontrasten und Seitenlicht. Die durch die senkrechte Linie in der Mitte bewirkte Teilung scheint Entschlossenheit auszudrücken. Dies war eine gewagte Komposition, die aber gut geglückt ist.

Dit portret van een Koreaanse monnik die een ascetische levenswijze praktizeert toont een rechtstreekse benadering door de sterke toonwaardencontrasten en de verlichting van opzij. De verdeling door de verticale lijn in het midden schijnt vastbeslotenheid uit te drukken. Een gedurfde compositie, maar wel geslaagd!

Este retrato de un monje coreano de vida extraordinariamente ascética ha sido obtenido con gran atrevimiento formal, acentuado por los fuertes contrastes tonales y la iluminación lateral. La división determinada por la línea vertical del centro parece expresar una fuerte determinación.

Ce portrait d'un moine Seoul de Corée pratiquant l'ascétisme traduit une approche hardie due à des tons fortement contrastés et à un éclairage latéral. La séparation résultant de la ligne verticale centrale semble exprimer la détermination. Composition hardie, mais réussie.

88

Photographer E. Chambré Hardman, FRPS

The shadow of an elegant aqueduct built by Thomas Telford, the famous 18th century engineer, has been used as the basis of an elegant design and a significant message. The impression of height has been enhanced by photographing the shadow rather than the structure itself.

Der Schatten eines eleganten von Thomas Telford, dem berühmten Ingenieur des 18.Jahrhunderts, gebauten Aquädukts dient hier als Grundlage einer eleganten Darstellung und einer bedeutenden Botschaft. Indem der Schatten, und nicht das Bauwerk selbst aufgenommen wurde, konnte der Eindruck der Höhe noch verstärkt werden.

De schaduw van een sierlijk aquaduct uit de achttiende eeuw diende als basis voor deze foto. De indruk van hoogte werd versterkt door de schaduw te fotograferen in plaats van het bouwwerk zelf.

En esta imagen la sombra proyectada por un artístico acueducto diseñado en el siglo XVIII por el famoso ingeniero Thomas Telford se ha utilizado como base para obtener una elegante composición no exenta de mensaje. Al haberse captado la sombra, en lugar de la estructura real, se ha exagerado la impresión de altura.

L'ombre d'un élégant aqueduc construit par Thomas Telford, le célèbre ingénieur du 18e siècle, a été utilisée comme élément de base d'une élégante composition et d'un message significatif. L'impression de hauteur a été renforcée par la photographie de l'ombre plutôt que de l'ouvrage lui-même.

89

Photographer Wolfgang Volz

A significant social message is provided by this picture which shows the rape of the countryside produced by open cast mining. The author has also endowed it with mood and atmosphere by side lighting, distant haze and an attractive sky, thus raising it from a record shot to an artistic interpretation.

Dieses Bild, das die Verheerung der Landschaft durch Tagebau darstellt, enthält eine wichtige soziale Lehre. Der Künstler hat durch Seitenlicht, Dunst in der Ferne und einen interessanten Himmel eine besondere Stimmung geschaffen, so dass diese Aufnahme nicht nur in historischer sondern auch in künstlerischer Hinsicht bemerkenswert ist.

Een belangrijke sociale boodschap wordt overgebracht door deze foto die de vernietiging weergeeft van het landschap door een open mijn. Door het zijlicht wist de fotograaf stemming en sfeer in te brengen, waartoe ook de luchtperspectief en de aantrekkelijke lucht bijdragen. Op deze wijze stijgt de foto boven een nuchtere registratie uit tot een artistieke interpretatie.

El objetivo primordial de esta instantánea, en la que vemos los efectos producidos en el paisaje rural por la apertura de una mina, es la formulación de un mensaje de denuncia social. Sin embargo, el autor ha sido capaz de proporcionar a este mensaje unas innegables dimensiones artísticas, a través de la utilización de la iluminación lateral y la introducción en la escena del cielo y la bruma.

Cette photographie transmet un message social significatif en illustrant le massacre de la campagne dû à l'exploitation d'une mine à ciel ouvert. L'auteur lui a également conféré une touche de mélancolie et d'atmosphère en recourant à un éclairage latéral, renforcé par une brume lointaine et un ciel séduisant, faisant ainsi d'une photographie de reportage une interprétation artistique.

90

Photographer	Rostislav Kõstál
Camera	Minolta SRT 101
Lens	28mm Rokkor
Film	Orwo NP 20

An emotive portrait because of the slightly apprehensive, but intense, expression of the lady with her beautiful eyes. The setting is dramatic because of its key and the placing of the subject produces a composition which breaks all the "rules" with great success.

Infolge des unruhigen und gleichzeitig intensiven Gesichtsausdrucks der Dame mit den schönen Augen ist dies ein sehr anregendes Bild. Der Hintergrund ist dank der Tönung dramatisch, und die Position der Person ergibt eine Komposition, die alle "Regeln" mit grossem Erfolg bricht.

Een roerend portret door de wat angstige, maar intense gelaatsuitdrukking van de vrouw met haar prachtige ogen. De plaatsing van het hoofdmotief draagt bij tot een compositie waarin alle 'regels' met succes worden doorbroken.

He aquí un retrato de fuerte contenido emotivo, determinado por la expresión concentrada y ligeramente aprensiva de la modelo. La tonalidad obtenida introduce cierto dramatismo en la composición, en la que, por otra parte, no se han respetado en absoluto las reglas consideradas normales. Cabe reconocer, sin embargo, que el resultado ha sido positivo.

Portrait émouvant en raison de l'expression intense mais légèrement craintive de cette femme aux beaux yeux. Le décor est saisissant en raison de sa luminosité, et l'emplacement choisi pour le sujet engendre une composition qui rompt brillamment avec toutes les "règles".

91

Photographer Harald Hirsch
Camera Praktica LTL
Lens 20mm Flektogon
Film Orwo NP 27

The photograph is appropriately titled *Funny Girl* with good reason. The distortion produced by getting close with a wide angle lens emphasises the mood and the shading which has produced a low key background makes it a compelling picture.

Diese Aufnahme trägt mit Recht den Titel "Funny Girl". Die Verkürzung, die durch Aufnahme aus der Nähe mit einem Breitwinkelobjektiv erzielt wurde, betont die Stimmung. Auch die Schattierung, die einen dunkel getönten Hintergrund ergeben hat, trägt zu der Qualität des Bildes bei.

De fotograaf had een goede reden om deze foto 'Funny Girl' te noemen. De vertekening die ontstond door met een groothoekobjectief dichtbij het motief te gaan benadrukt de stemming.

El título de esta fotografía, *Chica divertida*, resulta totalmente adecuado. La distorsión producida por la utilización de un objetivo gran angular a poca distancia de la modelo acentúa la atmósfera creada por el autor y las sombras introducidas por un fondo de baja tonalidad subrayan la fuerza de la imagen.

Cette photographie est judicieusement intitulée "Funny Girl" (Drôle de fille). La déformation engendrée par le rapprochement dû à la prise de vue au moyen d'un grand angle ajoute à l'état d'âme tandis que l'ombrage qui a engendré un arrière-plan sombre contribue à rendre cette image attachante.

92

Photographer Hans J. Anders

The author, from *Stern*, has managed in a single photograph to portray the plight of children in high rise blocks of flats. The impression of being trapped with nowhere to play has been emphasised by the wide angle distortion of the children squeezed between a railing and a balcony wall.

Der Künstler, ein Mitarbeiter der Zeitschrift *Stern*, hat es verstanden, in einem einzigen Bild das tragische Schicksal von in Hochhäusern lebenden Kindern zum Ausdruck zu bringen. Die durch das

Weitwinkelobjektiv bewirkte Verzerrung der Kinder, die zwischen einem Geländer und einer Balkonwand eingezwängt sind, unterstreicht, dass sie Gefangene sind und keinen Raum zum Spielen haben.

De auteur is erin geslaagd in een enkele foto de positie te karakteriseren van kinderen die in torenflats wonen. De indruk van gevangen te zijn, zonder een plaats om te spelen wordt versterkt door de groothoek-vertekening van de kinderen die hier ingeklemd zijn tussen een balustrade en een balkonafscheiding.

El autor. reportero de la revista *Stern*, ha conseguido reflejar claramente en la fotografía la triste situación de los niños que viven en grandes bloques de viviendas. La impresión de estar atrapado sin lugares para jugar se ve acentuada por la distorsión introducida al captar con un objectivo gran angular a los niños encerrados entre la baranda y la pared.

L'auteur, photographe du magazine *Stern*, a réussi à représenter sur une seule photographie la détresse des enfants vivant dans les grands ensembles. L'impression d'être pris au piège, sans aucun endroit pour jouer, a été renforcée par la déformation, due à l'utilisation d'un grand angle, de ces enfants bien à l'étroit entre une balustrade et un mur de balcon.

93

Photographer Jonathan C. Pitt
Camera Minolta SRT 101
Lens 50mm Rokkor
Exposure 1/250 at f/16
Film Tri-X

A dramatic and expressive picture by a young student of the Gloucestershire College of Art and Design. It is powerful and technically superb as well as a good design. Showing the hand against the sky invokes a mood of appeal but many viewers will read different messages in it.

Ein dramatisches und ausdrucksvolles Bild eines jungen Studenten des Gloucestershire College of Art and Design. Die Aufnahme ist kraftvoll und technisch hervorragend und die Komposition erstklassig. Die Hand mit dem Himmel als Hintergrund scheint etwas zu fordern, doch lässt sich die Aufnahme auf verschiedene Weisen interpretieren.

Een expressieve foto gemaakt door een jonge academiestudent. De opname is technisch perfect, maar vertoont ook een krachtige en goede compositie. Het weergeven van de hand tegen de lucht roept een smekende stemming op, maar veel kijkers zullen er totaal andere dingen in zien.

Aquí tenemos una expresiva instantánea tomada por un estudiante del Gloucestershire College of Art and Design. Técnicamente es casi perfecta. La situación de la mano contra el fondo de cielo constituye una especie de llamada, pero seguramente existen muchas otras interpretaciones válidas.

Saisissante et expressive photographie due à un jeune étudiant du Gloucestershire College of Art and Design. Elle est puissante et d'une technique parfaite, en même temps qu'elle constitue une excellente composition. Cette main qui se détache sur le ciel évoque un appel, mais chacun pourra ressentir le message à sa façon.

94

Photographer Martin Wolmark
Camera Pentax Spotmatic
Lens 55mm
Film Tri-X rated at 800 ASA

A portrait of Earl "Fatha" Hines at Ronnie Scott's Club in London. It has all the atmosphere of a night club and it is a good likeness. The technical disadvantage of spot-lighting which produces over-exposed areas is acceptable in circumstances like this.

Ein Porträt von Earl "Fatha" Hines aufgenommen im Ronnie Scott's Club in London. Es gibt die Persönlichkeit des Klavierspielers und die Nachtklub-Atmosphäre gut wieder. Der technische Nachteil der Beleuchtung mit dem Spotlicht, die überbelichtete Bereiche ergibt, ist bei Aufnahmen dieser Art annehmbar.

Dit portret van Earl 'Fatha' Hines bezit alle sfeer van een nachtclub en is bovendien goed gelijkend. Het technische nadeel van de spotverlichting, die overbelichte partijen veroorzaakt, is onder omstandigheden als deze acceptabel.

Vemos aquí a Earl "Fatha" Hines en el Ronnie Scott's Club de Londres. En la instantánea se ha recogido perfectamente la atmósfera típica de un club nocturno. En fotos de este tipo resultan aceptables las zonas sobreexpuestas producidas por la utilización de focos como fuentes luminosas.

Portrait de Earl "Fatha" Hines, prise au Ronnie Scott's Club de Londres. Il s'en dégage toute l'ambiance d'un night-club, et c'est un bon portrait. L'inconvénient technique de l'éclairage par spots, qui donne des zones surexposées, est acceptable dans des circonstances comme celles-ci.

95

Photographer František Dostál
Camera Minolta SRT 303
Lens 50mm Rokkor
Exposure 1/250 at f/5.6
Film Orwo NP20

An amusing picture of father taking his double bass to his daughter's wedding. Unusual combinations like this are often missed because the photographer has not noticed it or has not got a camera with him.

Ein amüsantes Bild eines Vaters, der seine grosse Bassgeige auf die Hochzeit seiner Tochter mitnimmt. Ungewöhnliche Kombinationen dieser Art werden oft übersehen, weil der Fotograf sie nicht bemerkt oder keine Kamera dabei hat.

Een amusante opname van een vader die zijn contrabas meeneemt naar het huwelijk van zijn dochter. Ongewone combinaties als deze worden vaak gemist doordat de fotograaf ze niet opmerkt of juist zijn camera niet bij zich heeft.

Divertida imagen en la que vemos a un contrabajista asistiendo a la boda de su hija. Las combinaciones de este tipo son captadas muy pocas veces, ya que o bien escapan a la atención del fotógrafo o éste no lleva en aquel momento la cámara consigo.

Amusante photographie d'un père emportant sa contrebasse au mariage de sa fille. Les compositions insolites comme celle-ci passent souvent inaperçues parce que le photographe ne les a pas saisies ou parce qu'il n'avait pas d'appareil avec lui.

96

Photographer Kwanjo Lee
Camera Nikon F2
Film Tri-X

Depicting young Seoul monks in their leisure hours. There is a powerful impression of strength and sporting contest in this picture which has captured the figures in a dramatic pose while the background sets the scene, as well as adding its own interest.

Seoul-Mönche in ihrer Freizeit. Dieses Bild bringt Kraft und sportlichen Wettkampf gut zum Ausdruck. Die beiden Männer sind in dramatischer Haltung erfasst, während der Hintergrund eine Art Bühnenbild bildet und selbst auch zu dem Interesse der·Aufnahme beiträgt.

PHILIPS

You shouldn't be in the dark in the darkroom.

Philips electronics are the complete answer to any darkroom problem.

Giving you precision control over filtration, analysis, exposure and timing.

Our all-electronic Tri-One colour enlarger system is fully remote-controlled.

With a unique colour light source, and no moving parts to jar or vibrate.

For spot-on colour balance on almost every print, there's the Philips PCA 061 colour analyser.

The PCD 011 exposure timer gives you accuracy to 1/10th of a second.

The PDT 024 gives similar accuracy combined with a built-in exposure meter.

With Philips electronics, you need never be in the dark in your darkroom again.

Simply ask your dealer about Philips electronics for your darkroom.

Philips darkroom equipment is only available from selected dealers.

For full details and the address of your nearest dealer, write to:
Philips Lighting,
FREEPOST, City House,
420-430 London Rd,
Croydon CR9 9ET.

Photomakers

Bring new precision
to your photo performance.

Van deze opname gaat een duidelijke indruk van kracht en krachtmeting uit. De houding van de hoofdpersonen is veelzeggend. De achtergrond geeft de lokatie aan en voegt nog eigen elementen toe.

En esta instantánea, en la que vemos a un grupo de monjes– momentos de asueto. Destaca sobre todo la impresión de fuerza física y energía deportiva conseguida a través de las dramáticas poses en que se hallan las figuras humanas. El fondo actúa como marco de la escena, a la que añade además una nueva nota de interés.

Image représentant des moines Seoul au cours de leurs moments de loisir. Il se dégage de cette photographie une puissante impression de force et de combativité sportive. Elle a saisi les personnages dans une pose saisissante, tandis que l'arrière-plan crée le décor en y ajoutant son intérêt propre.

97

Photographer F. Reavey, ARPS
Camera Bronica S2A
Lens 150mm
Film Vericolor

What a dynamic effect has been obtained in this beautiful print by the technique of revolving during enlargement! This would have been an excellent picture without it but the device employed has raised it to greatness.

Welch dynamische Wirkung wurde durch die Technik des Drehens während dem Vergrössern erzielt! Dies wäre unter allen Umständen ein ausgezeichnetes Bild gewesen, doch ist es in dieser Form ein echtes Meisterwerk. Aufgenommen auf einem Rodeo in Oxford.

Wat een dynamisch effect werd in deze prachtige vergroting verkregen door de techniek van roteren tijdens het vergroten! Zonder dat zou de foto ook uitstekend zijn geweest, maar de extra bewerking tilde hem uit boven het gemiddelde.

¡Qué efecto tan dinámico se ha obtenido en esta hermosa instantánea al hacerla girar durante el proceso de ampliación! Sin este efecto hubiéramos tenido ya una imagen de gran interés, pero con él alcanza dimensiones impresionantes.

Quel bel effet dynamique ce tirage a permis d'obtenir grâce à la technique de la rotation durant l'agrandissement! Cette photographie aurait été excellente sans cela, mais l'artifice utilisé en a fait une merveille. Prise lors d'un rodéo à Oxford.

98

Photographer R. Dexter

Made from a sandwich of two transparencies this print has a fantasy theme created by the association of time with telephones and the use of a star screen adds a lot of sparkle.

Dieser Kopie, die durch Überlagerung von zwei Diapositiven erzielt wurde, liegt ein auf der Assoziation von Zeit mit Fernsprechern beruhendes Fantasiemotiv zugrunde. Eine Gitterlinse hat sehr zu dem interessanten Effekt beigetragen.

Deze sandwich uit twee dia's heeft een fantasiethema, ontstaan uit de associatie van de tijd met telefoons. Het sterfilter werd met succes toegepast.

Obtenida mediante un "sandwich" de dos diapositivas, esta instantánea presenta un tema fantástico creado por la asociación del tiempo y los

teléfonos, mientras que el uso de una trama en forma de estrella le ha añadido una "chispa" especial.

Obtenu par la mise en sandwich de deux diapositives, ce tirage traduit une certaine fantaisie due à l'association du temps et du téléphone, et l'utilisation d'un écran étoilé le rend particulièrement étincelant.

99 (Upper)
Photographer Gary Radchik

A pure design picture made by cutting up portions of different prints and mounting them on glass so that the spaces between would be black. It was then copied by flash on a large format camera and printed on Ektacolor paper. It is an original way of showing a sequence.

Ein zusammengesetztes Bild, das durch Ausschneiden von Teilen verschiedener Kopien und deren Anordnung auf Glas erzeugt wurde, so dass die Zwischenräume schwarz erscheinen. Die Montage wurde bei Blitzlicht mit einer Grossformat-Kamera kopiert und dann auf Ektacolor-Papier übertragen. Dies ist eine originelle Methode der Darstellung einer Vorgangsfolge.

Deze fotomontage kwam tot stand door het in vierkante stukjes snijden van diverse vergrotingen en deze zodanig op glas te monteren dat de randen ertussen zwart zouden worden. Het geheel werd daarna met flitslicht opgenomen met een grootformaat-camera en afgedrukt op Kodak Ektacolor-papier. Dit is een originele wijze om een fotoserie te presenteren.

He aquí una imagen puramente compositiva obtenida mediante el montaje sobre vidrio de partes de varias fotografías. Se la reprodujo utilizando flash y una cámara de gran formato para pasar luego a copiarla en papel Ektacolor. ¿No es ésta una forma original de mostrar una secuencia?

Photographie de pure invention, obtenue en coupant des portions de différents tirages et en les montant sur du verre de telle façon que les espaces de séparation soient noirs. Elle a été copiée au flash sur un appareil de grand format et tirée sur papier Ektacolor. C'est là un moyen original de présenter une séquence.

99 (Lower)
Photographer Al Bridel

This picture, entitled "Alpine Fantasy" is typical of a modern trend towards abstract effects by the use of ribbed or mottled glass. Such treatment means that the result depends largely on design for its success or otherwise and this example fulfils that requirement.

Dieses Bild, "Alpenfantasie", ist für die moderne Tendenz zur Erzielung abstrakter Effekte durch Gebrauch von gerieptem oder gesprenkeltem Glas typisch. Bei dieser Bahandlung hängt das Ergebnis weitgehend von der Gestaltung ab. Diese Aufnahme ist ausserordentlich gut geglückt.

Opnieuw een foto waarbij gebruik werd gemaakt van geribbeld glas. Bij zulke uitwerkingen is het succes vooral afhankelijk van het ontstane patroon, dat hier bijzonder attractief is.

En esta imagen, titulada *Fantasía alpina*, se refleja la tendencia exhibida actualmente por los fotógrafos hacia la obtención de efectos abstractos mediante la utilización de cristales estriados o jaspeados. Con este tipo de tratamiento el diseño adquiere una importancia capital.

Cette photographie intitulée "Alpine Fantasy" (Fantaisie alpine) est typique d'une tendance moderne aux effets abstraits par l'utilisation de verre strié ou tacheté. Ce traitement signifie que le résultat – succès ou échec – dépend dans une large mesure de la conception d'ensemble et nous en avons là un remarquable exemple.

100 (Upper)
Photographer Leo Mason
Camera Nikon FE
Lens 50mm
Film Kodachrome 64

A dramatic action shot of Larry Stanley leaping the big surf off a Hawaii beach. The low angle has given a tremendous emphasis to the movement and the thrill of the moment is enhanced by strong colour contrasts. Reproduced from a 15 × 12 print.

Eine dramatische Aktionsaufnahme von Larry Stanley, der auf einem Strande in Hawaii die grosse Brandung überwindet. Die Froschperspektive verleiht dem Bild ungewöhnliche Lebhaftigkeit, und der Reiz des Moments wird durch starke Farbkontraste noch erhöht. Aufgenommen mit einem Motorantrieb in einem Unterwassergehäuse, während sich Leo Mason selbst in der See befand. Reproduktion einer 38 × 30 cm Kopie, die mit dem Sports Photographer of the Year Award ausgezeichnet wurde.

Een spectaculaire windsurf-foto, die vooral door het lage standpunt boeit. De foto werd gemaakt met motor drive in een onderwaterhuis, waarbij de fotograaf zich in de zee bevond. De foto, die bij Hawaii werd gemaakt, won een prijs als 'sportfoto van het jaar'.

He aquí una dramática imagen en la que vemos a Larry Stanley practicando el surf en una playa de Hawai. El ángulo bajo ha acentuado la energía del movimiento y la emoción del momento recogido está subrayada por los fuertes contrastes cromáticos. Imagen reproducida de una copia de 15 × 12 pulgadas.

Photographie saisissante d'action de Larry Stanley pratiquant la planche à voile au large d'une plage de Hawaii. La prise de vue en contre-plongée a donné un relief considérable au mouvement, et l'excitation du moment est renforcée par de puissants contrastes entre les couleurs. Elle a été prise avec un appareil à moteur monté dans un boîtier pour plongée sous-marine, et l'auteur était réellement dans la mer. Reproduite à partir d'un tirage de 15 × 12 pouces qui a remporté le Sports Photographer of the Year Award (Récompense décernée à la meilleure photographie d'un thème sportif de l'année).

100 (Lower)
Photographer G. I. Ratcliffe

The use of multi-colour attachments is rather overdone since the advent of Cokin and Hoya but the author has used one to very good effect on a suitable subject and given a dramatic aspect to a familiar scene. The boy gives it life and shooting against the sun gives it sparkle.

Der Gebrauch von Mehrfarben-Zusätzen wird seit der Einführung von Cokin und Hoya sehr übertrieben, doch dieser Fotograf hat davon sehr guten Gebrauch gemacht, um einer vertrauten Szene eine dramatische Wirkung zu verleihen. Der Junge belebt die Szene, und durch Aufnahme gegen die Sonne wurde ein besonders ansprechender Effekt erzielt. Aufgenommen in Nordwales.

In deze foto werd een goed gebruik gemaakt van de mogelijkheden van een tweekleurenfilter om aan een tamelijk gewoon onderwerp een speciaal tintje te geven. Het tegenlicht zorgde voor het sprankelende effect.

El advenimiento de los dispositivos Cokin y Hoya ha contribuido al uso algo excesivo de los accesorios multicolores, pero este fotógrafo se ha servido apropiadamente de uno de ellos para proporcionar cierta profundidad dramática a una escena que nos resulta familiar. El muchacho le proporciona vida a la misma, mientras que la toma a contraluz introduce una alegre "chispa".

L'utilisation d'accessoires multicolores est plutôt exagérée depuis l'apparition de Cokin et Hoya, mais l'auteur y a eu recours ici pour obtenir un très bon effet sur un sujet approprié, et a ainsi donné un aspect saisissant à une scène familière. Le garçon l'anime, et la prise de vue contre le soleil contribue à son éclat. Photographie prise dans le nord du Pays de Galles.

101

Photographer Giusseppe Balla
Camera Canon FTB
Lens 100mm
Exposure 1/250 at f/5.6
Film Kodachrome 25

This photograph of an acrobatic skier must be rated one of the finest shots ever to come out of this sport. The author's timing was superb and his impeccable technique has enabled him to record a lot of detail of the subject, even though shooting against the light.

Diese Aufnahme eines akrobatischen Skiläufers ist gewiss eine der besten, die je im Zusammenhang mit dem Skisport erzielt wurden. Das Zeitgefühl des Künstlers war hervorragend, und dank seiner einwandfreien Technik konnte er viele Einzelheiten erfassen, trotzdem er gegen das Licht fotografierte.

De timing van de fotograaf was subliem toen hij deze schitterende foto van de acrobatische skiër maakte. Een superieure techniek zorgde ondanks het tegenlicht voor voldoende detaillering.

Esta instantánea, en la que se recoge una acrobacia realizada por un esquiador, es una de las mejores que he visto sobre este tema. La sincronización fue perfecta y el gran dominio técnico evidenciado por el autor le ha permitido captar al sujeto con gran lujo de detalles a pesar de haber disparado la cámara a contraluz.

Cette photographie d'un skieur acrobate est l'une des meilleures qu'il ait jamais été donné d'obtenir dans le contexte de ce sport. Le minutage de l'auteur était parfait, et sa technique impeccable lui a permis d'enregistrer de nombreux détails du sujet tout en photographiant à contre-jour.

102

Photographer Peter Gant, ARPS
Camera Olympus OM-1
Film Kodachrome 64

Humour in photography was once frowned upon but in recent years it has been accepted as another form of expression. Those in the 1980 Year Book were praised by many critics because, like this example which is entitled "Impending Doom", they depended on the photographer's "seeing eye" and not on contrived situations or mis-spelt signs.

Einst pflegte man Humor in der Fotografie abzulehnen, doch in den letzten Jahren wurde er als eine weitere Ausdrucksform akzeptiert. Die humoristischen Aufnahmen in dem Jahrbuch 1980 wurden von vielen Kritikern sehr gelobt, da sie wie dieses Bild, das den Titel "Drohendes Schicksal" trägt, auf der Intention des Fotografen beruhen, und nicht das Ergebnis künstlicher Situationen oder Rechtschreibfehlern auf Schildern sind.

Humoristische foto's zoals deze zijn voornamelijk afhankelijk van de visie van de fotograaf en van zijn oog voor bijzondere situaties.

Antiguamente no se consideraba adecuado introducir el humor en las fotografías, pero en los últimos años se lo ha ido aceptando paulatinamente como una nueva dimensión expositiva. Varias imágenes de características parecidas a las de ésta incluidas en el Anuario de 1980 recibieron críticas muy favorables en las que se

destacaba el que su eficacia dependiera estrictamente del "ojo clínico" del autor y no de situaciones creadas de modo artificial. El título de esta instantánea es El hado que nos amenaza.

L'humour en photographie était naguère accueilli avec une grand réserve, mais ces dernières années il a été accepté comme une autre forme d'expression. Les photographies de ce genre reproduites dans l'édition 1980 du Photography Year Book ont été louées par de nombreux critiques parce que, comme cet exemple, intitulé "Impending Doom" (L'épée de Damoclès), elles dépendaient de la capacité de voir du photographe et non pas de situations montées de toutes pièces ou d'enseignes à l'orthographe douteuse.

103

Photographer Robert Hallmann
Camera Kowa 66
Lens 85mm
Film Agfa 50S

There is plenty of room for humour in photography and recent exhibitions have attracted a large and appreciative public. To be successful they require an eye for a situation, something which this author obviously has in full measure.

In der Fotografie gibt es viel Raum für Humor, und in letzter Zeit abgehaltene Ausstellungen haben grossen Anklang und viel Anerkennung gefunden. Um mit so einer Aufnahme erfolgreich zu sein, benötigt der Fotograf einen Blick für das Komische, was bei diesem Künstler offensichtlich voll und ganz zutrifft. Diese Tiere sieht man normalerweise nicht gemeinsam.

Deze ongewone combinatie van motieven werd door de fotograaf betrapt in een dierentuin in Colchester. Hij maakte er een goed gebruik van, zowel technisch als creatief.

El humor se puede introducir en la fotografía de múltiples maneras; lo único necesario es que el fotógrafo sea capaz de captar las posibilidades de las situaciones que se le ofrecen. Aquí, por ejemplo, el fotógrafo ha sacado partido de la rareza con que sujetos de este tipo aparecen juntos, presentándolos con gran perfección técnica y composicional.

La photographie ouvre un vaste champ à l'humour, et de récentes expositions ont attiré un public aussi large qu'intéressé. Pour être réussies, les photographies de ce genre exigent de savoir saisir une situation, et c'est là un don que, de toute évidence, l'auteur de cette image possède au plus haut degré.

104 (Upper)

Photographer Josep Maria Ribas I. Prous, ARPS
Camera Nikon F-2
Lens 28mm
Exposure 1/500 at f/11
Film Kodachrome

A superb example of the use of petroleum jelly on a polarising filter to give a soft surround which concentrates the interest on the central subject. It was also zoomed during copying.

Ein hervorragendes Beispiel dafür, wie man durch Bestreichen eines Polarisierfilters mit Vaseline weiche Konturen erzielen kann, die das Interesse auf den eigentlichen Aufnahmegegenstand konzentrieren. Beim Kopieren wurde auch von einer Gummilinse Gebrauch gemacht.

Een goed voorbeeld van het gebruik van vaseline op een polafilter om een vervloeiende omgeving te krijgen rondom het scherpe kernbeeld, teneinde de aandacht daarop te concentreren. Bij het dupliceren werd 'gezoomd'.

He aquí un excelente ejemplo de cómo se puede embadurnar con vaselina un filtro polarizador para obtener un contorno suave que lleve la atención del espectador al centro de la imagen. Por otra parte, el copiado se efectuó con un objetivo zoom.

Magnifique exemple d'utilisation de la vaseline sur un filtre polarisant pour donner un environnement flou, qui concentre l'intérêt sur le sujet central. Elle a, en outre, été prise au zoom durant le tirage.

104 (Lower)

Photographer Josep Maria Ribas I. Prous, ARPS
Camera Nikon F-2
Lens 20mm
Exposure 1/8th at f/3.5
Film Kodachrome

Another artistic interpretation by this very versatile Spanish photographer. It was photographed in a disused bodega cellar by ambient light only.

Eine weitere künstlerische Leistung dieses sehr vielseitigen spanischen Fotografen. Sie wurde nur bei natürlichem Licht in einem alten Bodega-Keller aufgenommen.

Deze veelzijdige Spaanse fotograaf fotografeerde zijn 'Naakt in de bodega' uitsluitend bij het bestaande licht in een buiten gebruik zijnde kelder van een bodega. Het resultaat is bijzonder aantrekkelijk.

Otra interpretación de gran fuerza artística llevada a cabo por este versátil fotógrafo español. La imagen fue tomada en una bodega en desuso únicamente con luz ambiental.

Autre interprétation artistique de ce photographe espagnol aux talents multiples. Cette photographie a été prise à la seule lumière ambiante dans une bodega (cave) désaffectée.

105

Photographer Josep Maria Ribas I. Prous, ARPS
Camera Nikon F-2
Lens 105mm
Exposure 1/125 at f/11
Film Orwo

The inventiveness of this photographer seems endless and every transparency he submitted was both original and artistic. This was a planned picture made from a sandwich of two transparencies taken with the same lens.

Die schöpferische Fantasie dieses Künstlers scheint unerschöpflich zu sein, denn jedes von ihm eingereichte Diapositiv war originell und künstlerisch. Dieses geplante Bild ist das Ergebnis der Überlagerung von zwei mit dem gleichen Objektiv aufgenommenen Diapositiven. Der Titel lautet "Como Madera".

De vindingrijkheid van deze fotograaf schijnt onuitputtelijk en elk dia dat hij inzond was zowel origineel als artistiek. Zo ook deze opzettelijke sandwich van tee met hetzelfde objectief gemaakte dia's.

La capacidad de invención de este fotógrafo parece inacabable, puesto que todas las diapositivas que nos ha enviado resultan extraordinariamente originales y artísticas. Esta instantánea la obtuvo mediante un "sandwich" de dos diapositivas tomadas con el mismo objetivo.

L'esprit inventif de ce photographe semble infini, et toutes les diapositives qu'il a envoyées étaient à la fois originales et artistiques. Cette photographie est le résultat de la mise en sandwich de deux diapositives prises avec le même objectif. Le titre est "Como Madera" (Comme du bois).

106/107

Photographer Albert Bernhard

A magnificent impression of speed is projected in this beautiful colour print. Photography of ski-jumping is not so easy as it looks and the author has avoided the temptation to freeze the action, thus producing an artistic result enhanced by the attractive background.

Diese schöne Farbkopie gibt ein wundervolles Gefühl der Schnelligkeit. Einen Skisprung zu fotografieren ist nicht annähernd so leicht, wie es aussieht, und der Fotograf hat der Versuchung widerstanden, die Aktion "festzufrieren". Das Ergebnis ist künstlerisch, wozu auch der ansprechende Hintergrund beiträgt.

Een magnifieke impressie van snelheid is in deze foto terug te vinden. Het fotograferen van skispringen is niet zo eenvoudig als het lijkt en de auteur heeft de verleiding weerstaan de actie te 'bevriezen'. Hierdoor kreeg hij een artistiek resultaat, dat wordt versterkt door de aantrekkelijke achtergrond.

Esta fabulosa instantánea en color proyecta una magnífica impresión de velocidad. Captar el salto de un esquiador resulta bastante difícil; y en este caso el fotógrafo ha resistido la tentación de "congelar" la acción, obteniendo un resultado muy artístico subrayado por la belleza del fondo.

Une magnifique impression de vitesse se dégage de cette très belle photographie en couleur. La photographie du saut à skis n'est pas aussi facile qu'elle peut le paraître, et l'auteur a su résister à la tentation de "geler" l'action, donnant ainsi une image très artistique, rehaussée par un séduisant arrière-plan.

108

Photographer Egill Oscar Gustafson

This picture entitled "Is this Art?" tells a story whether perceived or posed. The dramatic contrast between the geometrical black and white shapes of the mural and the human interest evoked by the little girl is emotive. I only wish she had been a few inches to the right to keep her clear of the design. In spite of this – an amusing and original print on Ektacolour paper.

Dieses Bild mit dem Titel "Ist das Kunst?" enthält eine Botschaft, wobei es keine Rolle spielt, ob die Szene zufällig beobachtet oder künstlich erzielt wurde. Der dramatische Kontrast zwischen den geometrischen schwarzen und weissen Formen des Wandgemäldes und dem kleinen Mädchen ist anregend. Schade dass sie nicht ein paar Zentimeter weiter rechts gestanden ist, in welchem Falle sie keinen Teil des Gemäldes verdeckt hätte. Trotzdem ist dies eine amüsante, originelle Kopie auf Ektacolor-Papier.

Een foto die een verhaal vertelt, of het nu een candid shot of een geposeerde opname is. Het contrast tussen de geometrische zwartwit-vormen van de muurschildering en het menselijk element in de vorm van het kleine meisje is roerend. Voor mij had ze iets meer rechts mogen staan zodat ze los zou zijn geweest van de schildering.

Esta instantánea, titulada ¿Es esto arte?, nos cuenta una interesante historia. El contraste entre las formas geométricas negras y blancas del mural y el interés humano despertado por la niña posee gran fuerza emotiva. Ojalá la niña hubiera sido situada

un poco más a la derecha para que no tapara el diseño. Se trata, de todas formas, de una imagen de gran originalidad copiada sobre papel Ektacolor.

Qu'elle ait été effectivement perçue ou délibérément posée, cette photographie intitulée "Is this Art?" (L'art, est-ce cela?) raconte une histoire. Le saisissant contraste entre les formes géométriques en noir et blanc du panneau mural et l'intérêt humain de la petite fille sont émouvants. Je souhaiterais seulement qu'elle soit décalée de quelques centimètres vers la droite pour ne pas masquer la composition. Mais en dépit de ce détail, c'est là une photographie amusante et originale, sur papier Ektacolor.

109

Photographer Trevor Fry, FRPS
Camera Leica M2
Lens 28mm
Film Ektachrome 160 Tungsten

Reproduced from a Cibachrome print made from a transparency photographed by tungsten halogen lighting. The significance of the graffiti will not be lost on the viewer.

Diese Reproduktion beruht auf einer Cibachrome-Kopie eines bei Wolframhalogen-Beleuchtung aufgenommenen Diapositivs. Die Botschaft auf der Wand fügt sich gut in das Gesamtbild ein, und die Froschperspektive hat die Gesamtwirkung erhöht.

Reproduktie van een Cibachrome-vergroting van een dia dat werd opgenomen met halogeenverlichting. Het lage standpunt leidde tot een goede compositie.

Esta imagen se ha reproducido de una copia Cibachrome obtenida a partir de una diapositiva impresionada con luz de tungsteno. La introducción de los "graffiti" posee en este caso especial importancia.

Reproduction d'un tirage sur Cibachrome obtenu à partir d'une diapositive prise sous un éclairage halogène au tungstène. Le spectateur ne manquera pas d'apprécier l'importance des graffiti sur cette photographie, à laquelle la prise de vue en contre-plongée a contribué à donner de l'impact.

110

Photographer G. Leighton
Camera Nikkormat FT3
Lens 50mm f/2
Film Ektachrome 200

This candid picture of Angus Young of the AC/DC group is full of mood and atmosphere. It is a good example of a successful shot taken under difficult conditions by uprating the film speed, in this case to 400 ASA. The author has judged his moment well to catch the guitarist's dedication and to make a good composition.

Diese unbemerkte Aufnahme von Angus Young, einem Mitglied der AC/DC-Gruppe, ist sehr stimmungsvoll. Dies ist ein gutes Beispiel dafür, wie sich durch Erhöhen der Filmempfindlichkeit, in diesem Falle auf 400 ASA, selbst unter schwierigen Bedingungen ein erfolgreiches Bild erzielen lässt. Der Fotograf hat den Augenblick der Aufnahme gut gewählt und die Konzentration des Gitarrespielers wirksam erfasst. Auch die Komposition ist sehr gut.

Deze foto van Angus Young van de groep AC/DC is vol stemming en atmosfeer. Het is een goed voorbeeld van een succesvolle opname, gemaakt onder moeilijke lichtomstandigheden door de film op hogere gevoeligheid te belichten. Het moment is goed gekozen en de compositie is uitstekend.

Esta imagen de Angus Young, miembro del conjunto AC/DC, posee una atmósfera totalmente apropiada. Para superar las malas condiciones de iluminación existentes el fotógrafo se vio obligado a forzar la película a 400 ASA. La composición es perfecta y revela claramente la dedicación con que el guitarrista se consagra a su labor artística.

Cette photographie, prise sur le vif, d'Angus Young du groupe pop AC/DC est tout empreinte de mélancolie et d'atmosphère. C'est un bon exemple de photographie réussie prise dans des conditions difficiles en augmentant la sensibilité de la pellicule, pour la porter, dans ce cas, à 400 ASA. L'auteur a bien choisi son moment pour saisir l'expression de recueillement du guitariste et réaliser une bonne composition.

111

Photographer Michael Barrington-Martin
Film Agfachrome Professional

This well known glamour photographer is a keen yachtsman who obviously has an eye for a good picture at sea. The contre jour lighting and artistic composition would have made a straight shot of this subject most attractive, but the grain treatment and colour changes have made it exciting as well.

Dieser bekannte Modefotograf ist ein eifriger Jachtsportler, der offensichtlich ein Auge für ein gutes Bild auf dem Wasser hat. Das Gegenlicht und die künstlerische Komposition hätten genügt, um eine sehr ansprechende Wirkung zu erzielen, doch dank der Körnigkeit und Farbänderung ist das Bild auch dramatisch.

Deze bekende glamourfotograaf is een actief zeiler die kennelijk een goed oog heeft voor een goede foto op het water. De verlichting met tegenlicht en de artistieke compositie zouden een gewone opname van dit onderwerp al heel aanvaardbaar maken, maar de korrelbehandeling en de kleurveranderingen maakten er een opwindend en interessant geheel van.

Este conocido fotógrafo de modas es un entusiasta practicante de los deportes marinos, por lo que no es de extrañar que sepa captar al mar en momentos particularmente expresivos. Los efectos obtenidos a través de la iluminación a contraluz y la composición (de gran mérito artístico) se ven subrayados por el tratamiento del grano y los cambios de color.

Ce photographe de mode bien connu est un fervent adepte de la voile qui, de toute évidence, sait voir les choses de la mer. L'éclairage en contre-jour et la composition artistique auraient à eux seuls rendu ce sujet des plus séduisant, mais le grain et les variations de couleur lui confèrent une touche particulière.

112

Photographer Dave Wheeler, ARPS
Camera Pentax SPII
Lens Takumar 135mm
Film Kodachrome 25

A very dramatic landscape which shows a good eye for design. The early morning lighting has highlighted the plant in the foreground and produced a striking contrast with the sweeping lines and majesty of the background. The transparency shows a remarkable impression of depth. It was taken on the Great Sand Dunes in the National Monument, Colorado.

Eine sehr dramatische Landschaftsaufnahme, die sich durch gute Komposition auszeichnet. Die Pflanze im Vordergrund wurde durch das Licht des frühen Morgens hervorgehoben und kontrastiert auf bemerkenswerte Weise mit den majestätischen Kurven des Hintergrunds. Das Diapositiv vermittelt ein starkes Gefühl der Tiepe. Aufgenommen auf den Great Sand Dunes im National Monument, Colorado.

Een wonderlijk landschap waaruit een goede kijk op vormgeving blijkt. Het vroege morgenlicht verlichtte de plant in de voorgrond en zorgde voor een pittig contrast met de vage lijnen en de kracht van de achtergrond. Het dia toont een

merkwaardige impressie van de diepte. De opname werd gemaakt in de Great Sand Dunes in het National Monument in Colorado.

Esta instantánea, en la que el paisaje se refleja con gran fuerza dramática, revela un perfecto dominio del diseño por parte de su autor. La suave luz de las primeras horas del día provoca un fuerte contraste entre la brillantez de la planta del primer plano y la majestuosidad de las líneas del fondo, que nos hace pensar en profundidad. La imagen se obtuvo en las grandes dunas del National Monument de Colorado.

Paysage particulièrement saisissant, qui traduit un sens aigu de la composition. L'éclairage du matin de ce lever du jour a mis en relief la plante du premier plan et engendré un contraste frappant avec les lignes ondulantes et la majesté de l'arrière-plan. La diapositive donne une remarquable impression de profondeur Elle a été prise sur les Great Sand Dunes du National Monument, dans le Colorado.

113

Photographer Margaret Salisbury, FRPS
Camera Pentax SP500
Lens 20mm
Film FP 4

A beautifully perceived picture of a railway house beside the line. It has been given drama by isolation against a low key background which was probably darkened considerably in printing to give the effect usually seen just before a storm.

Ein schön erfasstes Bild eines Eisenbahnhauses an der Strecke. Durch Isolierung des Hauses von den dunkel getönten Hintergrund wurde eine dramatische Wirkung erzielt. Der dunkle Effekt wurde wohl beim Kopieren erheblich verstärkt und ergibt eine Stimmung, wie sie in der Regel unmittelbar vor einem Gewitter besteht.

Deze opname van een langs een spoorweg staand huis kreeg een dramatiserende uitwerking door bij het vergroten de achtergrond een lowkey effect te geven waartegen het huis licht afsteekt. Een dergelijke situatie kan men vaak waarnemen vlak voor een storm.

He aquí una hermosa instantánea de una casa situada junto a la vía del tren. Su fuerza dramática deriva de su aislamiento contra el fondo de tonos bajos, al que probablemente se oscureció en el copiado para obtener la atmósfera anunciadora de una tormenta próxima.

Magnifique image, bien perçue, d'une maison de garde-barrière derrière la ligne de chemin de fer. Son aspect saisissant est dû à son isolement sur un arrière-plan sombre, qui a probablement été assombri encore lors du tirage pour donner un effet que l'on voit généralement juste avant un orage.

114

Photographer Philip Bernard
Camera Rolleiflex 6 × 6
Lens 75mm Planar
Exposure ½ sec at f/11
Film Panatomic

Old men on benches are common enough but this has a touch of originality because they rarely read the "top people's" paper. The bandaged face is reminiscent of the invisible man films and poses an intriguing question. The ghost image in the background gives balance to the composition.

Alte Männer auf Bänken bilden ein häufiges Motiv, doch diese Aufnahme ist insofern originell, als sie selten die Zeitung der "prominenten Leute" lesen. Das mit Bandagen umwickelte Gesicht, das an die Filme über den unsichtbaren Mann erinnert, wirkt mysteriös. Das Nebenbild im Hintergrund verleiht der Komposition ein gewisses Gleichgewicht.

Foto's van een oude man op een bank ziet men vaak genoeg, maar deze steekt daartegen af door de 'elite' krant die de man leest. Het in verband gewikkelde gezicht doet denken aan de 'onzichtbare man' uit een vroegers televisieserie en roept intrigerende vragen op. De spookachtige figuur in de achtergrond zorgt voor evenwicht in de compositie.

Es muy frecuente que los fotógrafos tomen como tema a personas mayores sentadas en un banco, pero no lo es tanto que éstas lean el periódico de la gente bien. La cara vendada despierta en nuestra memoria el recuerdo de las películas de hombres invisibles y, en cierta forma, formula una pregunta intrigante. La imagen "fantasma" del fondo equilibra la composición.

Les vieillards assis sur un banc sont un thème assez courant, mais cette photographie tire son originalité du fait qu'ils lisent rarement le journal des "gens de la haute". Le visage bandé rappelle les films de l'homme invisible, et pose une question embarrassante. L'image du fantôme à l'arrière-plan donne de l'équilibre à la composition.

115

Photographer V. Koreškov

This picture is entitled *Conductor and his Chorus* although the dress and the ambience does not associate them with music making. Nevertheless, it is an interesting study because of the great human interest and the very unusual grouping. The symmetry of the composition has been successfully broken by the man's right arm.

Dieses Bild trägt den Titel 'Dirigent mit Chor', obgleich die Kleidung und die allgemeine Stimmung nichts mit Musik zu tun haben. Trotzdem ist dies eine interessante Studie, da das menschliche Interesse stark und die Gruppierung recht ungewöhnlich ist. Die Symmetrie der Komposition wurde mit Erfolg durch den rechten Arm des Mannes gestört.

Deze foto draagt als titel "Dirigent met koor", hoewel de kleding en de ambience niet onmiddellijk met het maken van muziek in verband zullen worden gebracht. Toch is het een interessante studie, onder andere door de ongewone opstelling. De symmetrie in de compositie is vernuftig onderbroken door de rechterarm van de man.

El título de esta imagen es *Director con su coro*, pese a que, por su forma de vestir y la situación en que se hallan, uno difícilmente asociaría a estas personas con el ámbito musical. Se trata, sin embargo, de un interesante estudio, por su interés humano y la insólita agrupación de las figuras. La rotura de la simetría de la instantánea por parte del brazo derecho del hombre resulta muy efectiva.

Cette photographie est intitulée "Conductor and his Chorus" (Chef d'orchestre et son choeur) bien que les vêtements et l'ambiance n'évoquent pas la musique. Néanmoins, c'est une étude remarquable en raison du grand intérêt humain et du groupement très insolite. La symétrie de la composition a été judicieusement rompue par le bras droit de l'homme.

116

Photographer Mervyn Rees
Camera Nikon F2
Lens 50mm Nikkor
Exposure 1/200 at f/2
Film FP4

The use of multi-facet lens attachments has often been overdone but here it has given a touch of fantasy – in fact the picture is entitled *Flight of Fancy*, and it shows Alan Williams, the pole vaulter, in the Southern Counties AAA Championships. The impression of height is breathtaking.

Prismenlinsen werden oft am falschen Platz benutzt, doch hier wurde damit eine fantastische Note getroffen. In der Tat trägt das Bild den Titel "Flug der Fantasie". Es zeigt den Stabhochspringer Alan Williams während des Southern Counties AAA Meisterschaftswettbewerbs. Der Eindruck der Höhe ist atemberaubend.

Met veel fantasie werd hier een facetlens gebruikt waardoor de foto een bijzonder accent kreeg. De titel luidt dan ook niet voor niets 'Vlucht in de fantasie'. De indruk van hoogte in de foto is adembenemend.

Muy a menudo la utilización de un accesorio de facetas múltiples acoplado al objetivo produce resultados excesivamente espectaculares, pero en este caso introduce en la imagen un brillante "toque" de fantasía. El título de la imagen es *Vuelo fantástico* y el protagonista es el saltador de pértiga Alan Williams compitiendo aquí en los Campeonatos de atletismo de las provincias del sur de Inglaterra. La impresión de altura llega a cortar la respiración.

L'utilisation d'un objectif à facettes multiples a souvent été exagérée, mais ici elle a donné une note de fantaisie: la photographie est d'ailleurs intitulée "Flight of Fancy" (Un brin de fantaisie), et elle montre Alan Williams, le sauteur à la perche, lors des Southern Counties AAA – Amateur Athletics Association – Championships. L'impression de hauteur est à couper le souffle.

117

Photographer Stanley Matchett
Camera Nikon F2
Lens 50mm Nikkor
Exposure 1/60 at f/11
Film FP4

A very good example of "panning" during exposure to keep a fast moving subject comparatively sharp against a background streaked with movement. This was taken by a *Daily Mirror* photographer and its impression of speed is so strong that one can almost imagine the sound of thudding hooves.

Ein sehr gutes Beispiel des "Schwenkens" während der Belichtung, um ein relativ scharfes Bild eines in schneller Bewegung befindlichen Gegenstands bei bewegtem Hintergrund zu erzielen. Dieses Bild wurde von einem Fotografen des *Daily Mirror* aufgenommen, und der Eindruck der Geschwindigkeit ist so stark, dass man fast meinen könnte, man höre das Dröhnen der Hufe.

Een heel goed voorbeeld van het 'meetrekken' van de camera gedurende de belichting om een snel bewegend onderwerp min of meer scherp tegen een vervaagde achtergrond te doen afsteken. De impressie is zo sterk dat men bijna het gekletter van de paardehoeven kan horen.

He aquí una buena muestra de cómo utilizar el "barrido" para captar de forma relativamente nítida a un objeto en movimiento contra un fondo en el que el movimiento juega también un importante papel. En este caso la impresión de velocidad es tan acentuada que parece como si estuviéramos oyendo el ruido producido por las pezuñas al golpear la tierra.

Très bon exemple de "panoramiquage" durant l'exposition, destiné à détacher assez nettement sur un arrière-plan traversé de mouvement un sujet se déplaçant rapidement. Cette photographie a été prise par un photographe du *Daily Mirror* et l'impression de vitesse qu'elle engendre est si forte que l'on peut presque imaginer le bruit des sabots frappant le sol.

118

Photographer M. Draždauskaite

A rather sad portrait in which the subject seems to be worried and forlorn for no apparent reason. Nevertheless it arouses a response in the viewer because of the sad eyes and the simple setting with bold areas of dark tone contrasted against uncomplicated highlights.

Ein recht trauriges Porträt, dessen Gegenstand aus einem nicht erkennbaren Grunde bekümmert zu sein scheint. Die Wirkung des Bildes beruht auf den traurigen Augen und der einfachen Szene, bei der kühne Flächen dunkler Tönung mit einfachen Glanzlichtern kontrastieren.

Een nogal triest portret waarin het onderwerp om onduidelijke redenen bezorgd en troosteloos schijnt te zijn. Toch roept het bij de kijker een reactie op door de droevige ogen en de simpele omgeving van krachtige, donkere tinten die contrasteren met het ongecompliceerde hoge licht.

Retrato tristón en el que el modelo parece estar preocupado sin motivo aparente. Despierta, sin embargo, una respuesta positiva a través de la expresividad de sus ojos y del contraste entre las zonas de tonalidad oscura y los toques de luz simplificados.

Portrait assez triste sur lequel le sujet semble ennuyé et perdu sans raison apparente. Il engendre néanmoins une réaction chez le spectateur parce que les yeux tristes et la composition simple avec des zones hardies de tons noirs contrastent avec des zones claires nettement marquées.

119

Photographer Asad Ali

Reminiscent of an old Chinese proverb – "Let the birds of sorrow fly over your head but not to nest in your hair!" This picture entitled *Homeless* inspires sadness and despair, a sentiment which must have inspired the author when printing-in the birds.

Dieses Bild, dessen Titel "Obdachlos" lautet, erinnert an das alte chinesische Sprichwort "Lasse die Vögel des Kummers über deinem Kopf fliegen, aber nicht in deinem Haar nisten!" Als der Künstler die Vögel einkopierte, stand er wohl im Banne der hier zum Ausdruck gebrachten Trauer und Verzweiflung.

Deze opname doet denken aan een oud Chinees spreekwoord: 'Laat de vogels van de zorgen over uw hoofd vliegen, maar sta ze niet toe zich in uw haar te nestelen.' De titel 'Thuisloos' accentueert het gevoel van triestheid en wanhoop, gevoelens die de fotograaf waarschijnlijk inspireerden tot het indrukken van de vogels.

Esta imagen, titulada *Sin hogar*, puede ser tomado como una ilustración del viejo proverbio chino que nos dice: "Deja que los pájaros anunciadores de la tristeza revoloteen sobre tu cabeza pero no dejes que aniden en tu pelo." Tristeza y desesperación son las sensaciones que nos sugiere, aunque en el autor esta impresión ha actuado evidentemente como musa inspiradora.

Cette photographie rappelle un vieux proverbe chinois: "Laissez les oiseaux du chagrin voler par-dessus vos têtes, mais non pas faire leur nid dans vos cheveux." Cette photographie intitulée "Homeless" (Sans logis) traduit de la tristesse et du désespoir, sentiments qui ont dû inspirer l'auteur lorsqu'il a rapporté les oiseaux sur son tirage.

120/121

Photographer Stephen Shakeshaft
Camera Nikon F2
Lens Novoflex 400mm
Film Tri-X

Six very good character portraits taken by this well-known *Liverpool Post and Echo* camera man at a political party conference. Having been caught unawares the poses and the expressions are very natural. They are, reading from left to right, Lord Carrington, William Whitelaw, Sir Keith Joseph, Margaret Thatcher, Peter Walker and Francis Pym.

Sechs sehr gute Charakterstudien dieses bekannten Fotografen der Zeitung *Liverpool Post and Echo*. Unbeobachtet auf einer politischen Parteikonferenz aufgenommen wirken die Haltungen und Gesichtsausdrücke sehr natürlich. Von links nach rechts sieht man Lord Carrington, William Whitelaw, Sir Keith Joseph, Margaret Thatcher, Peter Walker und Francis Pym.

Zes goede karakterportretten die ongemerkt werden gemaakt tijdens een congres van de Britse conservatieve partij. De poses en gelaatsuitdrukkingen zijn volkomen natuurlijk. Van links naar rechts ziet u: Lord Carrington, William Whitelaw, Sir Keith Joseph, Margaret Thatcher, Peter Walker en Francis Pym.

He aquí seis retratos excelentes tomados por este conocido fotógrafo del *Liverpool Post and Echo* en la conferencia anual del partido conservador británico. No habiéndoseles prevenido, los retratados se hallan en poses extremadamente naturales. Son, de izquierda a derecha: Lord Carrington, William Whitelaw, Sir Keith Joseph, Margaret Thatcher, Peter Walker y Francis Pym.

Six bons portraits pris par ce photographe bien connu du *Liverpool Post and Echo* lors d'une conférence d'un parti politique. Ayant été saisies à l'insu des sujets, les poses et les expressions sont très naturelles. Ce sont, de gauche à droite, Lord Carrington, William Whitelaw, Sir Keith Joseph, Margaret Thatcher, Peter Walker et Francis Pym.

122

Photographer Michael Gnade
Camera 6 × 6 cm
Lens 250mm
Exposure 1/250 at f/16
Film 100 ASA

A nude figure taken in strong sunlight to emphasise sculptural shapes rather than the figure. The author states in his book *People in my Camera* that he was inspired by Rodin who said "A shape is forced outwards from inside". However, Michael Gnade has also made great use of texture to complement the shapes.

Eine bei starkem Sonnenlicht aufgenommene Aktstudie, in der die Betonung nicht so sehr auf der Gestalt wie auf skulpturellen Formen liegt. Der Verfasser meldet in dem von ihm verfassten Werk, er sei unter dem Einfluss von Rodin gestanden, der erklärte "Eine Form entwickelt sich von innen nach aussen", Michael Gnade hat aber die Formen durch künstlerische Behandlung der Textur hervorgehoben.

Bij dit naakt, opgenomen bij fel zonlicht, ligt de nadruk meer op de beeldhouwkundige vormen dan op de figuur. De fotograaf vermeldt dat hij werd geïnspireerd door Rodin die zei: 'Een vorm drukt van binnenuit naar buiten.' Gnade maakte een goed gebruik van de structuur om de achtergrond om de vormen van het model aan te vullen.

He aquí un desnudo fotografiado bajo la luz solar para acentuar sus formas esculturales. El autor nos dice en su libro *Fotografía de gente* que la frase de Rodin "A las formas se las debe crear desde el interior" ha ejercido sobre él una gran influencia. De todas formas hay que decir que Michael Gnade ha sabido usar también la textura como perfecto complemento de las formas.

Photographie de nu prise sous un soleil violent pour souligner les formes sculpturales plutôt que le corps. L'auteur indique dans son livre "Les gens dans mon appareil photo" qu'il a été inspiré par Rodin, qui a dit "Une forme est poussée à l'extérieur de l'intérieur". Toutefois, Michael Gnade a également fait un grand usage de la texture pour compléter les formes.

123

Photographer Jose Torregrosa
Camera Nikon F
Lens 135mm
Film Tri-X

A study which proves that glamour photography does not always depend on a high key presentation. In fact, in this example, the heavy low key tones have emphasised femininity and sensuality, enhanced by the fur and the nearly exposed breast. The expression is also in keeping with the mood.

Diese Studie beweist, dass erotische Fotografie nicht immer helle Töne erfordert. In der Tat betonen hier die intensiven dunklen Töne die Weiblichkeit und Sinnlichkeit des Modells, und auch der Pelz und die nahezu entblösste Brust leisten in dieser Hinsicht einen Beitrag. Auch der Gesichtsausdruck entspricht der Stimmung.

Een studie die aantoont dat glamourfotografie niet altijd afhankelijk is van een highkey-presentatie. In dit voorbeeld benadrukken de zware lowkey-tinten de vrouwelijkheid en sensualiteit, daarbij ondersteund door het bont en de bijna ontblote borst. De gelaatsuitdrukking is in harmonie met de sfeer van de foto.

Este estudio nos demuestra claramente que no siempre es necesario utilizar tonos altos en las fotografías orientadas a realzar la belleza femenina. De hecho el interés se despierta aquí a través del empleo de tonos muy bajos, que acentúan la sensualidad de la modelo, redondeando el efecto producido por la piel y la exposición de uno de los senos. La expresión de la modelo concuerda perfectamente, por otra parte, con la atmósfera de la imagen.

Etude qui prouve que la photographie de mode ne dépend pas toujours de la présentation lumineuse. En fait, sur cet exemple, les tons sombres très appuyés ont mis en relief la féminité et la sensualité, renforcées par la fourrure et par la poitrine légèrement exposée. L'expression aussi est en harmonie avec l'état d'âme.

124

Photographer John Walker
Camera Rolleiflex
Exposure 10 sec at f/16
Film Ektachrome ASA200

A humorous picture entitled *Big Brother is Watching*. Undoubtedly posed, but it shows that the author has originated an idea and thus been creative. He has also executed it well and made a picture which, while having no deep meaning or lasting value, will give a passing pleasure to all who see it.

Ein humorvolles Bild mit dem Titel "Big Brother sieht zu". Hier handelt es sich ohne Zweifel um eine künstliche Pose, doch ist die Idee schöpferisch und originell. Auch die Ausführung ist gut, und obgleich das Bild weder eine tiefe Bedeutung noch dauernden Wert haben mag, ergötzt es sicher jeden, der es sieht.

Een amusante foto onder de titel 'Big brother is watching'. Zonder twijfel geposeerd, maar de opname toont aan dat de fotograaf een eigen idee heeft uitgevoerd en daarmee creatief bezig is geweest. Hij heeft zijn idee goed uitgewerkt en een foto gemaakt die, zonder een diepe betekenis of een blijvende waarde te hebben, toch menige kijker zal boeien.

Rollei. For those who appreciate the difference.

There's something about a Rollei.

It's not just the advanced technology, not just the simplicity of operation, not even the picture perfection it delivers again and again.

It's a feeling.

A feeling that you're holding a masterpiece of camera engineering that has evolved through 60 years of intensive research and development. A feeling that you're holding a legend.

In the electronics age, Rollei still lead the rest. The 6 x 6 cms format SLX is the most advanced electronic camera in the world. Electronic accuracy controls virtually every function, from the linear-motor shutter to the motorwind, from the incredible LED metering system to the automatic film wind-off at the final exposure.

In the 35 mm range, the tradition of simplicity and perfection continues.

The SL35E combines split image and microprism focusing. Its 16 LED readout in the view-finder will even memorize light readings, with a wealth of unique features that include a special, all-metal, vertically operated focal plane shutter.

In compacts, Rollei boasts a point-and-shoot classic. The 35 LED contains a brilliant fail-safe device in the viewfinder, where either the red light tells you to adjust speed or aperture or a green light tells you it's safe to shoot.

Contact us and we'll send full details of the complete Rollei range, describe the pin-sharp accuracy of the precision Rollei-Zeiss lenses and show specifications that put Rollei in a class apart.

But there's only one way to appreciate the legend. Hold a Rollei. Feel that perfect combination of function and form, the confidence that stems from knowing that every control is the perfect size, in the perfect place, at exactly the right time.

That's the Rollei difference.

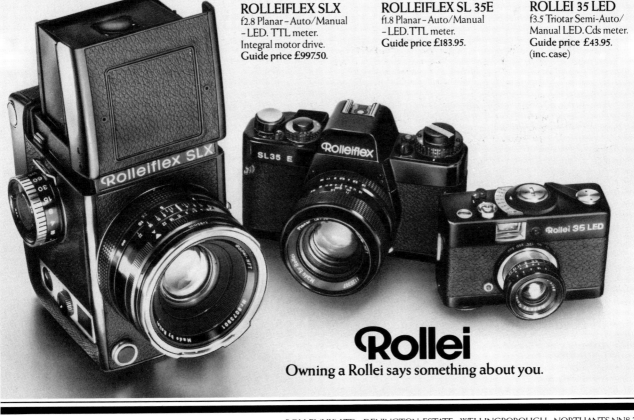

ROLLEIFLEX SLX
f2.8 Planar – Auto/Manual
– LED. TTL meter.
Integral motor drive.
Guide price £997.50.

ROLLEIFLEX SL 35E
f1.8 Planar – Auto/Manual
– LED. TTL meter.
Guide price £183.95.

ROLLEI 35 LED
f3.5 Triotar Semi-Auto/
Manual LED. Cds meter.
Guide price £43.95.
(inc. case)

Rollei
Owning a Rollei says something about you.

ROLLEI (UK) LTD · DENINGTON ESTATE · WELLINGBOROUGH · NORTHANTS NN8 2RG

He aquí una fotografía humorística titulada *El hermano mayor vigila* (el autor ha tomado la frase prestada de la obra de George Orwell *1984*). En este caso el sentido creativo del fotógrafo se ha centrado en la representación de una idea. El resultado ha sido una imagen que, a pesar de no entrañar ningún significado profundo, proporciona un indiscutible placer visual.

Photographie humoristique intitulée "Big Brother is Watching" (Grand frère veille). Elle est indubitablement posée, mais elle montre que l'auteur a eu une idée et a donc fait oeuvre de créateur. Il l'a également bien traduite et a ainsi réalisé une photographie qui, sans avoir beaucoup de signification ou de valeur durable, procurera un plaisir passager à tous ceux qui la verront.

125

Photographer John Pattenden
Camera Pentax SP 2
Lens Vivitar 105mm
Film HP5

The sideways glance of the man with the cymbals in the centre of the band has turned this from an ordinary snapshot into an intriguing picture. Who is he looking at? Could it be the girl on the opposite page! He has provoked the question and therefore stimulated our imagination – which should be the aim and object of all photography.

Was ein gewöhnlicher Schnappschuss hätte sein können, ist dadurch, dass der Mann mit dem Becken in der Mitte der Kapelle zur Seite blickt, zu einem interessanten Bild geworden. Was er wohl sieht? Könnte es das Mädchen auf der gegenüberliegenden Seite sein? Indem die Frage gestellt wird, wird unsere Fantasie angeregt – was das Ziel aller Fotografie sein sollte.

De blik opzij van de man met de bekkens in het hart van het orkest veranderde deze foto van een simpele snapshot in een intrigerende plaat. Naar wie kijkt hij? Misschien naar het meisje op de tegenoverliggende bladzijde! Hij lokte de vraag uit en stimuleerde daarmee onze verbeelding, hetgeen uiteindelijk het doel zou moeten zijn van alle fotografie.

La mirada de soslayo del tocador de platillos situado en el centro de la banda proporciona a esta imagen cierta intriga. ¿A quién mira? ¡Quizás a la chica de la página opuesta! Al provocar la pregunta el fotógrafo ha estimulado nuestra imaginación, cumpliendo así con la principal obligación de todo buen artista.

Le coup d'oeil de l'homme aux cymbales situé au centre de l'orchestre a fait de cette scène banale une photographie qui ne laisse pas d'intriguer. Qui regarde-t-il? Serait-ce la jeune femme de la page opposée? Il a provoqué la question et, par conséquent, stimulé notre imagination, ce qui devrait être le but et l'objet de toute photographie.

126

Photographer Jason Apostolidis

This shows an interesting treatment of silhouettes on the horizon because the halation streaks from the cycles give a sense of movement to otherwise static subjects. This darkroom dodge is getting overdone but it has been effective in this example.

Diese Behandlung der Silhouetten am Horizont ist interessant, da die durch die Räder erzeugten Lichtstreifen einer an und für sich statischen Szene ein Gefühl der Bewegung verleihen. Dieser Dunkelkammertrick wird heute ein wenig zu oft verwendet, hat sich hier jedoch gut bewährt.

Dit is een interessante wijze van behandeling van de silhouetten door de straling die van de fietsers schijnt uit te gaan en een indruk van beweging geeft aan een overigens statisch onderwerp. Dit donkerekamertrucje is niet nieuw, maar het is hier op effectieve wijze toegepast.

He aquí un interesante tratamiento de una serie de siluetas contra el horizonte en una instantánea donde los halos derivados de las bicicletas proporcionan cierta impresión de movimiento a un tema estático. Este truco de laboratorio se está empezando a utilizar demasiado, pero en este caso resulta efectivo.

Cette photographie traduit une manière intéressante de profiler des silhouettes sur l'horizon parce que les stries émanant des bicyclettes donnent une impression de mouvement à des sujets statiques. Cette gymnastique en chambre noire est devenue assez banale, mais elle se révèle efficace sur cet exemple.

127

Photographer Peter J. Hoare
Camera Nikon F
Lens 35mm Nikkor
Exposure 1/125 at f/8
Film FP4

An impressive "night" shot made by photographing the subject with an orange filter to gain contrast and then copying onto graphic arts film which is then printed as a negative. The "moon" was added by placing a coin on the print for part of the final exposure.

Eine eindrucksvolle "Nachtstudie", bei der von einem Orangefilter Gebrauch gemacht wurde, um den gewünschten Kontrast zu erzielen, worauf das Bild auf Kunstfilm kopiert und dann als Negativ gedruckt wurde. Während eines Teils der Endbelichtung lag eine Münze auf dem Film, die den "Mond" ergab.

Het 'nachteffect' in deze opname ontstond door het gebruik van een oranjefilter teneinde contrast te krijgen bij de opname en door achteraf omkopiëren op grafische lijnfilm, die daarna als negatief werd afgedrukt. De 'maan' werd toegevoegd door gedurende een deel van de belichtingstijd een munstuk op het vergrotingspapier te leggen.

Impresionante imagen "nocturna" producida fotografiando al sujeto con un filtro naranja para obtener cierto contraste y trasladando luego la instantánea a una película para artes gráficas que se positivó como si fuera un negativo. La "luna" se añadió manteniendo una moneda sobre el papel de copiado durante una parte de la exposición final.

Saisissante photographie "de nuit" due au fait que le sujet a été pris avec un filtre orange pour augmenter le contraste, puis copié sur une pellicule d'art graphique qui a ensuite été tirée comme un négatif. La "lune" a été ajoutée en plaçant une pièce de monnaie sur le tirage pendant une partie de l'exposition finale.

128

Photographer Pawel Pierściński

A traditional landscape, but a very good one, taken in Poland. The bold sweeping curve of the ridge is "echoed" in the foreground and the tree is placed just right to provide a focal point of interest and it balances the composition by providing a vertical line.

Eine traditionelle aber sehr erfolgreiche Landschaftsaufnahme aus Polen. Die kühne, ausladende Kurve des Kammes hat ein "Echo" im Vordergrund, und der Baum ist gerade in der richtigen Lage, um als Brennpunkt des Interesses zu dienen. Ausserdem verleiht er der Komposition das nötige Gleichgewicht, da er eine senkrechte Linie bildet.

Een traditioneel, maar wel heel goed landschap, opgenomen in Polen. De boom bevindt zich juist op de goede plaats en vormt een goed verticaal tegenwicht tegen de golvende horizontale lijnen.

He aquí una excelente instantánea de un paisaje polaco obtenida de forma tradicional. La atrevida curva de la sierra encuentra un "eco" en el primer plano y el árbol está situado exactamente en el punto adecuado para atraer el interés del espectador, equilibrando la composición con su silueta vertical.

Paysage traditionnel, mais excellent, photographié en Pologne. La courbe hardie de la crête trouve son écho au premier plan, et l'arbre est placé juste à l'endroit voulu pour constituer un centre d'intérêt. Il a, en outre, pour effet d'équilibrer la composition en constituant une ligne verticale.

129

Photographer V. Straukas

A well composed landscape which caught the eye in the original for its beautiful print quality. Occasionally a picture with a full range of tones that can only be obtained by the photographic process comes along to remind us of the fact that this alone can have impact. The subject itself has gained added interest by the wide angle perspective of the fish-eye lens and the emphasis on the pattern in the sand.

Ein Landschaftsbild mit guter Komposition, das mir wegen der Schönheit der Kopie auffiel. Gelegentlich sieht man ein Bild mit einem vollen Tonspektrum, das sich nur auf fotografischem Wege erzielen lässt und uns daran erinnert, dass sich auf diese Weise ganz eigene Effekte erzielen lassen. Das Motiv des Bildes ist dank der durch das Fischaugenobjektiv bedingten Weitwinkelperspektive unter Betonung des Musters im Sande besonders interessant.

Een goed gecomponeerd landschap, dat mijn aandacht trok door de uitstekende kwaliteit van de vergroting. Soms worden wij geconfronteerd met een opname waarin een heel gamma aan toonwaarden, zoals alleen via het fotografisch procédé kan worden verkregen, ons herinnert aan het feit dat dit op zich reeds boeit. Het onderwerp zelf kreeg extra aantrekkingskracht door de fisheye-perspectief en de nadruk op de structuurpatronen in het zand.

Vemos aquí un paisaje que llamó nuestra atención por su excelente composición y la calidad de la copia original. De cuando en cuando nos encontramos con instantáneas de este tipo en las que se han reproducido perfectamente todos los matices tonales del tema, recordándonos que es precisamente esta característica la más típica de las imágenes fotográficas.

Paysage bien composé qui a retenu mon attention sur l'original en raison de l'excellente qualité du tirage. Parfois, une photographie présentant toute une palette de tons qu'il n'est possible d'obtenir que par un procédé photographique vient nous rappeler que celle-ci peut avoir son propre impact. Le sujet lui-même y a gagné en intérêt par suite de la perspective due à l'utilisation du grand angle du *fish-eye* et de l'accent mis sur le dessin dans le sable.

130

Photographer John P. Delaney, Hon.FRPS
Camera Rollei E3
Lens Planon f/3.5
Film Plus X

The vertical format and the high viewpoint, together with the *contre-jour* lighting, has given a tremendous feeling of depth to this scene. The eye is led into the picture by the line of the kerb and one is not disappointed at the end of it. The richness of tone also adds to the atmosphere.

Das senkrechte Format und der hohe Aufnahmestandpunkt sowie das Gegenlicht haben dieser Szene ein ausserordentlich starkes Gefühl der Tiefe verliehen. Das Auge wird durch die Linie des Randsteins in das Bild geführt und am Ende nicht enttäuscht. Auch die reiche Tönung trägt zu der stimmungsvollen Wirkung bei.

Het staande formaat en het hoge standpunt, te zamen met het tegenlicht, geven een enorm gevoel van diepte in deze foto. Het oog wordt in de foto geleid door de trottoirband en men wordt aan het eind daarvan niet teleurgesteld. De rijke toonwaarden droegen hun steentje aan de sfeer bij.

El formato vertical y el punto de vista alto, junto con la iluminación a contraluz han proporcionado a esta escena una tremenda impresión de profundidad. Nuestra mirada es dirigida por la línea del bordillo y nunca se ve defraudada. La riqueza del tono, por otra parte, da mayor vigor a la atmósfera.

Le format vertical et la prise de vue en plongée ajoutés à un éclairage en contre-jour ont conféré à cette scène une extraordinaire sensation de profondeur. L'oeil est amené à l'image par la bordure du trottoir et le spectateur n'est pas déçu lorsqu'il l'atteint. En outre, la richesse des tons ajoute à l'atmosphère.

131
Photographer Witaly Butyrin

This picture is entitled *Magician* and comes from a cycle called *Sea Tales*. The author has produced an air of fantasy, almost of menace, by printing-in a swirl of water in place of the sky, and upside down as well. It shows a lot of imagination and has created a mood of drama.

Dieses Bild mit dem Titel "Zauberer" gehört dem Zyklus "Geschichten vom Meere" an. Der Künstler hat eine fantastische, nahezu bedrohliche Stimmung geschaffen, indem er anstatt des Himmels einen Wasserwirbel, und noch dazu einen umgekehrten Wasserwirbel, einkopiert hat. Die Stimmung in diesem Bild ist dramatisch.

De titel van deze plaat is 'Tovenaar'. De opname is er een uit een serie getiteld 'Verhalen van de zee'. De fotograaf creëerde een sfeer van fantasie, bijna van dreiging, door een draaikolk van water in te kopiëren in plaats van de lucht, en dan nog wel ondersteboven.

Esta instantánea, a la que su autor ha titulado *Brujo*, forma parte de un ciclo denominado *Cuentos del mar*. En ella encontramos una atmósfera de fantasía casi amenazante, conseguida al sustituir el cielo por un remolino de agua puesto cabeza abajo. El dramatismo imprimido a la escena revela la gran fuerza imaginativa del autor.

Cette photographie intitulée "Magician" (Magicien) nous vient d'une série intitulée "Sea Tales" (Contes de la mer). L'auteur a su donner un air de fantaisie, presque de menace, en rapportant un tourbillon d'eau à la place du ciel, et en le renversant. Elle est la marque d'une vive imagination et a engendré une atmosphère saisissante.

132
Photographer Joseph Cascio
Camera Nikon F
Lens 105mm Nikkor
Film Kodachrome

An interesting combination of a straight negative of the sky and a landscape given a partial line treatment. This part was apparently taken direct from the transparency via lith film which would account for it being negative instead of positive. The result is unusual and striking.

Eine interessante Kombination eines unmittelbaren Negativs des Himmels und einer zum Teil linienmässig behandelten Landschaft. Anscheinend wurde dieser Teil über Lithofilm von einem Diapositiv abgenommen, was wohl erklärt, dass es sich hier um ein Negativ und nicht ein Positiv handelt. Das Ergebnis ist ungewöhnlich und eindrucksvoll.

Een interessante combinatie van een normaal negatief van de lucht met een landschap waaraan gedeeltelijk een lijnbewerking werd gegeven. Dit gedeelte werd kennelijk rechtstreeks van het dia gereproduceerd via lithfilm, hetgeen verklaart waarom het negatief is in plaats van positief. Het resultaat is ongewoon en boeiend.

He aquí una interesante combinación de un negativo del cielo y un paisaje al que se tomó directamente de una diapositiva a través de una película lith. El resultado es harto insólito e impresionante.

Intéressante combinaison d'un négatif direct du ciel et d'un paysage qui a été partiellement ligné. Cette partie a apparemment été reprise directement de la diapositive par le biais d'une pellicule lithographique, ce qui pourrait expliquer qu'elle est négative au lieu de positive. Le résultat est insolite et frappant.

133
Photographer Miguel Bergasa

The wide grey border has given a "through the window" effect to this picture, and it makes the scene look very bright. The significance of the word "Victory" in association with the cyclist will be given different interpretations by different viewers because it poses a question. From this point of view the picture is very successful.

Der breite graue Rand gibt den Eindruck, dass wir die Szene durch ein Fenster sehen und dass sie sehr hell ist. Was mit dem Worte "Victory" gemeint ist, ist nicht klar, und kann auf verschiedene Weisen ausgelegt werden. In diesem Sinne ist dieses Bild sehr erfolgreich.

Het grote grijze passepartout gaf een 'doorkijk'-effect aan deze foto en doet de scène zeer helder lijken. De betekenis van het woord 'Victory' (overwinning) in associatie met de fietser zal bij verschillende kijkers ook verschillende reacties oproepen, doordat het een vraag aan de orde stelt. Uit dit gezichtspunt is de opname zeer succesvol.

El amplio borde gris proporciona a esta instantánea la impresión de haber sido captada a través de una ventana, acentuando además su brillantez luminosa. La asociación de la palabra "Victoria" con el ciclista plantea una pregunta a la que cada espectador debe encontrar su propia respuesta. Y es aquí precisamente donde reside el interés de la imagen.

La large bordure grise confère à cette photographie un effet de "vu par la fenêtre". L'importance du mot "Victory" (Victoire) en association avec le cycliste sera interprétée différemment selon les spectateurs parce qu'elle appelle une question. De ce point de vue, la photographie est très réussie.

134/135
Photographer Stephen Shakeshaft
Camera Nikon F2
Lens Novoflex 400mm

One rarely sees sequence pictures of sporting events in the papers so this strip has a special interest. It shows the famous golfer Jack Nicklaus driving, waiting for the ball to land and his reaction on its landing. The expressions tell it all and are strong character portraits as well.

In den Zeitungen sieht man nur selten Bildserien, die mehrere Stufen eines sportlichen Vorgangs behandeln, und diese Reihe ist daher von besonderem Interesse. Sie zeigt den berühmten Golfspieler Jack Nicklaus, der den Ball schlägt, darauf wartet, bis er wieder am Boden ist und dann darauf reagiert. Die Gesichtsausdrücke sind deutlich, und ausserdem bilden sie ausgezeichnete Charakterstudien.

Deze fotoserie van de bekende golfer Jack Nicklaus geeft zijn reacties weer na een slag. De gelaatsuitdrukkingen spreken voor zich en vormen elk op zich een sterk karakterportret.

El hecho de que cada vez resulte más raro el encontrar en los periódicos secuencias descriptivas de tema deportivo confiere un interés especial a estas fotografías tomadas en el campeonato abierto de golf de Inglaterra por un reportero del *Liverpool Post and Echo*. En ellas vemos al gran jugador Jack Nicklaus golpeando la bola, contemplando su recorrido y reaccionando finalmente al tomar la bola contacto con el suelo. Las expresiones nos muestran con puntual exactitud el estado de ánimo del jugador y nos permiten incluso hacernos una idea de su carácter.

Etant donné la rareté des photographies séquentielles d'événements sportifs dans les journaux, cette bande présente un intérêt tout particulier. Elle montre le célèbre joueur de golf Jack Nicklaus jouant une crossée, attendant l'arrivée de la balle, puis sa réaction lors de sa retombée au sol. Tout est dans les expressions, qui sont autant de portraits de caractère fortement marqués.

136
Photographer Stanley Matchett
Camera Nikon F2
Lens 85mm
Exposure 1/30 at f/5.6
Film HP5

Unusual viewpoints always help to give a photograph originality but in this case it has provided humour as well. The author must have been looking for something different from straight news pictures and a dog show often provides such opportunities.

Ungewöhnliche Standpunkte verleihen einer Aufnahme stets Originalität, doch in diesem Falle war hier das Ergebnis auch recht humorvoll. Stanley Matchett muss nach etwas gesucht haben, das nicht einfach journalistischer Art war. Hundeausstellungen bieten oft solche Möglichkeiten.

Ongewone gezichtshoeken dragen altijd bij tot de originaliteit van een opname, maar in dit geval gaf het bovendien een humoristisch tintje aan de foto.

Un punto de vista insólito confiere siempre una marcada originalidad a una instantánea, pero en este caso introduce además unas gotas de humor. El autor, reportero del *Daily Mirror*, se hallaba en Belfast intentando captar algo distinto a la acostumbrada fotografía de noticias y, por ello, la exposición canina despertó inmediatamente su interés.

Un point de vue insolite contribue toujours à donner de l'originalité à une photographie; dans le cas présent, celui qui a été choisi a, en outre, apporté un élément humoristique. L'auteur cherchait probablement à rompre avec les photographies de reportage directes.

137
Photographer Vladimir Filonov

Another picture which shows that rear views are often more effective than frontal aspects. The low viewpoint employed here has given a fine impression of size while the simplified tone process has given a good impression of strength. The counterchange of tones between elephant and background also helps the artistic effect.

Auch dieses Bild erweist, dass Aufnahmen von hinten oft wirksamer sind als Frontaufnahmen. Der niedrige Standpunkt hebt auf wirksame Weise die Grösse des Tieres hervor, während durch die vereinfachte Tönung ein überzeugender Eindruck von Kraft erzielt wurde. Auch der Tonkontrast zwischen dem Elefanten und dem Hintergrund trägt zu der künstlerischen Wirkung bei.

Ook deze foto toont aan dat achteraanzichten vaak effectiever zijn dan vooraanzichten. Het lage standpunt dat hier werd toegepast gaf een goede indruk van de afmetingen van het onderwerp, terwijl de lijnuitwerking een sterk gevoel van kracht gaf. Het toonwaardencontrast tussen de olifant en de achtergrond verleende het geheel een artistiek effect.

He aquí una nueva prueba de que las vistas traseras resultan a menudo mucho más eficaces que las imágenes frontales. El punto de vista bajo proporciona una perfecta impresión de tamaño, mientras que la simplificación de la tonalidad nos traslada una marcada impresión de fuerza. La calidad artística de la instantánea se ve reforzada, por otra parte, por el contraste tonal entre el elefante y el fondo.

Autre photographie qui montre que les vues de dos sont souvent plus expressives que les vues de face. La prise de vue en contre-plongée utilisée ici a donné une belle impression de dimension, tandis que le procédé de simplification des tons a engendré une bonne impression de puissance. L'alternance des tons entre l'éléphant et l'arrière-plan contribue également à l'effet artistique.

138

Photographer Bryan Petrie
Camera Nikon F
Lens 105mm
Film Plus X

The author seized his opportunity when this little boy with his toy clarinet joined the busker who was entertaining outside a pavement café in Salisbury, Zimbabwe Rhodesia. A study in contrasts and a nice human touch, coupled with a little humour.

Der Künstler wählte für seine Aufnahme den richtigen Augenblick, als der kleine Junge mit der Spielzeug-Klarinette gerade mit dem Gitarrespieler ausserhalb eines Kaffees in Salisbury, Zimbabwe Rhodesien, "mitmusizierte". Eine Studie von Kontrasten, die menschlich recht ansprechend ist und gleichzeitig humorvoll wirkt.

De fotograaf maakte gebruik van de gelegenheid toen zijn zoontje zich met zijn speelgoedklarinet voegde bij de straatmuzikanten voor een café in Salisbury in Zimbabwe-Rhodesië. Een studie in contrasten en een leuk menselijk trekje, gepaard gaande aan een vleugje humor.

El autor supo aprovechar perfectamente la oportunidad que se le presentó al unirse el niño con su clarinete de juguete al hombre que actuaba frente a un café de Salisbury (Zimbabwe-Rhodesia). Podemos definir a esta imagen como un estudio de contrastes en el que no falten ni el toque de ternura ni las gotas de humor.

L'auteur a saisi l'occasion au vol lorsque le petit garçon à la clarinette est venu se joindre à l'homme qui jouait de la guitare à la terrasse d'un café de Salisbury, au Zimbabwe (ex-Rhodésie). Etude tout empreinte de chaleur humaine et non dénuée d'humour.

139

Photographer Rudolf Bieri, ARPS
Camera Leicaflex SL2
Lens 180mm Apo-Telyt
Exposure 1/60 at f/3.4
Film Tri-X

Chris Barber in familiar pose and familiar lighting. Portraits like this tell more about the man than a studio study, although the latter has its uses. The horizontal format makes for a good composition and the diagonal line of the flute gives a feeling of movement.

Chris Barber in vertrauter Haltung und bei üblicher Beleuchtung. Porträts wie dieses sagen mehr über die Person aus, als eine Atelierstudie, obgleich auch diese ihren Wert hat. Das waagerechte Format ergibt eine gute Komposition, und die diagonale Linie der Flöte schafft ein Gefühl der Bewegung.

Chris Barber in een bekende houding en een niet ongebruikelijke verlichting. Portretten zoals dit vertellen meer over de mens dan studioportretten, hoewel er voor deze laatste natuurlijk ook argumenten aan te voeren zijn. Het horizontale formaat zorgt voor een goede compositie, terwijl de diagonale lijn van de fluit een gevoel van beweging veroorzaakt.

Chris Barber en una pose familiar con iluminación también familiar. Los retratos de este tipo nos revelan más cosas del modelo que los obtenidos en el estudio, aunque éstos ofrecen también sus ventajas. El formato horizontal acentúa el equilibrio de la composición y la línea diagonal de la flauta proporciona cierta impresión de movimiento.

Chris Barber dans une attitude et sous un éclairage familiers. Les portraits comme celui-ci en disent plus long sur l'homme qu'une étude en studio, bien que celle-ci ait son utilité. Le format horizontal contribue au succès de la composition, et la ligne diagonale de la flûte donne une impression de mouvement.

140

Photographer John Walker

A pure fun picture and deliberately set up for the purpose but very well carried out. Thinking up ideas is what makes a good news photographer, especially if the result is appropriate to a topical event or to the season.

Einfach ein Spassbild und eigens zu diesem Zwecke aufgenommen, doch sehr gut ausgeführt. Originalität ist bei einem Pressefotografen wichtig, und es hilft auch, wenn das Ergebnis auf ein aktuelles Ereignis oder die Jahreszeit Bezug hat.

Een 'gekke' foto, die ongetwijfeld geposeerd is, maar wel goed uitgevoerd. Het bedenken van ideeën is vaak onmisbaar voor goede nieuwsfotografen, speciaal als het resultaat passend is voor een actuele gebeurtenis of voor het seizoen.

Imagen puramente humorística, planeada cuidadosamente hasta en sus más mínimos detalles. Es la capacidad para encontrar ideas adecuadas lo que nos descubre a un buen reportero, especialmente si sabe aplicarlas en la captación de las características de la situación o el dramatismo del suceso.

Photographie pleine de drôlerie et délibérément montée pour les besoins de la cause, mais fort bien exécutée. L'imagination est le propre d'un bon reporter photographe, en particulier si le résultat est approprié à un événement particulier ou à la saison.

141

Photographer Arthur Edwards
Camera Nikon F2
Lens 150mm
Film HP5

An amusing picture by a *Sun* photographer which can be interpreted in a number of ways. Was Prince Charles "cocking a snook" at the pomposity of the local big-wigs or had he seen something like the child on the opposite page? He is obviously trying to choke a laugh and the contrast between the expressions of these two people is fascinating.

Ein amüsantes Bild von einem Fotografen der "Sun", das auf verschiedene Weisen ausgelegt werden kann. Machte sich Prinz Charles hier über die örtlichen Würdenträger lustig oder hat er gerade etwas wie das Kind auf der gegenüberliegenden Seite bemerkt? Offensichtlich versucht er ohne viel Erfolg ernst zu bleiben, und der Kontrast zwischen den Gesichtsausdrücken dieser beiden Personen ist faszinierend.

Deze vrolijke foto kan op verschillende wijzen worden geïnterpreteerd. Amuseerde Prins Charles zich over de pompeusiteit van de plaatselijke notabelen of zag hij iets leuks, zoals het meisje op de tegenoverliggende bladzijde? In elk geval is het duidelijk dat hij een lach probeert te onderdrukken. Het contrast in gelaatsuitdrukking van de twee personen is fascinerend.

He aquí una divertida imagen obtenida por un fotógrafo de *The Sun*, a la que se pueden proporcionar varias interpretaciones. ¿Se estaba mofando el príncipe Carlos de Inglaterra de la pomposidad de los señorones locales o había visto algo tan gracioso como el niño de la página anterior? Evidentemente se está esforzando en contener la risa y el contraste entre las expresiones de estas dos personas resulta realmente fascinante.

Amusante photographie, due à un photographe du *Sun*, que l'on peut interpréter de différentes manières. Le Prince Charles était-il en train de "faire la nique" devant la solennité des grosses perruques locales ou avait-il vu quelque chose comme l'enfant de la page opposée? Il s'efforce visiblement d'étouffer un rire, et le contraste entre les expressions de ces deux personnes est fascinant.

142

Photographer Hideki Fujii

Most of the photography from Japan is in colour these days so it is nice to see a black and white study which exhibits all the delicacy and serenity of oriental art of former times. At first glance it would appear to be a porcelain figurine but a closer look shows it to be a nicely posed nude wearing a mask.

Dieser Tage kommen aus Japan hauptsächlich Farbfotografien, und es ist daher schön, eine Schwarzweissstudie zu sehen, die durch das ganze Feingefühl und die gelassene Heiterkeit alter orientalischer Kunst gekennzeichnet ist. Auf den ersten Blick könnte man meinen, dass dies eine Porzellanfigur sei, doch bei näherer Betrachtung erweist es sich, dass es sich um ein nacktes Modell in schön gewählter Pose und mit einer Maske handelt.

Tegenwoordig zijn bijna alle foto's die uit Japan komen in kleur. Het is dan ook plezierig eens een zwartwitstudie te zien waarin alle fijngevoeligheid en sereniteit van de oosterse kunst uit vroeger tijden weer eens word tentoongespreid. Op het eerste gezicht lijkt het alsof het gaat om een porseleinen beeldje, maar een nadere beschouwing toont dat het gaat om een fraai geposeerd naakt met een masker op.

Ahora que los fotógrafos japoneses utilizan con tanta frecuencia el color, resulta doblemente agradable encontrarse con un estudio en blanco y negro conteniendo la delicadeza y sensibilidad que siempre han caracterizado al arte oriental. A primera vista nos parece estar viendo una figura de porcelana, pero un examen detallado nos revela que se trata de un desnudo femenino con una máscara.

La plupart des photographies qui nous viennent du Japon sont aujourd'hui en couleur; il est donc intéressant de voir une étude en noir et blanc présentant toute la délicatesse et la sérénité de l'art oriental de jadis. A première vue, cela ressemble à une figurine de porcelaine mais, à y regarder de plus près, on constate qu'il s'agit d'un nu bien posé portant un masque.

143

Photographer Stanislav Trzaska
Camera Nikon F2
Lens 24mm Nikkor
Film Tri-X

Most of the figure work coming from Poland has been taken outdoors or in domestic surroundings. Although posed, this example is a nice interpretation of the mother/child theme and the tone scheme, although shaded-in rather obviously, has created a distinctive mood.

Die meisten Aktaufnahmen aus Polen wurden im Freien oder in häuslicher Umgebung angefertigt. Obgleich die Szene künstlich ist, verleiht sie dem Thema Mutter und Kind auf interessante Weise Ausdruck. Die Tönung hat trotz recht offensichtlichen Einschattierens eine besondere Stimmung geschaffen.

De meeste figuurstudies die uit Polen komen zijn buiten genomen of in huiselijke omgeving. Hoewel geposeerd, is dit voorbeeld een fijne interpretatie van het moeder-en-kind thema.

La mayor parte de retratos que nos han llegado de Polonia se han tomado en exteriores o en ambientes domésticos. Aunque resulta evidente que se ha hecho posar a los protagonistas, esta instantánea constituye una excelente interpretación madre-hijo y el esquema tonal, a pesar de revelar un evidente sombreado, he producido una atmósfera característica.

La plupart des photographies qui nous viennent de Pologne ont été prises à l'extérieur ou dans un cadre domestique. Bien qu'elle ait été posée, cette photographie est une bonne interprétation du thème de la mère et de l'enfant, tandis que la palette des tons, bien qu'elle ait, de toute évidence, été ombrée, a créé une atmosphère remarquable.

144

Photographer Maurice K. Walker
Camera MPP
Lens 210mm Schneider
Film Plus X

A beautifully clear picture of a jay (garrulus glandarius) at the nest. In spite of the use of flash the texture rendering is brilliant and the whole photograph is most informative.

Ein schönes deutliches Bild eines Eichelhähers (garrulus glandarius) im Nest. Trotzdem von einem Blitzlicht Gebrauch gemacht wurde, ist die Textur brillant wiedergegeben, und die ganze Aufnahme ist ausserordentlich aufschlussreich.

Een mooie heldere opname van een vlaamse gaai (Garrulus glandarius) op het nest. Ondanks het gebruik van flitslicht is de wijze waarop het patroon van de veren is weergegeven briljant, terwijl de hele foto zeer informatief is.

He aquí una hermosa imagen de un arrendajo (Garrulus glandarius) en su nido. A pesar de que se utilizó el flash, la textura resulta harto brillante, confiriendo a la instantánea un elevado valor informativo.

Magnifique photographie – qui se signale par sa clarté – d'un geai (garrulus glandarius) dans son nid. En dépit du recours au flash, la texture est brillamment rendue et la photographie dans son ensemble est remarquablement expressive.

145

Photographer Anthony J. Bond, FRPS
Camera Mamiya C 330
Lens 80mm Sekor
Film Tri-X

Another exceptionally good flash shot, this time by night. The author has exposed at exactly the right moment to capture the wing spread and included enough background to show the owls' natural environment.

Noch eine ausserordentlich erfolgreiche Blitzaufnahme, dieses Mal bei Nacht. Der Künstler hat genau im richtigen Augenblick belichtet, um die Flügel in gehobener Lage zu erfassen. Das Bild enthält genügend Hintergrund, um die natürliche Umwelt der Eule anzudeuten.

Nog een erg goede flitsfoto, nu 's nachts gemaakt. De fotograaf belichtte precies op het juiste moment om de gespreide vleugels vast te leggen en toont voldoende achtergrond om de natuurlijke ambience van de uil weer te geven.

Otra excepcional instantánea obtenida con flash, esta vez de noche. El autor ha efectuado la exposición en el momento exacto para captar el ala abierta y ha incluido los suficientes elementos para mostrar el medio natural del búho.

Autre photohraphie prise au flash particulièrement réussie, cette fois de nuit. L'auteur a su déclencher exactement au moment voulu pour saisir le battement d'aile et a mis juste ce qu'il fallait d'arrière-plan pour montrer l'environnement naturel des hiboux.

146

Photographer Erwin Kneidinger

A characteristic and lively portrait of jazzman Elvin Jones which has caught a vital expression and also achieved a lot of sparkle as a result of having the highlights in the foreground out of focus.

Ein charakteristisches, lebensvolles Porträt des Jazzsängers Elvin Jones mit intensivem Gesichtsausdruck. Die unscharfen Glanzlichter im Vordergrund erzeugen eine funkelnde Wirkung.

Een karakteristiek portret van jazzmusicus Elvin Jones, waarin een levendige expressie is vastgelegd en dat een sprankelend effect kreeg doordat de hoge lichten in de voorgrond onscherp zijn weergegeven.

Tenemos aquí un retrato característico y lleno de vida del músico de jazz Elvin Jones, al que se ha captado de forma harto expresiva. Por otra parta, la situación de las toques de luz en primer plano ha conferido a la instantánea una alegría "chispeante".

Portrait caractéristique et vivant du joueur de jazz Elvin Jones, qui a saisi une expression essentielle et qui se signale par son éclat, dû au fait que les spots du premier plan sont hors champ.

147

Photographer Pavol Schramko
Camera Praktica FX
Film Orwo 20

A very unusual and creative composition which was apparently made by enlarging the petals of a flower to give an effect like a diffraction filter but more interesting because of the grain. It certainly concentrates interest on the centre of the picture.

Eine sehr ungewöhnliche, schöpferische Komposition, die anscheinend durch Vergrössern von Blumenblättern erzielt wurde. Der Effekt ist wie bei einem Beugungsfilter, doch infolge der Körnigkeit interessanter. Jedenfalls wird das Interesse ganz auf die Mitte des Bildes konzentriert.

Een heel ongewone en creatieve compositie, kennelijk gemaakt door de blaadjes van een bloem te vergroten zodat het lijkt alsof een diffractiefilter werd toegepast. De korrel verhoogt het effect. Het geheel leidde zonder meer tot een goede concentratie van de aandacht op het midden van de foto.

Composición insólita y creativa obtenida aparentemente ampliando los pétalos de una flor para conseguir un efecto parecido al producido por un filtro de difracción, pero más interesante en este caso gracias al grano. La consecuencia directa es la concentración del interés en el centro de la imagen.

Composition très insolite et extrêmement évocatrice qui a apparemment été obtenue par agrandissement des pétales d'une fleur pour donner un effet semblable à celui que l'on obtiendrait avec un filtre à diffraction, mais plus intéressant en raison du grain. Elle concentre indubitablement l'intérêt sur le centre de la photographie.

148

Photographer Oleg Burbowskij

A portrait of the Russian athlete, Vaschenko, which is conventional and almost static in pose, but which has been given a powerful impact and an impression of strength held in check, by the contrast in tones, elimination of detail and the large areas of rich black.

Ein herkömmliches und nahezu statisches Porträt des russischen Athleten Vaschenko, dem jedoch durch den Tonkontrast eine intensive Wirkung und ein Ausdruck verhaltener Stärke verliehen wurde. Auch die Ausschaltung von Details und die grossen tiefschwarzen Flächen tragen zu der Wirkung bei.

Een portret van de Russische atleet Vaschenko dat conventioneel en bijna statisch van pose is, maar dat een krachtige uitwerking kreeg, alsmede een indruk van ingehouden kracht, door het contrast in toonwaarden. Het weglaten van details en de grote zwarte partijen droegen er ook aan bij.

Retrato del atleta ruso Vaschenko. Resulta convencional y profundamente estático, pero produce un fuerte impacto y despierta la sensación de encontrarnos frente a una carga considerable de energía, a través del contraste de tonos, la eliminación de los detalles y la inclusión de grandes zonas negras.

Portrait de l'athlète russe Vaschenko, très classique et presque statique dans sa pose, mais qui a reçu un puissant impact et une impression de force contenue par le contraste des tons. L'élimination des détails et les vastes zones de noirs riches ont également contribué à donner cet effet.

149

Photographer David Balsells
Camera Nikkormat FT 2
Lens 24mm
Film HP 5

Pregnancy used to be a dark secret until the birth, but a healthier attitude today means that women are proud to show their figures in public. In this portrait entitled Maternidad the low viewpoint and wide angle lens have actually been employed to exaggerate the swollen figure and make a most original picture of a state rather than a person.

Schwangerschaft pflegte bis zur Entbindung geheim gehalten zu werden, doch die heute vorherrschende gesündere Einstellung bedeutet, dass die Frauen nicht mehr fürchten, sich in diesem Zustand in der Öffentlichkeit zu zeigen. In diesem Porträt mit dem Titel Maternidad wurde der Effekt durch die Froschperspektive und das Weitwinkelobjektiv noch verstärkt. Das Ergebnis ist ein äusserst originelles Bild, dessen Thema ein Zustand und nicht die Person bildet.

Vroeger was zwangerschap een duister geheim tot aan de geboorte, maar een gezondere instelling tegenwoordig heeft ertoe geleid dat de vrouwen niet bang meer zijn om hun figuur te tonen. In dit portret werden het lage standpunt en het groothoekobjectief benut om de gezwollen figuur te benadrukken en een bijzonder originele foto te maken ven een positie meer dan van een persoon.

No hace tanto tiempo que el embarazo se mantenía casi en secreto hasta el momento del parto, pero la visión desinhibida que hoy predomina sobre el tema incita a las mujeres a mostrar su figura en público. En este retrato, titulado *Maternidad*, se ha utilizado el punto de vista bajo y el objetivo gran angular para exagerar la curva del vientre y obtener así más bien la representación de un estado que la de una mujer en particular.

La grossesse était jadis un secret que l'on gardait jalousement jusqu'à la naissance; aujourd'hui, une attitude plus saine traduit le fait que les femmes ne craignent plus de montrer leur corps en public. Sur ce portrait intitulé "Maternidad" (Maternité), la prise de vue en contre-plongée et le grand angle ont, en fait, été utilisés pour exagérer le corps gonflé et donner ainsi une photographie des plus originales d'un état plutôt que d'une personne.

150

Photographer Joyce Newcombe, ARPS
Camera Bronica
Film Tri-X

This would have been rather a conventional studio portrait were it not for the genuine expression of anger and the excellent technique. The lower key than usual for baby subjects complements the mood.

Dies wäre ohne den echten Ausdruck des Zornes und die hervorragende Technik ein recht alltägliches Studioporträt. Die Tönung ist dunkler als sonst in Baby-Aufnahmen, was die Stimmung verstärkt.

Dit zou een tamelijk conventioneel studioportret zijn geweest, ware het niet dat de oprechte uitdrukking van boosheid en de excellente techniek het daarboven uittilden.

Este habría sido un retrato de estudio más bien convencional si no fuera por la genuina expresión de enfado y la excelente técnica. La atmósfera se ve complementada por los tonos bajos utilizados.

Cette photographie aurait été plutôt un portrait en studio classique, ne serait-ce l'expression véritable de colère et l'excellence de la technique. Le traitement plus sombre qu'il n'est d'usage pour les bébés complète l'ambiance.

151

Photographer John O'Reilly
Camera Canon
Lens 85mm
Film Tri-X

An interesting comparison with the picture opposite. Taken in domestic surroundings, the expression is natural and relaxed, but at the same time very amusing. He (she?) could almost be saying "sh sh" to the photographer, or even to the child on the opposite page!

Ein interessanter Vergleich mit dem Bild auf der gegenüberliegenden Seite. In häuslicher Umgebung aufgenommen, ist der Gesichtsausdruck natürlich und entspannt, doch gleichzeitig sehr amüsant. Man könnte fast meinen, dass er (oder sie?) "sch" zu dem Fotografen oder vielleicht gar zu dem anderen Kinde sagt.

Een interessante vergelijking met de foto op de tegenoverliggende bladzijde. Thuis opgenomen is de gelaatsuitdrukking natuurlijk en ontspannen, maar tegelijkertijd amusant. Zo te zien zegt hij (of zij) 'sssttt' tegen de fotograaf of tegen het kind op de andere bladzijde.

¡Qué diferencia entre esta imagen y la anterior! En este caso la expresión es natural y relajada y resulta ademas muy divertida. Parece como si él (o ella) intentara dirigir unas palabras al fotógrafo o al niño de la página anterior.

Intéressante comparaison avec la photographie de la page opposée. Prise dans un cadre domestique, l'expression est naturelle et détendue, mais en même temps très amusante. On pourrait presque penser qu'il (elle) fait "chut, chut" au photographe, ou même à l'enfant de la page opposée!

152

Photographer Andrej Krynicki
Camera Pentax ES
Lens 50mm Takumar
Film Plus X

An artistic figure study by this prolific Polish amateur. The pose is not unusual but look how the author has lined up the figure with the curve of the dunes in the background so that there is a rhythmic echo in the composition. In spite of the strong sun, there is plenty of detail in the shadows without destroying the bold tone scheme.

Eine künstlerische Aktstudie dieses schöpferischen Amateurs. Die Pose ist nicht ungewöhnlich, doch beachte man, wie der Künstler die Gestalt mit der Kurve der Dünen im Hintergrund ausgerichtet hat, so dass die Komposition ein rhythmisches Echo enthält. Trotz der starken Sonne lassen sich in den schattigen Bereichen reichlich Einzelheiten erkennen, ohne jedoch das kühne Tonbild zu zerstören.

Een artistieke figuurstudie van deze Poolse amateurfotograaf. De pose is niet ongewoon, maar kijk eens hoe de fotograaf de figuur in evenwicht heeft gebracht met de golving van de zandduinen in de achtergrond zodat er een ritmische herhaling in de compositie ontstond. Ondanks de felle zon is er genoeg detail in de schaduwen zonder het krachtige toonwaardenschema te verstoren.

Otro excelente estudio de este prolífico fotógrafo polaco. La pose resulta más bien convencional, pero es interesante subrayar cómo el autor ha introducido un paralelismo rítmico en la composición al alinear la figura con la curva de las dunas del fondo. A pesar del fuerte sol, abundan los detalles en las sombras sin llegar a destruir el atrevido esquema tonal.

Etude artistique de nu par ce prolifique amateur polonais. La pose n'est pas inhabituelle, mais voyez comment l'auteur a modelé le corps sur la courbe des dunes de l'arrière-plan, de sorte qu'il s'en dégage un écho rythmique dans la composition. En dépit de l'éblouissant soleil, on distingue de nombreux détails dans les ombres sans que la palette hardie des tons ait eu à en souffrir.

153

Photographer Andrzej Sawa
Camera Nikon F2
Lens 400mm
Exposure 1/1000 at f/8
Film Tri-X

Photographing coloured people in bright sunshine is not easy but the author has managed to retain tone and texture, even in the black parasol. It is also an attractive and natural outdoor portrait of considerable documentary interest.

Das Fotografieren farbiger Menschen in hellem Sonnenschein ist nicht leicht, doch dem Künstler ist es geglückt, Ton und Textur, selbst bei dem schwarzen Schirm, wiederzugeben. Dies ist übrigens ein ansprechendes, natürlich wirkendes Freiluft-Porträt von erheblichem dokumentarischem Interesse.

Het fotograferen van gekleurde personen in helder zonlicht is niet gemakkelijk, maar de fotograaf is erin geslaagd de toonwaarden en de structuur te bewaren, zelfs in de zwarte parasol. Het is een aantrekkelijk en natuurlijk daglichtportret geworden met aanzienlijke documentaire waarde.

No es fácil fotografiar a personas de color bajo la luz del sol, pero en este caso el autor ha sido capaz de captar perfectamente los tonos y texturas, incluso los de la sombrilla negra. Se trata, por tanto, de un atractivo retrato al aire libre que posee un considerable interés documental.

Il n'est pas facile de photographier des gens de couleur en plein soleil, mais l'auteur a réussi à retenir le ton et la texture jusque dans le parasol noir. C'est aussi un portrait en extérieur séduisant et naturel, du plus haut intérêt documentaire.

154

Photographer L. B. Ferešovi
Camera Minolta SR 7
Lens 58mm Rokkor
Exposure 1/60 at f/8
Film 400 ASA

Yet another picture showing that rear views are often effective, especially when the subjects are walking away from the camera. The contrast between these two subjects is amusing and the atmosphere of a dull, damp day has been well recorded.

Noch ein Bild, das zeigt, dass Aufnahmen von hinten oft wirksam sind, besonders wenn die Aufnahmeobjekte sich von der Kamera wegbewegen. Der Kontrast zwischen diesen beiden Personen ist amüsant, und die Stimmung eines trüben, feuchten Tages wurde gut erfasst.

Nog een foto met een achteraanzicht die zeer effectief is, vooral doordat de afgebeelden van de camera weglopen. Het contrast tussen de twee is leuk en de sfeer van de trieste, vochtige dag is goed weergegeven.

Otra instantánea que nos demuestra que las vistas desde atrás pueden resultar muy eficaces, especialmente si el sujeto está alejándose de la cámara. El contraste resulta en este caso realmente divertido y la atmósfera de un día lluvioso y apagado ha sido captada con gran fidelidad.

Voici encore une autre photographie qui montre que les vues de dos sont souvent expressives, en particulier lorsque les sujets s'éloignent de l'appareil. Le contraste entre les deux sujets est amusant et l'ambiance d'une journée terne et humide a été bien saisie.

155

Photographer Mike Hollist
Camera Nikon
Lens 105mm
Exposure 1/30 at f/2.5
Film Tri-X

A very natural picture that will appeal to all mothers who have struggled to dress a restless child. The young mother's expression says it all! The author has chosen his moment well.

Ein sehr natürliches Bild, das alle Mütter, die je ein zappeliges Kind anziehen mussten, ansprechen wird. Der Gesichtsausdruck der jungen Mutter spricht Bände! Der Künstler hat gerade den richtigen Augenblick gewählt.

Deze foto zal alle moeders aanspreken die wel eens problemen hadden een weerbarstig kind aan te kleden. De expressie van de jonge moeder op de foto spreekt boekdelen! Het moment is goed gekozen.

Una imagen muy natural que seducirá probablemente a todas las madres que más de una vez han tenido que librar una fiera batalla para vestir a sus hijos. El autor ha elegido muy bien el momento para trasladarnos el estado de ánimo de la madre a través de su expresión.

Photographie très naturelle qui saura émouvoir toutes les mères qui ont eu à lutter pour habiller un enfant turbulent. L'expression de la jeune mère en dit long! L'auteur a su choisir son moment.

156

Photographer W. H. Murenbeeld
Camera Nikon Ftn
Lens 500mm Nikkor mirror lens

A dynamic action picture shot at just the right moment. It shows Don Sweet kicking in a match against the Eskimos in Ottawa. The out of focus crowd in the background shows the characteristic "doughnut rings" produced by mirror lenses.

Eine dynamische Aktionsaufnahme gerade im richtigen Moment. Sie zeigt Don Sweet, wie er in einem Kampf gegen die Eskimos in Ottawa den Ball schiesst. Die verschwommene Zuschauermenge im Hintergrund weist die charakteristischen "Doughnut Rings" auf, die durch Spiegelobjektive verursacht werden.

Een dynamische actiefoto die juist op het goede moment werd gemaakt. In de onscherpe menigte in de achtergrond is duidelijk te zien dat een spiegelobjectief werd gebruikt door de karakteristieke ringvormige lichten.

He aquí una instantánea de acción obtenida en el momento justo. En ella vemos a Don Sweet efectuando una jugada en un partido disputado contra Los Esquimales en Ottawa. En la multitud desenfocada del fondo aparecen los clásicos "anillos" producidos por los objetivos de espejo.

Photographie d'action dynamique, prise juste au moment voulu. Elle montre Don Sweet en train de lancer le ballon lors d'un match contre les Esquimaux à Ottawa. La foule hors champ de l'arrière-plan présente les "ronds de crêpe" caractéristiques des objectifs à miroir.

157

Photographer Dave Hartley
Camera Nikon F2
Lens 50mm Nikkor
Exposure 1/250 at f/1.4
Film HP5

A picture taken during a basketball match between disabled and able bodied persons at Wantage Sports Centre, Oxfordshire. Apart from the action and other photographic qualities it is also a picture with a message.

Ein während eines Korbballspiels zwischen körperbehinderten und gesunden Menschen im Wantage Sports Centre, Oxfordshire, aufgenommenes Bild. Abgesehen von seiner Dynamik und anderen fotografischen Merkmalen ist es auch ein Bild mit einer Botschaft.

Deze foto werd gemaakt tijdens een basketball-wedstrijd tussen gehandicapte sportbeoefenaren. Los van de actie en andere fotografische kwaliteiten is het ook een foto met een boodschap.

Esta imagen se tomó durante el curso de un partido de baloncesto que enfrentó a disminuidos físicos y personas normales en el Wantage Sports Centre de Oxfordshire. Dejando de lado la acción y las cualidades fotográficas que la instantánea posee, hay que destacar que nos traslada un importante mensaje.

Photographie prise au cours d'un match de basket-ball disputé entre des handicapés et des non-handicapés au Wantage Sports Centre, Oxfordshire. Outre l'action qu'elle traduit et ses autres qualités photographiques, cette image est aussi chargée d'un message.

158

Photographer John Davidson

The dramatic effect of stage lighting with dark backgrounds when the star is lit by a spotlight, is well evident in this very natural shot. The photo-grapher cannot control the lighting but he can choose his viewpoint as a rule and that has been done here to good effect.

Die dramatische Wirkung der Bühnenbeleuchtung, die, wenn der Star im Lichte eines Scheinwerfers steht, dunkle Hintergründe erzeugt, ist in dieser sehr natürlichen Aufnahme offensichtlich. Der Fotograf kann auf die Beleuchtung keinen Einfluss ausüben, doch kann er in der Regel seinen Standpunkt wählen, und dies ist hier mit grossem Erfolg geschehen. Gegenstand des Bildes ist der Komiker Ben Warriss.

Het effect van de toneelverlichting, die donkere achtergronden ten gevolge heeft als de ster door een spotlight wordt verlicht, is duidelijk zichtbaar in deze opname. De fotograaf kan wel zijn standpunt zorgvuldig uitkiezen en dat is hier dan ook gebeurd.

En esta instantánea se refleja claramente el dramático efecto obtenido al iluminar a un artista con un foco para fotografiarlo en el escenario contra un fondo obscuro. Evidentemente el fotógrafo no puede controlar la iluminación; pero sí pueda, como ha hecho en este caso, elegir el punto de vista más adecuado.

L'effet saisissant de l'éclairage de scène qui engendre des arrière-plans sombres lorsque la vedette est éclairée par un spot est tout à fait évident sur cette photographie très naturelle. Le photographe ne peut agir sur l'éclairage, mais il peut généralement choisir son point de vue, et c'est ce qui a été fait ici avec bonheur. Le sujet est le comédien Ben Warriss.

159

Photographer Mike Hollist
Camera Nikon
Lens 20mm
Exposure 1/15 at f/4
Film Tri-X

A marvellous portrait of Count Basie, the world famous jazz pianist, talking about his music. His pose and expression is so characteristic and unselfconscious while the setting and the background are full of interest.

Ein wunderbares Porträt von Count Basie, dem berühmten Jazz-Klavierspieler, der über seine Musik spricht. Seine Haltung und der Gesichtsausdruck sind kennzeichnend und völlig natürlich, und sowohl die Szene als auch der Hintergrund sind sehr interessant.

Een subliem portret van Count Basie, de wereldberoemde jazzpianist, pratend over zijn muziek. Zijn pose en gelaats-uitdrukking zijn karakteristiek en ongedwon-gen, terwijl de omgeving en achtergrond interessant zijn.

Maravilloso retrato del famoso pianista Count Basie hablando de su música. El autor, reportero del *Daily Mail,* ha captado al modelo en una de sus expresiones más características sin renunciar a la inclusión de un fondo dotado de especial interés.

Merveilleux portrait de Count Basie, le pianiste de jazz célèbre dans le monde entier, parlant de sa musique. Sa pose et son expression sont caractéristiques et naturelles, tandis que le décor et l'arrière-plan sont pleins d'intérêt.

160

Photographer Stanislav Trzaska
Camera Nikon F2
Lens 24mm Nikkor
Film Tri-X

A carefully posed scene which has a lot of charm and atmosphere. Contrasts in subject matter as well as in tone give plenty of interest and this is yet another picture which is typical of the romantic figure work coming from Poland today.

Eine sorgfältig gestaltete Szene mit viel Charme und Stimmung. Die Kontraste zwischen den Modellen und in der Tönung verleihen dem Bild erhebliches Interesse. Auch diese Aussenaufnahme ist für die romantischen Aktstudien aus dem modernen Polen typisch.

Een zorgvuldig geposeerde scène met veel charme en atmosfeer. De contrasten zowel in het onderwerp als in de toonwaarden houden de aandacht gevangen. Deze foto is kenmerkend voor het romantische werk dat tegenwoordig uit Polen komt.

Imagen cuidadosamente estudiada para que resulte lo más agradable posible. Los contrastes presentes en el tema y también en la tonalidad acentúan el interés de la instantánea, a la que hay que inscribir en la abundante serie de trabajos de corte romántico que tanto prodigan en la actualidad los fotógrafos polacos.

Scène soigneusement posée, tout empreinte de charme et d'ambiance. Les contrastes tant chez le sujet que dans le ton confèrent à cette photographie un maximum d'intérêt, et c'est encore un autre exemple caractéristique des photographies romantiques qui nous viennent aujourd'hui de Pologne.

161

Photographer Michael Barrington-Martin
Film Agfacontour 9 × 12 cm

This is a superb example of an appropriate use of the intriguing, but not always predictable, Agfacontour process by which many colour combinations can be obtained from the same subject.

Hier haben wir ein hervorragendes Beispiel der richtigen Verwendung des interessanten Agfacontour-Prozesses, dessen Ergebnisse sich nicht immer im voraus bestimmen lassen, bei denen man aber mit dem gleichen Motiv zahlreiche Farbkombinationen erzielen kann.

Dit is een fraai voorbeeld van een passend gebruik van het intrigerende, maar niet altijd voorspelbare, Agfacontour-procédé waarmee veel kleur-combinaties kunnen worden verkregen van het zelfde onderwerp.

He aquí una excelente muestra de la utilización apropiada del intrigante y no siempre controlable proceso Agfacontour que permite obtener varias combinaciones cromáticas en un mismo sujeto.

Nous avons là un magnifique exemple de l'utilisation judicieuse du procédé Agfacontour, au résultat étonnant mais pas toujours prévisible, qui permet d'obtenir de nombreuses combinaisons de couleurs à partir du même sujet.

162 (Upper)

Photographer A. Coats
Film Agfa CT21

A pleasing study in which the subject is incidental to the movement. The use of daylight type film in artificial lighting has given an overall warmth which is appropriate, and the whole composition has caught the authentic atmosphere of a dance hall.

Eine hübsche Studie, in der das Motiv weniger wichtig ist als die Bewegung. Durch Gebrauch eines Tageslichtfilms in künstlicher Beleuchtung wurde mit gutem Effekt ein Eindruck allgemeiner Wärme erzielt. Die ganze Komposition bringt die in einem Tanzsaal vorherrschende Atmosphäre einwandfrei zum Ausdruck. Während der Belichtung wurde die Kamera geschwenkt.

Een interessante studie, waarin het onderwerp ondergeschikt is aan de beweging. Het gebruik van daglichtfilm bij kunstlicht gaf een warme sfeer die karakteristiek is voor een balzaal. Meegetrokken gedurende de belichting.

Agradable estudio en el que el movimiento se convierte en característica fundamental. La utilización de una película para luz natural con iluminación artificial ha introducido una apropiada impresión emotiva, mientras que la composición refleja perfectamente la atmósfera típica de un salón de baile.

Plaisante étude dans laquelle le sujet est secondaire par rapport au mouvement. L'utilisation d'une pellicule "lumière du jour" sous un éclairage artificiel a donné une chaleur particulièrement appropriée, tandis que la composition dans son ensemble reflète bien l'atmosphère d'une salle de danse. L'appareil a panoramiqué pendant l'exposition.

162 (Lower)
Photographer W. H. Humphreys

A picture full of the vitality and eagerness of boys begging for "baksheesh". The author has emphasised the movement by tilting the camera to produce strong diagonals, and the high viewpoint will awake memories in many who have taken coach tours abroad.

Ein lebensvolles Bild dieser Knaben, die in Kalkutta um eine Gabe bitten. Der Künstler hat die Bewegung durch Schrägstellen der Kamera betont, was kräftige Diagonalen ergibt, und der hochgelegene Aufnahmestandpunkt dürfte bei manchem, der das Ausland im Omnibus bereist hat, Erinnerungen erwecken.

Een foto vol van de vitaliteit en begerigheid van om 'baksheesh' vragende jongens in Calcutta. De auteur legde de nadruk op de beweging door de camera te kantelen zodat sterke diagonalen ontstonden. Het hoge standpunt zal herinneringen oproepen bij velen die wel eens busreizen naar het buitenland maakten.

El autor ha captado a maravilla el ansia y la emotividad de estos ninos mendigando "baksheesh". La inclinación de la cámara ha producido fuertes diagonales, que acentúan el movimiento, y el punto de vista alto despertará seguramente las sensaciones dormidas en el inconsciente de las personas que hayan efectuado viajes turísticos por zonas subdesarrolladas.

Photographie pleine de vitalité et d'ardeur de jeunes garçons mendiant un pourboire à Calcutta. L'auteur a renforcé le mouvement en inclinant l'appareil pour engendrer de puissantes diagonales, et l'angle de vue en forte plongée ravivera les souvenirs de bon nombre de ceux qui ont fait des voyages organisés en autocar á l'étranger.

163
Photographer Vlado Bača
Camera Mamiya RB 67S
Exposure 1/90 at f/38
Film Agfachrome Professional 50L

A conventional but beautifully executed portrait study which makes good use of an attractive profile and a soft focus treatment. It is in contrast to the bulk of the work received from Czechoslovakia depicting harsher subjects in very strong and contrasty tones.

Eine traditionelle aber wunderschön ausgeführte Porträtstudie, bei der das ansprechende Profil durch Weichzeichnen gut wiedergegeben wurde. Diese Aufnahme ist anders als die meisten aus der Tschechoslowakei eingereichten Fotografien, die in der Regel ernstere Themen in sehr kräftigen und kontrastreichen Tönen darstellen.

Een conventioneel, maar schitterend uitgevoerd portret waarbij een goed gebruik werd gemaakt van het attractieve profiel en van een softfocus-behandeling. Het vormt een contrast met het merendeel van het uit Tsjechoslovakije ontvangen werk.

He aquí un retrato de estudio convencional, pero artísticamente ejecutado, en el que se ha sacado un excelente partido del atractivo perfil de la modelo y del tratamiento de foco suave. No concuerda con la tendencia general de las fotos recibidas este año de Checoslovaquia, en las que abundan los temas enérgicos tratados con fuertes tonalidades contrastantes.

Etude de portrait classique mais magnifiquement exécutée, dans laquelle l'auteur a su tirer le meilleur parti d'un profil séduisant et d'un traitement flou. Elle contraste avec la plupart des photographies reçues de Tchécoslovaquie, qui présentent des sujets beaucoup plus durs dans des tons très accusés et contrastés.

164 (Upper)
Photographer David Morey
Camera Canon A1
Lens 50mm
Film Kodachrome 25

It was inevitable that this year's entry should produce a number of photographs employing a Cokin Cosmos diffraction filter, and this one was the best. It has actually been taken of a puddle in which a strong highlight has given the filter effect full rein. A polarising filter was also used to sharpen the effect and reduce other reflections.

Es lag auf der Hand, dass wir dieses Jahr eine Anzahl von Bildern erhalten würden, die mit Hilfe eines Cokin Cosmos Beugungsfilters aufgenommen wurden. Dieses war eines der besten. In der Tat zeigt es eine Wasserlache, in der ein kräftiges Glanzlicht die Filterwirkung ganz zur Geltung bringt. Um die Wirkung zu erhöhen und andere Reflektionen einzuschränken, wurde auch von einem Polarisierfilter Gebrauch gemacht.

Het lag voor de hand dat bij de inzendingen van dit jaar er een aantal zou zijn die werden gemaakt met behulp van een 'regenboog'-filter. Deze, gemaakt met een Cokin Galaxie filter, was de beste. Het onderwerp was een plas waarin een lichtbron reflecteerde, zodanig dat het filter volledig tot zijn recht kwam. Een polarisatiefilter werd bovendien gebruikt om het effect te verscherpen en om andere reflecties te onderdrukken.

Era inevitable que este año nos llegaran bastantes fotografías obtenidas con un filtro de difracción Cokin Cosmos; ésta nos parece la mejor de todas ellas. Las luces altas concentradas en el charco han subrayado el efecto introducido por el filtro de difracción, y para reducir los demás reflejos el autor se ha servido además de un filtro polarizador.

Parmi les photographies de cette année, il était inévitable d'en trouver un certain nombre prises avec interposition d'un filtre à diffraction Cokin Cosmos, et celle-ci a été jugée la meilleure. Elle représente une flaque d'eau dans laquelle un puissant faisceau lumineux a permis à l'effet de filtre de se manifester sans restriction. Un filtre polarisant a, d'autre part, été utilisé pour renforcer l'effet et réduire les autres réflexions.

164 (Lower)
Photographer Frank Martin, FIIP
Camera Petri TTL
Lens Petri 70–230mm 200mm
Film Kodachrome 64

This well known mountain photographer has made good use of the evening light to produce a marvellous atmosphere. The planes were well separated by the low sun and this gives a great impression of depth, while the dark foreground helps to emphasise the height and majesty of the peak which reaches 6,352 metres. It is in the Himalayas and is called Berthartoli Himal.

Dieser bekannte Gebirgsfotograf hat das Abendlicht gut verwertet, um eine wunderbare Stimmung zu erzielen. Die Ebenen waren durch die tiefe Sonne gut getrennt, und dies ergibt einen erheblichen Eindruck von Tiefe, während der dunkle Vordergrund die Majestät des 6 352 m hohen Berges hervorhebt. Es ist dies der Berthartoli Himal im Himalaja-Gebirge.

Een goed gebruik werd hier gemaakt van het avondlicht om een fijne sfeer te creëren. Door het effect van de lage zon ontstond een grote dieptewerking, terwijl de donkere voorgrond meehelpt de hoogte en de massiviteit van de top van de 'Berthartoli Himal' in de Himalaya met zijn 6,352 meter te benadrukken.

Este fotógrafo, muy aficionado a la captación de escenas de montaña, ha utilizado aquí la luz crepuscular para obtener una atmósfera de fantasía. La separación de los planos por el sol, muy bajo en el cielo, ha incrementado la sensación de profundidad, mientras que la oscuridad del primer plano acentúa la altura y majestuosidad de la cumbre, que alcanza 6.352 metros. Esta, integrada en la cordillera himaláyica, es conocida con el nombre de Berthartoli Himal.

Ce célèbre photographe de montagnes a su tirer le meilleur parti de la lumière du soir pour engendrer une merveilleuse atmosphère. Les plans sont bien séparés par le soleil couchant, et cela donne une bonne impression de profondeur, tandis que le sombre premier plan contribue à souligner la hauteur et la majesté du pic qui s'élève à 6 352 mètres. Il s'agit d'un des sommets de la chaîne de l'Himalaya, connu sous le nom de Berthartoli Himal.

165
Photographer Robert Hallmann
Camera Kowa 66
Film Agfa 50L

Aptly and topically entitled "Star Wars" this multiple exposure, made in the camera, well illustrates the fantasy theme of the popular film.

Diese Aufnahme, die den treffenden Titel "Star Wars" trägt und das Fantasie-Thema des beliebten Filmes auf originelle Weise behandelt, wurde durch Mehrfachbelichtung in der Kamera erzielt. Die Robotermodelle waren 5 bzw. 10 cm hoch.

Deze meervoudige belichting, getiteld 'Star Wars', werd in de camera gemaakt en illustreert het thema van de bekende film. De robots waren ca. 5 en 10 cm hoog.

Esta instantánea, obtenida mediante una exposición múltiple, recoge perfectamente la atmósfera fantástica sugerida por su título: La guerra de las galaxias.

Judicieusement intitulée "Star Wars" (Guerres d'étoiles), cette exposition multiple obtenue dans l'appareil au moyen d'une bande d'une trentaine de centimètres de longueur de lumière noire illustre bien la fantaisie du film populaire. Les robots modèles avaient respectivement 50 mm et 100 mm de hauteur.

166 (Upper)
Photographer Phil Mahre
Film Kodachrome

Another very fine ski shot which manages to be different from the majority. The inclusion of a Lake Placid flag shows the location and its upright lines contrast with the diagonal made by the skier, thus heightening the impression of speed associated with a slalom.

Noch eine sehr schöne Skiaufnahme, die sich von den meisten Aufnahmen dieses Genres unterscheidet. Durch Einbeziehung der Lake Placid-Flagge ist erkenntlich, wo das Bild aufgenommen wurde, und die aufrechten Linien kontrastieren mit der durch den Skiläufer gebildeten Diagonale. Dies unterstreicht den beim Slalomlauf üblichen Eindruck hoher Geschwindigkeit.

Deze fijne skifoto slaagt erin verschillend te zijn van de meerderheid. Het in de foto betrekken van de Lake Placid vlag geeft de lokatie aan. De verticale lijnen daarvan contrasteren met de diagonaal van de skiër, waardoor de indruk van snelheid die altijd met een slalom gepaard gaat werd versterkt.

Una excelente imagen de esquí cuyas características le confieren una originalidad muy particular. La inclusión de la bandera de Lake Placid nos hace saber dónde ha sido tomada; y sus líneas verticales contrastan vivamente con la diagonal determinada por el esquiador, con lo que se acentúa la sensación de velocidad ya de por sí asociada al slalom.

Autre très belle photographie de ski, qui tranche sur la plupart de celles que l'on voit habituellement. La présence du drapeau de Lake Placid indique l'endroit dont il s'agit et ses lignes verticales contrastent avec la diagonale constituée par le skieur, rehaussant ainsi l'impression de vitesse associée à un slalom.

166 (Lower)

Photographer	Lee Jenn Shyong
Camera	Minolta
Lens	17mm
Shutter Speed	1/250
Aperture	f/8
Film	Fujicolor

Taken from an Ektacolor print, this picture shows the great "joie de vivre" evinced by the attractive dancers contrasted with a sombre background. The *contre-jour* lighting and the halation add a lot of sparkle and create a most artistic effect.

Dieses Bild, das auf einer Ektacolor-Kopie beruht, kontrastiert die grosse Lebensfreude der hübschen Tänzerinnen mit einem düsteren Hintergrund. Das Gegenlicht und der Lichthof tragen sehr zu der Lebendigkeit bei und bewirken ein ausserordentlich künstlerisches Ergebnis.

Gereproduceerd van een vergroting op Ektacolor-papier, toont deze foto de "joi-de-vivre", aan de dag gelegd door de charmante danseressen die hier contrasteren met de sombere achtergrond. Het tegenlicht en de overstraling zorgen voor een sprankelend effect.

Reproducida a partir de una copia Ektacolor, esta imagen constituye una perfecta representación de la más elemental alegría de vivir, encarnada en el contraste entre las atractivas bailarinas y el fondo obscuro. La iluminación a contraluz y el halo se combinan para producir un efecto de gran eficacia artística.

Reprise d'un tirage sur Ektacolor, cette photographie traduit la joie de vivre qui émane des séduisantes danseuses qui se détachent sur un sombre arrière-plan. L'éclairage en contre-jour et le halo ajoutent beaucoup d'éclat, et engendrent ainsi un effet des plus artistiques.

167 (Upper)

Photographer	M. R. Owaisi
Camera	Canon AE-1
Exposure	1/60
Film	Kodacolor II

A fine example of "panning" with the movement and very well timed to obtain just the right amount of movement in the subject and to place it well in the picture space. The overall warmth of colour is most appropriate for this sport which is usually found in tropical or desert areas.

Ein schönes Beispiel für das "Mitschwenken" mit der Bewegung und mit sehr gutem Zeitgefühl ausgeführt. Der Eindruck der Bewegung ist gerade richtig, und der Reiter und sein Pferd passen gut in die Bildfläche. Die allgemein warmen Farben entsprechen sehr gut diesem Sport, der normalerweise in den Tropen oder in der Wüste ausgeübt wird.

Een goed voorbeeld van meegetrokken camera, goed getimed om de juiste hoeveelheid beweging in het motief te krijgen om dit goed in het beeldveld onder te brengen. De overheersende warme kleur is kenmerkend voor deze sport die in tropische (woestijn-)gebieden wordt beoefend.

Una excelente muestra de barrido, cuya perfecta realización ha permitido introducir el grado de movimiento exactamente requerido así como situar al tema en la posición más conveniente.

Bel exemple de "panoramiquage" associé au mouvement, avec un excellent minutage qui a permis d'obtenir exactement la quantité de mouvement voulue chez le sujet et de le placer dans les limites de la photographie. La chaleur qui se dégage de la couleur est particulièrement appropriée à ce sport, qui se pratique généralement dans les régions tropicales ou désertiques.

167 (Lower)

Photographer	G. Leighton

One of a series depicting pop singers and their groups. This is better than most as it does not appear to be unduly forced in development, and the atmosphere is authentic. Some might see some humour in the "three-armed" figure, or even a significant message!

Diese Aufnahme gehört einer Reihe an, deren Thema Pop-Sänger und ihre Gruppen sind. Diese Aufnahme ist besser als die meisten ihrer Art, da die Entwicklung nicht zu künstlich zu sein scheint und die Stimmung echt wirkt. Die "drei Arme" sind übrigens humorvoll, und man könnte sogar meinen, dass das Bild eine wichtige Botschaft enthält! Der Sänger ist Judas Priest, ein Mitglied einer "Heavy Rock Band", während einer Aufführung in der Sheffield Town Hall.

Een opname uit een serie over popzangers en hun groepen. Deze is beter dan de meeste omdat de sfeer autentiek is. Sommigen zien misschien enige humor in de figuur met de drie armen.

Esta instantánea forma parte de una serie dedicada a los cantantes y grupos pop, y posee una calidad especial, ya que no parece haber sido forzada en el revelado y refleja una atmósfera auténtica. Puede que algunas personas piensen que se esconde algún mensaje en la figura de "tres brazos".

Photographie extraite d'une série consacrée à des chanteurs pop et à leurs groupes. Celle-ci est meilleure que la plupart des autres du fait qu'elle ne semble pas avoir été indûment forcée au développement et que l'atmosphère est authentique. Certains verront peut-être une touche d'humour, voire un message significatif, dans le chanteur "à trois bras"! Le sujet est Judas Priest, membre d'un orchestre de rock particulièrement "musclé", pris lors d'une représentation à l'Hôtel de Ville de Sheffield.

168

Photographer	Giuseppe Balla
Camera	Canon F1
Lens	24mm
Exposure	1/15 at f/8
Film	Kodachrome 25

An expression of the eternal relationship is given powerful and imaginative treatment in this picture entitled "Tentazione". It is beautifully composed in form and in colour and the contrast between the silhouetted male and the sensuously rendered nude is striking.

In diesem Bild, das den Titel "Tentazione" trägt, wird der ewigen Beziehung dynamischer, fantasiereicher Ausdruck verliehen. Die Komposition in Form und Farbe ist sehr gelungen, und der Kontrast zwischen der Silhouette des Mannes und dem sinnlich wirkenden nackten Modell ist eindrucksvoll.

Een expressie van de eeuwenoude relatie tussen man en vrouw kreeg een krachtige en fantasierijke behandeling in deze opname die is getiteld 'Tentazione'. De compositie is zowel wat kleur als wat vorm betreft erg fraai, terwijl het contrast tussen de als silhouet weergegeven man en het sensueel poserende naakt treffend is.

En esta instantánea, denominada *Tentazione*, se da un tratamiento poderosamente imaginativo a las relaciones amorosas. La composición es perfecta, tanto en los aspectos formales como en los cromáticos, y el contraste entre la silueta masculina y el desnudo femenino posee un fuerte impacto sensual.

Sur cette photographie intitulée "Tentazione" (Tentation), la relation éternelle a été exprimée par une touche puissante et pleine d'imagination. Elle est magnifiquement composée tant du point de vue de la forme que de celui de la couleur, tandis que le contraste entre la silhouette masculine et le nu sensuellement traduit est saisissant.

169

Photographer	Leslie Thompson
Camera	Olympus OM-1
Exposure	1/30 at f/2.8
Film	Kodachrome 64

A powerful portrait, entitled "Rose", which typifies modern young womanhood, not only because of the masculine cap but because of the confident expression on her face. The whole mood is emphasised by sharp definition and strong contrasts. This has been reproduced from a 10 × 8 in Cibachrome print.

Dieses wirkungsvolle Porträt, das den Titel "Rosa" trägt, zeigt eine junge Frau, die nicht nur wegen der männlich wirkenden Kappe sondern auch infolge des zuversichtlichen Gesichtsausdrucks ausserordentlich modern wirkt. Die ganze Stimmung ist durch Bildschärfe und starke Kontraste betont. Reproduktion aufgrund einer 25 × 20 cm Cibachrome-Kopie.

Een sterk portret, getiteld 'Rose', waarin de moderne jonge vrouw wordt getypeerd, niet alleen door de mannelijke pet, maar ook door de zelfbewuste gelaatsuitdrukking. De gehele sfeer is benadrukt door een goede detaillering en sterke contrasten. De reprodukte werd gemaakt van een vergroting op Cibachrome-papier.

He aquí un delicioso retrato, reproducido a partir de una copia Cibachrome de 24 × 18 cm, en el que la gorra masculina y la expresión resuelta resumen las características de las jóvenes de hoy. La nítida definición y el fuerte contraste dan énfasis a la atmósfera creada. El título es *Rosa*.

Puissant portrait intitulé "Rose", typique de la jeune féminité moderne, non seulement en raison de la casquette masculine mais aussi du fait de l'expression confiante du visage. Toute l'atmosphère est renforcée par une nette définition et par de puissants contrastes. Cette photographie a été reproduite à partir d'un tirage sur Cibachrome en 10 × 8 pouces.

170 (Upper)

Photographer	Wendy Alldis

It is typical of the originality of idea and simplicity of approach which is seen in many young peoples' work and represents a healthy trend.

Die Originalität und Einfachheit der angewandten Mittel sind für die Arbeiten vieler junger Menschen kennzeichnend und entsprechen einer gesunden Tendenz. Die Fotografin ist einer der Gründer von *Decade 80*, einer Gruppe von Freunden des Impressionismus, die die Zukunft so darstellen wollen, wie sie sie sehen.

Deze foto, gereproduceerd van een kleurvergroting van een jonge studente van een fotoschool, is typerend voor de originaliteit van ideeën en de eenvoudige benadering die te zien zijn in het werk van veel jonge mensen.

En ella encontramos la originalidad temática y la sencillez de ejecución características de los trabajos de los fotógrafos jóvenes.

Elle traduit de manière caractéristique l'originalité de l'idée et la simplicité d'approche que l'on trouve sur les photographies de nombreux jeunes, et représente une saine tendance. L'auteur est le fondateur de *Decade 80*, groupe composé de personnes tout acquises à l'impressionnisme et à l'avenir tel qu'elles le voient.

170 (Lower)
Photographer Joan Wakelin, FRPS

Like the picture above, this shows an attractive simplicity of idea coupled with a most attractive design which defies all the so-called "rules" of composition. The subdued colour scheme is pleasing and aids the impression which has justified the title of "Desert".

Ebenso wie das vorstehende Bild, verbindet diese Aufnahme ansprechende Einfachheit mit einer serd gelungenen Komposition, die allen sogenannten "Regeln" widerstrebt. Die verhaltenen Farben sind angenehm und betonen den Eindruck, der dem Titel "Wüste" zugrundeliegt. In Sambia aufgenommen.

Ook in deze foto is de ideee simpel. De compositie is aantrekkelijk, maar ontkent alle 'regels'. Het onderdrukte kleurenschema doet plezierig aan en versterkt de impressie die titel 'Woestijn' rechtvaardigt. De opname werd gemaakt in Zambia.

Al igual que la anterior, esta instantánea presenta una atractiva sencillez temática y una gran belleza formal, obtenida a través de un originalísimo diseño que desafía las habituales "reglas" de composición. Los colores son suaves y agradables, justificando plenamente el uso del título *Desierto* por parte de la autora.

Comme la photographie ci-dessus, celle-ci traduit une remarquable simplicité d'idée, associée à une conception des plus séduisantes qui défie toutes les "règles" de la composition. Les teintes pastel des couleurs sont agréables et contribuent à donner l'impression qui a justifié le titre de "Desert" (Désert). Photographie prise en Zambie.

171 (Upper)
Photographer Derek Gould

A very imaginative version of a sunrise made by a combination of two transparencies, one of which is a pure but most attractive silhouette, while the other has employed a grain treatment to very good effect. How much more artistic and exciting than the thousands of straight sunset pictures taken by the average snapshotter!

Eine sehr fantasiereiche Darstellung eines Sonnenaufgangs, die durch Kombination von zwei Diapositiven erzielt wurde. Eines davon enthielt eine einfache aber ausserordentlich ansprechende Silhouette, während das andere mit grossem Erfolg stark vergrössert wurde, um Körnigkeit zu bewirken. Wie viel künstlerischer und interessanter ist dieses Bild als die tausenden einfachen Schnappschüsse, die man normalerweise sieht.

Een fantasierijke uitbeelding van een zonsondergang, gecreëerd door een combinatie van twee dia's, waarvan het ene een zuiver, maar wel aantrekkelijk silhouet is, terwijl het andere door vergaand uitvergroten een sterk korreleffect kreeg. Deze foto is veel artistieker en aantrekkelijker dan de duizenden gewone zonsopgang- en zonsondergangfoto's die door de gemiddelde amateurfotograaf worden gemaakt.

He aquí una imaginativa visión del alba obtenida mediante la combinación de dos diapositivas, una de las cuales está ocupada en su totalidad por una silueta mientras que la otra presenta un artístico tratamiento de grano. ¿No es verdad que resulta mucho más interesante que los miles de imágenes del crepúsculo tomadas por tantos y tantos aficionados?

Version pleine d'imagination d'un lever de soleil obtenue par la mise en sandwich de deux diapositives dont l'une est une silhouette pure mais des plus attrayantes, tandis que l'autre a été traitée lors d'un agrandissement très poussé de façon à présenter beaucoup de grain, ce qui est du plus bel effet. N'est-ce pas là une image plus artistique et plus séduisante que les milliers de photographies banales de lever ou de coucher de soleil prises directement par le photographe moyen?

171 (Lower)
Photographer Dr M. D. Constable

This amateur photographer's name is frequently seen among the prizewinners in photo magazine contests. His pictures are often of familiar subjects, but always given an original treatment such as we see here. The slide of the children alone is attractive because of the sparkle in the lighting and the intrinsic appeal of the subject, but the slide sandwiched with it has framed them very nicely and given an impression of depth.

Den Namen dieses Amateurfotografen findet man oft unter den Siegern in von Fotozeitschriften veranstalteten Wettbewerben. Die Bilder behandeln in vielen Fällen vertraute Themen, doch is die Behandlung hier stets originell. Das Diapositiv der Kinder allein ist schon wegen der Lebhaftigkeit der Beleuchtung und des dem Motiv eigenen Interesses ansprechend, doch das überlagerte Diapositiv hat einen sehr schönen Rahmen gebildet und einen Eindruck der Tiefe bewirkt. Diese Aufnahme soll den Geist des Sommers zum Ausdruck bringen.

De naam van deze amateur komt men dikwijls tegen als prijswinaar in fotowedstrijden. Zijn foto's zijn vaak van vertrouwde onderwerpen, maar vertonen altijd een originele uitwerking zoals in dit geval. Het dia van de kinderen is op zich aantrekkelijk door de fonkeling in de verlichting en door het onderwerp zelf, maar het dia waarmee het werd gesandwiched vormde een fraai kader en zorgde voor een goede diepteweking.

El nombre de este aficionado a la fotografía aparece muy a menudo en las listas de ganadores de los concursos organizados por las revistas especializadas. Elige frecuentemente temas familiares, pero les da un tratamiento muy original. La diapositiva de los niños posee por sí sola un gran atractivo, conseguido sobre todo a través de la manipulación de la luz, pero la diapositiva con la que se la combina le ha dado un contexto visual y le ha introducido una impresión de profundidad.

On voit souvent le nom de ce photographe amateur parmi les titulaires de prix des concours organisés dans les magazines de photographie. Ses photographies représentent souvent des sujets familiers, mais ont toujours une marque originale comme nous le voyons ici. La diapositive des enfants seuls est séduisante en raison de l'éclat de l'éclairage et de l'appel intrinsèque du sujet, mais la diapositive prise en sandwich avec elle a permis de

les cadrer judicieusement et a ainsi donné une impression de profondeur. Elle a été prise pour synthétiser l'ambiance de l'été.

172
Photographer Lars Oddvar Løvdahl

A very lovely portrait study somewhat similar to the approach seen in the study on page 163 by Vlado Bača, although coming from a different country. The unusual lighting has introduced a note of drama which stimulates the imagination.

Eine sehr schöne Porträtstudie, die etwas an die Studie von Vlado Bača auf Seite 163 erinnert, obgleich sie aus einem anderen Lande kommt. Die ungewöhnliche Beleuchtung erklären würde, die die Fantasie anregt.

Een heerlijke portretstudie, die enige overeenkomst vertoont met het portret van Vlado Bača op blz. 163, hoewel beide uit twee verschillende landen komen. De ongewooe verlichting prikkelt de verbeelding.

Excelente retrato de estudio obtenido bajo una aproximación similar a la seguida por Vlado Bača en la instantánea de la pág. 163. La insólita iluminación ha introducido un toque "dramático" que estimula nuestra imaginación.

Délicieuse étude de portrait qui n'est pas sans ressemblance avec la photographie de la page 163 de Vlado Bača, bien qu'elle provienne d'un autre pays. L'éclairage insolite a introduit une note saisissante qui stimule l'imagination.

173 (Upper)
Photographer Frank Peeters
Camera Nikon FE
Lens 28mm
Film Kodachrome 64

An intriguing transparency which excites the imagination because it has no title to explain its meaning. It is artistic in form and colour composition, the contrast of which has been helped by the use of a polarising filter to darken the sky.

Dieses Diapositiv regt die Fantasie an, da es keinen Titel hat, der seine Bedeutung erklären würde. Seine Komposition ist, was Form und Farbe anbelangt, künstlerisch, und der Himmel wurde mit Hilfe eines Polarisierfilters verdunkelt, um den nötigen Kontrast zu erzielen.

Een intrigerend dia dat de aandacht trekt en de verbeelding stimuleert omdat het geen titel heeft die de bedoeling verklaart. Het is artistiek wat vorm en kleurcompositie betreft. Het contrast werd mede veroorzaakt door het gebruik van een polarisatiefilter dat de lucht donkerder maakte.

Intrigante diapositiva que excita nuestra imaginación, ya que el autor no ha creído conveniente explicarnos su significado mediante un título. Posee un marcado valor artístico en sus aspectos tanto composicionales como cromáticos, cuyo contraste se ve acentuado por el uso de un filtro polarizador que oscurece el cielo.

Intrigante diapositive, qui excite l'imagination du fait qu'elle n'a pas de titre pour expliquer sa signification. Elle est artistique dans sa forme et dans la composition des couleurs, dont le contraste a été favorisé par l'utilisation d'un filtre polarisant pour obscurcir le ciel.

173 (Lower)
Photographer R. K. Paul
Film Ektachrome 35mm

Child studies are usually only of interest to parents but this one is an example that is so natural in expression that it is typical of all childhood, and the excellent technique, using backlighting and fill-in flash, makes it artistically stimulating as well.

Kinderstudien sind in der Regel nur für Eltern von Interesse, doch hier ist der Gesichtsausdruck so natürlich, dass der Geist der Kindheit im allgemeinen erfasst zu sein scheint. Dank der ausgezeichneten Technik mit Gegenlicht und Blitzaufhellung wirkt die Aufnahme auch künstlerisch anregend.

Kinderportretten zijn gewoonlijk alleen interessant voor de ouders, maar dit is een voorbeeld dat zo natuurlijk is in zijn expressie dat het typerend is voor de gehele jeugd, terwijl de excellente techniek, waarbij gebruik werd gemaakt van tegenlicht en invulflits, het ook artistiek aanvaardbaar maakt.

A menudo los retratos infantiles sólo poseen interés para los padres, pero en éste la expresión resulta tan natural que lo convierte en una especie de representación general del tema de la infancia. Además, la utilización de una iluminación a contraluz con relleno de flash le ha proporcionado excelentes cualidades artísticas.

Les études d'enfants n'ont généralement d'intérêt que pour les parents, mais cet exemple est si naturel dans son expression qu'il est caractéristique de l'enfance en général, cependant que la technique est excellente en ce qu'elle utilise un éclairage arrière et un flash d'appoint, qui en font une image stimulante du point de vue artistique.

174

Photographer Richard Hewins
Camera Mamiya RB 67
Exposure 1/60 at f/8
Film Ektachrome 64

This remarkable picture of swallowtail butterflies mating was taken without the aid of a tripod and the film was "pushed" by two stops. For the benefit of the technically minded naturalist the correct description is *Papilio Machaon F Aestirus* but the layman will just look on it as an interesting and pleasing photograph, as well as a fine technical achievement.

Diese erstaunliche Aufnahme von zwei sich paarenden Schwalbenschwänzen wurde ohne Stativ erzielt, und der Film wurde um zwei Blenden "beschleunigt". Streng gesprochen ist dies ein *Papilio Machaon f Aestivus*, doch Laien wird wohl nur die Schönheit der Fotografie und die eindrucksvolle technische Leistung ansprechen.

Deze opmerkelijke foto van twee parende vlinders werd zonder statief gemaakt, terwijl de film bij het ontwikkelen werd geforceerd. Ten behoeve van de naturalisten: de juiste benaming van de vlinders is *Papilio Machaon f. Aeatitvus*, maar de leek zal deze foto beschouwen als een interessante opname, die technisch goed is uitgevoerd.

Esta excelente instantánea en la que vemos el acoplamiento de una pareja de maaónes fue tomada sin la ayuda de trípode, y el autor forzó la película en dos grados. Digamos, por si puede ser de interés para los naturalistas que observen la fotografía, que el nombre científico del insecto es *Papilio Machaon f Aestirus*, aunque estamos seguros de que también los espectadores legos encontrarán gran placer en su contemplación, gracias a sus valores artísticos y a su perfección técnica.

Cette remarquable photographie de papillons porte-queue en phase d'accouplement a été prise sans l'aide d'un trépied, et la pellicule a été "poussée" de deux crans. Pour le naturaliste féru de technique, le nom exact est *Papilio Machaon f Aestivus*, mais le profane n'y verra qu'une intéressante et agréable photographie, en même temps qu'une belle prouesse technique.

175 (Upper)

Photographer Anthony J. Bond, FRPS

A remarkable shot which will fascinate the layman as well as the dedicated natural history photographer or bird watcher. The author chose exactly the right moment to show the wings of the adult bird at their best. Apart from superb technique this is also an artistic picture with a pleasing colour scheme and an avoidance of the hard flash shadows usually found in such photographs.

Eine bemerkenswerte Aufnahme, die sowohl Laien als auch naturgeschichtliche Fotografen oder Vogelbeobachter "mit Leib und Seele" faszinieren dürfte. Der Künstler wählte genau den richtigen Augenblick, um die Flügel des erwachsenen Vogels auf beste Weise zu erfassen. Abgesehen von der hervorragenden technischen Leistung ist dies auch ein künstlerisches Bild in schönen Farben, bei dem die harten, durch Blitzlicht erzeugten Schatten, die man normalerweise in solchen Aufnahmen antrifft, vermieden wurden. Zur Beleuchtung dienten ein Metz 402 sowie zwei Mecatwin-Lichter, die durch einen elektronischen Auslöser betätigt wurden.

Voor deze opmerkelijke foto koos de fotograaf exact het juiste moment om de gespreide vleugels van de volwassen vogel zo goed mogelijk weer te geven. Afgezien van de voortreffelijke techniek is dit ook een artistieke opname met een aantrekkelijk kleurenschema, waarin de harde slagschaduwen van het flitslicht, die men gewoonlijk in zulke opnamen tegenkomt-zijn vermeden.

Excelente instantánea que no sólo fascinará a las personas interesadas en el estudio de las ciencias naturales, sino también al espectador medio. El autor supo elegir el momento exacto para captar las alas del pájaro adulto en su mayor esplendor. Pero no basta con destacar los aspectos técnicos; artísticamente la imagen es también excelente, destacando el agradable esquema cromático y la eliminación de las aparatosas sombras introducidas usualmente por el flash en este tipo de fotografías.

Remarquable photographie qui ne manquera pas de fasciner le profane tout autant que le photographe féru d'histoire naturelle ou l'observateur d'oiseaux. L'auteur a su choisir exactement le bon moment pour montrer les ailes de l'oiseau adulte dans toute leur splendeur. Indépendamment d'une remarquable technique, cette photographie traduit également un sens artistique développé et présente une agréable palette de couleurs, en même temps qu'elle évite les ombres dures du flash que l'on trouve généralement sur les photographies de cette nature. L'éclairage a été assuré par un Metz 402 et deux Mecatwins à déclenchement électronique.

175 (Lower)

Photographer Jane Craik, ARPS
Camera Nikkormat FT
Lens 55mm Nikkor Macro
Film Kodachrome 25

A picture which will please the naturalist for its excellent technique, and charm the layman with its subject matter. The Wood Mouse *(micromys minutus)* has been shown in its authentic surroundings to very good effect. The author is an elderly lady who only took up photography at the age of 60 years.

Ein Bild, das den Naturfreund durch die hervorragende Technik und den Laien durch das Motiv bezaubern wird. Die Waldmaus *(micromys minutus)* ist mit sehr grossem Erfolg in authentischer Umgebung erfasst. Die Aufnahme stammt von einer älteren Dame, die erst im Alter von 60 Jahren mit dem Fotografieren begann.

Een foto waar menigeen met plezier naar zal kijken. De techniek is subliem en het onderwerp interessant. De bosmuis *(Micromys Minutus)* is hier zeer effectief weergegeven in zijn natuurlijke omgeving. De auteur is een oudere dame die pas op de leeftijd van 60 jaar ging fotograferen.

Esta fotografía encantará al naturalista por su perfección ténica y al lego por su interesante tema. En ella vemos al *Micromys minutus*, o ratón de bosque, en su medio natural. La autora es una señora mayor cuya afición por la fotografía no se le despertó hasta después de cumplir los sesenta años.

Photographie qui ne manquera pas de plaire au naturaliste en raison de l'excellente technique dont elle atteste, et de charmer le profane par son sujet. Le mulot *(micromys minutus)* a été présenté dans son habitat naturel et est du plus bel effet. L'auteur est une vieille dame qui ne s'est intéressée à la photographie qu'à partir de l'âge de soixante ans.

176

Photographer Giuseppe Balla
Camera Canon F-1
Lens 100mm
Film Kodachrome 25

The drama of the parachute descent has been intensified by the addition, during copying, of a slide which shows the lines produced by a star attachment. They help to increase the feeling of movement already existing in the diagonal attitude of the subject.

Das Drama des Fallschirmsprungs wurde durch einen Spectrastar-Zusatz erhöht. Es wurde damit der Eindruck der Bewegung verstärkt, den bereits die schräge Lage des Aufnahmegegenstands zum Ausdruck brachte.

De actie van deze parachutesprong werd versterkt door het gebruik van een Spectral Star voorzetlens. De ontstane ster verhoogt het gevoel van beweging dat reeds aanwezig was door de diagonale wijze van opnemen.

El dramatismo propio del descenso en paracaídas se ha intensificado mediante la adición de una diapositiva en la que se recogen las líneas producidas por un accesorio en estrella. De esta forma se ha incrementado la sensación de movimiento producida por la situación en diagonal de la figura humana.

La situation saisissante créée par la descente en parachute a été intensifiée par l'utilisation d'un Spectrastar, qui contribue à augmenter l'impression de mouvement due à la position diagonale du sujet.

177

Photographer Witaly Butyrin

A striking and original picture which puts over an idea of male dominance that will not please the "women's libbers". It is a combination produced from several negatives at different degrees of enlargement and the elements are very well arranged. The line and grain treatment also helps the abstract idea by removing too much realism.

Ein eindrucksvolles, originelles Bild, das die männliche Vorherrschaft auf eine Weise betont, die den "Frauenrechtlerinnen" bestimmt keine Freude bereiten wird. Es ist dies eine Kombination mehrerer Negative in verschiedenen Stufen der Vergrösserung, und die Elemente sind sehr gut arrangiert. Die Linien- und Kornbehandlung betont ebenfalls den abstrakten Grundgedanken, da ein Übermass an Wirklichkeitsnähe vermieden wird.

De suggestie van mannelijke overheersing die van deze foto uitgaat zal de feministen niet aangenaam zijn. Het gaat hier om een montage uit diverse negatieven in verschillende vergrotingsmaatstaven. De elementen zijn goed gegroepeerd. De lijnuitwerking en de korrel helpen mee de idee te abstraheren door een overmaat aan realisme te elimineren.

La vindicación de la dominación del "macho" que parece encerrar esta original fotografía despertará probablemente las iras de las feministas. Se trata de una combinación obtenida a partir de varios negativos sometidos a distintos grados de ampliación. Los elementos están muy bien relacionados y la introducción del grano subraya el tratamiento abstracto del tema al apartarlo hasta cierto punto de la realidad.

Remarquable et originale photographie donnant une idée de dominance masculine qui ne plaira sans doute pas aux féministes. C'est une combinaison due à l'utilisation de plusieurs négatifs à différents stades d'agrandissement et dont les éléments ont été parfaitement arrangés. Le lignage et le grain contribuent à donner une idée d'abstraction en enlevant à cette photographie ce qu'elle a de trop réaliste.

178

Photographer Joan Wakelin, FRPS
Camera Mamiyaflex
Lens 135mm Sekor
Film FP4

A powerful portrait of a poacher with a sense of humour who, when asked if the picture could be titled "The Berkshire Poacher" said "That's all right mate, I live in Hampshire". The ferret struggling to get out provides some movement and the picture is a fine character study.

Ein markantes Porträt eines Wilddiebs mit Humor. Als die Künstlerin ihn fragte, ob er etwas gegen den Titel "Der Wilddieb von Berkshire" hätte, antwortete er, "das macht gar nicht, ich komme aus Hampshire". Das Frettchen, das loszukommen versucht, bringt Bewegung in das Bild, das übrigens eine schöne Charakterstudie ist.

Een sterk portret van een stroper met gevoel voor humor. Toen de fotografe vroeg of zij de foto 'De Berkshire stroper' mocht noemen, antwoordde hij: 'Doe maar gerust, ik woon in Hampshire'. De fret die zich probeert los te worstelen zorgt voor enige beweging in de foto, die overigens een fijne karakterstudie is.

He aquí un cazador furtivo captado "in fraganti". No le faltaba, sin embargo, el sentido del humor, ya que cuando se le preguntó su se podía dar a la fotografía el título de "El cazador furtivo de Berkshire" su respuesta fue "De acuerdo, compañera; yo vivo en Hampshire". El hurón introduce en la instantánea algo de movimiento.

Puissant portrait d'un braconnier pourvu d'un vif sens de l'humour, qui, lorsqu'il a été interrogé sur le point de savoir si la photographie pourrait être intitulée "The Berkshire Poacher" (Le braconnier du Berkshire), a déclaré: "Si vous voulez, mon vieux, puisque moi j'habite le Hampshire." Le furet qui lutte pour se dégager donne un certain mouvement à la photographie, qui est une fine étude de caractère.

179

Photographer Wu Chih Hung
Lens 105mm
Exposure 1/60 at f/11

A lot of the pictures now coming out of the Republic of China are similar in style and presentation to those which have come from Hong Kong over the last three decades. The theme of the relationship between children and the aged is a popular one and this example is full of vitality. Like the Hong Kong school, the print quality is superb with very rich black tones.

Viele Bilder, die uns gegenwärtig aus der Republik China erreichen, sind denen, die innerhalb der letzten drei Jahrzehnte aus Hongkong gekommen sind, in Stil und Präsentation ähnlich. Das Thema

der Beziehung zwischen Kindern und alten Leuten ist beliebt, und hier haben wir ein sehr lebensvolles Beispiel dieses Genre. Ebenso wie bei den Fotografien aus Hongkong ist die Qualität der Kopie hervorragend, und die Schwarztöne sind sehr intensiv.

Veel foto's die nu uit de Republiek China komen zijn wat stijl en presentatie betreft te vergelijken met wat de laatste dertig jaar uit Hongkong kwam. Het thema van de relatie tussen kinderen en ouderen is erg populair. Dit is daarvan een levendig voorbeeld. De vergrotingskwaliteit is subliem.

Muchas de las fotografías que nos llegan ahora de la República Popular China poseen un estilo y una presentación similares a los de las que nos han venido enviando desde Hong Kong en las tres últimas décadas. El tema de las relaciones infancia-vejez es uno de los más repetidos y en este caso adquiere gran vitalidad. Así como sucede con los productos de la escuela de Hong Kong, también en esta obra el copiado es absolutamente satisfactorio, destacando la riqueza de los tonos negros.

Nombre de photographies qui nous viennent aujourd'hui de la République populaire de Chine ressemblent par le style et par la présentation à celles que nous avons reçues de Hong Kong au cours des trois dernières décennies. Le thème de la relation entre les enfants et les personnes âgées est très populaire, et cet exemple traduit une grande vitalité. Comme dans le cas de l'école de Hong Kong, la qualité du tirage est superbe, notamment en raison de la richesse des tons noirs.

180

Photographer Jeanine Sarll
Camera Mamiyaflex
Lens 180mm
Film Plus X

An imaginative study which is full of mood and classic in design. The mood of prison confinement which it evokes is complemented by the severe dress and pensive expression.

Eine fantasiereiche Studie, die stimmungsvoll und gleichzeitig klassisch wirkt. Das spartanische Kleid und der nachdenkliche Gesichtsausdruck betonen die Gefängnisstimmung.

Een fantasierijke studie vol stemming; klassiek van opvatting. De sfeer van gevangenschap die wordt opgeroepen wordt aangevuld door de strenge kleding en de peinzende gelaatsuitdrukking.

He aquí un imaginativo estudio, de diseño clásico pero muy original. La impresión de encierro que despierta en el observador se ve complementada por la severidad del vestido y la expresión pensativa.

Etude tout empreinte d'atmosphère et classique par sa conception, qui traduit une grande imagination chez son auteur. L'idée de réclusion qu'elle inspire est complétée par la sévérité du vêtement et par l'expression pensive.

181

Photographer Neale Davison
Camera Pentax SP II
Lens 200mm Soligor
Exposure 1/250 at f/5.6
Film Tri-X

An orator at Speakers' Corner in Hyde Park has been powerfully portrayed by exposing only for the highlights on a sunny day so that the background is very dark and the contrasts very strong. The angle of the head and the eye express the fanaticism typical of most speakers on this site.

Ein kraftvolles Porträt eines Redners an Speakers' Corner im Hyde Park, bei dem an einem sonnigen Tag nur für die Glanzlichter belichtet wurde, so dass der Hintergrund sehr dunkel ist und die Kontraste sehr stark sind. Die Haltung des Kopfes und des Auges drücken den Fanatizismus aus, der für die meisten der Redner an Speakers' Corner kennzeichnend ist.

Een redenaar in Speaker's Corner in het Londense Hyde Park werd hier voortreffelijk geportretteerd door alleen te be lichten op de hoge lichten op deze zonnige dag, zodat de achtergrond heel donker is en de contrasten groot. De houding van het hoofd en het oog drukken het fanatisme uit dat zo typisch is voor de meeste sprekers in Speakers' Corner.

Este improvisado orador (está hablando en el Speaker's Corner de Hyde Park) ha sido captado maravillosamente al exponer en función de las luces fuertes de un día de sol, con lo que el fondo ha quedado muy oscuro y los contrastes son muy vivos. El ángulo en que se sitúan la cabeza y los ojos pone de manifiesto el fanatismo que muestran muchos de los oradores que acuden al parque londinense.

Orateur du Speakers' Corner au Hyde Park de Londres, puissamment saisi par le photographe qui, pour ce faire, a concentré sur son personnage la luminosité d'un jour de soleil, de sorte que l'arrière-plan est très sombre et le contraste très violent. L'angle de la tête et l'oeil expriment le fanatisme caractéristique de la plupart des orateurs de Hyde Park.

182

Photographer Lamberto Lamberti

A picture which is typical of the direct approach to figure photography that is acceptable today and differs greatly from the idealised approach of former times. Candour and natural poses in domestic surroundings are the modern trend and this is a good example. In spite of so much detail, it is a well knit composition.

Ein Bild, das für die Unmittelbarkeit der Aktfotografie, die heute annehmbar ist und sich von der Romantik früherer Zeiten sehr unterscheidet, typisch ist. Es ist modern natürliche Posen in häuslicher Umgebung ohne falsche Scham wiederzugeben, wovon dies ein gutes Beispiel ist. Trotz der vielen Einzelheiten ist dies eine gut geglückte Komposition.

Een opname die typerend is voor de directe benadering in de figuurfotografie van vandaag, die aanzienlijk afwijkt van de geïdealiseerde benadering in vroeger tijden. Oprechtheid en natuurlijke poses in huiselijke omgevingen zijn de moderne trend. Dit is daarvan een goed voorbeeld. Ondanks de vele details is het een goed opgebouwde compositie.

En esta imagen reconocemos el enfoque directo que se da en la actualidad en la captación de figuras humanas y que se sitúa en las antípodas de la idealización típica de épocas anteriores. Lo normal es hoy situar a las personas en su entorno doméstico y procurar que aparezcan lo más naturales posible, como se ha hecho en este caso. A pesar de la casi excesiva abundancia de detalles, la composición ha sido resuelta con eficacia.

Photographie caractéristique de l'approche directe des nus aujourd'hui acceptable et qui diffère grandement de l'approche idéalisée de naguère. La candeur et les poses naturelles dans un cadre domestique représentent la tendance moderne dont cette image est un bon exemple. En dépit d'un aussi grand nombre de détails, c'est une composition bien tissée.

183

Photographer David Balsells
Camera Nikon F2
Lens 20mm
Film HP5

An unusual figure study but very much in the modern idiom with a candid approach offset to some extent by tone simplification with lith film, plus a considerable exaggeration of grain. The excellent modelling, together with a black background gives a feeling of depth but suspended in space.

Eine ungewöhnliche Aktstudie, die aber sehr modern wirkt. Die Offenheit der Aufnahme wird in gewissem Masse durch Tonvereinfachung mit Hilfe von Lithofilm und erhebliche Übertreibung der Körnigkeit wettgemacht. Die ausgezeichnete Plastik vermittelt in Verbindung mit dem schwarzen Hintergrund ein Gefühl der Tiefe und des Schwebens im Raum.

Een ongewone figuurstudie, maar geheel in de moderne sfeer. De directe benadering vindt een tegenhanger in de vervreemding door de tussenbewerking via lithfilm en het opvoeren van de korrel. De pose geeft, te zamen met de zwarte achtergrond, een goede dieptewerking.

He aquí un estudio algo insólito de una figura humana, aunque se ha realizado con un "vocabulario" típicamente moderno, que se revela en el tratamiento abierto y sincero contrapuntado por la simplificación tonal conseguida con una película lith y la exageración del grano. El excelente modelado, suplementado por el fondo negro, proporciona una impresión de profundidad suspendida en el espacio.

Etude de nu insolite mais tout à fait dans la ligne moderne. Le caractère non apprêté est compensé dans une certaine mesure par la simplification des tons due à la pellicule lithographique, et par une exagération considérable du grain. L'excellente disposition du modèle alliée à un arrière-plan noir donne une impression de profondeur, mais suspendue dans l'espace.

184

Photographer Alan Millward
Camera Pentax Spotmatic I
Lens 55mm Takumar
Film Tri-X

A documentary picture to a large extent but full of action and youthful vitality. The author showed great perception by including the graffiti to balance the boy and to tell a little more of his environment.

Im wesentlichen ein Dokumentarbild, das von Dynamik und jugendlicher Vitalität sprüht. Der Künstler legte grosse Einsicht an den Tag, indem er die Inschrift auf der Mauer mitfotografierte. Diese stellt das erforderliche Gleichgewicht her und gibt uns einen noch besseren Eindruck von der Umwelt des Kindes.

Een documentaire foto zou men dit kunnen noemen, maar dan een vol actie en jeugdige vitaliteit. De fotograaf toonde een goed waarnemingsvermogen door de tekst op de muur mee op te nemen om een tegenwicht te vormen voor de jongen en om iets meer te vertellen over zijn omgeving.

Fotografía en cierto modo documental, llena de acción y vitalidad juvenil. La capacidad perceptiva del autor se refleja en la inclusión de los "graffiti", que nos proporcionan una importante información sobre el medio en que el niño se desenvuelve.

Photographie essentiellement documentaire, mais pleine d'action et de juvénile vitalité. L'auteur a fait preuve d'un sens aigu de la perception en insérant des graffiti pour faire pendant au jeune garçon et nous faire découvrir un peu plus son univers.

185

Photographer Stephen Shakeshaft
Camera Nikon
Lens 85mm Nikkor
Film Tri-X

Sequences have become popular since the introduction of motor drives, and they are sometimes able to tell a story better than a cine film. It is nice to see a set which shows the human side of the police instead of maligning them.

Seit der Einführung von Motorantrieben sind Bilderreihen beliebt geworden. Manchmal veranschaulichen sie einen Vorgang besser als ein Kinefilm. Es ist nett, wenn die Polizei einmal nicht angeprangert sondern ihre menschliche Seite herausgestellt wird.

Fotoseries hebben aan populariteit gewonnen sinds de introductie van de motoraandrijving. Vaak zijn zij ook beter in staat een verhaal te vertellen dan een filmscène en zeker beter dan een enkele foto. Deze serie laat iets van de menselijke kant van 'oom agent' zien.

A partir de la aparición de los motores de arrastre, las secuencias de fotografías se han utilizado con profusión, ya que muchas veces se puede desarrollar mejor una historia con ellas que con una cámara cinematográfica. En este caso, por ejemplo, resulta muy agradable ver representada la cara humana de la policía.

Les séquences sont devenues populaires depuis l'apparition des appareils à moteur, et elles permettent parfois de raconter une histoire mieux qu'un film cinématographique. Il est agréable de voir une sequence montrant le côté humain de la police au lieu de la calomnier.

186

Photographer S. T. U. Fairlamb
Camera Ricoh XR 2
Lens 135mm Vivitar
Film HP5

A picture showing the rather comic side of a chick whose legs seem too thin and too long for its body. Being seen actually on the nest it will be of interest to bird lovers and the author has handled a difficult subject well, especially by using natural lighting instead of flash.

Eine recht humorvolle Aufnahme, die einen jungen Vogel mit scheinbar zu dünnen und zu langen Beinen zeigt. Da er auf dem Nest steht, dürfte das Bild Vogelliebhaber besonders ansprechen. Der Künstler hat hier eine schwierige Aufgabe gut gelöst, vor allem da er von natürlicher Beleuchtung und nicht von Blitzlicht Gebrauch machte.

Deze foto toont de nogal komische kant van een kuiken waarvan de poten te dun en te lang schijnen te zijn voor zijn lichaam. Daar het een werkelijk op het nest gesignaleerde vogel is, zal menige vogelliefhebber hiervoor interesse hebben. De fotograaf heeft een moeilijk onderwerp goed uitgewerkt, vooral doordat hij het natuurlijke licht gebruikte in plaats van flitslicht.

Esta instantánea, en la que vemos a un pajarillo cuyas patas resultan demasiado largas y delgadas en relación con su cuerpo, resulta enormemente divertida y presenta un gran interés para los amantes de las aves. El autor, que ha preferido servirse de la luz natural antes que del flash, ha sabido tratar perfectamente este difícil tema.

Photographie montrant le côté plutôt comique d'un poussin dont les pattes sont trop grêles et trop longues pour son corps. Pris sur son nid, il ne manquera pas d'éveiller l'intérêt des amoureux des oiseaux, sujet difficile que l'auteur a su traiter avec bonheur, en particulier en recourant à la lumière naturelle au lieu du flash.

187

Photographer Valdis Brauns

Typical of some of the romantic work by Latvian photographers, this shows a good eye for composition and very good technique. It well illustrates the mood of *Spring* which is its title and although there is no deep meaning, it is a pleasing picture to look at.

Dieses Bild, das für die romantischen Werke lettischer Fotografen typisch ist, erweist ein gutes Auge für Komposition und sehr gute Technik. Es verleiht der Frühlingsstimmung – der Titel des Bildes

lautet *Frühling* – auf erfolgreiche Weise Ausdruck, und obgleich es keine tiefe Bedeutung hat, wirkt es sehr ansprechend.

Typerend voor een gedeelte van het romantische werk van fotografen uit Letland, getuigt dit voorbeeld van een goed oog voor compositie en een uitstekende techniek. Het illustreert heel goed de sfeer van de 'Lente', wat de titel van de foto is. Hoewel er geen diepere bedoeling is kan men toch met plezier naar deze foto kijken.

He aquí una instantánea perfectamente representativa de los trabajos actuales de los fotógrafos letones, que evidencia un perfecto dominio de la composición y de la técnica. Constituye una excelente ilustración del tema elegido *Primavera;* y aunque su significado no es muy profundo, resulta agradable de ver.

Caractéristique de certaines scènes romantiques dues à des photographes latviens, cette photographie montre que son auteur a le sens de la composition et possède une excellente technique. Elle illustre bien l'ambiance de "Printemps", qui est son titre, et, bien qu'elle ne signifie pas grand-chose, elle est agréable à regarder.

188

Photographer Arijs Klavinskis

A sad occasion depicted in a most original way by saying in effect that "life goes on". By solarising and printing down the burial scene so that the young child stands out in sharp relief, the photographer has produced a moving and significant visual statement.

Ein trauriger Anlass ist hier auf äusserst originelle Weise wiedergegeben. Die Botschaft lautet offensichtlich: "Das Leben geht weiter." Durch Solarisieren und Abdunkeln der Beerdigungsszene wurde das Kind in den Brennpunkt des Interesses gerückt. Der Künstler hat damit eine rührende und bedeutungsvolle visuelle Aussage gemacht.

Een droevige gebeurtenis, weergegeven op een originele manier door in feite te zeggen dat 'het leven doorgaat'. Door de solarisatietechniek en het donker houden van de begrafenisscène, zodat het jonge kind fel afsteekt, produceerde de fotograaf een roerend en veelbetekenend verhaal.

La tristeza del acontecimiento encuentra en esta imagen su contrapunto en la implícita aserción de que "la vida continúa". El fotógrafo sometió a la fotografía del entierro a un proceso de solarización y suavización para poner en relieve a la niña de manera que se obtenga una afirmación visual conmovedora.

Triste occasion, décrite de manière très originale, pour dire que "la vie continue". En solarisant et en tirant cette scène d'enterrement de telle façon que la petite fille apparaisse très en relief, le photographe a lancé un message visuel émouvant et significatif.

189

Photographer Witaly Butyrin

A picture with an immediate impact due to the unusual combination of negatives whereby the figure is out of proportion and perspective with the background, which itself is made from a sandwich of two negatives. The bold contrasts gain attention and the subject matter then stimulates the imagination.

Ein Bild mit unmittelbarer Wirkung dank der ungewöhnlichen Kombination von Negativen. Das Mädchen steht nicht in Proportion zu dem Hintergrund, der dürch Überlagerung von zwei Negativen erzielt wurde, und passt auch nicht in die Perspektive. Die kühnen Kontraste sind eindrucksvoll und das Motiv regt die Fantasie an.

Een foto die direct aanspreekt door de ongewone combinatie van negatieven, waarbij de persoon in andere afmetingen en perspectief is weergegeven dan de achtergrond, welke op zich reeds is samengevoegd uit twee negatieven.

Esta intantánea produce un impacto inmediato, derivado de la insólita combinación de negativos que hace que la figura aparezca totalmente desproporcionada y en una extraña perspectiva en relación con el fondo, el cual está constituido a su vez por un "sandwich" de dos negativos. Los atrevidos contrastes captan rápidamente nuestra atención a través de la estimulación de la capacidad imaginativa.

Photographie à l'impact immédiat par suite de l'association de négatifs, ce qui a permis de faire ressortir la silhouette qui se trouve ainsi disproportionnée et n'entre pas dans la perspective de l'arrière-plan, résultant lui-même de la mise en sandwich de deux négatifs. La hardiesse des contrastes force l'attention, de sorte que le sujet stimule l'imagination.

190/191
Photographer Jos Janssens

A moonlight scene on a beach which was probably taken in daylight with a red or infra-red filter. The strong texture rendering thus produced is reminiscent of a moonscape with the tyre tracks leading the eye into the picture. The star halation of the moon against a black sky adds a touch of fantasy.

Dieses Bild eines Strandes im Mondlicht wurde wahrscheinlich bei Tage mit Hilfe eines Rot- oder Infrarotfilters aufgenommen. Die auf diese Weise erzielte kräftige Textur erinnert an eine Mondlandschaft, und die Reifenspuren führen das Auge auf den Hintergrund zu. Der sternförmige Lichthof um den Mond und der schwarze Himmel verleihen der Szene eine fantastische Note.

Deze maanlichtscène op een strand werd waarschijnlijk overdag opgenomen met een rood- of infraroodfilter. De sterke structuur die daardoor wordt geaccentueerd wekt herinneringen op aan een maanlandschap. De stervormige overstraling van de maan in de donkere lucht voegt een snufje fantasie toe.

Esta imagen, que parece estar iluminada por la luna, fue tomada probablemente con luz diurna utilizando un filtro rojo o infrarrojo. La marcada textura obtenida nos hace pensar en un paisaje lunar, en el que las huellas de los neumáticos guían nuestra mirada. El halo producido por la luna contra el cielo negro añada un toque de fantasía.

Cette scène de clair de lune sur une plage a probablement été prise en plein jour avec un filtre rouge ou infrarouge. Le rendu puissant de la texture obtenu par cet artifice évoque un paysage lunaire, et les traces de pneus amènent l'oeil à l'image. Le halo des étoiles autour de la lune sur un ciel noir ajoute une touche de fantaisie.

192
Photographer David Burrows

Anyone who has never been in a dancing school or rehearsal room will get a good idea of the atmosphere from this picture. The lovely swirl of movement and the evident enjoyment and dedication of the dancers is authentic. As a photograph it is first class in both design and technique.

Auch wer niemals in einer Tanzschule oder einem Probesaal gewesen ist, kann sich anhand dieses Bildes die vorherrschende Atmosphäre gut vorstellen. Die exquisiten Bewegungen und die offensichtliche Freude und Konzentration der Tänzer sind echt. Sowohl die Komposition als auch die Technik der Aufnahme sind erstklassig.

Wie nog nooit in een dansschool of een repetitielokaal is geweest zal uit deze foto een goede indruk krijgen van de sfeer. De zwaaiende beweging en het kennelijke enthousiasme van de dansers zijn goed weergegeven. Zowel wat compositie als wat techniek betreft is dit een eerste klas foto.

Nos encontramos aquí con una perfecta captación de la atmósfera típica de una escuela de baile. La autenticidad deriva sobre todo de la acumulación de movimiento y la profunda dedicación con que los bailarines se entregan al trabajo. El autor, por otra parte, evidencia poseer un perfecto dominio de la técnica fotográfica.

Quiconque n'a jamais été dans une école de danse ou dans une salle de répétition pourra s'en faire une bonne idée grâce à l'atmosphère qui se dégage de cette photographie. La remarquable ondulation du mouvement ainsi que la joie et la pénétration évidentes des danseurs sont authentiques. Comme photographie, elle est de toute première qualité, tant par sa conception que par la technique mise en oeuvre.

193
Photographer A. Sutkus

Ballet dancers are rarely seen in photographs when they are relaxing instead of dancing. This is a very attractive double portrait, presumably twins, in which one is just a little sharper than the other, thus avoiding a symmetrical effect. It is an ideal dressing-room candid in which the dancers have not even had time to wipe off the sweat from their exertions.

Ballettänzer werden selten fotografiert, wenn sie sich gerade entspannen. Dies ist ein sehr schönes Doppelporträt, vermutlich von Zwillingen, in dem die eine Person etwas schärfer erfasst ist als die andere, so dass eine symmetrische Wirkung vermieden wird. Als unerwartete Aufnahme in einem Ankleideraum ist dieses Bild ideal. Die Modelle hatten nicht einmal Zeit, sich den Schweiss von der Stirne zu wischen.

Balletdanseressen worden zelden gefotografeerd als zij relaxen in plaats van dansen. Dit is een aantrekkelijk dubbelportret, waarschijnlijk van tweelingen, waarin de ene persoon net iets scherper is dan de andere, zodat een symmetrisch effect werd vermeden. De danseressen werden gefotografeerd direct na een oefening of een optreden, nog voordat zij gelegenheid hadden zich het zweet van het gelaat te vegen.

Muy pocas veces se fotografía a las bailarinas mientras descansan, como ocurre en este caso. Para evitar obtener una perfecta simetría (las modelos son gemelas) el autor ha utilizado distintos grados de nitidez. La oportunidad del momento elegido queda reflejada en el hecho de que las bailarinas no hayan tenido tiempo todavía para secarse el sudor producido por su reciente esfuerzo.

Les ballerines sont rarement photographiées au cours d'une pause. Il s'agit ici d'un double portrait très séduisant, représentant probablement des jumelles, dont l'une est juste un peu plus accusée que l'autre, ce qui permet d'éviter l'effet de symétrie. C'est une agréable photographie de loge d'artiste, prise sur le vif, sur laquelle les danseuses n'ont même pas eu le temps de s'éponger.

194
Photographer John Davidson

A lively picture of a happy goal scorer has been given an original touch by the embracing arms of another footballer. Everything in the picture, even to the upturned thumb, supports the mood of elation and the dark background concentrates all the interest on to the subject.

Diesem lebensvollen Porträt eines glücklichen Torschützen wurde durch die ihn umschlingenden Arme eines anderen Fussballers eine originelle Note verliehen. Alles in dem Bild, selbst der nach oben weisende Daumen, bringt das Hochgefühl zum

Ausdruck, während der dunkle Hintergrund das ganze Interesse auf den Sportler – Andy King, ein Mitglied der Mannschaft Everton – konzentriert.

Een levendige foto, gemaakt vlak na het scoren van een doelpunt (let op de armen van de andere voetballer!). Alles in deze opname, tot en met de opgestoken duim, ondersteunt de opgetogen stemming. De donkere achtergrond zorgt voor een goede concentratie van de aandacht op het onderwerp.

A la imagen de este jubiloso goleador se le ha añadido un toque original a través de la introducción de los brazos de un compañero que ha acudido a felicitarle. Todos los detalles de la instantánea, incluido el pulgar que mira hacia arriba, se inscriben perfectamente en la atmósfera de júbilo, mientras que el fondo oscuro concentra el interés en el tema principal.

Photographie très vivante d'un joueur de football qui vient de marquer un but; l'originalité de cette image tient aux bras d'un autre joueur de football qui l'enlacent. Tout dans cette photographie, y compris le pouce levé, évoque la joie, et le sombre arrière-plan concentre tout l'intérêt sur le sujet. Il s'agit d'Andy King, d'Everton.

195
Photographer Howard Walker
Camera Nikon F2 with motor drive
Lens 400mm Novoflex
Exposure 1/250 at f/5.6
Film Tri-X

Joe Corrigan, Manchester City goalkeeper, is receiving the "magic sponge" treatment for a painful head injury received during a match. His agony is self evident and the photographer has recorded a telling moment with which we can all sympathise. The technique is superb and the beautiful modelling makes it an artistic picture as well.

Joe Corrigan, der Torwart der Mannschaft Manchester City, wird hier mit dem Schwamm behandelt, um eine schmerzhafte Kopfverletzung zu lindern, die er während eines Wettspiels erhielt. Sein Leiden ist offensichtlich, und der Fotograf hat einen markanten Augenblick erfasst, den wir alle gut begreifen können. Die Technik ist hervorragend, und dank der plastischen Wiedergabe hat dieses Bild auch künstlerischen Wert.

De keeper krijgt een behandeling met de 'magische spons' voor een pijnlijke hoofdwond tijdens een wedstrijd. Zijn pijn blijkt duidelijk; de fotograaf legde een treffend moment vast. De technische afwerking van deze artistieke foto is uitstekend.

Joe Corrigan, portero del Manchester City, recibe aquí la ayuda de la "esponja mágica" tras haber sido golpeado en una de las incidencias del encuentro. Evidenciando poseer un perfecto dominio de la técnica y un claro sentido del modelado, el fotógrafo ha conseguido reflejar en toda su intensidad el sufrimiento del protagonista sin dejar de lado las dimensiones artísticas, que no han de faltar en un buen trabajo fotográfico.

Joe Corrigan, gardien de but de l'équipe de Manchester, entre les mains d'un soigneur qui lui applique "l'éponge magique" à la suite d'une douloureuse blessure à la tête reçue durant le match. Sa souffrance est évidente, et le photographe a su saisir un moment expressif qui appelle toutes les sympathies. La technique est remarquable et la magnifique composition fait de cette photographie un petit chef-d'oeuvre.

196
Photographer Witaly Butyrin

A picture which would make an attention-getting frieze in a modern dairy. The ultra-simplification of tones against a grainy background makes it striking and the arrangement and placing of the cows form a good design.

Eine Aufnahme, die in einer modernen Molkerei einen interessanten Fries ergeben würde. Die Ultra-Vereinfachung der Töne und der körnige Hintergrund sind eindrucksvoll, und die Verteilung und Lage der Kühe ergeben eine gute Komposition.

Een fraai voorbeeld van het omwerken van een zwartwitfoto tot een sprekende grafiek. De uiterste vereenvoudiging van de toonwaarden tegen de korrelige achtergrond levert een frappant werkstuk op, vooralook gezien de goede opstelling van de koeien.

La instantánea convierte a estas modernas instalaciones para la cría de ganado en un verdadero friso, lleno de potencialidad artística. La extremada simplificación tonal le confiere un toque insólito, pero la perfecta disposición de las vacas equilibra la composición.

Photographie qui pourrait constituer une fresque remarquable dans une laiterie moderne. L'ultra-simplification des tons sur un arrière-plan grenu lui donne son caractère, tandis que l'arrangement et la disposition des vaches en font une excellente composition.

197

Photographer Jean Berner
Camera Nikkormat FT
Lens 105mm
Film Tri-X from Fujichrome 100

One of the world's most photographed places, the Piazza San Marco in Venice, has been given an original twist. In fact, the people and the pigeons against the patterned paving have merely been used as the basis for a pattern picture – and with great success. Even with this simplified treatment the *contre-jour* lighting has been effective.

Einer der am meisten fotografierten Orte der Welt, die Piazza San Marco in Venedig, wurde hier auf originelle Weise behandelt. In der Tat wurden die Menschen und die Tauben auf dem vielgestaltigen Pflaster einfach als Grundlage für ein sehr erfolgreiches Musterbild benutzt. Selbst bei dieser vereinfachten Behandlung hat sich das Gegenlicht sehr bewährt.

Een van de meest gefotografeerde pleinen van de wereld, de Piazza San Marco in Venetië, hier op artistieke wijze grafisch weergegeven. Zowel mensen als duiven als het plaveisel werden gebruikt als elementen voor een grafisch patroon.

Una original interpretación de una de las plazas más famosas y fotografiadas del mundo, la de San Marcos en Venecia. De hecho la gente y los palomas actúan solamente como base de una instantánea centrada en la captación del diseño lineal del pavimento. La iluminación a contraluz resulta eficaz a pesar de la simplificación del tratamiento.

L'un des endroits le plus photographié du monde, la Piazza San Marco de Venise, a reçu ici une touche originale. En effet, les personnes et les pigeons qui se détachent sur le sol carrelé n'ont été utilisés, et avec beaucoup de bonheur, que pour constituer la base d'une image géométrique. Même avec un traitement simplifié, l'éclairage en contre-jour se révèle efficace.

198

Photographer L. B. Ferešovi
Camera Minolta SR 7
Lens 135mm Rikkor
Film 400 ASA

The modern candid approach to figure photography is well exemplified here. Natural outdoor lighting has been used to give good modelling, while the pose and open expression is healthy and refreshing. The artistic touch is added with grain and a dark background.

Dies ist ein gutes Beispiel der modernen Aktfotografie ohne falsche Scham. Um einen guten plastischen Effekt zu erzielen, wurde von natürlichem Licht im Freien Gebrauch gemacht. Die Haltung und der offene Gesichtsausdruck wirken gesund und erfrischend. Die Körnigkeit und ein dunkler Hintergrund verleihen dem Bild eine künstlerische Note.

Een goed voorbeeld van de moderne benadering van de naaktfotografie. Natuurlijk daglicht werd toegepast om een goede modellering te krijgen. De pose en de open gelaatsuitdrukking zijn verfrissend. De korrel en de donkere achtergrond voegen een artistiek element toe.

He aquí un perfecto ejemplo del tratamiento profundamente natural que los fotógrafos proporcionan en la actualidad a la figura humana. Se ha utilizado luz natural para obtener un buen modelado, el cual acentúa la sencilla frescura de la pose. El fondo obscuro se combina con el grano para introducir un delicado toque artístico.

Cette approche sur le vif de la photographie de nus selon une tendance moderne est bien représentée ici. L'éclairage extérieur naturel a été utilisé pour donner une bonne modelé tandis que la pose et l'expression ouverte sont saines et rafraîchissantes. La touche artistique est ajoutée grâce au grain et à l'arrière-plan sombre.

199

Photographer Peeter Tooming

A much more stylised study than the figure photograph opposite. The bold curves and strong tonal contrasts have formed the basis of an excellent design without losing the essential femininity of the subject. Printing on reflex paper has simplified the tones to good effect.

Eine mehr stilisierte Studie als die Aktaufnahme auf der gegenüberliegenden Seite. Die kühnen Kurven und die kräftigen Tonkontraste bilden die Grundlage einer ausgezeichneten Komposition, bei der die dem Modell eigene Weiblichkeit aber auf keine Weise in den Hintergrund getreten ist. Durch Kopieren auf Reflexpapier wurden die Töne wirksam vereinfacht.

Een veel meer gestyleerde studie dan de figuurfoto op de tegenoverliggende bladzijde. De krachtige vormen en de sterke toonwaardencontrasten vormden de basis van een uitstekende compositie zonder de essentiële vrouwelijkheid van het model te verliezen.

Nos encontramos aquí con un estudio mucho más estilizado que el de la figura de la página opuesta. Las atrevidas curvas y los fuertes contrastes tonales constituyen la base de un excelente diseño, del que no se excluye, a pesar de todo, la básica feminidad de la figura. El copiado en papel "reflex" ha permitido simplificar eficazmente los tonos.

Etude beaucoup plus stylisée que la photographie de nu de la page opposée. Les courbes hardies et les contrastes de tons très marqués ont formé la base d'une excellente composition sans rien faire perdre de sa féminité au sujet. Le tirage sur papier reflex a heureusement simplifié les tons.

200

Photographer V. Shonta

An amusing caricature made possible by moving in close with a wide angle lens. Much more interesting, more amusing, and even more artistic than the average seaside snapshot.

Eine amüsante Karikatur, die durch eine Nahaufnahme mit einem Weitwinkelobjektiv erzielt wurde. Dieses Bild ist viel interessanter, amüsanter und sogar viel künstlerischer als der durchschnittliche Schnappschuss am Strande.

Een aardige karikatuur, mogelijk gemaakt door met een groothoekobjectief dichtbij het onderwerp te komen. Veel interessanter en amusanter, zelfs artistieker, dan het gemiddelde strandkiekje.

Divertida caricatura obtenida fotografiando de cerca con un objetivo gran angular. Resulta mucho más interesante, inspiradora y artística que las típicas instantáneas tomadas a la orilla del mar.

Amusante caricature, rendue possible en photographiant de très près au moyen d'un grand angle. Photographie beaucoup plus intéressante, plus amusante et même plus artistique que la moyenne des photographies représentant des scènes de bord de mer.

201

Photographer Corry Wright
Camera Mamiya C33
Lens 80mm
Film Tri-X

A picture that is remarkable for its clean lines and outstanding print quality which has captured the cool atmosphere of a swimming pool extremely well. The chosen viewpoint has produced a good design and it is yet another proof that back views are often effective in stirring the viewer's imagination.

Ein Bild, das sich durch die schlichte Linienführung und die hohe Güte der Kopie auszeichnet. Die kühle Atmosphäre eines Schwimmbads ist hier gut erfasst. Die Wahl des Aufnahmestandpunkts hat eine gute Komposition ergeben, und hier haben wir noch einen Beweis dafür, dass Ansichten von hinten oft besonders anregend sind.

Deze foto vraagt de aandacht door de zuivere lijnen en de bijzondere vergrotingskwaliteit. De koele sfeer van een zwembad is hier goed getroffen. Het standpunt leverde een prima compositie op. Deze opname is het zoveelste bewijs voor de stelling dat achteraanzichten vaak veel daadwerkelijker de verbeelding van de kijker prikkelen.

En esta imagen destacan sobre todo sus líneas tan perfectamente dibujadas y la extraordinaria calidad del copiado que ha permitido a su autor captar al milímetro la fría atmósfera de una piscina. Tenemos aquí una nueva prueba de la eficacia con que muchas instantáneas tomadas desde atrás captan la atención del observador.

Photographie remarquable par ses lignes nettes et par l'excellente qualité du tirage, qui a parfaitement saisi la fraîche atmosphère d'une piscine. Le point de vue choisi a engendré une bonne composition, qui constitue une nouvelle preuve du fait que les vues de dos sont souvent expressives en ce qu'elles stimulent l'imagination du spectateur.

202

Photographer John Davidson

An appealing picture of a familiar North Country scene on a Sunday morning. The contrast between the little girl in white and the Salvation Army sisters in black directs interest to the main subject with her questioning look.

Ein ansprechendes Bild einer vertrauten Sonntagmorgen-Szene im Norden Englands. Der Kontrast zwischen dem weiss gekleideten "verlorenen Mädchen" und den Schwestern der Heilsarmee in ihren schwarzen Uniformen konzentriert die Aufmerksamkeit auf die Hauptperson mit ihrem fragenden Gesichtsausdruck.

Een aantrekkelijke foto, waarin het contrast tussen het 'verdwaalde meisje' in het wit en de Leger-des-Heils-zusters in het zwart duidelijk voorrang aan het belangrijkste onderwerp met haar vragende gelaatsuitdrukking.

Encontramos reproducida aquí una típica escena de domingo en el norte de Inglaterra. La mirada inquisitiva del sujeto principal ve reforzado su papel por el contraste entre la niña vestida de blanco y las dos miembros del Ejército de Salvación con sus ascéticos uniformes negros.

Séduisante photographie d'une scène courante dans le nord du pays un dimanche matin. Le contraste entre la "petite fille perdue" en blanc et les soeurs de l'Armée du Salut en noir concentre l'intérêt sur le sujet principal à l'expression interrogative.

203

Photographer Douglas Corrance

A child portrait which is so much better than the formal studio portrait. The face and the pose are most expressive while the forward lean of the body gives a feeling of movement and vitality. Technically excellent, it is a picture of childhood that will appeal to all parents.

Ein Kinderporträt, das bedeutend besser ist als förmliche Studioporträts. Das Gesicht und die Haltung sind ausserordentlich ausdrucksvoll, und die Vorwärtsneigung des Körpers schafft einen Eindruck lebensvoller Energie. Dieses technisch ausgezeichnete Bild der Kindheit wird alle Eltern ansprechen. Der Fotograf ist Mitarbeiter des Scottish Tourist Board.

Een kinderportret dat aanzienlijk beter is dan menig studioportret. Het gezicht en de pose zijn expressief, terwijl het naar voren leunen van het lichaam een gevoel van beweeglijkheid en vitaliteit geeft. Technisch perfect; een foto die alle ouders zal aanspreken.

Este retrato infantil posee mucha más viveza que los obtenidos habitualmente en el estudio. La cara y la pose presentan gran expresividad y la inclinación del cuerpo hacia adelante introduce una impresión de movimiento y vitalidad. Esta imagen, técnicamente perfecta, hará las delicias de todos los padres.

Portrait d'enfant nettement supérieur au portrait classique en studio. Le visage et la pose sont des plus expressifs, tandis que le corps légèrement penché en avant donne une impression de mouvement et de vitalité. Techniquement excellente, cette photographie est une image de l'enfance qui touchera tous les parents. L'auteur est photographe au Scottish Tourist Board.

204

Photographer Peter Hense
Camera Hasselblad
Lens 50mm
Film Tri-X

A discotheque dancer in West Germany who has paused for a breather and a photograph. A very candid shot indeed but unusual enough to have a lot of impact. Taken by flash but presumably bounced because the modelling, always difficult on coloured skin, is good and there are no hard shadows.

Eine Diskothektänzerin in der BRD, die einen Augenblick stehen geblieben ist, um sich auszuruhen. Dies ist in der Tat eine sehr natürliche und gleichzeitig ungewöhnliche Aufnahme mit grosser Wirkung. Bei Blitzlicht angefertigt, doch wahrscheinlich reflektiert, da die bei farbiger Haut stets schwer erzielbare plastische Wiedergabe sehr gelungen ist und harte Schatten vermieden wurden.

Een discotheekdanseres uit West-Duitsland tijdens een pauze om wat op adem te komen en tegelijk voor een foto te poseren. De opname is ongewoon

genoeg om de aandacht even vast te houden. Opgenomen met flitslicht, dat waarschijnlijk naar het plafond was gericht.

En las discotecas no queda más remedio que dejar de bailar de cuando en cuando para recuperar el aliento. Nos encontramos aquí frente a una instantánea muy natural, pero lo suficientemente insólita como para producir un impacto inmediato. El flash fue probablemente rebotado, ya que el modelado, siempre difícl cuando se trabaja con personas de piel oscura, resulta perfecto y no hay sombras acentuadas.

Danseuse de discothèque en Allemagne de l'Ouest, photographiée lors d'une pause. Photographie très naturelle et assez insolite pour avoir beaucoup d'impact. Prise au flash, mais probablement par réflexion du fait que le modelé, toujours difficile sur les peaux de couleur, est bon et sans ombres dures.

205

Photographer Luc Chessex

A picture which brims with life and activity as well as happiness. It is a scene familiar to many tourists these days, but well captured in this example. These lively lads are in Panama.

Ein von Leben, Aktivität und Glücksgefühl sprühendes Bild. Diese Szene ist vielen modernen Touristen bekannt, wurde aber besonders erfolgreich erfasst. Die lebhaften Burschen wurden in Panama fotografiert.

Een opname die bruist van het leven en de activiteit. Een foto waaruit blijheid en geluk spreken. Veel toeristen zullen de situatie herkennen, die uitstekend werd vastgelegd in Panama.

He aquí una imagen rebosante de felicidad y movimiento captada en Panamá. Puede que resulte ya familiar para muchos turistas, pero en este caso ha sido captada perfectamente.

Photographie pleine de vie et d'activité autant que de bonheur. C'est une scène familière à de nombreux touristes aujourd'hui, mais bien saisie sur cet exemple. Ces bouillants jeunes gens ont été photographiés à Panama.

206

Photographer Trevor Fry, FRPS
Camera Leicaflex SL
Lens 28mm
Film Plus X

Taken in April on Benne Eighe, Western Ross, this picture projects the atmosphere of a cold April day well up the mountain. The mood has been emphasised by the use of an orange filter and heavier than normal printing with low contrast in the sky and high contrast in the printing.

Im April auf Benn Eighe, Western Ross, aufgenommen bietet dieses Bild einen Eindruck von einem kalten Apriltag hoch auf dem Berge. Die Stimmung wurde durch ein Orangefilter und besonders intensives Kopieren hervorgehoben. Durch den geringen Kontrast des Himmels und den hohen Kontrast des Vordergrunds – vermutlich während des Kopierens erzielt – wurde ein ungewöhnlicher Effekt bewirkt.

Opgenomen in april in het noorden van Schotland draagt deze opname de atmosfeer over van een koude aprildag hoog in de bergen. De stemming werd opgevoerd door gebruik van een oranjefilter en door krachtiger dan normaal af te drukken. EEn ongewoon trekje vormt de tegenstelling tussen het lage contrast in de lucht en het hoge contrast in de voorgrond, dat er mogelijk bij het vergroten werd ingebracht.

Tomada en Benn Eighe, Western Ross, Escocia esta imagen recoge ficedignamente la atmosfera de un frío día abrileño en la montaña. Para darle mayor vigor se utilizó un filtro naranja en su captación y en el copiado se redujo el contraste en el cielo y se lo aumentó en las demás zonas.

Prise en avril sur le Benn Eighe, Western Ross, cette photographie projette l'atmosphère d'une froide journée sur les hauteurs. L'ambiance a été bien soulignée par l'utilisation d'un filtre orange et par un tirage plus poussé qu'il n'est d'usage. La faible contraste du ciel et le fort contraste du premier plan, probablement engendrés lors du tirage, donnent à cette photographie une touche insolite.

207

Photographer Jean Berner
Camera Nikkormat FT
Lens 105mm
Film Tri-X

A very nice landscape in modern style. The contrasts produced by late afternoon sunlight have separated the planes and given a good impression of depth. The contrast between old stones and a modern cottage give interest, while good print quality has added sparkle.

Eine sehr schöne Aufnahme im modernen Stil. Die durch das Sonnenlicht am späten Nachmittag bewirkten Kontraste haben die Ebenen voneinander getrennt und einen starken Eindruck der Tiefe ergeben. Der Kontrast zwischen alten Steinen und dem modernen Haus bedingt Interesse, und die hohe Güte der Kopie trägt zu der Lebhaftigkeit des Bildes bei.

Een plezierig landschap in moderne stijl. De contrasten die ontstonden door het zonlicht laat in de middag zorgden voor een goede staffeling in de diepte. Het contrast tussen de oude stenen en het moderne landhuis is interessant. De vergrotingskwaliteit is uitstekend.

Hermoso paísaje reproducio en función de los criterios que privan en la actualidad. Los contrastes producidos por la luz solar al acercarse el crepúsculo han separado los planos y han introducido una marcada impresión de profundidad. El interés temático se centra en el contraste entre las viejas piedras y la moderna construcción, mientras que el perfecto copiado añade un poco de "chispa".

Très beau paysage dans un style moderne. Les contrastes engendrés par la lumière du soleil d'une fin d'après-midi ont séparé les plans et donné une impression de profondeur. Le contraste entre les vieilles pierres et un cottage moderne ne manque jamais d'intérêt, tandis que l'excellente qualité du tirage lui a ajouté de l'éclat.

208 (Upper)

Photographer Jim Hart
Camera Canon FTb
Lens 50mm
Exposure 1/250 at f/11
Film HP5

There is something very funny about firemen having to push a modern fire appliance to get it started. Fortunately this was taken after the fire had been put out and the photographer, like all good newsmen, seized his opportunity for a visual postscript to his story.

Es ist etwas sehr Komisches an Feuerwehrleuten, die einen modernen Feuerlöschwagen schieben müssen, damit er anspringt. Zum Glück wurde diese Aufnahme nach dem Löschen des Brandes gemacht, und der Fotograf liess sich als guter Journalist einfach die Gelegenheit zu einem visuellen Post Scriptum zu seiner Story nicht entgehen.

Er is een komisch aspect aan brandweerlieden die hun moderne brandweerauto moeten duwen om hem gestart te krijgen. Gelukkig werd deze foto na het blussen van de brand gemaakt. De fotograaf maakte een dankbaar gebruik van de mogelijkheid een visueel post scriptum toe te voegen aan zijn verhaal.

Resulta verdaderamente gracioso que los bomberos tengan que empujar el dispositivo de extinción para que entre en funcionamiento. Afortunadamente la fotografía se tomo cuando el incendio había sido ya dominado, con lo que en cierto modo se la puede considerar como la "posdata" anadida por el autor a la historia visual captada anteriormente.

Il y a quelque chose de très drôle à voir des pompiers contraints de pousser un fourgon-pompe moderne pour le faire démarrer. Heureusement, cette photographie a été prise après l'extinction d'un incendie, le photgraphe ayant, comme tous les bons reporters, saisi cette occasion d'ajouter un post-scriptum visuel à son message.

208 (Lower)

Photographer R. Požerskis
Camera Minolta SRT 102
Lens 24mm
Film KN 3

Another example of opportunism – a picture which can only be got by keeping one's eyes open and always carrying a camera. Such pictures have little lasting artistic value but they will always sell if they raise a laugh like this one of a walking bedstead.

Noch ein Beispiel einer Gelegenheitsaufnahme. Bilder dieser Art lassen sich nur erzielen, wenn man seine Augen offenhält und stets seine Kamera bei sich hat. Aufnahmen wie diese haben wenig dauernden künstlerischen Wert, lassen sich aber stets verkaufen, wenn sie wie dieses Beispiel eines gehenden Bettgestells komisch wirken.

Nog een voorbeeld van opportunisme – een opname die alleen kon worden gemaakt door de ogen open te houden en altijd een camera bij de hand te hebben. Zulke foto's hebben weinig blijvende artistieke waarde, maar zij zorgen altijd wel voor een glimlach bij de kijker.

Esta fotografía y la anterior sólo se pueden obtener cuando uno lleva siempre la cámara consigo y mantiene los ojos bien abiertos en busca de la oportunidad. Tales fotografías no suelen destacar por sus valores artísticos, pero en algunos casos pueden resultar muy graciosas.

Autre exemple d'à-propos: c'est là une photographie qu'il n'est possible d'obtenir qu'en étant toujours en alerte et en portant toujours un appareil photographique sur soi. De telles images n'ont pas une valeur artistique bien durable, mais elles se vendent toujours bien si elles font rire, comme c'est le cas de ce châlit en marche.

209

Photographer Mike Hollist
Camera Nikon
Lens 105mm
Exposure 1/250 at f/5.6
Film Tri-X

Even baby hippos can be appealing and the shyness shown by "Winnie" at Whipsnade Zoo as she peeps out from behind her mother made this a worthwhile shot. Shortly after she left for South Africa to boost the dwindling hippo population.

Auch Nilpferd-Babies können süss wirken, und die Schüchternheit, mit der "Winnie" im Tiergarten Whipsnade hinter ihrer Mutter hervorguckt, hat ein lohnendes Bild ergeben. Kurz danach wurde Winnie nach Südafrika verfrachtet, wo angesichts des Dahinschwindens der Nilpferd-Bevölkerung ein Bedarf an diesen Tieren besteht.

Zelfs een nijlpaardbaby kan aantrekkelijk zijn. De verlegenheid die deze 'baby' toont als zij voorzichtig vanachter haar moeder de wereld ingluurt maakt de opname de moeite waard. Kort nadat de foto werd gemaakt werd de baby naar Afrika overgebracht om de uitstervende nijlpaarden-populatie te versterken.

Esta instantánea deriva su interés de la fascinación ejercida por la pequeña hipopótamo "Winnie", habitante del Zoo de Whipsnade, al asomar tímidamente la cabeza por detrás de su madre. Poco tiempo después se la trasladó a Sudáfrica, país que está tratando de aumentar el número de hipopótamos que viven en sus selvas.

Même les bébés hippopotames peuvent être émouvants, et la timidité de "Winnie", du zoo de Whipsnade, au moment où elle se montre avec circonspection derrière sa mère, est l'élément qui fait la valeur de cette photographie. Peu après, elle devait être emmenée en Afrique du Sud pour augmenter la population des hippopotames parmi laquelle sévit une forte baisse de natalité.

210

Photographer Rudolf Bieri
Camera Leicaflex R3
Lens 180mm Apotelyt
Film Tri-X

A very natural picture which could be snatched at any time on almost any railway station by the photographer on the lookout with a camera at the ready. This picture poses a question and that is always intriguing. A powerful tone scheme adds impact.

Ein sehr natürliches Bild, das jederzeit und nahezu auf jedem Bahnhof aufgenommen werden könnte, vorausgesetzt dass der Fotograf die Kamera bereithält. Dieses Bild stellt eine Frage, was stets das Interesse fördert. Die kräftigen Töne erhöhen die Wirkung.

Een heel natuurlijke foto die op elk moment en op elk spoorwegstation zou kunnen worden gemaakt door een fotograaf die er oog voor heeft en zijn camera paraat heeft. De opname roept een vraag op en dat is altijd intrigerend.

Una instantánea totalmente natural que uno puede captar a cualquier hora en una estación de ferrocarril si espera con paciencia a que se presente la oportunidad. El poderoso esquema tonal acentúa el impacto producido por el propio tema de la imagen, el cual abre un fascinador interrogante.

Photographie très naturelle qui pourrait être prise à n'importe quel moment et dans presque n'importe quelle gare par un photographe attentif équipé d'un appareil prêt à servir. Cette photographie soulève une question, et cela ne laisse jamais d'intriguer. Une puissante palette de tons lui confère en outre de l'impact.

211

Photographer Peter Hense
Camera Nikon F2A
Lens 24mm
Film Tri-X

A very dramatic view of a game of Boule achieved by an extremely low angle which turns the player into a giant. The tone scheme is powerful and the shading in the sky is acceptable because it balances the composition and adds atmosphere.

Eine sehr dramatische Aufnahme einer Boule-Partie. Der extrem niedrige Aufnahmestandpunkt hat aus dem Spielenden einen Riesen gemacht. Die Tönung ist dramatisch und die Schattierung des Himmels angemessen, da sie der Komposition Gleichgewicht verleiht und die Stimmung hervorhebt.

Een interessante visie op een spelletje 'jeu-de-boules', verkregen door een bijzonder laag standpunt dat de speler vooraan verandert in een reus. Het toonwaardenschema is krachtig; de nuancering in de lucht is verantwoord omdat zij de compositie in evenwicht brengt en sfeer toevoegt.

Dramática instantánea obtenida con un punto de vista bajo que convierte al jugador en un gigante. El esquema tonal posee gran energía, y el sombreado del cielo es aceptable porque equilibra la composición y da relieve a la atmósfera de la imagen.

Vue particulièrement saisissante d'une partie de pétanque, obtenue par une prise de vue en très forte contre-plongée, qui fait du jouer un géant. La palette des tons est puissante et l'ombrage du ciel est acceptable du fait qu'il équilibre la composition tout en ajoutant de l'ambiance.

212

Photographer Hartmut Rekort
Camera Pentax
Lens 135mm Takumar
Exposure 1/1000 at f/11
Film HP5

A picture which is successful because it will arouse a sympathetic reaction in every viewer who has ever been on a beach. In addition it is full of action and doggie appeal with even a touch of humour.

Ein Bild, dessen Erfolg darauf beruht, dass es jeden Betrachter, der jemals auf einem Strande war, ansprechen dürfte. Auch ist es sehr lebensvoll, das Hündchen wirkt bezaubernd, und ausserdem hat es auch einen gewissen Humor.

Een foto die succes heeft doordat hij een waarderende reactie zal opwekken bij ieder die wel eens op een strand is geweest. De opname is vol actie en niet ontbloot van humor.

La eficacia de esta imagen reside en el hecho de que despertará en seguida las simpatías de las personas que aman las playas. No falta, por otra parte, la acción y es incluso posible encontrar en ella unas leves gotas de humor.

Photographie réussie parce qu'elle ne manquera pas de soulever une réaction de sympathie chez toute personne ayant jamais vu une plage. Elle est en outre pleine d'action, très touchante et même non dénuée d'humour.

213

Photographer Peteris Jaunzems
Camera Zenith
Film Dulovic

A much more dramatised version of a beach scene than the one on the opposite page, but also with a touch of humour. Shooting against the light has given a lot of sparkle to the print and enabled the author to use very strong tones without destroying the holiday atmosphere.

Eine viel dramatischere Variante einer Strandszene als auf der gegenüberliegenden Seite, doch ebenfalls mit einigem Humor. Durch Aufnahme gegen das Licht wurde der Kopie erhebliche Lebhaftigkeit verliehen, und der Künstler konnte von sehr kräftigen Tönen Gebrauch machen, ohne die Urlaubsstimmung zu beeinträchtigen.

Een veel meer gedramatiseerde versie van een strandscène dan die op de tegenoverliggende bladzijde, maar ook wel met een vleugje humor. Het tegenlicht zorgde voor een sprankelend effect en stelde de fotograaf in staat krachtige toonwaarden toe te passen zonder de vakantiesfeer te verstoren.

Esta escena de playa resulta mucho más dramática que la anterior, pero presenta también algunos rasgos de humor. Al disparar la cámara a contraluz el autor ha proporcionado gran viveza a la copia y ha podido utilizar tonos muy fuertes sin llegar a destruir la atmósfera de fiesta.

Version d'une scène de plage rendue beaucoup plus saisissante que celle de la page opposée, mais également empreinte d'humour. La prise de vue en contre-jour a donné beaucoup d'éclat au tirage et permis à l'auteur d'utiliser des tons très marques sans détruire l'atmosphère de vacances.

214/215

Photographer Peteris Jaunzems
Camera Zorki
Lens 50mm Russar
Film Dulovic

A successful example of printing an image one way and then reversed left to right as if in a mirror. The idea of the horses appearing to be talking to each other was good and the whole picture looks genuine because the separately printed sky has avoided any possibility of a join being seen. One of the most impressive tone simplification pictures seen this year.

Hier wurde ein Bild mit Erfolg auf eine Weise kopiert und dann spiegelbildlich umgekehrt. Es war eine gute Idee, die Pferde so darzustellen, als wenn sie sich miteinander unterhielten, und das ganze Bild wirkt echt, da es dank dem getrennt gedruckten Himmel unmöglich ist eine Verbindung zu sehen. Dies war eines der eindrucksvollsten Bilder mit vereinfachten Tönen, die dieses Jahr eingereicht wurden.

Een interessant voorbeeld van een 'spiegelbeeld'-vergroting. De paarden lijken met elkaar in gesprek te zijn. Doordat de lucht afzonderlijk werd ingedrukt is er op geen enkele wijze een afscheiding tussen de twee beeldhelften te zien, zodat het lijkt of het om een enkele opname gaat.

Esta fotografía se ha obtenido copiando la imagen dos veces, invertida en la segunda ocasión en relación con la primera. Nos encontramos entonces con dos caballos que parecen mantener una conversación, impresión que se ve acentuada por el copiado separado del cielo que ha desterrado la posibilidad de que se percibiera la unión. Esta instantánea presenta una de las más eficaces simplificaciones tonales que hemos visto este año.

Exemple réussi de tirage d'une photographie d'abord dans un sens puis retournée de la gauche vers la droite pour donner un effet de miroir. L'idée des chevaux qui semblent converser entre eux était bonne, et toute la photographie semble vraie parce que le ciel tiré séparément a permis de supprimer toute possibilité de voir un joint. C'est là un des exemples le plus impressionnants de simplification de tons vus cette année.

216

Photographer Stephen Shakeshaft
Camera Nikon
Lens 25mm
Film Tri-X

In the year of *Star Wars, Wonder Woman* and other TV fantasies it was inevitable that we should receive many pictures of the actors in space age costumes. This is a typical example – not particularly artistic but a bit of fun and certainly glamorous.

In dem Jahre, in dem *Star Wars, Wonder Woman* und andere Fernseh-Fantasien gebracht wurden, war es wohl unvermeidlich, dass uns viele Bilder zugingen, in denen die Modelle "Space Age"-Kleidung trugen. Dieses Beispiel ist typisch. Es ist nicht besonders künstlerisch, doch recht humorvoll und bestimmt sehr "modebewusst".

In een tijd waarin science fiction-films hoogtij vieren is het niet zo vreemd foto's tegen te komen van acteurs en actrices in ruimtevaartcostuums. Dit is een typisch voorbeeld: niet bijzonder artistiek, maar met humor en zeker aantrekkelijk.

En un año en el que películas como *La guerra de las galaxias, Wonder Woman* y demás series televisivas de cienca-ficción han cosechado tantos éxitos era inevitable que recibiéramos alguna instantánea con protagonistas enfundados en trajes especiales. Este es un ejemplo típico; no posee grandes cualidades artísticas, pero resulta espectacular y graciosa.

L'année de *Star Wars, Wonder Woman* et d'autres autres fantaisies de la télévision, il était inévitable de recevoir de nombreuses photographies d'acteurs porteurs de costumes de l'âge de l'espace. Nous en avons là un exemple type, qui n'est pas particulièrement artistique, mais qui ne manque pas d'humour et qui est assurément fascinant.

217

Photographer Steve Butler
Camera Nikon F
Lens 50mm with red filter
Exposure Flash at f/5.6
Film Tri-X

A glamour picture in which the "sultry" look has been augmented by the wet hair and shiny plastic jacket. All this has combined to produce very good modelling and texture rendering. The low viewpoint has perhaps added a touch of hauteur as well.

In diesem Bild wird der "erotische" Effekt durch das nasse Haar und die glänzende Kunststoffjacke verstärkt. Das Endergebnis besteht in einem sehr plastischen Eindruck und guter Wiedergabe der Textur. Durch den niedrigen Aufnahmestandpunkt wurde wohl auch eine hochmütige Note erzielt.

Een glamourfoto waarin de 'zwoele' blik werd ondersteund door het natte haar en het glimmende plastic jasje. Het lage standpunt verleende het model iets hautains.

En este homenaje a la belleza femenina el cabello húmedo y la chaqueta de plástico brillante acentúan la seductora impresión producida por la mirada de la modelo. También el punto de vista bajo ha añadido cierto "toque" de distanciamiento, combinándose con los demás elementos para producir un excelente modelado y una perfecta captación de las texturas.

Photographie de mode sur laquelle l'air boudeur est renforcé par les cheveux mouillés et par la veste en matière plastique brillante. Tous ces éléments se sont ajoutés pour donner une excellente texture. La prise de vue en contre-plongée a peut-être ajouté aussi une touche de hauteur.

218

Photographer Vlado Bača
Camera Pentacon Six
Lens 50mm Flektogon
Exposure 1/30 at f/4
Film Orwo NP 20

At one time it was considered inartistic to place a head in the centre of a picture. Now it has almost become *de rigueur*, and even better when the rest of the picture is symmetrical, often by using a road or a bridge also in the centre. This is a good example and the expression, plus a good presentation, stimulates the imagination.

Früher einmal galt es als unkünstlerisch, einen Kopf in der Mitte eines Bildes zu zeigen. Nun ist es nahezu *de rigueur*, und die Wirkung ist noch besser, wenn der Rest des Bildes symmetrisch ist. Dies wird oft dadurch erreicht, dass man eine Strasse oder eine Brücke, ebenfalls in der Mitte, in das Bild einbezieht. Dies ist ein gut geglücktes Beispiel dieser Technik, und der Gesichtsausdruck sowie die einwandfreie Präsentation regen die Fantasie an.

Er was een tijd waarin het niet artistiek werd gevonden een hoofd in het midden van het beeld te plaatsen. Nu is het bijna mode geworden en wordt liefst ook de rest van de foto symmetrisch gehouden. Vaak wordt het gedaan met gebruikmaking van een weg of een brug, zoals in dit voorbeeld, waarin de verbeelding op intrigerende wijze wordt gestimuleerd door de gelaat-suitdrukking.

En ciertas épocas se ha considerado de mal gusto el situar una cabeza en el centro de una instantánea. En la actualidad se ha convertido casi en algo de rigor, sobre todo cuando el resto de la imagen es totalmente simétrica y presenta, también en su centro, una carretera o puente. Aquí tenemos una buena muestra de esta nueva tendencia, en la que destaca su excelente presentación.

Il fut un temps où l'on considérait comme peu artistique de placer une tête au centre d'une photographie. Aujourd'hui, cela est presque de rigueur, et est même jugé préférable lorsque le reste de l'image est symétrique. A cette fin, on utilise souvent une route ou un pont, également placés au centre. Nous avons là un bon exemple où l'expression, ajoutée à une bonne présentation, stimule l'imagination.

219

Photographer Stephen Shakeshaft
Camera Nikon
Lens 400mm Novoflex
Film Tri-X

The American Open Champion, Hale Irwin, seen in a "letter box" view instead of the more usual driving or putting situations. This well known *Liverpool Post and Echo* photographer always seems to put a more original, as well as artistic, interpretation on his news pictures.

Hale Irwin, der amerikanische Open Golf-Meister, ist hier wie durch einen "Briefkastenschlitz" hindurch zu sehen, und nicht wie sonst in verschiedenen Golfsituationen. Dieser bekannte Fotograf der Zeitung *Liverpool Post and Echo* scheint stets besonders originelle und künstlerische Presseaufnahmen zu liefern.

Een 'brievenbus'-foto van de Amerikaanse golfkampioen Hale Irvin. De fotograaf, die wij in dit jaarboek reeds herhaaldelijk tegenkwamen, weet in zijn nieuwsfoto's steeds een originele én artistieke interpretatie te leggen.

Aquí vemos al gran jugador de golf americano Hale Irwin enmarcado como en un buzón en lugar de la fotografía corriente del jugador golpeando la bola. Este conocido fotógrafo del *Liverpool Post and Echo* inventa continuamente nuevas y originales formas de presentación de sus instantáneas.

Hale Irwin, champion américain de golf, vu dans une "boîte à lettres" et non pas, comme il est si courant, en train de jouer une crossée ou de poter la balle. Ce

photographe, bien connu, du *Liverpool Post and Echo* semble donner à ses photographies de reportage une interprétation plus originale et même artistique.

220

Photographer Peteris Jaunzems
Camera Zenith
Lens 50mm Helios
Film Dulovic

Entitled *Revelation* this print will set every viewer wondering about its significance and probably everyone will put a different interpretation on it. Whatever the result it is a highly creative and artistic montage.

Jeder Betrachter wird sich fragen, was wohl mit dieser Kopie, die den Titel *Erkenntnis* trägt, gemeint ist. Gewiss kann man das Bild auf verschiedene Weisen interpretieren. Jedenfalls ist dies eine sehr schöpferische, künstlerische Montage.

Deze foto, die de titel 'Openbaring' draagt, zal elke kijker aan het denken zetten over de betekenis ervan. Waarschijnlijk zal ieder er een aparte interpretatie van geven. Hoe dan ook, het resultaat is een bijzonder creatieve en artistieke montage.

Esta instantánea, titulada *Revelación*, será probablemente interpretada de mil maneras distintas. En todo caso hay que reconocer que se trata de un montaje extraordinariamente creativo.

Intitulé "Revelation" (Révélation), ce tirage aura pour effet d'inciter le spectateur à s'interroger sur sa signification, et chacun en donnera probablement une interprétation différente. Quel qu'en soit le résultat, c'est là un montage très expressif et très artistique.

221

Photographer R. Rakanskas

A delightful and original montage which could be interpreted as an exercise in balanced design. The dainty prancing of the white horse is pleasing and stimulates a feeling of movement into the centre of the picture space.

Eine entzückende, originelle Montage, die wie eine Übung in ausgeglichener Komposition wirkt. Das zierliche Tänzeln des weissen Pferdes ist ansprechend und gibt ein Gefühl der Bewegung in die Mitte des Bildraums.

Een fijne en originele fotomontage die zou kunnen worden geïnterpreteerd als een oefening in evenwichtige compositie. De sierlijke gang van het witte paard is plezierig en stimuleert een gevoel van beweging naar het midden van het beeld toe.

He aquí un montaje deliciosamente original que se podría interpretar como un ejercicio de equilibrio compositivo. El elegante avance del caballo blanco introduce una agradable impresión de movimiento en el centro de la imagen.

Délicieux montage, qui se signale par son originalité, et qui pourrait être interprété comme un exercice de composition équilibrée. L'allure fringante, mais combien délicate, du cheval blanc est plaisante et engendre une impression de mouvement au centre de la photographie.

222

Photographer Frank Peeters
Camera Nikkormat FT 3
Lens 28mm
Film Tri-X

An interesting design photograph with a rhythmic echo created by the repetition of similar shapes both in the gables and the turrets. The author has intensified the effect by using a red filter and contrasty printing. The window below provides a good counter shape and is an important element in the composition.

Eine interessante Komposition, bei der die Wiederholung ähnlicher Giebel- und Turmformen ein rhythmisches Echo erzeugt. Der Künstler hat den Effekt durch ein Rotfilter und kontrastreiches Kopieren verstärkt. Das Fenster unten schafft ein gutes Gleichgewicht und bildet ein wichtiges Element der Komposition.

Een interessante foto met een ritmische herhaling van gelijke vormen, zowel de gevels als de torentjes. Peeters verhoogde het effect door een roodfilter te gebruiken en contrastrijk te vergroten. Het venster onderin is een goede tegenvorm en als zodanig een belangrijk element in de compositie.

Interesante instantánea dotada de un eco rítmico creado por la repetición de formas similares en los aguilones y las torres. El autor ha intensificado este efecto mediante la utilización de un filtro rojo y un copiado contrastante. La ventana de abajo constituye un interesante contrapunto y se revela como uno de los más importantes elementos de la composición.

Intéressante composition à l'écho rythmique engendré par la répétition de formes semblables tant dans les pignons que dans les tourelles. L'auteur a intensifié l'effet en recourant à un filtre rouge et à un tirage contrasté. La fenêtre du dessous constitue une excellente contre-forme, en même temps qu'un élément important de la composition.

223

Photographer Jose Torregrosa
Camera Nikon F
Lens 135mm
Film Tri-X

Millions see buses every day but very few would have seen photographic possibilities in part of one. This shot not only reveals a "seeing eye" but also a fine sense of design in the contrast between two simple shapes. And the kettle completes a story!

Millionen Menschen sehen jeden Tag Omnibusse, doch sehr wenige hätten die fotografischen Möglichkeiten in einem Teil eines Omnibusses erkannt. Diese Aufnahme erweist nicht nur die hochentwickelte Beobachtungsgabe des Künstlers sondern auch sein feines Gefühl für Komposition, das aus dem Kontrast zwischen zwei einfachen Formen hervorgeht. Und der Kessel vervollständigt die Story.

Miljoenen mensen zien elke dag autobussen, doch slechts weinigen zien fotografische mogelijkheden in een detail ervan. Deze foto onthult niet alleen een 'ziend oog', maar ook een fijn gevoel voor verhoudingen in het contrast tussen de twee simpele vormen. Het keteltje completeert het verhaal!

Millones de personas ven autobuses diariamente pero muy pocas serían capaces de sacar partido de las posibilidades plásticas ofrecidas por ellos. En esta instantánea su autor revela poseer no sólo una "mirada inquisitiva" sino también una extraordinaria capacidad para la combinación de las formas.

Des millions de gens voient des autobus chaque jour, mais bien peu d'entre eux auraient vu des possibilités photographiques dans une partie de l'un de ces véhicules. Cette photographie révèle non seulement un sens de l'observation, mais aussi un sens aigu de la composition dans le contraste entre deux formes simples. Et la bouilloire complète l'histoire!

224

Photographer Domingo Batista
Camera Canon F 1
Lens Canon 135mm

The sad and thoughtful expression of a young negro in Dominica is very well portrayed in this picture. Having half the face in darkness has a certain significance and the plastic lighting on the other half is photography at its best.

Der traurige, nachdenkliche Gesichtsausdruck eines jungen Negers in Dominica ist in diesem Bild sehr gut eingefangen. Dass sich das halbe Gesicht in Dunkelheit befindet, hat eine gewisse Bedeutung, und die plastische Beleuchtung der anderen Hälfte ist fotografische Kunst im besten Sinn des Wortes.

De nadenkende uitdrukking van deze jonge neger uit de Dominicaanse Republiek werd in deze opname goed vastgelegd. Het feit dat de helft van het gezicht in de schaduw is gebleven heeft een bepaalde betekenis. De plastische verlichting van de andere helft is 'fotografie op z'n best'.

En esta instantánea aparece perfectamente captada la expresión triste y pensativa de un negro dominicano. El hecho de que la mitad de la cara permanezca en la oscuridad posee un especial significado y la plástica illuminación de la otra mitad revela un perfecto dominio de la técnica fotográfica por parte del autor.

L'expression triste et pensive d'un jeune noir de la République Dominicaine est très bien saisie sur cette photographie. Le fait que la moitié du visage soit dans l'ombre a une certaine signification, et l'éclairage plastique de l'autre moitié fait de cette photographie un modèle du genre.

Back Endpaper

Photographer Joseph Cascio
Camera Nikon F
Lens 50mm Nikkor
Film Tri-X

A tremendous picture of a bull ring at night which is teeming with action. In spite of the large number of people involved it holds together as a composition because of the concentration of light in the centre.

Ein wundervolles, dynamisches Bild einer Stierkampfarena bei Nacht. Trotz der grossen Anzahl der in der Arena befindlichen Menschen ist die Komposition dank der Konzentration des Lichts in der Mitte einwandfrei.

Een schitterende foto van een avondlijk stierengevecht, die krioelt van de actie. Ondanks het grote aantal betrokken personen blijft de foto als compositie overeind dankzij de concentratie van het licht in het midden.

Tremenda imagen nocturna de una plaza de toros, en la que la acción se da a manos llenas. A pesar del gran número de personas recogidas, la composición no sufre menoscabo gracias a la acumulación de luz en el centro.

Extraordinaire image d'une arène la nuit, bouillonnante d'action. En dépit du grand nombre de personnes rassemblées, elle donne l'impression d'une composition par suite de la concentration de la lumière au centre.

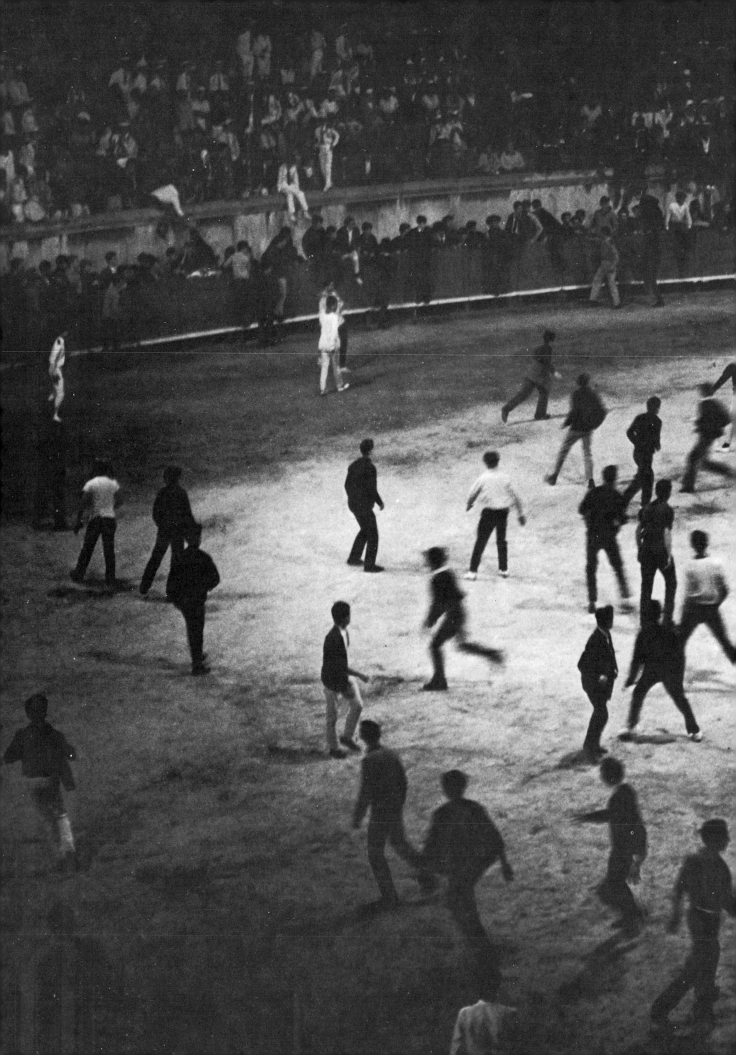